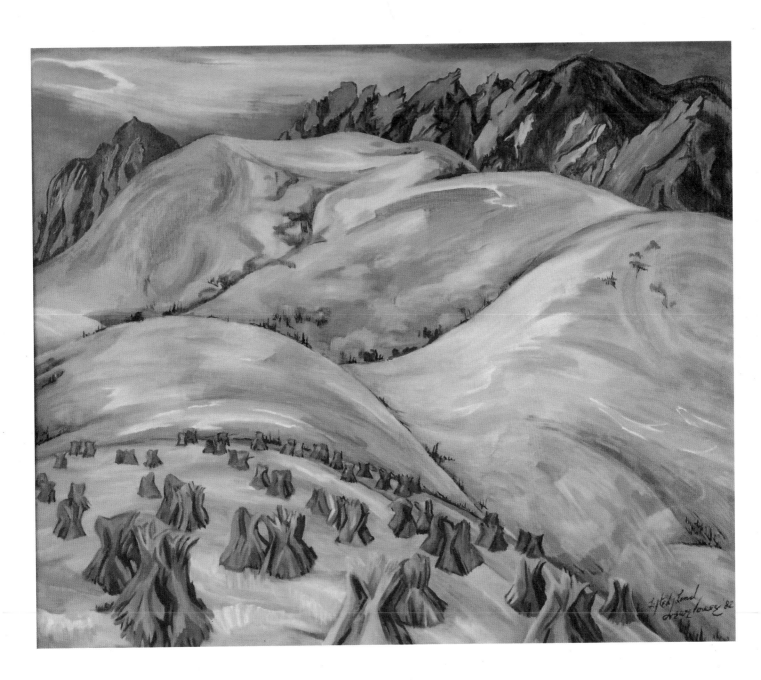

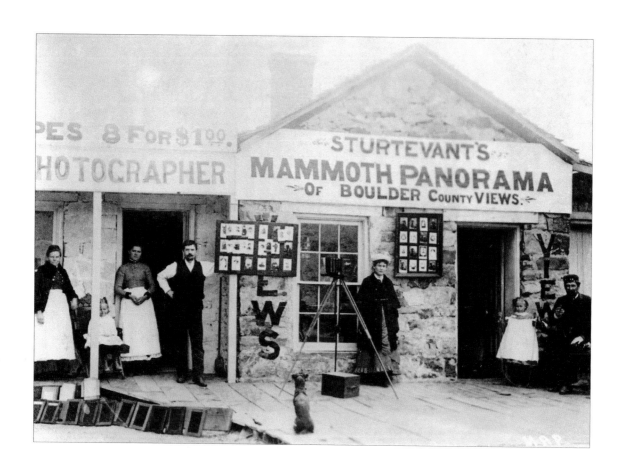

Above: Joseph Bevier Sturtevant (1851-1910), "J.B. Sturtevant's Photo Gallery," c. 1885, silver gelatin print. Courtesy of Art Source International.

Previous page: Eve Drewelowe (1899-1989), "Faces and Findings: The Past in the Present," 1982, oil on canvas. Collection of the City of Boulder.

Celebration!

A HISTORY OF THE VISUAL ARTS IN BOULDER

CELEBRATION! A HISTORY OF THE VISUAL ARTS IN BOULDER

Thanks to our

BENEFACTORS

Mark and Polly Addison | Avondale Trust | Boulder Arts Commission | Boulder Convention and Visitors Bureau | Jane Butcher | Jack Mullen | Boulder Library Foundation | Fine Arts Foundation | Andy & Audrey Franklin | Stephen Tebo/Tebo Properties

SPONSORS

Boulder County Arts Alliance | Tom and Carol Brock/Brock Media | Nini Coleman/phatpencil | *Daily Camera* | Jane Dalrymple-Hollo | Tom Dugan | Katie Elliott/3rd Law Dance-Theater | First National Bank of Omaha | Felicia Furman | Noel & Terry Hefty | Jewish Colorado/Bellock Morrison Philanthropic Foundation | Kathryn Keller/ReMax of Boulder | KGNU 88.5 FM/1390 AM | Clarissa King | Midge Korczak | Brandon Miller | Sacha Millstone/The Millstone Evans Group | Helmut Müller-Sievers/University of Colorado Center for Humanities and Arts | Sam and Cheryl Sussman/8 Days a Week | John Tayer/Boulder Chamber | Nicky Wolman

PARTNERS

Alison and Kurt Burghardt | Julie Carpenter | Michael & Tracy Ehlers |Kay Howe | Kevin Kelley | Gretchen C. King | Janet Martin | Janice McCullagh | Jim Palmer & Sue MacDougal Palmer | Robert Pelcyger & Joan C. Lieberman | Helen Redman | Diane Rosenthal | Alan Rudy | Cynthia Schmidt | Bud & Barbara Shark | Joyce Thurmer | Sherry Wiggins & Jamie Logan

FRIENDS

Elizabeth Abbott | Anonymous | Anonymous | Anonymous | Clark Barker & Melanie Yazzie | Wendy Baring-Gould | Cynthia Baxt | Anne Bliss | Joyce Bronson | Doug Caven | Amy Guion Clay | Joseph Clower | Priscilla Cohan | Poppy Copeland | Mark R. Correll | Gayle Crites | Benita Duran | Kathi George | Ann Getches | Margaretta Gilboy | Julie Golden | Marcelee Gralapp | Joanne Grillo | Betsy Jordan Hand | Jon T. & Jerrie Hurd | Linda Kelly | Linda Lowry | Ann Luce | Caroline Malde |Nancy Maron | Peter Michelson | Kathleen Noe | Bunny Pfau | Judith Potter | Elisabeth Relin | Alice Renouf & Jon Rush | Jeffrey Robinson | Cynthia Schmidt | Cindy & David Sepucha | Sally Shankman | Rickie Solinger | George Tuton | Pauline Wanderer | Doug West | Donald Yannacito | Lois B. Youngman | Dinah Zeiger

And so many others for their ongoing support and encouragement.

Celebration!

A HISTORY
OF THE
VISUAL ARTS IN
BOULDER

EDITED BY JENNIFER HEATH
PREFACE BY MARK ADDISON

ISBN 1-887997-37-7

Celebration! A History of the Visual Arts in Boulder
is
dedicated to the memory of
Karen Ripley Dugan
1939-2015

Photo by Cheri Belz, 1981.

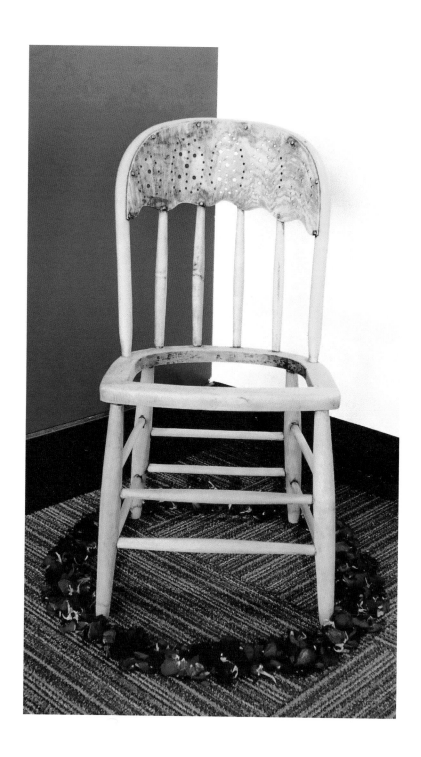

Antonette Rosato (1952-2006), "Altered Chair," from *The World So Far as I Know It*, c. 2003, wood. Collection of Deborah Haynes.

Contents

❖ LIST OF ILLUSTRATIONS — xi

❖ PREFACE: PERSONAL REMEMBRANCES
Mark Addison — xiii

❖ INTRODUCTION: TOWARD A LASTING LEGACY
Jennifer Heath — 1

❖ SHAPING BOULDER'S AESTHETIC: A BRIEF HISTORY
Carol Taylor — 9

❖ THE ART-ING OF DOWNTOWN BOULDER:
A PORTRAIT OF CARL A. WORTHINGTON
Collin Heng-Patton — 19

❖ WOMEN AT WORK: THE VISUAL ARTS IN BOULDER PRIOR TO 1950
Kirk T. Ambrose — 23

❖ WOW: THE STRUGGLE TO ESTABLISH A WOMAN'S MUSEUM
Collin Heng-Patton — 33

❖ LANDSCAPE AS NARRATIVE
Joan Markowitz — 35

❖ THE EXTRAORDINARY ARTISTIC PULSE OF THE UNIVERSITY OF
COLORADO'S VISITING ARTIST PROGRAM
Jade Gutierrez — 45

❖ A BOULDER HISTORY OF ART CINEMA: I'M NOT STEVE SEID,
AND THIS ISN'T RADICAL LIGHT
J. Gluckstern — 49

❖ FEATURE FILMS: BOULDER'S INVITING SURROUNDINGS FOR MOVIEMAKERS
Heather Perkins — 57

❖ SHARK'S INK: MAGIC FROM A MASTER PRINTMAKER
Collin Heng-Patton — 61

❖ ARTISTS OF PATTERN AND PARADOX: THE CRISS-CROSS COLLECTIVE
Jack Collom — 63

❖ PORTRAIT OF A BELOVED BOULDER ARTIST: ESTA CLEVENGER
Jane Wodening — 67

❖ ALWAYS A BOOK TOWN: A HISTORY OF BOOK ARTS IN BOULDER
Jane Dalrymple-Hollo — 69

❖ AN ADVENTURE IN CONFLUENCES, OR "STILLING THE WHIRLPOOLS OF THE MIND":
THE VISUAL ARTS AT NAROPA
Laura Marshall — 73

❖ A SHARED HISTORICAL MOMENT: FRONT RANGE WOMEN IN THE VISUAL ARTS
Fran Metzger — 79

❖ THE ESSENCE OF ART AS ACTIVISM
 Carol Kliger 81

❖ ONE WOMAN'S EFFORTS TO BLAZE A NEW PATH FOR ART IN THE
 ERA OF CLIMATE CHANGE: ECOARTS CONNECTIONS
 Nora Rosenthal 89

❖ DIVERSITY IN BOULDER ARTS: THIRTEEN VOICES
 Glenda Russell, George Rivera, Gesel Mason, Alan O'Hashi,
 Firyal Alshalabi, Carmen Reina-Nelson, Alphonse Keasley,
 Benita Duran, Melanie Yazzie, Donna Mejia, Daniel Escalante,
 Norma Johnson, Nikhil Mankekar 93

❖ LONGMONT'S RICH VISUAL ARTS HISTORY
 Lisa Truesdale 105

❖ PORTRAITS OF BOULDER ARTISTS BY BOULDER ARTISTS 109

❖ ARTISTS AT THE ABBEY 112

❖ THE CU ART MUSEUM: ITS DISTINGUISHED PAST AND NEW HORIZONS
 Jade Gutierrez 113

❖ FROM A TUMULTUOUS PAST TOWARD AN EXHILARATING FUTURE:
 BOULDER MUSEUM OF CONTEMPORARY ART
 Collin Heng-Patton 119

❖ BAG: A GENESIS STORY
 Tree Bernstein 125

❖ FROM MILK HOUSE TO ART HOUSE: THE DAIRY ARTS CENTER
 Collin Heng-Patton 127

❖ THE EYES HAVE IT: A HISTORY OF VISUAL EYES
 Kathy Mackin 135

❖ OPEN STUDIOS: A WIN-WIN PROPOSITION
 Brenda Niemand 137

❖ GETTING TO YES (AND BEYOND):
 SKIRMISHES AND COMPROMISES IN BOULDER PUBLIC ART
 Dinah Zeiger 145

❖ THE QUEEN BEE OF BOULDER CULTURE:
 A TRIBUTE TO KAREN RIPLEY DUGAN
 Jennifer Heath 159

 ❖ BIBLIOGRAPHY 163

 ❖ ABOUT THE ARTISTS, CURATORS, AND CONTRIBUTORS 165

 ❖ EXHIBITION CHECKLIST 212

 ❖ ACKNOWLEDGMENTS 221

 ❖ PROCLAMATION 222

LIST OF ILLUSTRATIONS

❖ Eve Drewelowe, "Faces and Findings: The Past in the Present" — i

❖ Joseph Bevier Sturtevant, "J.B. Sturtevant's Photo Gallery" — ii

❖ Cheri Belz, Karen Ripley Dugan — vii

❖ Antonette Rosato, "Altered Chair" — viii

❖ Haertling Gallery poster — xiii

❖ Richard Varnes, "Bill Vielehr" — xiv

❖ Celeste Rehm, "Taking the Law into Your Own Horns" — xiv

❖ Jerry Wingren, "Alabaster Study for Interiors" — xiv

❖ Robert Bellows, "Alfie" — xiv

❖ Sibylla Matthews, "Rhino Rump" — xiv

❖ Betty Woodman, "Alessandro's Room" — xv

❖ Patricia Bramsen, "Gerund" — xv

❖ Virginia Maitland, "Annunciation" - — xv

❖ Robert Ecker, "The Ecology of Time" — xvi

❖ Jim Johnson, "The Adventure of the Dancing Men" — xvi

❖ Frank Sampson, "A Candle-light Party" — xvii

❖ Dale Chisman, "Indian Rope Trick" — xviii

❖ *Harper's Weekly*, June 20, 1874 — 1

❖ Michael Lichter, "Ready for Takeoff" — 2

❖ William S. Sutton, "Dead Horse" — 2

❖ Richard Van Pelt, "Flatiron Gravel" — 3

❖ Carol Kliger, "Cut Pushed Tiles" — 4

❖ Jane Dillon, Untitled — 4

❖ Elaine Nixon, "Oriental Red Poppies" — 5

❖ Barb Olson, "Scattering Leaves" — 5

❖ San Juan del Centro mural — 6

❖ The Eccentric Garden — 7

❖ Elisabeth Relin, "Feet" — 8

❖ Charles Partridge Adams, Untitled — 9

❖ Steven Weitzman and Tara Brice, "Chief Left Hand" — 10

❖ Joseph Bevier Sturtevant, "Building the Shelter Road" — 11

❖ The "Art Hall" at Chautauqua — 12

❖ Old Firehouse #2 — 14

❖ George Woodman, "Betty Woodman," poster — 14

❖ Highland-Lawn School — 15

❖ Tulagi — 16

❖ Llloyd Kavich and mural details — 16

❖ Marilyn Markowitz, "Mountain Climber" — 18

❖ "Pearl Street Happening" — 19

❖ Carl A. Worthington — 19

❖ Saturday night at Gallery 1309 — 20

❖ Andrew Libertone, "Set Top Box" — 21

❖ Ann Jones, "Flatirons" — 22

❖ Eve Drewelowe, "The Tetons — Wyoming" — 23

❖ Adma Green Kerr, Untitled — 25

❖ Matilda Vanderpoel, "A Young Artist" — 26

❖ Myrtle Hoffman Campbell, "Old Spanish Mission" — 27

❖ Muriel Sibell Wolle with students — 28

❖ Muriel Sibell, "Leadville Stumptown" — 29

❖ Virginia True, "Rocks and Trees" — 30

❖ Hung Liu, "Sisters" — 33

❖ Anita Rodriguez, *Homenaje á Selena* — 33

❖ Alison Saar, "Washtub Blues" — 34

❖ Emmi Whitehorse, "Jackstraw" — 34

❖ Chuck Forsman, "Sacred Cows" — 35

❖ Elmer P. Green, "Boulder Falls" — 36

❖ Max Beckmann, "Boulder-Rocky Landscape" — 37

❖ Elizabeth Black, "Isabella and Jim Ascend" — 38

❖ Joseph Daniel, "On the Tracks at Rocky Flats" — 39

❖ John Matlack, "Landfill" — 40

❖ Jerry Kunkel, "Enough Said (Thomas Moran)" — 40

❖ Don Coen, "Manuel" — 41

❖ Robert Adams, "Wheat Stubble, South of Thurman" — 42

❖ Gayle Crites, "Simpatico" — 43

❖ Lynn Wolfe, "Spanish Dagger" — 45

❖ H.C. Westermann to Lynn Wolfe — 46

❖ Gene Matthews, "Forum 2" — 48

❖ Stacey Steers, *Phantom Canyon* (still) — 49

❖ Joel Haertling and Stan Brakhage, *Song of the Mushroom* (still) — 50

❖ Stan Brakhage at the blackboard — 51

❖ Philip Solomon, *Psalm IV: "Valley of the Shadow"* (still) — 52

❖ Mary Beth Reed, *Floating Under a Honey Tree* (still) — 53

❖ Patti Bruck, *House of Hazards* (still) — 54

❖ Jim Otis, *On Your Own* (still) — 55

❖ Robert Schaller, *To the Beach* (still) — 56

❖ James Balog, "Ilulissat Isfjord, Greenland" — 57

❖ Charles Haertling, Brenton House — 58

❖ Luis Eades, "Transoceanic 1" — 59

❖ Daniel Friedlander, "Isotope Breakfast" — 60

❖ Barbara Shark, "Lunch at Greens" — 61

❖ Barbara Takenaga, "Angel (Little Egypt) State I" 62

❖ George Woodman, "Parma" 63

❖ Clark Richert, "I.C.E." (detail) 64

❖ Richard Kallweit," Escher's Ladder" 64

❖ Marilyn Nelson, Untitled 65

❖ Charles DiJulio, "Reconstruction with Accuracy" 66

❖ Esta Clevenger and Badger 67

❖ Esta Clevenger, "Suzy's Front Porch" 68

❖ Clare Chanler Forster, "Sometimes" 69

❖ Laurie Doctor, "Chance Marks" 70

❖ Tree Bernstein, A Poet's Alphabet 71

❖ Sarah C. Bell, Black and White and Read All Over 71

❖ Anne Ophelia Dowden, Look at a Flower 72

❖ Laura Marshall, "The Dragon Comes Closer" 72

❖ Barbara Bash and Susan Edwards, performance 73

❖ Cynthia Moku, "Prajnaparamita Contemplating" 74

❖ Keith Abbott, "Monk" 75

❖ Joan Anderson, "Red Star Ancestors" (detail) 76

❖ Charles Roitz, "The Way Home: Idaho, 1979" 77

❖ Vidie Lange, "Wisconsin Window VI" 78

❖ Helen Barchilon Redman, "Artist Aflame" 79

❖ Fran Metzger, "Winter Colorado" 80

❖ John Craig Freeman, "Operation Greenrun" 81

❖ Barbara Donachy, "Amber Waves of Grain" 82

❖ Bunny Pfau, "The Shadow Project" 82

❖ Hank Brusselback, Crying Presidents 83

❖ Daily Camera, Peace Rally 84

❖ Graffiti, "Desaparecido" 85

❖ Colorado Daily, Zachary Garcia, 86

❖ Mark Bueno, "Nobody Builds Walls Better than Me" 87

❖ Peace Poles, Boulder Creek 88

❖ Melanie Walker and George Peters, "Coal Warm Memorial" 89

❖ Jane McMahan, "Arapaho Glacier: What Goes Around Comes Around" 90

❖ Mary Miss, "Connect the Dots" 91

❖ Anthony Ortega, "Super Hombre" 93

❖ Eddie Running Wolf, "Eagle Catcher" 95

❖ Pedro Romero, "Los Seis de Boulder" 97

❖ Melanie Yazzie, "When we Came" 98

❖ David Garcia Oceloti, "Struggle of Tonanzin Colorado" 100

❖ Mario Miguel Echevarria and Susan Dailey, "Unity Project" 101

❖ An African American Man models in a CU art class 102

❖ Ava Hamilton and Gabriele Dech, Everything Has a Spirit (still) 104

❖ Zoa Ace, "Fortune Teller" 105

❖ Alvin Gregorio, "A Place for Your Things" 106

❖ Longmont Museum, Día de Los Muertos 106

❖ Bunky Echo-Hawk, "When a Woman Loves a Man" 107

❖ Wanda Matthews, "Mountaintown 4 Alpenglow" 108

❖ Ralph Clarkson, "Jean Sherwood" 109

❖ Portraits of Boulder Artists by Boulder Artists 110-111

❖ Artists at the Abbey, Valari Jack and Esta Clevenger 112

❖ Garrison Roots, "I'm Not a Racist" 113

❖ Exhibition at Henderson Art Gallery 114

❖ Sibell Wolle Building 114

❖ J. Gluckstern, destruction of Sibell Wolle Building 114

❖ Deborah Haynes, "Cantos for (This) Place" 115

❖ Teresa Booth Brown, "Jacket, Bag, Dress, Watch, Ring" 116

❖ Evan Colbert, "Eye Candy" 117

❖ Mark Amerika, Filmtext 2.0 (still) 118

❖ Dan Boord and Luis Valdovino, Tree of Forgetting (still) 119

❖ City Storage and Transfer Building, 1954 120

❖ Boulder Museum of Contemporary Art, 2014 120

❖ Rebecca DiDomenico, "Whirl" (detail) 121

❖ Sherry Hart, "Once in a Blue Moon" 121

❖ Martha Russo, "allay" (detail) 122

❖ Ana María Hernando, Por los ojos se me escapan" 123

❖ Margaret Neumann, "Searching for Rye" 124

❖ Jerry Downs, "What is a BAG?" 125

❖ Irene Delka McCray, "Mother Without Father" 126

❖ Steven Weitzman and friends transport the "Treegle" 126

❖ Cha Cha, "Dragon Bench" 126

❖ Sherry Wiggins, "Performing the Drawing" 127

❖ Sally Elliott, "To Bulgaria with Love" 128

❖ Jim Lorio, "Wood-Fired Pot #1" 129

❖ Paul Gillis, "I Forgive You My Sins" 130

❖ Amos Zubrow, "Girl on Bicycle" 131
❖ Buff Elting, "Illusion of Order" 132
❖ Joe B. Ardourel, "Falcon and Falconer" 133
❖ Mary Rowan Quinn, "Winter Ravens" 134
❖ John Haertling, "Visual Eyes" 135
❖ Kevan Krasnoff, "Blue Waunder" 136
❖ Caroline Douglas, "Lady of Enchantment" 137
❖ Paint-by-numbers gorilla 138
❖ Gary Zeff, "Ode to Scobie" 139
❖ Jerrie Hurd, "Rocket to the Moon" 139
❖ Chris Brown, "Aspen Grove, V-PAN" 140
❖ Julie Maren, "Rabbit Test" 141
❖ Gerda Rovetch, "Philosophical Ex-Dancer" 142
❖ Amy Guion Clay, "Crossing Over Chasms" 143
❖ Kim Field, Untitled 144
❖ Airworks and Ken Bernstein, "StrataVarious" 145
❖ Boulder High School bas reliefs 146
❖ Cairns in Boulder Creek 148
❖ Yoshikawa, "Correspondence" 149
❖ Kristine Smock, Skunk Creek 150

❖ Melissa Gordon, Untitled 150
❖ Maria Neary and Ken Bernstein, "African Patterns" 151
❖ Ken Bernstein, "Goose Creek Mural" 151
❖ Bill Vielehr, "Human Glyph" 152
❖ Randi Sue Eyre, Spruce Pool mural 153
❖ Artist unknown, wolf mural 154
❖ Mario Martinez, "TORUS" 155
❖ Charles Moone,"Re/Opening" 157
❖ Suzy Roesler, Untitled 158
❖ Cheri Belz, Karen Ripley Dugan & children 159
❖ Artist unknown, poster "ArtFeast" 160
❖ Artist unknown, poster Boulder Artists' Guild Retrospective 161
❖ Gayle Crites, "Flagstaff Star" 162
❖ Jim Colbert, "Lost at Sea" 164
❖ Artists' bios with images 166-205
❖ Terry Kruger, "Generic Boulder" 222
❖ Dorothy Mandel, "In the Ruts of the Highway" 223
❖ Gene Matthews, "Utterances 2" 224

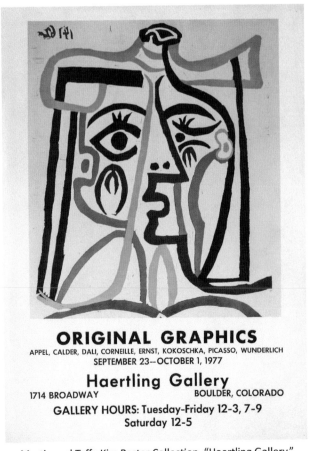

Martin and Taffy Kim Poster Collection, "Haertling Gallery," n.d., poster, Museum of Boulder.

Richard Varnes, "Bill Vielehr," 1998, silver gelatin print.

Celeste Rehm, "Taking the Law into Your Own Horns," 2000, oil on canvas.

Jerry Wingren, "Alabaster Study for Interiors," 2009, Colorado alabaster.

Robert Bellows, "Alfie," 2012, farm implements.

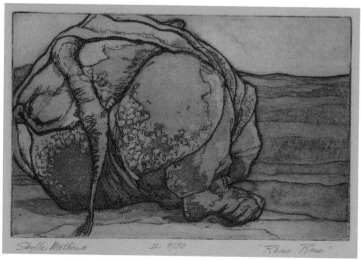

Sibylla Mathews, "Rhino Rump," 1978, intaglio print. Collection of Mark & Polly Addison.

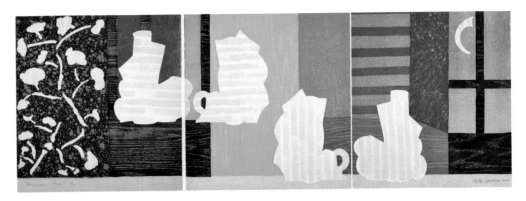

Preface
Personal Remembrances

Mark Addison

Polly and I married in late 1957. Soon we were busy raising five kids. Still we found time to look at art in Boulder. Here is some of what we remember. This catalog will tell you much more. With a bit of luck, it will bring back your own memories of additional artists who have been part of Boulder's visual art history.

Here are some of my memories.

In the early 1960s, the old Boulder Public Library was the place to see original art by members of the Boulder Art Association. I remember being fascinated by a painting of a hippopotamus laying an egg. Hmmm. That later led to our very first purchase: an elegant etching titled "Rhino Rump" by Sibylla Mathews. She's still with us and so is the BAA.

On my walks to the office, I passed Will Collins' house on Marine Street. We talked. He described himself as "third generation Taos school" and his woodcuts surely looked right out of the 1930s. Will was another BAA artist and his oil painting "Chasm Lake" hangs in the living room of our mountain condo.

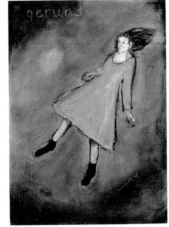

Patricia Bramsen, "Gerund," 1998, acrylic on canvas.

BAA exhibits weren't the only place to see original art in Boulder. Carl Worthington opened Gallery 1309 on Spruce Street, showing local artists in the late 1960s. Paul Heffron followed with a contemporary art gallery in the '70s. Both might have been too early; there didn't seem to be very many art collectors in town.

Polly's friend Joan Bartos had lots of kids, too, but found time to paint Western art with a twist. Her friend Patricia Bramsen took matters even further with humorous but pointed self-portraits. If you visited the exhibits around town for *A History of the Visual Arts in Boulder*, you saw

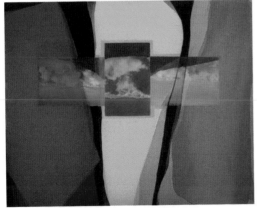

Virginia Maitland, "Annunciation," 1997, acrylic and photos.

Above: Betty Woodman, "Alessandro's Room," 2013, Edition 30. Color woodcut/lithograph triptych with chine collé and collage. Courtesy of Shark's Ink.

xv

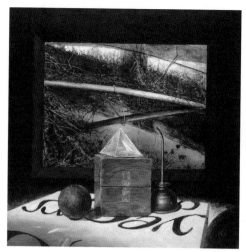

Robert Ecker, "The Ecology of Time," 2010, acrylic on wood.

what I mean. Both artists are still painting in 2016, as are many others from those early days.

When we moved to Rosehill Drive in the mid-1960s, we met Ann Bliss and Diana Bunnell early members of the Handweavers Guild.

The '70s were fruitful for visual arts. The Boulder Art Center opened in a house on Pine Street and soon moved to its present home in the old City Storage and Transfer Building at 1750 13th Street, with Karen Ripley Dugan — then Karen Hodge — as the director. She set the standard for contemporary art in town. I was a board member in the '70s, as was Polly in the '80s, with people like writer Ina Russell, fiber artist Elaine Nixon, and landscape painter Merrill Mahaffey. The BAC later changed its name to the Boulder Center for the Visual Arts, now the Boulder Museum of Contemporary Art.

Young Master Printer Bud Shark chose to settle in Boulder after apprenticing in London. Soon he was working with national and international artists like Jack Beal, Robert Kushner, Bernard Cohen, and Red Grooms to name just a few. Shark's Ink is still going strong.

Bud's wife Barbara, an inspired cook and artist, kept Shark's visitors well-satisfied and still found time to paint with the influential feminist group, Front Range Women in the Visual Arts, which included, among others, Fran Metzger, Margaretta Gilboy, Helen Redman, Vidie Lange, Celeste Rehm, and Sally Elliott.

Also in the mid-1970s, Jeanie Weiffenbach was hired as the first curator/director of what is now the University of Colorado Art Museum, located on the site of the old Sibell Wolle building that dated back to the 1920s. Jeanie brought important and challenging contemporary art to the community. Words like "Pop Art" and "minimalism" were heard around town.

Betty and George Woodman were teaching at CU. Betty soon had the Pottery Lab on Aurora filled with activity. Best for neighbors like us was Betty's summer sale where we could see the experiments that led, years later, to her becoming the first contemporary woman artist to show at the Metropolitan Museum of Art.

George kept busy with colorful pattern-and-decoration paintings and later was a member of the Criss-Cross Collective with Richard Kallweit and Clark Richert, who helped start Drop City, an artists' commune in southern Colorado. Many of the original group are still active in the Denver area.

In the early '80s Polly took art classes at CU from Chuck Forsman, who made beautiful paintings of man's effect on the landscape; Frank Sampson, with his imaginary miners and now animals; Bob Ecker, the master of inscrutable mezzotints; and Jim Johnson, who provided intellectual wit.

I learned about people like near neighbor Virginia Maitland and her poured paintings; Robert Bellow's farm implement sculptures; Jean Roller, who made boxes I thought better than Joseph Cornell's; Margaret Prentice's compositions on handmade paper; and Scott Chamberlin's ceramics.

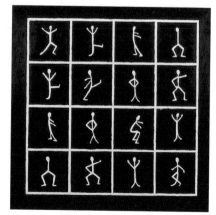

Jim Johnson, "The Adventure of the Dancing Men," 1980, oil on canvas.

xvi

In the late 1980s, the few years of Boulder's Sculpture in the Park were a great treat. Doug Wilson, Jerry Wingren, Frank Swanson, Bill Vielehr, and a few others donated the time and energy to move large outdoor sculpture to Boulder's Central Park. Bill and his brother Chuck became famous for very funny invitations to their annual Christmas parties.

Wonderful support for all arts came from Boulder Public Library Director Marcelee Gralapp, who hired artists like Clark Richert and provided both an income and encouragement. Marcelee also put Karen Ripley in charge of the City of Boulder Arts Commission. If Marcelee wanted something done for the arts in Boulder, it got done.

James Turrell, the famed artist of light and space, created three magical light projections at the BCVA that were a high point for an organization, which soon after had its troubles, now long since resolved.

The 1990s saw two very important events that impacted the visual arts in Boulder.

As a member of the Boulder Arts Commission, I listened to many painters, sculptors, and artists of all disciplines complain that, "no one ever comes to see my work." Then Gary Zeff came to town. He told them – very nicely – to stop whining, get up, get out, and help themselves. With Gary's inspiration and his solid planning, Boulder's annual Open Studios became a "must see" two weekends every autumn. No more complaints from artists about being lonesome in their garrets!

Of course the second event was, finally, the realization of an arts center for Boulder. Originally called the Flatirons Art Center, the dream was to reclaim and re-purpose the former Watts-Hardy Dairy as a multi-disciplinary center for all the arts. Russ Wiltse was the visionary who drove the dream. It took years and much devoted effort to realize the Dairy Arts Center we see today.

What is now BMoCA traveled a parallel path. Both it and the Dairy are beneficiaries of city financial support for their buildings. Their programming has kept right on improving with the decades. Karen would have approved.

That's what I remember.

What are your memories of visual art in Boulder?

Frank Sampson, "A Candle-light Party," 2015, acrylic on Gatorboard.

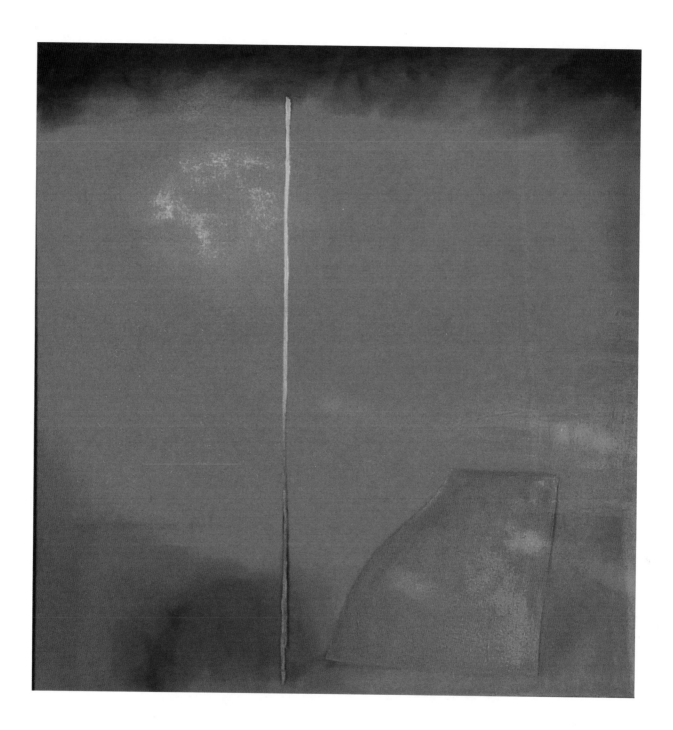

Dale Chisman (1943-2008), "Indian Rope Trick," c. 2000, medium unspecified. Private collection.

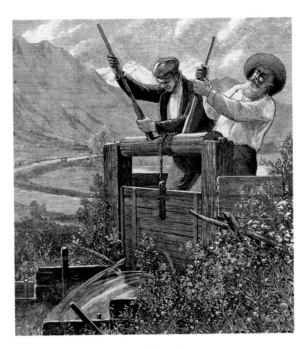

Introduction
Toward a Lasting Legacy

Jennifer Heath

The notion of a history of the visual arts in Boulder percolated in my mind for several years as I watched the inevitable changes that have taken place in the city and Boulder County across the four decades I've lived here. The transformation started slowly and intensifies as the population explodes along with the cost of living ... especially for artists.

I've worked in the arts all my life, as a writer, curator, and cultural journalist. At first I thought the documentation of Boulder's artists and art history should be a book, but a volume, even one as wide-ranging as we've tried to make this, seemed insufficient to illustrate an illustrious past. More was needed. Thus, *Celebration! A History of the Visual Arts in Boulder* – dubbed HOVAB and called by that acronym ever since – was born. Its mandate was to revisit Boulder's lively arts past, beginning in the late 19th century and progressing into the

present, a long stretch designed for breadth and perspective.

HOVAB could not have happened without the brilliance, creativity, experience, and knowledge of our steering and curatorial committee: artist and teacher Sally Elliott, curator Kathy Mackin, curator and art historian Joan Markowitz, and financial advisor Kevin Kelley. Karen Ripley Dugan, to whom this project is dedicated, was an original member of our group, but sadly passed away in 2015. The final essay in this book is a tribute to her life as a champion of the Boulder arts community, who nurtured much of what we enjoy today.

And HOVAB would have been meaningless without the unwavering, wise mentorship of our Boulder Arts Commission liaison, Felicia Furman, whose support strengthened the project and brought it into being.

Above: *Harpers Weekly* cover, June 20, 1874, showing the work of "ditch riders," opening the sluices.
From the "Ditch Project," courtesy of Elizabeth Black.

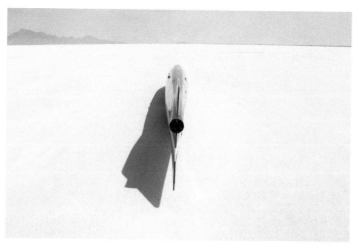

Michael Lichter, "Ready for Takeoff. Bonneville Salt Flats, Utah, 2006," 2006, pigment ink print mounted on wood.

Together, our committee gathered more than three hundred artists, whose work was displayed – with the help of a bevy of associated curators, partners, and friends – at eighteen venues, including the University of Colorado Art Museum, the Boulder Museum of Contemporary Art, The Dairy Arts Center, Boulder Public Library's Main Library and its Canyon Gallery, Mr. Pool Gallery, Highland City Club, First Congregational Church Gallery, First United Methodist Church Sanctuary Gallery, Pine Street Church Gallery, Mercury Framing Gallery, Macky Auditorium, Naropa University, National Center for Atmospheric Research, Open Studios at Rembrandt Yard, Boulder Creative Collective, Longmont's Firehouse Art Center, and the Boedecker Theater at the Dairy. An exhibition checklist at the back of this book records each artwork with the venue where it appeared. Additionally, we staged fifty events, including receptions, film screenings, panels and speakers. This was a massive project and we apologize for any errors or omissions.

In order to make the best choices possible, our committee drew up a set of goals and criteria: to celebrate Boulder's visual artists who have made an impact locally, regionally, nationally, and internationally; to locate and identify, wherever appropriate, Boulder artists in national and/or international contexts; to heighten visibility of local artists past and present; to educate the community about the vibrancy of Boulder's past and present art scene; and to lay a foundation for the future of visual arts in Boulder by providing access to the past.

William S. Sutton, "Dead Horse, Johnson County. Wyoming," 2014, 5/40, inkjet print.

Among the serendipities that befell this project during its two-year-and-a-half-year gestation is an exhibition titled *Pioneers: Women Artists in Boulder, 1898-1950*, at the University of Colorado Art Museum, co-curated by Art and Art History Department Chair Kirk T. Ambrose and Stephen V. Martonis. I can no longer remember how our committee discovered that *Pioneers* was in the works, but what a relief when we did. Ambrose and Martonis kindly agreed to mount *Pioneers* during the months that our shows would be on display (September 2016 to January 2017), therefore saving us much head-scratching, not to say time and expense in research and permission fees.

Ambrose has provided this book with a sparkling essay, "Women at Work: The Visual Arts in Boulder Prior to 1950," which covers the lives and dynamic activities of those he calls Boulder's first and second generations of women artists – among them Jean Sherwood (1848-1938), Muriel Sibell Wolle (1898-1977), and Eve Drewelowe (1899-1988), who were seminal in establishing Boulder as a cultural beacon, at least in Colorado. That essay is preceded by historian Carol Taylor's wonderful chronology, "Shaping Boulder's Aesthetic," outlining the city's development and changing attitudes toward art and otherwise. Taylor reminds us that the earliest human occupants — notably the Arapaho and Cheyenne — had nearly disappeared altogether from the area by the late 1800s, thanks in large measure to the 1859 Colorado Gold Rush and the 1864 Sand Creek Massacre. Boulder's art scene, she writes, was energized not only with the establishment of the state university here, but — perhaps more essentially — with the debut of Chautauqua Park in 1898.

Richard Van Pelt, "Flatiron Gravel, 55th Street," n.d., Pizography on Hahnemuhle paper.

Taylor and other contributors note that it was, of course, the land, these glorious surroundings, that stimulated, astounded, and dazzled the first Euro-American artists (just as it inspired Indigenous inhabitants, spiritually and artistically). Art historian Joan Markowitz writes in her deeply insightful essay, "Land as Narrative," that our magnificent environs continue to stir Boulder artists, for better or worse. Artists, such as Charles Partridge Adams, were dazzled by the light and the wild terrain — the beauty. Today's artists still love the light and landscape, but many now grapple with the consequences of human interference in the ecology — the crisis.

We regret there could be no essay exclusively about photography, though the artform has been conspicuous here since Joseph Bevier Sturtevant (1851-1910), whose pictorial record provides us with our first comprehensive documents of life in Boulder at around the turn of the 20th century, right through to contemporary photographers such as Ken Abbott, Albert Chong, Caroline Hinkley, Tom Quinn Kumpf, Michael Lichter, Roddy MacInnes, Elisabeth Relin, Charles Roitz, William Sutton, Alex Sweetman, Richard Van Pelt, Melanie Walker, Nurit Wolf, George Woodman, and others. In a curatorial statement for the HOVAB exhibit, *Peripheral Landscapes in Photography*, Laurie Britton Newell writes

> "Photographers based [in Boulder] are confronted daily with the powerful and dominating landscape that surrounds them. They have learned how to look at their surroundings, noticing daily, even hourly, changes in weather and light. ...They frame the view but are brave enough to off-center it, take risks, and suggest what lies just beyond the image, the peripheral landscape."

Carol Kliger, "Cut Pushed Tiles," 2010, porcelain.

This book does double duty. While it's meant to serve as an exhibition catalogue, it is also a history anthology. We open with a charming preface by distinguished art collector Mark Addison, whose dancing recollections include his first purchases with his wife Polly (an artist in her own right) and the Boulder artists they esteemed as collectors and as friends and neighbors.

The renowned photographer and poet Robert Adams (who makes an appearance in "Landscape as Narrative") once told me in an interview during the early '90s, while he lived in Longmont – and I paraphrase — that the light in Colorado is right for painters and photographers, whereas the overcast skies of the Northwest (where Adams eventually moved) are a gift to writers. There are certainly exceptions, as Jane Dalrymple-Hollo notes in her sharp essay, "Always a Book Town," which considers the ubiquity of book arts and small presses in Boulder, particularly since Naropa University arrived in 1974. In "Adventures in Confluences," Laura Marshall perceptively describes the sway on Boulder artists of Naropa's original raison d'etre to transmit

Buddhist principles of contemplation and "mindfulness," and, in the process, teach Asian art forms.

Adams surely knew whereof he spoke. It may have been this light, these 360-odd days of sunshine a year — as well as the formidable influence of avant-garde film artist Stan Brakhage — that stirred countless filmmakers and thrust Boulder into the forefront, internationally, of experimental film. J. Gluckstern muses on this phenomenon in his brilliant brief history of Boulder's love affair with art cinema since the mid-1950s. In more recent years, Heather Perkins reminds us, Boulder has also become a hub for feature filmmaking and hosts numerous film festivals annually.

This book attempts to document some of the remarkable activities and accomplishments of Boulder artists and/or arts lovers, such as architect Carl A. Worthington, who helped to bring us the Pearl Street Mall and much else, the late eccentric visionary artist Esta Clevenger, memorialized by her friend Jane Wodening, and Bud Shark, a master printmaker, who collaborates with artists worldwide. Collin Heng-Patton's stellar interviews include an essay remembering the gallant, beautifully conceived, but unfortunately ill-fated, attempt to establish a Women of the West Museum in Boulder.

Jane Dillon, Untitled, n.d., ceramic. Private Collection.

"Pattern and Paradox" — an admiring glance back at the Criss-Cross Collective by Jack Collom — and "A Shared Historical Moment" —a proud gaze back at Front Range Women in the Visual Arts by Fran Metzger — reflect the national impact of two art movements that originated in Boulder in the 1970s. Criss-Cross, which spread across the United States and into Europe, rose out of Drop City, an artists' commune in southern Colorado, while Front Range Women were CU Fine Arts students who took steps against misogyny in the department and the art world. I think of the five founders – Metzger, Sally Elliott, Jaci Fischer, Helen Redman, and Michele Amateau — as grandmothers of today's Guerilla Girls, insisting on female artist representation in museums, galleries, publications, and universities.

Other essays in this volume also address activism, although in quite different ways. Carol Kliger's reflective essay, "The Essence of Activism in Art," extracted and updated from her 1993 *A Public Art Primer for Artists of the Boulder-Denver Area*, reaches back to some of Boulder's protest art (much of it in the 1980s and '90s around the deadly Rocky Flats Nuclear Weapons Plant located only twelve miles outside the city). Kliger studies activist artists' processes, techniques, engagements, and the

Barb Olson, "Scattering Leaves," 2003.
Fabrics, paint, stitching.

relationship – natural and obvious – between activist and public art. Meanwhile, Nora Rosenthal pays tribute to EcoArts Connections and its founder/director Marda Kirn, who endeavors to raise consciousness about climate change and sustainability by, among other global undertakings, marrying science and art.

Boulder is notoriously wanting in racial, ethnic, and class diversity, a condition that can fail, ultimately, to nourish real cultural wholeness and can leave voids in the collective imagination, resulting in creative dead ends. For "Diversity in Boulder Arts: Thirteen Voices," artists of various disciplines and backgrounds were asked to fill in a questionnaire (or use it as a jumping-off point to stimulate ideas) about their experiences of exclusion and inclusion (personally and culturally) in Boulder, to talk about how they maintain agency within challenging circumstances, and to offer suggestions about what might be done to improve life and artmaking for themselves and the rest of the city.

Jade Gutierrez, a graduate student in Art History, was invited through a collaboration between HOVAB and CU's Center for

Elaine Nixon, "Oriental Red Poppies," 2015, handwoven tapestry.

Humanities and Arts to produce a slide show about the university's Visiting Artist Program from its origins in the 1940s to the present. The slide show, meant to reach town, as well as gown, was displayed on a continuous loop at the Boulder Museum of Contemporary Art and at the university. Gutierrez subsequently wrote an essay about the program. The town-gown divide is too infrequently breached, but the guest artists —from Max Beckmann to Mark Rothko to Howard Finster to Jaune Quick-to-See Smith and hundreds more – are dependably exceptional and have enriched artists in both communities. Geographically isolated as Colorado is, the program has allowed local artists to stretch without leaving home.

Visiting artists have contributed artwork that has helped to build CU's Permanent Collection, so Gutierrez's chronicle of the CU Art Museum — titled "Its Distinguished Past and New Horizons" — acts as a kind of sequel, but leads as well to histories by Collin Heng-Patton of two other prominent art institutions: the Boulder Museum of Contemporary Art and the Dairy Arts Center.

Lodged between those stories is a small saga by Tree Bernstein about the genesis of BAG in the early 1980s. The Boulder Artists

Gallery arose from a yearning for space where their art could see a little daylight, and where artists could kick up a little luminous dust. Lack of hometown attention has been an ongoing source of frustration that's repeatedly resulted in artists taking imaginative action.

In "From Milk House to Art House," Heng-Patton reminds us that The Dairy started life as a squat where it was hoped that artists of all disciplines could work, alone and in partnerships, creating a more fertile milieu for both artists and audiences. BAG's objectives were not unlike those of Visual Eyes, which Kathy Mackin recalls in "The Eyes Have It." That annual event's heyday was followed by the launch of Open Studios, whose history is described by Brenda Niemand. As she notes in her title, Open Studios has been a "Win-Win Proposition," helping to bring more interest to local art.

Once upon a time, downtown Boulder was replete with galleries, albeit commercial, that nonetheless were available to Boulder artists and our myriad, talented craftspeople. This book has not given enough space to the evolution of the Art of Crafts – ceramics, fiber arts, wood turning, metalsmithing, and more – their immense popularity, particularly in the '70s and '80s, and breathtakingly talented

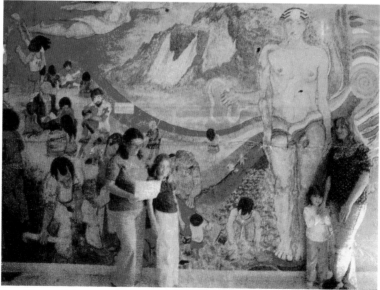

In 1980, residents of the San Juan del Centro low-income housing complex created this mural, which was painted over five years later.

practitioners, such as — to name just a bare few — Jim Lorio, Elaine Nixon, Diana Bunnell, Jane Dillon, Gary Zeff, Barb Olson, and, of course, world-renowned Betty Woodman. In 2016, during HOVAB's exhibitions (another serendipity), the Boulder Arts & Crafts Cooperative, unique and maybe the last of its kind — and miraculously surviving downtown — celebrated its forty-fifth anniversary.

Although galleries inevitably come and go, lamentably, Boulder's astronomical rent has reduced their numbers drastically. To survive, most can no longer take chances and occasionally supplement by selling other goods (from jewelry to tea sets). Some have bushwhacked into outlying areas where they struggle to maintain visibility.

With few visual art organizations and studios, without competition or thriving smaller venues to, as it were, feed them, larger institutions risk becoming fiefdoms, closed shops in grave danger of stagnation, isolation, and mediocrity. In 2016, corporatization and the monetization of art are all too threatening. City-supported enterprises, such as the Pottery Lab and recreation center dance programs, have privatized. What one former resident calls "the don'ts and don'ts of Boulder," whereby business interests dominate, act too frequently as deterrents to artistic, non-commercial, intelligent innovation, and endurance.

Dinah Zeiger has produced a thorough, often amusing investigation, "Getting to Yes (and Beyond)," of Boulder's decades-long struggles for universally acceptable public art. Boulder is not unusual. Most cities experience hullabaloos and uphill battles when it comes to agreement about which artworks should be public. Some of what is seen as Boulder's "public art" is, in fact, located on private property, and, having passed the city dress codes, are allowed to take center stage. Across time, there have been city purchases or simply "plops," that have neglected to attract continuing attention. In the process of coordinating HOVAB, however, our committee discovered a treasure trove of artwork owned by the city, much of it housed at the public library and now thankfully being carefully inventoried and conserved.

And Boulder has an exemplary history of producing beloved (and usually temporary) community art projects, most generated by artists themselves. Worthington's "Pearl Street Happening" in 1968 was a radiant example of an art project that led directly and almost immediately to the betterment of the city.

In 1980, Lee Morey Bentley gathered one-hundred residents (from three to sixty years old) of San Juan del Centro, a low-income housing complex then owned by St. John's Episcopal Church, to paint a 10-foot by 16-foot mural showing young and old of multiple races

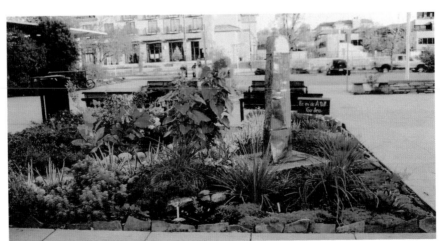

The Eccentric Garden in front of the Boulder Public Library on Canyon Boulevard, created as a community project by Boulder artists in 2006. Sculpture by Bill Vielehr, collection of the City of Boulder.

and ethnicities working and playing together, symbolizing the unity of the community. The mural survived for five years until it was painted over at the behest of the new owners, despite tenant objections and petitions.

The "Eccentric Garden Tour," which Tree Bernstein contrived during the late ′90s in response to conventional garden tours that exclude artists' peculiar, idiosyncratic yards, attracted hundreds of curious, delighted visitors. After Bernstein left Boulder, the tour expanded (to more than forty artists) and went on for years organized by artists Cha Cha and Elizabeth Black. Volunteer artists even added a small, exquisite eccentric garden in front of the public library (that has since been torn down).

And there have been many others, not least the 2009 "Ditch Project" — curated by Black and Bob Crifasi, a water resource specialist for City of Boulder Open Space and Mountain Parks — which brought artists and citizens together, with art exhibitions, film screenings, storytelling, and a symposium, to consider how a semi-arid landscape was transformed into a lush city.

Artnauts, an art collective founded in Boulder by CU Art Professor George Rivera, has enlisted hundreds of artists to acknowledge and support victims of oppression worldwide. In 2016, the group celebrated its twentieth anniversary and its more than 230 exhibits on five continents — and counting.

Everyone has a different interpretation and viewpoint of what constitutes history. Therefore, we call this project "**A** History of the Visual Arts in Boulder." Decisions were made thoughtfully by the HOVAB curatorial and steering committee, based on the criteria listed above. Debates were long (arguments were always friendly) and compromises were taken about which artists and what aspects might comprise Boulder's art history. Some artists and some topics in this book (whose flaws are entirely my responsibility) may have been overlooked or not given the emphasis others feel they might deserve. This is "our" history, as objective as we could make it, but we realize it will not satisfy everyone. Others will come along with "their" histories … and that is as it should be.

Our committee undertook HOVAB in the certainty that, before we can face the future with any clarity, it is vital to look back at, explore, and honor the city's vibrant past, to fashion a living archive and thereafter a lasting legacy for generations to come. *Celebration! A History of the Visual Arts in Boulder* strove to do just that. This book continues that effort.

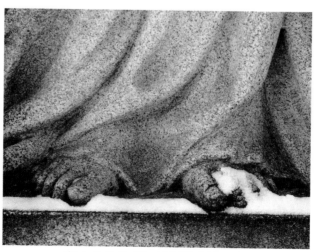

Elisabeth Relin, "Feet," 2013, inkjet print.

Shaping Boulder's Aesthetic
A Brief History

Carol Taylor

Boulder's visual art history reflects Boulder history in general. Both are intertwined with the dramatic beauty of the natural landscape, which surely drew Native Americans to the area, and which has shaped arts and attitudes since the beginning of white settlement. Citizen efforts have had tremendous influence and sometimes choices have been fraught with controversy among a citizenry that has always been engaged and very vocal.

Before It Was Named Boulder

The first artistic creations in Boulder began with the first human presence.

In 1989, arrowheads and pottery fragments were found on Boulder County Open Space and were dated between 600 and 1000 BCE. Further investigation of this site in 1992 uncovered charred fragments that indicated through

radiocarbon dating the presence of indigenous peoples 6,000 years ago.[1] In May 2008, a group of eighty-three ancient tools was discovered on the banks of Gregory Creek, west of University Hill. An investigation revealed proteins from animals that roamed North America 13,000 years ago. Crafted with precision, the "Mahaffey Cache" quickly became known in archeological circles worldwide.[2]

These rare discoveries of material culture are clues to our past and what it meant to have a human cultural experience in this particular landscape. As Terry Tempest Williams wrote

> Artifacts are alive. Each has a voice. They remind us what it means to be human — that it is our nature to survive, to create works of beauty, to be resourceful, to be attentive to the world we live in.[3]

Charles Partridge Adams, American (1858 – 1942), Untitled [mountain sunrise scene], c. 1920 - 1925, oil paint on canvas, 9 x 12 inches framed, Gift of Lorine Pickett, CU Art Museum, University of Colorado Boulder, 53.13.02, Photo: Jeff Wells, © CU Art Museum, University of Colorado Boulder.

More recently, since the 1500s, the Ute territory spanned almost all of Colorado. The Utes were one of the early tribes to become expert horsemen.[4] Evidence survives of fifty-two different tribes who have called Colorado home, according to Ernest House, Jr., a member of the Ute Mountain Ute tribe and Executive Director of the Colorado Commission on Indian Affairs.[5] The Arapaho and Cheyenne arrived in the late 1700s, migrating from the Great Lakes region.

"Art and the natural world were inseparable for Plains Indians…--as they were for all North American Native peoples," Gaylord Torrence wrote.[6] Plains Indians artists created embellished works of beauty with materials from nature, including buffalo, deerskin, antlers, shells, bones, and porcupine quills. By the 1800s, trading posts, such as Bent's Fort in southeastern Colorado, offered European goods. Glass beads began to replace porcupine quills as decoration in Native artwork. Ute, Arapaho, and Cheyenne artisans became renowned for their beadwork designs.

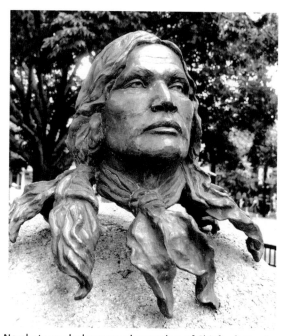

No photographs have ever been taken of Chief Left Hand, but several Boulder artists have fantacized about what he might have looked like. Here, artists Steven Weitzman and Tara Brice "symbolically rendered" the Arapaho chief's image with a 1980 bust that now graces the Boulder County Courthouse. Photo: Laura Marshall

White settlers from Nebraska arrived at the place we now call Boulder's Red Rocks in 1858, where they encountered Southern Arapahos, led by Chief Left Hand (also called Chief Niwot), who denied them permission to settle. The entire Front Range was acknowledged to be Indian land by the 1851 Treaty of Fort Laramie, and the settlers agreed to leave by spring. That promise was broken with the discovery of gold in 1859 near today's Gold Hill and, by February, Boulder City Town Company was formed.[7] Left Hand, renowned for his efforts at peacemaking, is famously said to have "cursed" the settlers, but his statement – "People seeing the beauty of this valley will want to stay, and their staying will be the undoing of the beauty" – could as easily be a prediction.

On November 29, 1864, an estimated two hundred Arapaho and Cheyenne people were massacred at Sand Creek, including Chief Left Hand. Many Boulder residents participated in the slaughter and were congratulated upon their return. By the late 1800s, virtually all Colorado Native Americans were forced to reservations.

Building a Cultural City

Boulder grew as a mining-supply town, with its center at Pearl Street. From the start of white settlement, the area landscape was altered for economic rewards. Mineral resources were extracted — gold at first, then silver, telluride, tungsten, and fluorspar, as well as much coal and an oil boom at the turn of the century. Ditches diverted water from mountain streams to serve farmers.[8]

The University of Colorado-Boulder opened its doors in 1877, comprising one building, Old Main. Gradually, art classes were added to course offerings. The Boulder community was hungry for art. Two CU professors, Dr. Raymond Brackett and Mary Rippon were champions for culture in the pioneer community. They both gave illustrated lectures on art, architecture, and travel.[9]

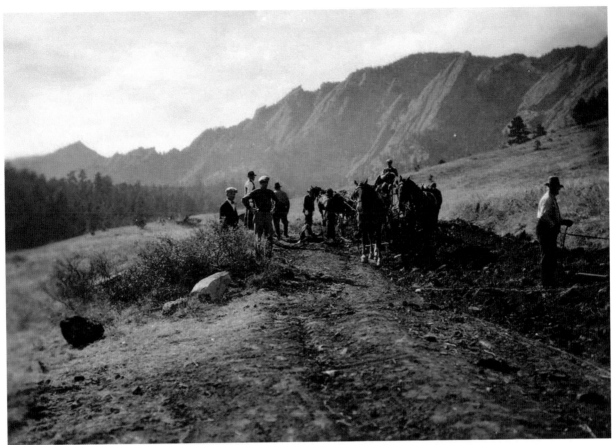

Joseph Bevier Sturtevant, "Building the Shelter Road," n.d., photograph.

In 1895, prominent Boulder citizen, Ivers Phillips, financed a significant collection of photographs and plaster casts of European painting and sculpture, an endorsement for arts at the university.[10]

Boulder competed with other cities to land the Texas-Colorado Chautauqua Institute in 1898, a much needed cultural amenity. Voters approved bonds to buy the land and the auditorium and dining hall buildings were completed in less than eight weeks, in time for a July 4 opening.[11]

In the early 1900s, art instructors were brought to Chautauqua from other states. Programs described art lectures and courses including "Drawing from Nature" and "Outdoor Sketching."[12] Art instruction, as well as art appreciation classes, were part of a Chautauquan's experience from the beginning.[13]

Joseph Bevier Sturtevant, known as Rocky Mountain Joe, set up a photography studio on the grounds as the Chautauqua's official photographer. His images give us unparalleled documentation of the early Chautauqua experience, as well as Boulder life and the surrounding landscape.[14]

Professional artists were attracted to Boulder, too. Charles Partridge Adams (1858-1942), the prolific Colorado landscape painter, had a showing downtown in 1906.[15] In keeping with its mission to support the arts, in 1907, the Woman's Club of Boulder purchased a large Adams for the new Carnegie public library.[16]

Beauty and Culture for Quality of Life

Influenced by the City Beautiful Movement, in 1908 members of the Boulder City Improvement Association commissioned the most noted landscape designer and city planner of the time to write a report. Frederick Law

Olmsted, Jr., son of the designer of New York's Central Park, published *The Improvement of Boulder* in 1910. Olmsted advocated planting more trees and buying up land on both sides of Boulder Creek. He believed Boulder was perfectly situated to become a town of desirable neighborhoods and homes.[17]

The Woman's Club of Boulder had done much to beautify Chautauqua through landscaping as well. Additional plantings were made and Boulder became lush and verdant — a far cry from the dusty, treeless plain it had been before white settlement. Meanwhile, artists continued to discover the beauty of the Rocky Mountains. Swedish-born impressionist painter Birger Sandzén visited Boulder often, beginning in 1913. "Colorado is an artist's paradise." he said, "Material is so abundant here that it is fairly bewildering. It is the greatest sketching ground in the world." In response, a Chautauqua newsletter suggested that folk "come along with plenty of paint and canvas or films for your cameras and put Mr. Sandzén's statement to the test."[18]

By the 1920s, the university was growing faster than the town and had created a separate department for fine arts. By 1927, a Bachelor of Arts degree was established.[19] Craftsman bungalows were built on University Hill for CU faculty and architecture enjoyed a further boom with many fraternity houses built in an array of classic styles. As Olmsted had recommended, a new zoning ordinance pushed industry to the east.

The Boulder Art Association was formed in 1923 and the Boulder Artists Guild in 1926. They hosted talks, mounted exhibitions, and contributed much support for artists.[20]

Public Projects During the Great Depression

Like many cities in the West, Boulder benefited from New Deal Programs. The Civilian

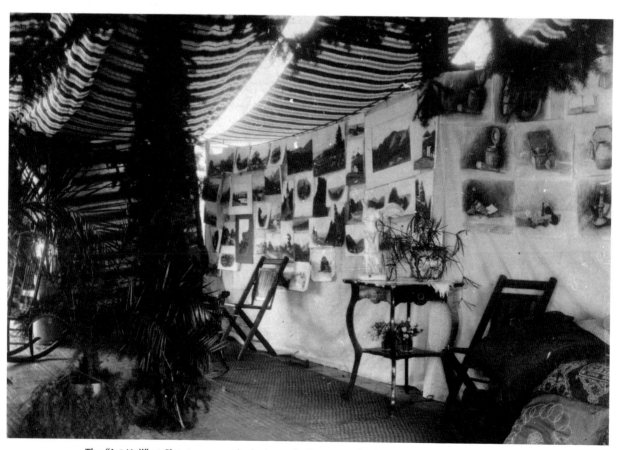

The "Art Hall" at Chautauqua, n.d, photograph. Courtesy of Colorado Chautauqua Assoociation.

Conservation Corps set up two camps in town in 1933, employing dozens of young men during the Great Depression. They completed the Flagstaff Amphitheater and the Green Mountain Lodge, among others. The Works Progress Administration was responsible for landscaping at Beach Park and other beautification projects.[21] In 1934, Glen Huntington designed Boulder County Courthouse and in 1936, he completed Boulder High School, both in the Art Deco style. Bas reliefs on the courthouse façade commemorate the city's early history of mining and agriculture.[22]

When the Boulder School Board commissioned Denver artist Marvin Martin to create a piece for the new high school entrance, controversy ensued. The unveiling of the modernist concrete bas reliefs of Jupiter (Roman God of thunder and the skies) and Minerva (Roman Goddess of wisdom), sparked a vehement "what is art?" debate. Ultimately, the sculptures, affectionately known today as Jake and Minnie, were allowed to stay.[23]

Mid-Century Modern Boom

Big science came to Boulder in 1949, when the town was selected for the National Bureau of Standards' Central Radio Propagation Laboratory, stimulated by the Chamber of Commerce, which encouraged citizens to buy land with ads for "prosperity insurance."[24] In 1951, residents were excited by news that a top-secret atomic plant – Rocky Flats Nuclear Weapons Plant – was being built in nearby Jefferson County.[25]

The atmosphere and space were new frontiers and research institutions flourished. The atomic age brought hope and fascination to Boulderites. With increasing jobs at Rocky Flats, Ball Brothers Research (now Ball Aerospace), the National Center for Atmospheric Research, and others, Boulder's population boomed. Scientists arrived by the dozens and the city was forever changed.

In the late 1950s, university faculty and other professionals commissioned young architects, with clients often giving them complete artistic freedom. Building boomed. Land was cheap and residential development was unencumbered by today's codes and restrictions. As Tician Papachristou wrote in 2000, "Boulder, although a small town and relatively isolated from the big city hubs of creative activity, has nevertheless been unusually friendly to modern avant-garde design. … Innocence, some ignorance, and youthful daring moved us to explore the unprecedented."[26] Papachristou was among the bold, visionary group of talented modernists, with Charles Haertling at the forefront, and including Glen Huntington, James Hunter, Roger Easton, Hobart Wagener, and L. Gale Abels.

During this time of population growth, new ideas and optimism, the CU Art Department invited cutting-edge abstract expressionists, such as Max Beckmann, Paul Burlin, Jimmy Ernst, Mark Rothko, and Clyfford Still to teach in the summer sessions.[27]

In a 1949 letter to Reinhardt Piper, Beckmann wrote

> being here in Boulder is not that different from being in Garmisch Partenkirchen [a Bavarian ski resort], but they have extraordinarily beautiful and different flowers here. Life at a mountain university is very amusing. … I worked like mad in St. L[ouis], while I am taking it relatively easy here and still getting paid for it.

Rothko was unenthusiastic about his Boulder experience. In one letter, he wrote of the "physical and human desert" that was Boulder and bemoaned the fact that all his local acquaintances wanted him to climb mountains, which he had no intention of doing.[28]

During the same period, local artist Llloyd Kavich painted wild, humorous, irreverent comic-book style murals covering entire walls at The Sink, a legendary CU student hangout on University Hill.[29]

The Boulder Pottery Lab opened in 1956 in the old Boulder Fire Department No. 2 building, with the help and endorsement of up-and-coming modernist ceramic artist Betty Woodman.[30]

With increasing population came a renewed concern for protection of the landscape. When development threatened the area called Enchanted Mesa, the community responded to save it.[31] Later, a ballot initiative for an imaginary marker known as The Blue Line west of Boulder (no city water or sewer above 5,750 feet).[32] In 1967, citizens voted to tax themselves to put aside land for open space, and by 1971, Boulder voters approved a 55-foot building height limit, further defining the importance of a mountain backdrop that would be visible and pleasurable to all.[33]

Changing Times, Changing Arts

Youth politics, fashion, music, and new ideologies were changing the nation and Boulder was moving on, too.

By the late 1960s, Boulder had become a mecca for hippies. With the mountain backdrop, a lively campus, plenty of political and social protests, and a thriving rock-and-roll music scene, the attraction was clear. Though Boulder had been "dry" since 1907, the city's prohibition ended in 1967 and young people,

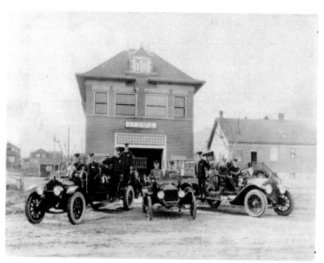

Old Firehouse #2, now the Pottery Lab.

eighteen to twenty, could legally drink the less potent 3.2 percent beer. The Sink and Tulagi on University Hill were happy to oblige.

Hippies settled in. Public parks were taken over by the young transients and, in some cases, the grounds became public health hazards. Many residents disapproved and resisted efforts to change the established order. In a guest editorial for the *Daily Camera*, architect James Hunter wrote, "We cannot afford the luxury of permitting Boulder to be a 'play pen' for maladjusted and defiant young people or a laboratory for bleeding heart social reformers."[34]

The Community Free School was committed to re-forming education. For a decade beginning in 1968, classes were offered in painting, drawing, stained glass, cooking, ceramics, macramé, batik, photography and more. "The perennial winners were the arts-and-crafts classes," director Dennis DuBé remembers. The school, housed for a time at 9th and Arapahoe in what is now the Highland City Club, provided much needed studio space for art and dance, as well as a leather shop and community darkroom. The popular Free School catalogue, full of drawings, cartoons, and photographs, offered a fresh opportunity for artists to display their work.[35]

George Woodman, "Betty Woodman Pottery Seated," n.d., poster. Martin and Taffy Kim Poster Collection, Museum of Boulder.

Meanwhile, in 1974, another educational alternative, The Naropa Institute (now University), was formed by Chogyam Trungpa, Rinpoche, and promised a reflective artistic experience with an emphasis on traditional Eastern arts. All this activity begot further activity with the founding of the Boulder Art Center in 1972, in a small house on Pine Street. In 1976, the BAC moved to 13th Street and was eventually renamed the Boulder Center for the Visual Arts, today the Boulder Museum of Contemporary Art.

Preservationists organized to form the non-profit Historic Boulder and subsequently saved many deteriorating historic properties with private funding. Chautauqua, too, had fallen into decline since the mid-century, and was revived in the 1970s, thanks to the efforts of Mary Galey. Because of her successful campaign, Chautauqua continues to be a center for arts, with performances and national speakers, although less emphasis is placed on art classes and workshops like the ones that fueled Boulder's early artists.

Highland-Lawn School was built in 1891, based on the Gothic-Romanesque Revival architectural styles. It functioned as an elementary school until 1971. It was a home for the Community Free School and today is an elegant office space and gathering place, Highland City Club.

Growth Control Wins, but the Arts Need Focus

The Danish Plan's growth limitations went into effect in 1977, followed by a revised Boulder Valley Comprehensive Plan in 1978, which outlined controlled minimal city growth.[36] Many counterculture participants who'd stayed in town now were part of the establishment, though this did not mean the city had retreated into conventionality. The makeup of City Council changed dramatically and included women, "longhairs," and Boulder's first and only African American mayor, Penfield Tate II.

The Boulder Public Library had been a venue for art exhibitions since at least 1926, when it hosted a painting display by the Boulder Art Association.[37] Later, particularly under the leadership of Marcelee Gralapp, BPL grew to be a strong force, supporting the visual arts with its Canyon Gallery, and, in 1977, a National Endowment for the Arts grant funded the Colorado Visual Artist's Register, housed and administered there.[38]

Daily Camera publisher, J. Edward Murray, weighed in on the Boulder art scene in 1978, with an editorial stating that the arts needed focus. "Although it is a pioneering as well as a sophisticated town in many of the urban amenities," he wrote, "Boulder, surprisingly, has had difficulty pulling itself together in terms of the visual and performing arts." A study suggested that Boulder groups coordinate and collaborate to "sell" Boulder as an arts community, among other strategies.[39] In 1979, the Boulder Arts Commission was established, with five rotating members appointed by the City Council, in order to help develop the arts, and in particular award grants to artists of all disciplines to support their projects.

Struggling and Controversy

During the late 1970s and early 1980s, Boulder finally made the transition from a Republican town to one that has voted consistently Democratic. But the 1980s seemed to be a

counterpoint to the free-spirited hippie days.

Following the first Bolder Boulder 10K running race in 1979, the jogging boom came into full force. Young urban professionals focused on work and conspicuous consumption. In a featured titled, "Where the Hip Meet to Trip," *Newsweek* described Boulder as a city of well-heeled liberals, drug use, and hedonism.[40] The Pearl Street Mall, originally conceived by the Boulder Tomorrow group, was completed in 1977, and quickly became a gathering point for musicians, restaurants, outdoor entertainment, and small, locally owned shops and galleries, among them The Boulder Arts and Crafts Cooperative, Smith Klein Gallery, and Whitehorse Gallery. With time, and rising rent, many businesses on the mall are now chains, and galleries, such as Mary Williams Fine Arts, have been forced into more remote areas. Many have closed: Lodestone, Albatross, Mustard Seed, and Maclaren Markowitz.[41]

Although Boulder was becoming more affluent, the art scene seemed to struggle. "I'm surprised at how little support there is for the arts considering how

Tulagi 1951. Carnegie Branch Library for Local History, Boulder.

sophisticated Boulder is," Whitehorse Gallery owner, Janet Esty, told the *Daily Camera* in 1986. "It just makes me stand back in disbelief."[42]

Citizens rallied. After an organized effort, the Dairy Arts Center came into being in 1992, providing much needed space for over a dozen small art groups. Open Studios was established in 1995, by Gary Zeff, designed to give an inside look into local artists' work spaces, thus bringing them out of isolation and obscurity. But support for the new arts groups didn't prevent controversy.

In 2001, Boulder resident Bob Rowan, aka "El Dildo Bandito," stole a piece of an installation from the library's Canyon Gallery, "Hanging 'Em Out to Dry," a comment on domestic violence featuring twenty-one ceramic penises. An American flag was left at the scene, a response to then-library director Gralapp's denial of a request to hang the flag at the library entrance.[43] The incident took place in the aftermath of September 11. Boulder residents debated patriotism and free expression for weeks, reminiscent of the reactions to Jake and Minnie nearly 70 years earlier.

Llloyd Kavich (d. 2013) spelled his name with three Ls and was renowned for his murals that cover the walls of The Sink.

And So It Goes

Little changes among people of wildly diverse opinions and ideas, so controversy continues to rage.

Recent growth, fueled by the boom in technology[44] companies and other businesses, creates challenges for art venues and artists alike. Although Boulder regularly lands on lists of best places to live, increase in housing prices and commercial spaces pose the threat of a community without any working artists at all.

As a fledgling city, Boulder did everything then possible to make sure the Chautauqua came here and, with the university, that art and culture were available to all our citizens. Unlike many small towns, the early inhabitants of Boulder recognized that a community needs its art and resident artists. History tends to repeat itself, and perhaps there are important lessons to learn from Boulder's artistic past.

Notes

1 Zach Zoich. "Caching in," *Archaeology*, May/June 62 62.3 (2009), 9.
2 Associated Press. "6,000-year-old campsite fires up archaeologists" *Denver Post* (March 8, 1993).
3 Terry Tempest Williams. *Refuge: An Unnatural History of Family and Place* (New York: Pantheon, 1991).
4 Jan Pettit. *Utes: The Mountain People* (Boulder, CO: Johnson Books, 1990), 1-12.
5 Ernest House, Jr., in a lecture on November 15, 2015, "Searching for Truth and Reconciliation: The Colorado Example," Third Annual Niwot Forum, Museum of Boulder.
6 Gaylord Torrence. *The Plains Indians: Artists of the Earth and Sky* (New York: Skira Rizzoli, 2014), 22.
7 Margaret Coel. *Chief Left Hand* (Norman, OK: University of Oklahoma Press, 1981), 68-81.
8 Phyllis Smith. *A Look at Boulder: From Settlement to City* (Boulder: Pruett Publishing Company, 1981), 42 and 20.
9 Wilfred Rieder. "The Phillips Collection. CU's art Heritage," *Daily Camera*, May 14, 1978.
10 Ibid.
11 Mary Galey. *The Grand Assembly: The Story of Life at the Colorado Chautauqua* (Boulder, CO: Colorado Chautauqua Association, 2015), 8, 9, 10.
12 Colorado Chautauqua Association records, 1898-1980, Carnegie Branch Library for Local History, Boulder, CO.
13 Silvia Pettem. *Boulder: A Sense of Time and Place* (Longmont, CO: The Book Lode, 2000), 147-149.
14 Galey, *The Grand Assembly*, 40.
15 Archives, *Daily Camera*, November 19,2006.
16 *Women's Club of Boulder: Seventy-Five Years of History* (Boulder, CO: Woman's Club of Boulder, 1976), 168.
17 Smith, *A Look at Boulder*, 151-152.
18 "Artists Enjoy Chautauqua." *Newsletter of the Colorado Chautauqua Association*, March 26, 1940, Vol. III., No. 3.
19 William E. Davis. *Glory Colorado! A History of the University of Colorado 1858-1963* (Boulder, CO: Pruett Press, 1965), 165.
20 Pettem, *Boulder*, 147-149.
21 Smith, *A Look at Boulder*, 180.
22 Sylvia Pettem. *Positively Pearl Street: A Chronicle of the Center of Boulder, Colorado* (Ward, CO: The Book Lode, 2007), 101. Smith, *A Look at Boulder*, 183.
23 Smith, *A Look at Boulder*, 183.
24 Joseph P. Bassi. *A Scientific Peak: How Boulder Became a World Center for Space and Atmospheric Science* (Boston: American Meteorological Society, 2015), 74 and 187-189.
25 Smith, *A Look at Boulder*, 189.
26 *Historic Context and Survey of Modern Architecture in Boulder, Colorado 1947-1977* (Boulder, CO: City of Boulder, 2000).
27 University of Colorado, Summer Session catalogues (Boulder, CO: University of Colorado, 1949, 1950, 1951, 1955, 1956); Mark Rothko. Miguel López-Remiro, ed. *Writings on Art* (Hew Haven: Yale University Press, 2006), 116-117; "Noted Artist to Be Here This Summer," *Daily Camera*, February 24, 1960; "Visiting Artist on University Faculty, Jimmy Ernst, To Lecture Next Week," *Daily Camera*, July 10, 1956; "Jimmy Ernst Giving Lecture Here Wednesday," *Daily Camera*, July 6, 1954; Jimmy Ernst To Be Honored at Central City," *Daily Camera*, July 16, 1954; "Creative Arts Should be the Core of Living," *Daily Camera*, undated.
28 "The Beckmanns' House in Boulder, Colorado, 1949." *Art in Exile*. http://kuenste-im-exil.de/KIE/Content/EN/SpecialExhibitions/MaxBeckmann-en/Objects/03StLouis/beckmann-fotos-boulder-house-en.html?single=1; Rothko, *Writings on Art*, 116-117.
29 Sarah Kuta. "Boulder remembers Llloyd Kavich, artist who painted iconic murals at The Sink," *Daily Camera*, October 21, 2013.
30 Amber Tschabrun. "Silver ceramics anniversary: Pottery Lab celebrates with special exhibit," *Daily Camera*, February 6, 2006.
31 "Citizens for Mesa Bond Issue Set July 4 Picnic," *Daily Camera*, June 22, 1962.
32 Smith, *A Look at Boulder*, 196.
33 Ibid, 200, 213.
34 James M. Hunter. "Statement to Council, Administration," *Daily Camera*, June 13, 1971.
35 Dennis DuBé, personal telephone interview, April 14, 2016; Community Free School catalogues. (Boulder, CO: Community Free School, 1974, 1976, 1977).
36 Smith, *A Look at Boulder*, 213.
37 "Paintings on Display in Exhibit Room of Library," *Daily Camera*, January 30, 1926.
38 Virginia Braddock. *Municipal Government History, Boulder, Colorado 1975-1979* (Boulder, CO: Boulder Public Library Foundation, 1986), 177.
39 J. Edward Murray. "Arts in Boulder Need Identifiable Focus." *Daily Camera*, October 15, 1978.
40 Lynn Langway and Janet Huck. "Where the Hip Meet to Trip," *Newsweek*, July 28, 1980.
41 Pettem, *Positively Pearl Street*, 198; Susan Smith. "Art dealers depend on tourist $$," *Daily Camera*, September 23, 1986.
42 Smith, "Art dealers depend on tourist $$."
43 Greg Avery. "Boulder Public Library flaps few far and wide – Controversy over flags, art display gains national attention," *Daily Camera*, December 29, 2001.
44 Erika Meltzer. "Boulder 'sets stage' for public art after YES! rejection," *Daily Camera*, July 24, 2014.

Marilyn Markowitz (1925-2007), "Mountain Climber," 1974, mixed media. Private Collection.

The Art-ing of Downtown Boulder
A Portrait of Carl A. Worthington

Collin Heng-Patton

Prior to the early '60s, Boulder was most certainly not the city it is today. In the late 1800s to the 1950s, it was part mining town, surrounded by farm country, with a university. A train ran down what is now Canyon Boulevard to 9th Street, transporting supplies to and from the mountain mining communities. Downtown Pearl Street had a few local businesses that, on a good day, saw only as many as ten people come through along with the occasional tumbleweed. In 1961, Crossroads Mall (now 29th Street Mall) was built and was taking many of Pearl Street's retailers out of downtown. Large department stores in the mall drew crowds away from the increasingly dismal heart of

Carl A. Worthington, 1971.

the city. Officials and citizens began to grow concerned.

In March 1968, graduate students from the University of Colorado-Boulder approached architect Carl A. Worthington with a problem. They were hard-pressed to find an exhibition space large enough for their spring show. Worthington, a prominent citizen and known supporter of the arts was more than willing to help. Almost overnight, he secured the vacant old Elks building on 13th and Spruce, in the heart of the city. Problem solved? Sure, the graduate students had an exhibition space, larger than they had imagined, but Worthington would not stop there. He arranged for the city

Above, right to left: Before the crowd surge at the 1968 "Pearl Street Happening," the incipient event that began the push toward revitalizing downtown Boulder.

Saturday night at Gallery 1309.

to close down the three city blocks surrounding the courthouse in order to create what would be called the "Pearl Street Happening."

A year earlier, Worthington had established Gallery 1309, in the front end of his architectural firm at 1309 Spruce Street. He began to gain notoriety in the downtown area for his efforts to showcase contemporary artists. Each month he dedicated his gallery space to local, up-and-coming artists who pushed the limits beyond what much of Boulder considered art at the time. Artists like Andrew Libertone, George and Betty Woodman, Eve Drewelowe, Jerry Johnson, and Thomas Benton exhibited at 1309, "the place to be," on the first Saturday night of each month. People were going downtown for the first time in a long time. Gallery 1309 and Worthington were big supporters of the arts, so, naturally, when the graduate students from CU came asking for a large space for their MFA exhibition, he was more than happy to help.

The "Pearl Street Happening" was the incipient event that began the push toward revitalizing downtown Boulder. In '68, Pearl Street was entirely a motorway with few pedestrians. Worthington pulled strings with City Manager Ted Tedesco to have the three blocks surrounding the courthouse closed off for the art students. On a Sunday in May, four flatbed trailers blocked each intersection and each bed became a stage. Worthington

arranged for eighteen rock bands to play throughout the day from noon to midnight. Enormous wood sculptures created by the students were brought in and placed on the lawn in front of the county courthouse. Two large-scale projectors, donated by CU, were run up through the sheriff's office to the roof for two psychedelic slide shows. The National Center for Atmospheric Research donated 1,000 balloons. People came by the thousands, more than to the annual Powwow Parade, so many that police were brought in to protect the large hippie community that had congregated in the courthouse square. It was an event that, for the first time in the majority of Boulder history, brought hundreds and hundreds of folk together in the downtown area.

To say the "Pearl Street Happening" was a success is an understatement. Short of the Boulder County Fair, a festival, let alone an art festival, that big had never taken place in the city's history. The following day brought mixed reviews. Conservative country folk in east Boulder were upset that such a public nuisance had been allowed to occur in the city. For months, people were either calling for Tedesco to resign or congratulating him for encouraging such excitement in a quiet little town sometimes likened to the fictional TV village, "Mayberry RFD." After the dust settled, however, people began to realize how important it was to have a bustling city center. Subsequently, in 1973, the Downtown Business Association hired Worthington to develop a master plan to revitalize the heart of the city.

Worthington is the person we can thank for getting planning approval for the most popular location in Boulder, the Pearl Street pedestrian mall. Beyond that, he has been the mastermind behind many luxuries Boulderites don't even think twice about today. For example, in 1967, while on the City Planning Board, Worthington helped initiate the Boulder Valley Green Belt plan, which raised the sales tax 1 percent in

order for the city to buy 45,000 acres and the county to purchase 100,000 acres and place them in the open space system. That included open space around Chautauqua and the Flatirons, as well as surrounding farm land enjoyed by residents and tourists alike. In 1968, Worthington proposed a plan to make it safer to bike in the city, which ultimately led to the extensive bike paths so many people now use every day. In 1973, his Aesthetic Action, Inc., a non-profit group, got the Boulder City Council to adopt an Outdoor Art Master Plan for the city. Unfortunately, it was never implemented.

The art-ing of Boulder, including honoring the profound relationship we have with our natural surroundings, began with Carl A. Worthington's innovative ideas and the "Pearl Street Happening," which inspired so many more community art events across the years and established a contemporary art scene in a once sleepy American community.

Andrew Libertone. "Set Top Box," 2012, powder-coated steel.

Ann Jones, American (1905-1989), "Flatirons," 1983, watercolor on paper. Gift of Helen Davis,
collection Kirkland Museum of Fine & Decorative Art, Denver, 2006.1290 © Kirkland Museum of Fine & Decorative Art.

Women at Work
The Visual Arts in Boulder Prior to 1950

Kirk T. Ambrose

In July 1917, Georgia O'Keeffe escaped the summer heat of the Texas panhandle, where she was teaching at West Texas State Normal College, and headed to the mountains of Colorado. Along with her sister, she traveled by train on the now defunct Switzerland Line to the mountain hamlet of Ward, west of Boulder. O'Keeffe spent roughly three weeks taking long hikes on which she painted watercolors of the majestic scenery. These visceral works signal her embrace of the landscape to which she subsequently signaled a desire to return in a letter, dated 5 November 1917, to Mrs. Schmoll, her hostess in Ward.

Predating her visits to New Mexico, O'Keeffe's Colorado voyage presents a little-known episode in the life of a celebrated artist. Yet, this trip likewise aligns with broader social movements from the period. Largely at the impetus of a group of Texas schoolteachers, the 1898 foundation of the Chautauqua Institute in Boulder encouraged many women to visit each summer. By the time of O'Keeffe's journey, hundreds of women interested in the arts had already traveled to the city, some settling permanently. These transplants played a defining role in the cultural life of Boulder. In addition to pursuing their own artistic practices, many established and participated actively in arts organizations, as well as regularly teaching classes to members of the community, young and old. In short, this pioneering group of women played two roles: as practitioners and as ambassadors of the arts to the broader community.[1]

Eve Drewelowe, American (1899-1988), "The Tetons -- Wymong," 1936, oil paint on canvas, 32 x 38 inches composition.
Gift of Mary Rogers Thoms, CU Art Museum, University of Colorado Boulder, 85.1744.
Photo: Jeff Wells, © CU Art Museum, University of Colorado Boulder.

By contrast, men were secondary figures in Boulder's early cultural history. This phenomenon can be partly attributed to the fact that many male artists called the city home for brief periods of time. Elmer P. Green, who moved from out east in the 1880s and who painted what may be the earliest rendering of Boulder Falls, was about 29 when he died in 1892, likely from Bright's Disease. Jozef Bakos taught painting at the University of Colorado-Boulder for about a year prior to its shutdown during the influenza pandemic of 1918-19. Thereafter, he moved to Santa Fe, where he helped establish the group, Los Cinco Pintores, which sought to bring art to the "common man."

Most women artists who settled in Boulder prior to 1950 had trained in Midwestern and Eastern art schools. It bears stressing that women outnumbered men in most American schools from the period just after the Civil War until the 1920s. During this period, careers in the arts were a viable option for women, who could pursue work as portraitists, as interior designers, and as teachers, among other paths. In other words, professional women artists were the rule, not the exception.

Helen Chain (1849-92) offers an early Colorado example of a career in the arts. A San Francisco native who trained on the East Coast, perhaps with George Innes, Chain moved to Denver in 1871. She was an indefatigable hiker and painter of mountain scenes, including several canvases of the Mount of the Holy Cross, which she had summited. In 1882, Chain became the first woman to exhibit at the National Academy of Design in New York City. In Denver she taught private art lessons, including to the celebrated landscape painter Charles Partridge Adams. Additionally, in a pattern followed by many subsequent women artists in Boulder, Chain took an abiding interest in social causes, advocating for the rights of Chinese immigrants, to whom she

and her husband taught English from their downtown bookshop. Chain's life was cut short on a trip with her husband to Southeast Asia, during which their ship went down in a typhoon.

Many artists note in their writings that natural beauty drew them to the region, but another draw was likely the relatively greater social opportunities afforded women in the West in comparison to regions east of the Mississippi. By the year 1900, Colorado, Utah, and Wyoming had granted suffrage to women, the first three states in the Union to do so. Montana elected the first woman senator in 1916, only one year after a referendum to extend the vote to women in New York State was defeated and four years prior to the ratification of the 19th Amendment to the United States Constitution. An anecdote from the University of Wyoming is illustrative of progressive attitudes from the period. In 1920, a group of women formed the University Professors Club. When their male colleagues protested that they had been excluded from this organization, club members responded that the protestors were free to form a "Men's Faculty Club."

Challenges doubtless existed for women, but so did prospects. The establishment of art programs at state universities across the West in the 1910s and 1920s offered viable careers. Art departments at state schools across the American West, such as the universities of California (Berkeley), Hawaii, New Mexico, and Wyoming, to name a few, hired women early on. The University of Colorado-Boulder marched in step with this trend, opening the doors of its Fine Arts Department in 1917 and counted women among its faculty within less than a decade.[2]

The personal significance of the West for many women artists in Boulder is evident in the prevalence of landscape in their art. Although there was already a long tradition of landscape

Adma Green Kerr, American (1878 – 1949), Untitled, n.d. Oil on canvas and foam core, 30"x36".
Courtesy and © The Wilson Family Collection.

painting in the Western United States, for many of these women the genre marked a departure from their student training, which typically stressed the rendering of the human figure. In their unpublished manifesto, the Prospectors, a group of five artists active in Boulder from the 1920s to the 1940s, recognized that landscape was both internal and external, suggesting that place actively participated in the formation of personal identity. Perhaps partly for this reason, these artists typically included people within their landscapes, thereby evoking constitutive interrelations between culture and nature.

Human presence within the landscape mattered deeply for these Boulder women, many of whom had a significant ethnographic aspect to their work, recording, among others, Spanish Colonial and Native American traditions within the region. One can identify here a profound paradox, for the presence of these women, typically of Northern European lineage, literally displaced the cultures and histories that they sought to record. By the same token, their ethnographic activities sought to honor and acknowledge local cultures.

Several tribal authorities have noted the respect with which Muriel Sibell Wolle (1897-1977) recorded indigenous rituals, even as she made multiple errors of interpretation, and the Hopi honored Gwendolyn Meux (1893-1973) with an honorary membership in their Snake Clan. The fraught and complex nature of the region's intercultural relations is signaled by the fact that I have failed to identify indigenous artists active in Boulder during the early 20th century, though there is record from this period of Native Americans participating in local festivals that celebrated their long histories within the Boulder Valley.

Based largely on unpublished archival materials at the University of Colorado-Boulder and at the Carnegie Branch Library for Local History in Boulder, the following historical sketch provides an overview of women artists in the city during the early decades of the 20th century in terms of two generations. The first includes figures active from the 1898 foundation of the Boulder Chautauqua, while the second begins with the arrival of a significant cohort of women in the mid-1920s. The activities

of these two generations can be described as pioneering, with all the complex and variegated associations of this term. These women worked to forge a vibrant cultural life for the city, one that welcomed all individuals irrespective, say, of their gender or race. By the same token, in moving to the West these women participated in fundamental transformations of the landscape, both cultural and natural, processes that continue to unfold to this day.

First Generation

Any account of the history of the visual arts in the city of Boulder rightly begins with artist, lecturer, and philanthropist, Jean Sherwood (1848-1938). Née Wirth, Sherwood's father was a Congregationalist minister in Oberlin, Ohio, and her mother was one of the earliest women graduates of that city's eponymous college. Sherwood studied briefly at Olivet College in Michigan before transferring to Oberlin, where she took art classes. Unfortunately, no work by her hand is known to survive.

Matilda Vanderpoel, Dutch, (1862-1950), "A Young Artist," n.d. Pastel on paper, 17 x13 inches framed, Harriett & Wendell Harris, 01.20.1 Photo: Boulder History Museum / Museum of Boulder, © Vanderpoel Family.

Shortly after receiving her undergraduate degree, Sherwood moved to Chicago, where she would marry John B. Sherwood, a successful businessman who manufactured classroom desks sold to schools across the nation. John and Jean shared an interest in pedagogy, as well as promoting social causes. Jean argued that if only one in a hundred individuals could become an artist, all lives could be enriched by art. She likewise advocated for what she called the "working girls" of the city of Chicago, many of whom had moved from rural farms to find jobs. To combat the social isolation that many of these young transplants experienced, Sherwood established noon clubs where working women could meet, have meals, read, and develop social networks. Sherwood championed women's rights, as evinced by her letter-writing campaign to Chicago newspapers that argued that any individual should be able to walk alone at night in safety and without raising any suspicions regarding her character.

The Sherwoods summered in Boulder and, after the death of her husband, Jean began to spend even more time in the city. Joining forces with a broad coalition of organizers, she helped shepherd the opening of a Chautauqua community in Boulder. Sherwood soon began work to extend the benefits of the Chautauqua experience to her "working girls." In 1911, she helped fund the Blue Bird Cottage in Chautauqua, selling subscriptions to young women in Chicago. Five dollars entitled a subscriber to two weeks' residence in the cottage each year. Individuals could take classes in the arts or simply pursue these interests independently. As many as 5,000 women had participated in the program by the time it ended in the late 1950s.

During the inaugural year of Chautauqua, Sherwood met Mathilda Vanderpoel (1862-1950), who would come to identify herself as the first Blue Bird. Vanderpoel had immigrated from the Netherlands as a child and taught at the Chicago Art Institute, for a time directed

by her brother John H. Vanderpoel, whom Georgia O'Keeffe praised as a gifted teacher. Mathilda spent summers in Gold Hill, a small community a few miles to the west of Boulder, where she enjoyed hiking and painting. She assisted Sherwood on various projects in Boulder and Chicago over the course of their enduring friendship. In 1921, the two women acquired the Gold Hill Inn, a former lodge for miners, as a satellite site for the Blue Birds.

in the 1923 foundation of the Boulder Art Association, an organization dedicated to promoting the arts through a variety of means, including lectures on the history of art and courses in drawing and painting. Three years later, Sherwood was a founding member of the Boulder Artists Guild, which aimed to support practicing artists. Sherwood's legacy endures to this day. The Boulder Artists Guild continues to thrive. The current Boulder Museum

Myrtle Hoffman Campbell, American (1886-1978), "Old Spanish Mission," c. 1948.
Watercolor on paper, 29"x36" framed,.Collection of Deborah and Warren Wadsworth
© Estate of Myrtle Hoffman Campbell and Deborah and Warren Wadsworth.

Sherwood, often with the assistance of Vanderpoel, worked tirelessly to promote the arts in Boulder. A key collaborator in this effort on the CU campus was F.B.R. Hellems, dean of the College of Arts & Sciences. Sherwood persuaded Hellems to introduce an art gallery within the campus library, now the Theater and Dance Building, as well as to require all undergraduates to take an art appreciation class. Sherwood argued that it was important for all undergraduates to experience examples of good works of art in person. Within the broader community, Sherwood participated

of Contemporary Art and The Dairy Arts Center can trace their roots directly back to Sherwood's activities.

In recognition of her tireless advocacy for the arts, members of the university and community dedicated the Jean Sherwood Gallery in 1932 on the 1200 block of Arapahoe Avenue. The building no longer exists, but for nearly a decade it hosted exhibitions, including works on loan from the Metropolitan Museum of Art and from the Museum of Modern Art in New York City. Virginia True (1900-

1989), who was a member of the Prospectors, was particularly active in organizing these exhibitions, as lectures and art classes for the community, from school children to working adults. In short, the Sherwood gallery served to enhance the social aspect of the visual arts for all citizens of Boulder.

Second Generation

Eve Drewelowe (1899-1989) was an active participant in the Boulder Artists Guild. The eighth of thirteen children in a family in Hampton, Iowa, she claimed that she decided to become an artist while she was in her mother's womb. To pursue that ambition, she attended the University of Iowa from 1919-1923 and then successfully petitioned Iowa's Dean of Arts & Sciences, Carl Seashore, to create a graduate degree in art, of which she was the first recipient in 1924. Drewelowe married fellow student, Jacob Van Ek, who was hired as professor of political science in 1925 by the University of Colorado. Drewelowe occasionally taught at the university, in 1927 to 1928 and during the summers of 1936 and 1937. Soon after their arrival in Boulder, Van Ek received a fellowship that allowed the couple to travel around the world for thirteen months in 1928 and 1929, a voyage that was transformative for the young artist.

Drewelowe's notebooks from this trip feature striking pen-and-ink drawings of scenes in Asia and Europe. On the final leg of the voyage, while crossing the Atlantic, Jacob received a telegram that he had been elected Dean of the College of Arts and Sciences at the University of Colorado, a position he held until 1959.

Drewelowe was overwhelmed by the expectations associated with her husband's new administrative position at the university. The couple had returned to Boulder virtually penniless, in the depths of the Great Depression, and, on the slimmest of budgets, she entertained guests of the university. She haggled with local farmers over the price of chickens, which she would slaughter and prepare into meals. Over the course of her husband's tenure as dean, Drewelowe increasingly distanced herself from university obligations, which she late in life described as unpaid labor that ran counter to her "feminist" views. A final turning point came in 1940, after her first solo exhibition in New York City, when she nearly died from a gastric polyp that had negatively affected her health for several years. This ailment was finally diagnosed and successfully treated at the Mayo Clinic. Drewelowe described this brush with death as a second birth that resulted in her eschewing all university obligations and strengthening her resolve as an artist.

Muriel Sibell Wolle, 3rd from right on bottom row, with students at the 1946 Founders Day Banquet for Delta Psi Delta. Archives of Art & Art History, CU Boulder.

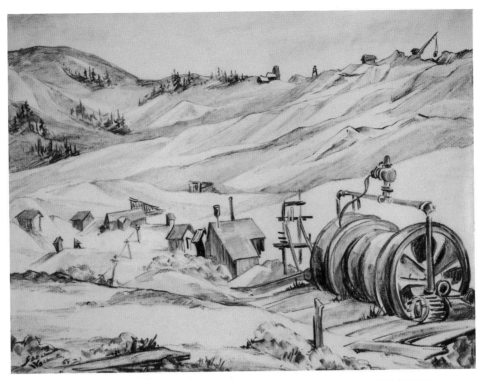

Muriel Sibell Wolle, American (1898-1977), "Leadville Stumptown," 1934 | 1968,
Sanguine (red chalk) and black crayon on paper, 26 9/16 x 18 13/16 inches. Gift of Mr. Hart D. Gilchrist, CU Art Museum,
University of Colorado Boulder, 94.06.01. © CU Art Museum, University of Colorado Boulder.

Her disillusionment with the University of Colorado was sealed during a rededication ceremony of Old Main, the first building on campus, as an administrative center. During this ceremony, Drewelowe sat on a stage next to her husband, the sole woman and the only individual on stage not acknowledged at any point. She took this silence as a failure to recognize the many sacrifices she had made for the institution. Her profound bitterness at this experience helps explain her motivation for gifting her unsold paintings to the University of Iowa, which named her a distinguished alumna.

Drewelowe's paintings manifest a remarkable range, from kinetic landscapes, such as a painting of the Tetons, to portraits to experimentations with pure abstraction, a movement which she embraced around 1955. In many instances, her work takes an empathetic view of the cause of women or of the underprivileged, including immigrant workers. Among her peers, Drewelowe received the greatest national recognition during her lifetime through invitations to numerous group and solo exhibitions, including in Chicago and New York.

Another key figure of the second generation was Muriel Sibell Wolle, widely known in her day as the "Grande Dame" of the arts in Boulder. Graduating from the New York School of Fine and Applied Arts (later Parsons) with a degree in costume design and advertising, Sibell Wolle first taught at the Texas State College for Women in Denton, but soon returned to New York and earned a BS in art education from New York University. In 1924, she accepted a teaching position at CU and became department chair in 1927, a position she held for twenty years. In 1929, she began the collection that would later become the CU Art Museum. She further pursued and was granted an MA degree in English at CU. In recognition of her work as scholar and educator, the CU Board of Regents ranked her among the "Alumni of the Century" and voted to name

the Fine Arts Building after her in 1978. This building was demolished in 2008 to make way for the new Visual Arts Complex, which today includes a gallery named in her honor.

Sibell Wolle was a tireless educator, serving for several years as the president of Delta Phi Delta, a national arts organization that published annual reviews of student exhibitions. Perhaps most impressively, she advocated for arts education for all students, regardless of gender, race, or ethnicity. For example, she was a staunch supporter of Dolores Hale, a black art student, who in 1943 helped lead a successful campaign against illegal segregationist policies of businesses in the Boulder neighborhood known as the Hill. Photographs of Sibell Wolle and her students from the 1930s and 1940s attest to her deep commitment to supporting diversity among the student body.

Virginia True (1900-1989), "Rocks and Trees," after 1934. Oil on canvas board, 13 3/8" x 11 ½". Collection Kirkland Museum of Fine & Decorative Art, Denver, 2011.0218 © Kirkland Museum of Fine & Decorative Art.

Stage set design was an important aspect of Sibell Wolle's creative work, as well as that of many of her colleagues in the Fine Arts Department. She collaborated on productions with the university's Theater Department, as well as designed with the Central City Opera and the Colorado Ballet in Denver. Many of her drawings for these sets survive. Her talents in this arena were likewise employed in lavishly decorating student events, including costume balls and other dances that were important sources of entertainment.

* * *

In her writings, Sibell Wolle describes a profound connection to the Western landscape through which she traveled tirelessly, drawing, painting, and taking photographs.[3] Her vision of the landscape was by no means of a pristine idyll in the manner of Albert Bierstadt, but embraced the history of human presence in the West, from Indigenous communities to Spanish colonial settlers. Sibell Wolle's many hundreds of drawings of abandoned mining and logging towns align with her abiding interest in place. A view outside of Leadville is characteristic of the hundreds of such studies to survive in public and private collections, many of which served to illustrate her books on ghost towns, including her celebrated *Stampede to Timberline*. This book, even reviewed in *Time* magazine, offers a highly personal account of the region's history as the author engages in a quest to find yet another forgotten site. As with her admirably precise prose, there is a scrupulous attention to detail in her drawings, a dedication to recording the deleterious effects of time on the buildings that had once constituted thriving communities. Rather than adopt the logic of Manifest Destiny, which regarded the West as a tabula rasa, Sibell Wolle's sensitive engagement with the region's history offered a vehicle to define her own identity. Evidence for this can be found in the decoration of her home, which included, among other objects, Navajo rugs, her drawings of ghost towns, and Spanish colonial furniture.

In her wide-ranging travels throughout the West, Sibell Wolle frequently had the company of other members of the Prospector group: Frances D. Hoar (1898-1985), Gwendolyn Meux (1893-1973), Virginia True, and Clement Trucksess, Hoar's husband. The group was committed to producing art that embraced the landscape, but in this common goal each member likewise aimed to articulate her own artistic vision. The group exhibited their work in venues across the nation, a promotional strategy employed by other groups of this period.

The career trajectories of the Prospectors largely resembled Sibell Wolle's. Hoar was born in Philadelphia and studied at the Pennsylvania Museum School of Industrial Art. After her marriage to artist Frederick C. Trucksess in 1927, she settled in Boulder to teach at the university.

Studying on a government scholarship at Canada's Owens Art Gallery at Mount Allison University in Sackville, New Brunswick, Meux taught in that institution's Fine Arts Department and subsequently at the University of Oklahoma. During this early period, she also studied at the art colonies of Provincetown and Santa Fe. In 1925, she married Arthur Gayle Waldrop, journalism professor at the University of Colorado, where she would teach art classes during the summer. One of the founding members of the Boulder Artists Guild in 1925, Meux also wrote and illustrated articles for the *Christian Science Monitor* and *Trail and Timberline*, the Colorado Mountain Club's monthly magazine.

During her lifetime, True arguably enjoyed the most individual success as an artist. She studied at the John Herron Art Institute in Indiana, where she received her BA, and the Pennsylvania Academy of Fine Arts for a year, prior to coming to the University of Colorado in 1929. Because she did not have her MFA, she could not be offered a tenure-track position. In 1937, Cornell University commissioned her to paint a mural titled "Home Economics," for the Martha Van Rensselaer Hall. That same year, True received her MFA and subsequently joined the faculty at Cornell in 1939 and eventually became head of the Home Economics Department. Though True continued to make trips back to Colorado and New Mexico, her ties with the Prospectors waned; the group dissolved in 1942. Throughout her life, True continued to exhibit in venues along the East Coast and in New Mexico. Her work ranged from landscapes to portraits to, toward the end of her life, pure abstractions.

While important for mutual support, it would be mistaken to regard arts groups, including the Boulder Artists Guild and the Prospectors, as defining or promoting a characteristic style or mode of production. Rather, the formation of arts stemmed from a strong desire to associate with other artists in mutually supportive relationships, for these women construed the life of an artist in profoundly social terms. Drewelowe, who was never a member of the Prospectors, regularly traveled with Sibell Wolle, including to the Grand Tetons in Wyoming, and painted with other members of the group. Drewelowe and Meux each painted portraits of a Mrs. Thompson, an owner of an inn in Ward, during the same sitting; both paintings survive.

The signatures of second generation artists in Boulder offer insights into how these women understood their artistic practices. In contrast to many early California artists who used initials for their given names as a way to disguise their gender, women artists in Boulder typically spelled out their first names. There were likewise creative approaches to surnames among these women. Early in her career, Drewelowe, a spelling she transformed from the family "Drewlow," used her husband's name on her paintings, but soon abandoned this practice when she learned that some mistakenly attributed her works to her husband. Some of Drewelowe's paintings even

show a "Van Ek" crossed out and replaced above by "Drewelowe." Hoar favored her maiden name over her married name in her paintings, but socially went by Trucksess. As a young woman, Meux changed the spelling of her maiden name from "Mews," and would occasionally use her husband's name, Waldrop, to write reviews of exhibitions that included her own work.[4] While the motivations for these signatory practices are doubtless complex, they share in a common ambition to establish and assert individual agency through their art.

Conclusion

There were many other women artists active in Boulder in the early decades of the 20th century who made enduring contributions. Ann Jones (1905-1989), for one, played a particularly important role in the development of art instruction at the University of Colorado during the century's middle decades. A Colorado native, Jones received her BA and MA degrees from Colorado State College, now the University of Northern Colorado in Greeley. She likewise studied ceramics in Denver with John St. Gaudens, nephew of noted sculptor Anthony St. Gaudens. After brief teaching stints in Iowa and Philadelphia, Jones joined the faculty of CU-Boulder in 1943. Around 1951, after a trip to study the Ceramics workshop at Cranbrook Academy in Michigan, Jones established a Ceramics Lab in the Fine Arts Department. Today, the Ceramics program at CU ranks among the top five in the nation.

Unfortunately, many Boulder artists mentioned in the archives are simply names, with no known extant works that can be linked with them. For this reason, our picture of the visual arts in Boulder prior to 1950 is partial and incomplete. Even so, it is clear that women played a leading and defining role during this period, a scenario with parallels elsewhere in Colorado. A significant number of the artists who, in 1929, founded the Boulder Artists Guild were women, as were the founding members of The Denver Art Museum. Similarly, in Colorado Springs, women were early leaders in the visual arts. In view of these regional patterns, the case of Boulder offers just one chapter within a larger history of women in the arts of the Rocky Mountain Region, an important history that remains to be written.

Notes

1 The CU Art Museum exhibition, *Pioneers: Women Artists in Boulder, 1898-1950* (on view September 16, 2016 through February 4, 2017) features works by Eve Drewelowe, Frances Hoar (Trucksess), Anne Jones, Adma Green Kerr, Gwendolyn Meux, Virginia True, Matilda Vanderpoel, and Muriel Sibell Wolle. There are plans for a catalogue based on this exhibition, an affiliate of *Celebration! A History of the Visual Arts in Boulder*.

2 Students studied art at the University of Colorado prior to the establishment of the Fine Arts Department. Adelaide Morris (Gardner), who was born in Iowa in 1881 and who graduated from CU in 1903 with a BA degree in liberal arts, took art lessons through the Chautauqua Drawing Society before pursuing studies later in life in Paris and the University of California-Los Angeles. Gardner corresponded with Jean Sherwood and Mathilda Vanderpoel, as well as with Mary Rippon, a celebrated CU professor of French and German. Gardner would go on to teach art at the universities of Wyoming and Hawaii, before becoming a tenured professor at the University of California-Berkeley. In 1950, Gardner retired to Boulder, where she remained until her death in 1974.

3 Like all the members of the Prospectors, Sibell Wolle made many trips to New Mexico. The Denver Public Library possesses several of her drawings of Abiquiú, near Ghost Ranch, where Georgia O'Keeffe spent much time beginning in 1929. It's unclear whether Sibell Wolle and O'Keeffe met. Virginia True, another Prospector discussed here, painted an untitled portrait in New Mexico; the sitter strongly resembles O'Keeffe.

4 In changing the spelling of her surname, Meux may have had in mind Lady Meux (1847-1910), pronounced "Mews." Lady Meux was a larger-than-life figure and patroness of the arts in the United Kingdom. In 1881, for example, James McNeill Whistler painted three portraits of her. One was destroyed, likely during an argument between artist and sitter. Lady Meux was likewise a great collector of Egyptian and Ethiopian art. Remarkably, she attempted to repatriate five Ethiopian manuscripts to the Emperor Menelik by leaving them to him in her will. The British government did not honor this wish, eventually selling the manuscripts to William Randolph Hearst.

WOW

The Struggle to Establish a Woman's Museum

Collin Heng-Patton

Founded in 1991 in Boulder by Toni Dewey, the Women of the West Museum was a trailblazing institution. It was one of the first museums to focus solely on the impact of women in shaping the American West. Interrogating what it meant to be a woman not simply living, but surviving in this vast, highly romanticized landscape in both past and present was a foundational principle of the museum. Equally important was to challenge popular conceptions of the West, especially those which placed white men (cowboys) front and center while depicting women of all backgrounds and ethnicities as passive spectators to the growth of the nation. WOW began by engaging a simple yet powerful idea: to share unheard stories of ordinary women from the past, thus challenging accepted versions of the history of the American West.

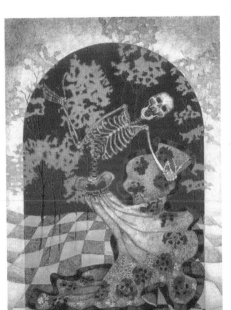

Anita Roderiguez "Homenaje á Selena," 2000, lithograph on Rives BFK.

WOW was as innovative as it was cutting-edge. It began as a completely virtual museum, labeled as a "museum without walls." At the time, there were only seven museums in the United States dedicated to women's history and the Women of the West Museum aimed to expand on the conversation. The site contained a database about important, unrecognized women, as well as created a space for visitors to contribute their own histories. Arguably one of the museum's most innovative and engaging projects was "Walk a Mile in Her Shoes," a kind of field guide geared toward encouraging children to learn history outside the canon by tracking down and providing access to the historical records pertaining to notable female figures. The project encouraged the children to take what they were learning and go outside

Above: Hung Liu "Sisters," 2000, lithograph with Chiné Colle on Magnani Pescia Creme.

the classroom in order to pursue alternative histories and to create history trails of their own. Ahead of its time, the museum took advantage of a technology not yet popularized in order to engage, educate, and, most importantly, empower.

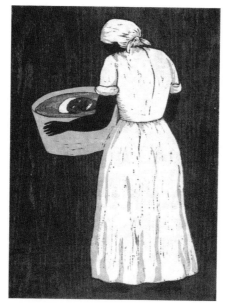

Alongside its many educational programs, WOW considered the visual arts to be a cornerstone of its foundational mission. One of its largest exhibitions, *Expanded Visions: Four Women Artists Print the American West*, brought together artists to share their diverse understandings of the history of the West and how it has shaped their own personal histories. In a project curated by Joan Markowitz, artists Hung Liu, Anita Rodriguez, Alison Saar, and Emmi Whitehorse collaborated with master printmaker, Bud Shark, to evoke a myriad of connotations from Hispanic and Chinese migration, to Mexican pop culture, African American, and plenty in between. Placed in conversation with one another, these four works expand what it means to be a woman of the American West and

Alison Saar "Washtub Blues," 2000, woodcut on unbleached Thai Mulberry paper.

displace the commonplace images of dowdy pioneer women and hypersexualized cowgirls. The museum created a tear in the fabric of time to allow women of all backgrounds to share their unique perspectives.

Unfortunately, WOW's innovative online format was underappreciated. The organization struggled to find a location to begin amassing a physical collection. After losing a battle to settle in Boulder, it moved its offices to Denver and continued to run its pop-up events across the metro area. Eventually, in 2001, the Women of the West Museum merged with the Autry Museum of the American West in Los Angeles and its ongoing exhibits and archives can still be seen online at the Autry's website. The struggle of WOW's mostly female board to acquire funding for the presentation of women's stories reflects many of the difficulties faced by women comprising the history of the American West.

❖ ❖ ❖

Emmi Whitehorse "Jackstraw," 2000, lithograph on white Thai mulberry paper.

Landscape as Narrative

Joan Markowitz

Artists have forever been seduced by landscape. From the beginning of visually recorded time, on every continent, we witness the ubiquitous influence of landscape; in earliest mark making, as backdrop, and as subject itself. Time, place, and culture provide the particular inspirations for artistic creation, and the American West has offered rich source material for observation and interpretation. Previously inhabited seasonally by Native Americans, in the mid-1800s it was settled by European-Americans who adopted prevailing notions of expansion as Manifest Destiny. Emboldened by a sense of American exceptionalism, they considered it their duty to enlarge territorial boundaries. They were independent and adventurous, and came West to stake their claims, explore, possess the land, relocate, or vanquish the indigenous population, and be one with nature in a quest for spiritual renewal.

Artists invite us to see the world in ways formerly unimaginable. By so doing, they act as visionaries, arbiters of taste, architects of change. *Evolving Visions of Land and Landscape* — an exhibition curated for *Celebration! A History of the Visual Arts in Boulder*, which took place at the Boulder Museum of Contemporary Art from September 29, 2016 to January 15, 2017 — explores the multitude and evolution of ways artists have viewed the land and landscape. All of the works were created by people who live or lived in Boulder at some point from the mid-1800s to the present. As a place of choice which attracts those who identify with lifestyles predicated on love of the outdoors and appreciation of natural beauty, it is not surprising that so many artists working in Boulder have focused on landscape. As renowned art critic Lucy R. Lippard has written in her 1997 book, *The Lure of the Local*: "Sometimes a spontaneous attraction to a place is really an emotional response to landscape."

Above: Chuck Forsman, "Sacred Cows," 2011, oil on panel.

In the mid-19th century, artists followed adventurers and settlers West to visually document the unique landscape and help define an American identity. Many, originally from Europe but living on the East Coast of the United States, came to explore the wilderness: unspoiled, unfamiliar, and exciting. Some arrived to complete government-supported surveys of flora, fauna, natural resources, and transportation routes. Two 20th-century artists in particular defined visually the contemporary Western landscape. Ansel Adams, a conservationist and thirty-seven-year member of the Sierra Club, photographed Yosemite and other national parks. His adulated and often reproduced photograph "Moonrise, Hernández," taken in Northern New Mexico in 1941 and considered by many to be a "perfect" photograph. And Georgia O'Keeffe — who came through Boulder long enough to catch the train to Ward — created some of her most influential works after leaving New York

Elmer P. Green, American (c. 1863 - 1892), "Boulder Falls," 1891, oil paint on canvas .Gift of Mrs. Myrtle Lyon Lombard & Mrs. Olive Sosey Hoge from the collection of Winnie Mary Hamm Sosey, CU Art Museum, University of Colorado Boulder, 69.404.01, Photo: Jeff Wells / © CU Art Museum.

and settling in Abiquiú, New Mexico. Her paintings of rolling hills, dry animal carcasses, and glorious desert flowers have become iconic images synonymous with the West.

Most of the twenty-six featured artists' works in *Evolving Visions* have their sights set on local environs. Some look beyond, to other parts of the state, some to other regions of the globe. Some have recorded a non-place-specific landscape, others a universal landscape, while a few have looked at landscapes of the imagination. Interpretations have been literal, realistic, abstracted, and metaphorical. Their visions range from observational photographic recording, romantic idealization of new frontiers, wonderment, and awe at the magnificence and sublimity of nature, remembrance of time past, reflection of cautionary and proprietary concern about the endurance of our landscape to visions which remind us of the redemptive power of beauty. Their use of media is as diverse as their messages. Like the settlers who preceded them, these artists operate as independent and adventurous spirits.

Like contemporary artists worldwide, those in *Evolving Visions* stretched the boundaries of traditional artistic practice. An impressive number have been preoccupied with ecological aspects of visual inquiry, long before discussions about the perils of climate change and man-made disasters entered the mainstream of conversation. Much like internationally renowned pioneers of environmental and ecological art — Helen and Newton Harrison, Mary Miss, and Agnes Denes — some of Boulder's artists have dealt with similar issues for more than forty years. In 2007, *Weather Report: Art and Climate Change* was proposed to the Boulder Museum of Contemporary Art by Marda Kirn

of Boulder's EcoArts Connections. Curated by Lippard and comprising fifty-one artists, including those listed above, *Weather Report* was an exceptionally impactful exhibit that drew international attention. Artists and collaborators from Boulder played a significant role in this city-wide exhibit. Three are represented in *Evolving Visions*: Gayle Crites, Rebecca DiDomenico, and Jane McMahan.

The earliest works in this exhibition were created by the photographer Joseph Bevier Sturtevant (1851-1910). Attired in buckskins and wide-brimmed hat, Rocky Mountain Joe, as this larger-than-life Wild West character was known, was Boulder's most prolific chronicler of the city and its expansion into the outlying areas. He photographed its natural landscapes, its constructed central core of homes, businesses, and cultural sites, its inhabitants working on

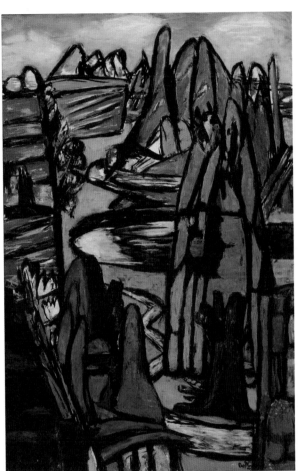

Max Beckmann, German (1884-1950), "Boulder-Rocky Landscape," 1949, oil on canvas. Saint Louis Art Museum, Bequest of Morton D. May 865:1983, © 2016 Artists Rights Society (ARS), New York, NY / VG Bild-Kunst, Bonn.

farms, in oil fields, and in mines, or recreating on foot or horseback. By so doing, he helped establish a visual identity of early Boulder. In his studio on Pearl Street, he sold postcards for a dime. They were originally printed from glass-plate negatives by Martin Parsons. After Sturtevant's death, Parsons found the negatives behind the artist's house. He kept the prints for himself and donated the negatives to the Boulder Historical Society. The prints were eventually purchased at an estate sale

after Parsons' death by George Karakehian, owner of Art Source International. Most have subsequently been donated to Boulder's Carnegie Branch Library for Local History.

Elmer P. Green's 1891 "Boulder Falls" is an early landscape painting held by the University of Colorado Art Museum. There is little information about Green — who died young of Bright's Disease — aside from a letter from Winnie Mary Sosey (neé Hamm), his sweetheart, who years later wished to acknowledge and enhance his artistic importance. Mountains, pine trees, rocks, and cascading waters fill the canvas. It is an early traditional Western American landscape painting, realistic, and imbued with the power and majesty of the surroundings.

In 1949, the German expressionist Max Beckmann came to Boulder to teach a summer semester at CU, where he painted "Rocky Landscape," now in the collection of the St. Louis Art Museum. The painting's perspective is unique in its stylistic expressions. Beckmann was unlike earlier European artists who came with Romantic notions of a sublime and edenic landscape. Instead he infused this expressionistic painting with localized emotionalism and an aggressive cacophony of colors defined by thick black outlines. These muscular, jaggedly imposing, and primordial

Elizabeth Black "Isabella and Jim Ascend, Longs Peak, 1873," 2008, oil on watercolor paper.

rock formations were described by the artist in a letter to his first wife as "petrified outbreaks of anger."

Many of the artists exhibited in *Evolving Visions* investigate the landscape utilizing memory, reverence, wit, humor, irony, concern, and hope. Two have created visual interpretations of historical fiction. In "Isabella and Jim Ascend, Longs Peak, 1873," Elizabeth Black has created an historic tableau illustrating an incident which investigates the romance and myth of the West. In it, Isabella Bird, an eccentric Englishwoman, and her guide, the heartthrob desperado Rocky Mountain Jim Nugent, attempt to reach the mountain's 14,000-foot summit. Black's subtle palette of shades of burnt umber shining off the peaks and rocks is repeated in the characters' buckskin attire, serving to make them one with their surroundings. The potential danger of their situation, as they attempt to conquer the elements, heightens the glory of the landscape and serves as a metaphor for their romantic visions.

Amelia Carley's "Lost Miners of Dream Canyon" is another fictitious historical narrative, created in the style of touristic scenic markers in national parks delineating areas of historical or natural importance for viewing. It exemplifies the treachery of the harsh topography, exacerbated by hallucinatory hauntings from fierce Ute Indians, as well as weather disasters implicit in the icy winter

Reverence for the land itself is evidenced in Joseph Daniel's photographs of demonstrations in 1978 at the Rocky Flats Nuclear Weapons Plant. The image is from the cover of his book, *A Year of Disobedience*, which documents actual historical events, just 10 miles south of Boulder, attended by thousands of locals and outsiders, who joined notables and celebrities like Daniel Ellsberg and Allen Ginsberg in blocking the railroad tracks and performing other acts of civil disobedience. These were the largest anti-nuclear protests in the nation's history, condemning the government's attempt at a monumental cover up of the toxic effects of radioactive waste on the land, on the

groundwater, on flora, fauna, and people. Also displayed is Daniel's looped fourteen-minute film, *A Criticality of Conscience*, addressing current controversies at Rocky Flats and the continuing nuclear threat worldwide.

Joseph Daniel, "On the Tracks at Rocky Flats," from *A Year of Disobedience*, 1978, 35mm Tri-X Film.

Following the path of early artists such as Albert Bierstadt, Thomas Moran, and William Henry Jackson, commissioned to join geological expeditions in order to gather information toward eventual Western settlement, three artists in *Evolving Visions* view landscape from a topographical perspective. They deal with borders isolated and eradicated, personal and conceptual. Buff Elting is interested in the visual designs of the natural world as seen from the air. In "Illusion of Order," the overlapping patterns of the cultivated field, the long shadows, the surrounding bushes, and just the hint of a farm structure seem to place the human handprint harmoniously into the landscape.

John Matlack's abstracted heavily impastoed painting, "Landfill," implies the intrusion of technology into nature. On close observation, we glimpse computer circuit boards and other electronic detritus of our contemporary technological age embedded into the surface. It's an imagined aerial landscape inspired by flights over California and Colorado and reminds us of the abundance of toxic cell phone and computer parts stacking up in landfills.

"Whirl," by Rebecca DiDomenico is a dimensional topography which invites the viewer to consider the changing nature of a world with familiar and unknown forces at work. It is solid and diaphanous, linear and swirling, with stitched topography and glass alembic vessels, seemingly precariously attached to delicately crocheted metal mesh, ready to witness alchemical transformations. Whirling chaos and a peaceful state of animation exist simultaneously in this work infused with emotional intensity.

Postmodernism's influence — characterized by appropriation, dismantling of notions of high and low art, and popular culture references — are cannily employed by artists like Ken Iwamasa, whose "Expulsion" mines imagery from the Bible in a contemporized version of a Renaissance altar piece. In the top section, Adam and Eve are being expelled from the Garden of Eden. The lower section is an image of a golden aspen tree in a field of grasses surrounded by distant pine trees. But the rusted, abandoned vintage automobile which appears to have struck the aspen is another reflection of human incursion into nature.[1]

Jerry Kunkel's "Enough Said (Thomas Moran)," and "Albert Bierstadt on Thomas Cole 2" are from a series of paintings in which the artist critiques glorified 19th-century Romantic landscape images. Kunkel describes these works as "visual love letters" to artists whose works he holds in high esteem. He has utilized appropriated images from paintings

John Matlack, "Landfill," 1998, mixed media on Masonite.

by the three artists named in the titles, all renowned painters of the Hudson River School who came West with idealized, transcendental notions of the great wilderness. Kunkel subverts the messages of sublimity and pristine glory by artistic interventions like the trompe l'oeil masking tape holding the top edges to the rough wooden hand-crafted frame in "Enough Said," and the image of a hand, possibly the artist's own, holding a postcard-sized photograph of a Bierstadt painting in front of one by Cole.

The later decades of the 20th century saw art move off the wall and off of pedestals. The emergence of conceptual, video-based, and installation art contemporaneously prevalent worldwide is evidenced by artists in *Evolving Visions*. But realism in paintings and photographs still maintains a place in the contemporary Western landscape view. Some artists have taken a unique approach, focusing on human incursion and its consequences as land is rutted and paradise paved. Jim Colbert's realistic Western landscapes are conjoined with

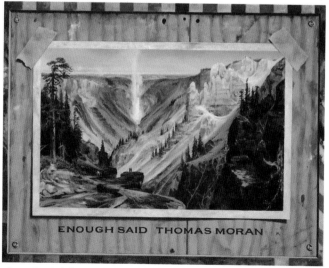

Jerry Kunkel, "Enough Said (Thomas Moran," 2011, oil on canvas.

a contemporary perspective, bearing witness to the Earth's serenity as well as to its destruction. In "River Move Our Thoughts (Colorado River at Dotsero)," we see Colorado's Western Slope, mountains and creek, nestled homes, and a gaily striped tent set up in anticipation of a gathering, or possibly left up after. Two roadside crosses, adorned with pink posies are situated in a clump of yellow daffodils. Life and death convene.

Considered one of the nation's first contemporary painters to directly address

Two cows sit complacently in the center of the scene. These "sacred cows" are elevated, as if on an altar, perhaps observing the ramifications of the West's two sacred cows, mining and ranching, and wondering where it all went awry.

Don Coen's monumental paintings depict rural range images and the agricultural production economy of the migrant workers who tend the land. Coen's respect for and connection to the place of his youth and the ranch which was his home on Colorado's eastern plains is obvious, as is his admiration for seasonal laborers such

Don Coen, "Manuel," from the *Migrant* series, 2001-2010, airbrush acrylic and pencil on canvas.

issues of land use, Chuck Forsman's advocacy for ecology is exemplified in "Sacred Cows," highlighting human interference in unspoiled landscapes. This large and imposing painting destabilizes idealized notions of an untarnished West. As viewers, we set our sights from the edge of the painting. Close enough to feel the vulture's extended wingspan in the foreground rustle the air around us. We look across at the panorama where the dry mountain forms have been carved into roads and switchbacks.

"Manuel," from his *Migrant* series. Without these men and women, the harvest from which others benefit, would not be possible.

Eve Drewelowe's 1982 "Faces and Findings: The Past in the Present" shows an absence of workers. The hay bales — which proclaim their toil — seem to echo the mountain landscape, and are a haunting reminder of the need for harmony between humans and environment.

Merrill Mahaffey's paintings of the Grand Canyon are realistic depictions highlighting

his appreciation of the recreational aspects of one of the West's most magnificent sites. In *Evolving Visions*, he shows "Bear Creek Schist." His many river rafting experiences lend a unique perspective, usually seen from the water. Inspired by and often compared to Thomas Moran, Mahaffey's glorious, luminescent colors of rocks reflecting the sunlight create a magical spectacle.

Robert Adams, one of our country's preeminent photographers, has recorded the changing Western landscape poignantly and written about it eloquently. The photographs exhibited here — "Wheat Stubble, South of Thurman, Colorado" and "North of Keota. The Pawnee Grassland, Colorado" — are spare and stunning. They are from a series of works begun in the 1960s in which he documented quiet, light-infused, wide prairie vistas. He has said that in his photographs he wants to explore what is glorious as well as what is disturbing. In later works, the tranquility of the land once so revered, gives way to a different West, lost and transfigured by shopping malls, urban blight, suburban sprawl, and misuse of resources. Adams has said that he believes "the job of a photographer is not to catalogue indisputable fact, but to try to be coherent about intuition and hope."

In "Oasis," a ceramic tabletop installation partitioned like city blocks, and its accompanying wall mount, Chandler Romeo envisions a city sprouting up from the land. This is a recent work in a series she has been exploring at length. Here the squares are moveable. It is much like Boulder itself, perennially under major transformation in the name of "progress," and plagued by the typical attendant vicissitudes of change.

Kim Dickey's "Mirage" evokes a different kind of oasis replete with sculptural ceramic palm trees, a flashing "Vacancy" sign on the wall, and a landscape of the imaginary. The artist describes it as "the place one can dream about but never attain."

Robert Adams, "Wheat Stubble, South of Thurman, Colorado," 1965, silver gelatin print. Collection of Chuck Forsman.

Gayle Crites "Simpatico," 2013 Brush & ink drawing, cochineal natural pigment, tea and coffee, on Mexican amate handmade bark paper.

James Balog, an internationally renowned climate photographer, investigates vanishing glaciers worldwide, as evidenced in his film, *Chasing Ice*. In the film and his stills — of which "Ilulissat Isfjord, Greenland," is displayed in *Evolving Visions* — he utilizes time-lapse photography to create glorious images which capture the impact of climate change on our planet.

Gayle Crites, long recognized as an influential plein air painter in Boulder, has spent the past decade searching out techniques and indigenous materials worldwide which face obsolescence if not protected from the ravages of climate change and man-made abuse. The imagery in "Simpatico," painted on Mexican amate bark, foretells a split in the fibrous circle of life, its graceful circular form interrupted by the deep red of cochineal, a natural dye made from beetles, which appears almost as a wound at the point of rupture.

Landscape artist Karla Dakin's "Fuzzy Balls Relate" — a constructed environment of three delicate prints of woolly plant forms accompanied by planted boxes — is influenced by the green roofs and gardens she creates in her architectural designs. She focuses on aesthetics and sustainability, and the engagement of all five senses. Her work affirms that even in challenging environmental situations, creative thought and design can result in stunning and efficient solutions.

Ana María Hernando is a proponent of the exquisiteness inhabiting the world of flora and the life-and-death cycles at its core. Using starched, dyed petticoats collected from Peruvian women, and delicate cloths, obtained from and embroidered by cloistered Argentine nuns, "*Amarillo Para la Ñusta*" (Yellow for the Ñusta),[2] her installation, is striking not only for its unique use of materials but also for its message about the redemptive power of the natural world and its bounty.

Melanie Yazzie's two-panel painting, "When We Came Here" springs from her Diné (Navajo) heritage, where all things are connected, where peace and harmony are life's goals, and the relationship of humankind to nature is sacred and instilled from birth. Traditionally, the Navajo newborn's umbilical cord is buried close to where the family lives. This symbolic act defines the land as sacred. Home, land, place, and self are all interconnected and explain the cultural imperative for Native Americans to

oppose the taking, polluting, and destroying of their venerated lands. Devastation due to greed for natural resources and a wanton disregard for property makes for contested landscapes. Much of Yazzie's recent work has been focused on collaborations with indigenous artists from around the globe. As an agent of change, she promotes cultural and societal awareness through her arts, and follows the Diné dictum to "walk in beauty."

Rounding out the exhibition are three video installations dealing with specific natural and unnatural disasters with devastating effects on the land and landscape. In 2010, Sunshine Canyon, just above Boulder, was the scene of an uncontrollable fire. More than 1,900 homes were destroyed and 1,500 damaged. With *From the Ashes*, filmmaker J. Gluckstern recorded the destruction of the home and studio of well-known sculptor Jerry Wingren. The process of rebuilding took years.

In *lyons, co, 10-10-13* and *Wood Water Run*, Gluckstern and Chris Pearce each documented the floods that overcame the town of Lyons, in the regional disaster of September 2013. In silent black and white, the filmmakers recorded the aftermath of ruined homes and businesses destroyed when waters from the two branches of the St. Vrain River merged and overflowed. Their combined footage describes the extremity of the devastation as so far reaching that there continues to be concern that the culture of the community is forever changed. Many residents, including visual artists, dancers, and musicians — many already expatriates from Boulder's rising cost of living — were unable to rebuild and were forced to move to other more affordable and less desirable areas.

Jane McMahan's "Collapse," is a multi-screen projection, accompanied by the buzz of honey bees and recording their activities within her own distressed hives, which eventually suffered colony collapse disorder. Scientists blame the use of pesticides and herbicides, which decimate bees by reducing plant sources dependent upon them for pollination. McMahan, as artist and environmentalist, created a shrine to bees, which fittingly explores the potentially ravaging effects of their loss on our ecosystem. A third of our food supply is dependent upon bees for pollination, and McMahan's work, she says, illustrates the link between "their survival and our own in a world of climate change and threatened planetary health."

The beginning of the 21ˢᵗ century brings new and invigorated ways for artists to investigate past and future. Many of the Boulder-based artists in *Evolving Visions*, academic or independent, have followed the larger art world and been exhibited and recognized regionally, as well as globally, for excellence and innovation. They are observers, activists, interpreters, and makers of meaning. Their legacy will likely be treasured by the next generation of young artists in the Boulder region, who, also drawn to this place, will take responsibility to continue visually innovating and informing. As concepts and the reality of land and landscapes take on new meanings with ecological and environmental changes, as meta-narratives are displaced by a continuous influx of new art "isms," as visual culture assaults us with constant and pervasive imagery, we look forward to seeing what the future can hold for emerging artists who will become our next visual seers and interpreters.

Notes

1 Unfortunately, at the last minute, Ken Iwamasa was unable to show "Expulsion," but it nonetheless seemed important to discuss in this essay.

2 Ñusta was the Quechua name for queens and princesses in the Inca Empire. Ñusta was a virgin and daughter of the Inca. The tradition of celebrating the Feast of the Pacha Mama (Mother Earth) continues in Perú, Bolivia, and Argentina. Older women of the village play Mother Earth, and a young virgin or ñusta is chosen to symbolize the land that was not yet fertilized.

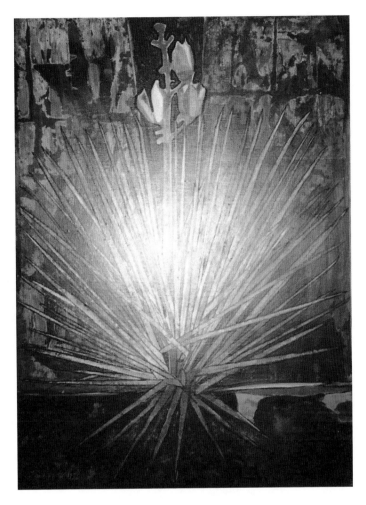

The Extraordinary Artistic Pulse
of the University of Colorado's Visiting Artists Program

Jade Gutierrez

In the wake of World War II, summer 1949, the world-famous painter Max Beckmann spent a three-year stint as a fine arts professor in the United States. Few know that, of the five universities where he taught, the University of Colorado-Boulder was one. For a ten-week summer session, Beckmann taught painting courses in the Department of Art and Art History at CU, but he was not the only one to do so. In a matter of a few years, the university became a popular destination for some of the most famous artists of the time: Ben Shahn (1945), Louis Schanker (1953), Jimmi Ernst

(1954), Mark Rothko (1955), Kenzo Okada, Clyfford Still (1960), Stuart Davis, Morris Kantor, David Hockney (1965), Robert Heineken (1972), and H.C. Westermann (1973). Each took their turn living in Boulder and sharing their knowledge with students during summer sessions. Over the course of three decades, this informal summer program, where practicing artists taught fine arts students, was established and paved the way for one of the longest and most renowned visiting artist programs in the United States, a program that continues as a formal part of CU's Department of Art and Art History today.

Above: Lynn Wolfe, "Spanish Dagger," 1985, acrylic on canvas.

At first glance on a map, the land-locked state of Colorado may seem only like a layover between New York and Los Angeles and a site of little, if any, cultural significance in the art world. Yet, here, in the heart of the Rockies, there has been a long-standing tradition of the arts. Through the university's Visiting Artist Program, Boulder has been the site of artistic dialogue between students, faculty, artists, and community across seventy years; graduating students have emerged practicing at the forefront of the various artistic movements that have characterized the last seven decades.

The Visiting Artist Program first emerged in the mid-1940s as an informal program that strove to bring a variety of top practicing artists to the university. Every summer one to three

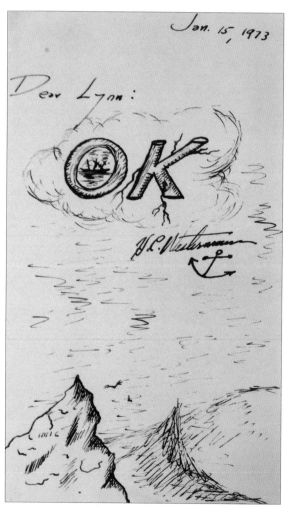

Letter of acceptance sent from H.C. Westermann to Lynn Wolfe in response to Wolfe's proposal that he teach at the University of Colorado, Boulder in the summer of 1973.

artists or art historians were invited to spend ten weeks teaching courses and making work. The artists were also given the opportunity to exhibit their work in the CU Museum Gallery of Art, which was then located in Henderson Building (now the Museum of Natural History). The program was initially funded by the Creative Arts Committee, a university program designed to encourage and sponsor programs significant and vital in the field of art, creative writing, drama, modern dance, and music.[2] It was not until 1972 that regular funding became available for the program when Roland Reiss, long-time painting professor, left the department. Rather than filling the vacant faculty position, the decision was made to set aside the money for an institutionalized version of the Visiting Artist Program.[3] Over the years the program has received recognition and additional funding from the National Endowment for the Arts through annual grants.[4]

Today's program features ten to fourteen nationally prominent artists, art critics, curators, and arts activists per year to bring their newest, most innovative works to share with the CU-Boulder campus. These artists not only present a free lecture open to the Boulder community and the campus, but they also participate in studio critiques with BFA and MFA candidates, who take the Visiting Artist Program course for credit. These students get a unique opportunity to work intimately with artists representing the current interests and aesthetic focuses of the time. Artists who have participated in the current program include: Alvin Lucier (1980), David Hickey (1984), Alfredo Jaar (1988), Adrian Piper (1989), Jaune Quick-to-see Smith (1989), Lorna Simpson (1993), Lucy R. Lippard (1994), Mel Chin (2000), Janine Antoni (2011), Alex Bag (2012), and an astounding number — more than 420 — of other acclaimed artists in all media and disciplines since 1980.

The enormous diversity that is seen in the current program is a direct result of the solid foundation that formed decades before. Those who taught the summer sessions in the early years of the program stayed in Boulder not just for a few short days, but shared their knowledge with students for three months. Lynn Wolfe, retired CU art faculty and Boulder resident, was both a graduate student and a teacher at CU-Boulder for over three decades. He had the exceptional experience of being both student and peer among the visiting artists. His first experience with the program was as a graduate student taking oil painting with Beckmann in 1949. Later, Wolfe was responsible for inviting many of the artists to campus, including Clyfford Still in 1960, with whom he developed a friendship. Wolfe states, "Our artist program has been fantastic in its diversity, exceptional in its 'lack of common ground,' both in the personalities of the artists and in their work."[5]

Yet it was never expected of these artists to teach students to imitate their personal style. Rather, the program was meant to promote a critical dialogue between artist and student. Artists were respected as significant members of the arts community and were given the freedom to conduct classes as they saw fit.[6] This resulted in unusual classroom experiences that differed with every visitor. Each artist brought his own personality and style to the studio: some like Beckmann were silent in nature, yet made a tremendous impression on those he came into contact with. Even with the language barrier (Beckmann never learned to speak English and his wife acted as translator), his students were forcefully impacted by his character and by the powerful nature of his work.[7]

Rothko was described as somewhat of a recluse. Despite the goal that artists should not teach students to be copyists of their work, Rothko often complained about the "uniformity" of students desiring to learn

"abstract impressionism."[8] Nevertheless, students had adopted strong styles affected by the movement long before Rothko arrived. In 1954, the year before his visit, university gallery shows were already displaying students' keen awareness of contemporary art forms, so that it placed them in the center of advanced abstract painting.[9]

The emphasis on abstraction did not deter students from the desire to learn from other styles. David Hockney was already a well-known figurative painter by the time he taught at CU in 1965. His quiet, yet frank, demeanor among the students earned him much respect as a teacher, even when certain members of the community were not as impressed. His 1965 show at Henderson received a scathing review from the *Daily Camera*, suggesting a blank canvas with the legend, "Mr. Hockney Regrets," would have been better than the etchings on paper comprising the majority of the show.[10] Ironically, those pieces, titled "The Rake's Progress" were later purchased by the department using funds from the Carnegie Foundation and the Muriel Sibell Wolle Fund.[11] The works are still owned by the CU Art Museum.

Clyfford Still was a much beloved visiting professor, described as clean-cut, wearing a white shirt and black tie with a cloud of white hair. Wolfe reports that Still was often seen chatting with faculty and students alike over a cup of coffee.[12] Even when he returned to New York, his connection to Boulder persisted. As a Christmas present in 1960, Wolfe and his wife Arlene sent Still and his family evergreen cuttings from Flagstaff Mountain. Still responded

> The interior of the studio appears as though it might be in Boulder, Colorado, instead of New York. The pine cones and evergreen branches are a sharp reminder of the many pleasant trips we enjoyed with you this past summer. We deeply appreciate your thoughtful and typically considerate gesture. We will always

look forward to seeing you, and will most certainly never pass you wonderful people without stopping to say hello.[13]

There is no denying that Boulder has been the center of a long and rich tradition of student and artist collaboration. Much has been gained from the visits of nearly 500 artists across seventy years, and there are few communities that can boast of the privilege Boulder has and continues to experience. The University of Colorado and the Boulder community are far from a cultural wasteland, as is too often implied, but are steeped in artistic tradition, and have played a part in influencing and shaping the art world through their interactions with the many artists who have temporarily called this city their home.

Notes

1 Max Beckmann and Barbara Copeland Buenger, *Self-Portrait in Words: Collected Writings and Statements, 1903-1950* (Chicago:University of Chicago Press, 1997).
2 "Summertime June, 1953: Louis Schanker of Brooklyn Museum of Art School Is the Visiting Artist Lecturer at CU Boulder," *The Colorado Alumnus* Sept 1952-1954, n.d.
3 *Visiting Artist Program, 20th Anniversary Show, January 15-February 22, 1992: Celebrating 20 Years of Program Excellence* (University of Colorado Boulder, 1992).
4 Ibid.
5 Lynn Wolfe, interview, June 24, 2016.
6 Ibid.
7 Ibid., and Beckmann and Buenger, *Self-Portrait in Words.*
8 Howard Singerman, *Art Subjects: Making Artists in the American University* (Berkeley: University of California Press, 1999).
9 Al Newbill, "University of Colorado Group," *Art Digest* 29, no. 2 (October, 15, 1954): 30.
10 Arnold Gassan, "Summer Faculty Exhibit at CU of Fine Quality," *Daily Camera*, July 26, 1965.
11 "Fine Arts Dept. Buys Works of Visiting Artists," *Daily Camera*, September 23, 1965.
12 Lynn Wolfe, Interview, June 24, 2016.
13 "Clyfford Still Museum Archival Collection," n.d., Still and Colorado, Clyfford Still Museum, accessed April 15, 2016.

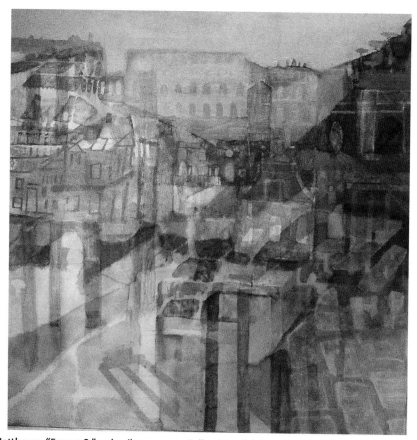

Gene Matthews, "Forum 2," n.d., oil on canvas. Collection of the First Congregational Church of Boulder. Matthews, who died in 2002, taught at CU-Boulder until 1996, and in 1985 helped establish the University Visiting Artists Program, becoming its first director. Valerie Albicker has directed the program since 2002.

A Boulder History of Art Cinema
I'm not Steve Seid, and this isn't Radical Light

J. Gluckstern

But there could be something instructive about comparing the experimental film scene of a sleepy college town to the orgiastic heights (and depths) of San Francisco during roughly the same time frame.[1]

For one, a qualitative analysis should yield far more than a quantitative one. The numbers weren't quite as important as the nature of the scene in Boulder, which owed some of its cachet to developments in Denver after World War II. For whatever odd confluence of reasons, Denver was a hub of counter-culture activity in postwar America. Jack Kerouac and Allen Ginsberg, and other prominent members of the Beat Generation left their mark (and recorded pertinent bits of the history of social change in Colorado). Boulder developed differently, but its proximity to Denver was an important aspect of its multi-faceted ecosystem.

A few important parallels with San Francisco were the presence of a stable film lab in Denver — known for many years as Western Cine Service, founded in 1952 by John Newell and Herman Urschel, then re-christened as Cinemalab, run by Robert David — and local film programs that screened experimental work being made elsewhere in the U.S. and internationally. A local lab, though primarily in business for commercial interests, made it much more convenient for local experimental filmmakers to create new work, and for local entities to offer workshops and academic classes using 16mm film. In the same vein as a groundbreaking series at the San Francisco

Above: Still from Stacey Steers, *Phantom Canyon,* 2006, 35mm.

Museum of Modern Art in the late '40s, Carla Selby, Gladney Oakley, and Bruce Conner were instrumental in the founding of the Experimental Cinema Group at the University of Colorado-Boulder in the mid-1950s. The longest running experimental film series in the country, ECG continues today as First Person Cinema. Along the way, it was also known as Avant-Garde Cinema, Born Again Cinema, and Ground Under Cinema.

According to Don Yannacito,[2] who's been involved with the many iterations of the ECG over the years, the group found out about work being produced elsewhere by various visiting filmmakers, as well as recommendations by Stan Brakhage — widely considered Colorado's most prominent living experimental filmmaker until his death in 2003 — who spent his teenage years in Denver. (Carmen Vigil, who met Yannacito before both of them went to CU-Boulder, recalls seeing Brakhage films while he was still in high school at the Vogue Theatre in Denver; by the time he met Brakhage at CU, Vigil said that, if Brakhage recommended it, there was no question that you had to see it.) During the '60s, the ECG was run by a colorful assortment of personalities— among them Diz Darwin, John Chick, and Greg Sharits (brother of filmmaker Paul Sharits) — as it morphed from coffeehouse bohemianism to drug-infused party scene to anti-war platform, and, ultimately, by the '70s, to an appreciative/scholarly academic venue.

Brakhage described crowds in the hundreds packing Macky Auditorium for experimental programs in the '60s. (Yannacito remarked, "[We'd show] Kenneth Anger's films, Harry Smith's films. We would do light shows and parties — anything worked in the '60s and early '70s.") While it was unlikely that everyone who attended had a conceptual appreciation of the innovative qualities of the work being shown, it was clear that film had cultural cachet as something more than commerce.

Still from Joel Haertling and Stan Brakhage, *Song of the Mushroom*, 2002, 16 mm film.

Stan Brakhage at the blackboard, n.d. Courtesy of Phil Solomon.

This raised a basic question as to what, exactly, constituted film as art, and while almost anyone who encountered Brakhage could attest that he wouldn't hesitate to rail against work that he declared *wasn't* art (including much of what was produced in Hollywood), definitions vary widely. Brakhage's own work was informed by a deep understanding of art, poetry, and music, teasing out new ways to understand the medium as a time-based modernist phenomenon. Essentially, it was a question of how the medium itself — sequential frames projected in a dark room for beings governed by human physiology and psychology — defines the form. (This approach can go far beyond narrative paradigms; the films of Paul Sharits and the projector performances of Ken Jacobs, for instance, create an illusion of 3-D color and space in the eyes/brain of the viewer.) Brakhage was also famous for declining to teach filmmaking — or how to make art, period — an indication,

perhaps, of how deeply personal a process it was for him and a notion that every artist needed to figure it out for themselves.

On the other hand, on a social level, the films shown by ECG in the '60s explored subjects that were more or less misrepresented in mainstream movies — sexuality, drug culture, the anti-war movement. Film and video makers explored new technologies — video image processing, for instance — and produced work that challenged conventional notions of storytelling, presentation, and aesthetic experience. (Some of that technology was built by local innovators such as Wyndham Hannaway, who donated a substantial amount of his old-school film and video equipment to CU to train future archivists of celluloid and electronic media, and Glenn Southworth, founder of Colorado Video, who helped create the sort of video processing hardware used by video artists such as Woody and Steina Vasulka[3] early in their careers.)

Still from Philip Solomon, *Psalm IV: "Valley of the Shadow,"* 2013, HD digital video.

Ultimately, it seems to stubbornly remain in the eye of the beholder. But what often seemed to be true of filmmakers living and working in Boulder was Brakhage's passionately personal approach.

As the ´60s ended — as with a number of other realms of art nationally and internationally — the study of film academically opened up new avenues (and budgets) for the discussion, creation, and distribution of new experimental work. Locally, Virgil Grillo, a CU-Boulder English professor, started the Film Studies program at CU, which gave the ECG an institutional home, and Yannacito a job administering it and teaching Super-8 filmmaking. Jim Otis, Bill Stamets, Jenny Dorn, Jerry Aronson, and, later, Patti Bruck, Stacey Steers, and Mary Beth Reed also taught at CU. Elsewhere in Boulder, veterans of Colorado's famed art collective, Drop City (notably Clark Richert and filmmaker Charlie DiJulio), started a collective and magazine called Criss-Cross, which included work by another Boulder filmmaker, Fred Worden. The Boulder Public Library also helped promote new ways of looking at film, with its free program, spearheaded by Bob Grzenda in 1978. He worked with Yannacito to coordinate avant-garde programs beyond campus, including numerous events centered on Brakhage, as well as other regional film and video artists, such as Richard Lowenburg and Pat Lehman. (Grzenda recalls a "minimalist" program on Channel 8, which he helped run after stepping down from the film program, called "Eye On Boulder" — live broadcasts of specific locations around town, sort of a proto-Web cam.)

Joel Haertling took the reins of the library film program in the ´90s, which offered a perfect complement to his own music and filmmaking efforts since the ´70s. Haertling's wide-ranging activities became a regional (though largely informal) alternative arts institution, connecting with and fostering an interest in art film in the community at large in a way that the academic world couldn't.

Brakhage was hired as a professor at CU-Boulder in the early 80s, and this helped lay the foundation for Film Studies to become a

full-fledged major in the late '80s. Phil Solomon was hired as the department's first tenure-track production professor in the early '90s, and soon after, Luis Valdovino was hired to teach video in the Art and Art History department. This raised the stature of art film and video locally, and, in some ways, gave Brakhage the kind of filmmaking community he hadn't had locally since his early days.

Phil Solomon described a key moment while he was being interviewed for the position at CU-Boulder

> I remember distinctly taking a walk around campus at night during my interview weekend with Stan. We were essentially going through an intense courtship ritual, staying up late in my hotel room catching me up on his life after THE DIVORCE, talking about our mutual friends (Steve Anker, Ken Jacobs). He claimed that Boulder was about the size of Elizabethan London or something like that. I then flat out asked him: 'Stan, where are your peers?' And he said, 'You're my peer.'[4]

Certainly, CU's film program spawned those with more commercial ambitions — Peter O'Fallon, Trey Parker, Matt Stone, Derek Cianfrance — but, especially after Solomon joined the faculty, it also provided an intellectual and social foundation for newer generations of Boulder filmmakers passionate about the possibilities of experimental film. Carl Fuermann, Courtney Hoskins, Erik Waldemar, Robert Schaller, Mary Beth Reed, Victor Jendras, Casey Koehler, and Andy Busti all had CU connections, often with some relation to Brakhage as a local acquaintance, if not friend and mentor. Only a few film/video artists in the catalogue fall beyond that critical connection with CU in their formative years – Luis Valdovino (and his longtime collaborator, Dan Boord) and Michelle Ellsworth, whose video work began as an offshoot of her award-winning performance career. (Both Valdovino and Ellsworth knew and respected Brakhage, however, and both still teach at CU.)

Out in the community at large, various screening venues/entities rose and fell. The 24 Camels put on an annual festival for a few years in the early '80s at the Art Cinema on

Still from Mary Beth Reed, *Floating Under a Honey Tree*, 1999.

Still from Patti Bruck, *House of Hazards,* 2009, 16mm.

the downtown mall (then owned by the son of John Newell, founder of Western Cine in Denver); the Sunday Associates, a sort of bohemian variety show featuring music, poetry, performance, and films, also had a run at the Art Cinema in the mid-'80s; Jenny Blanchard (and later Erin Sax) organized and performed the projected image backdrops for The Samples in late '80s; in the early '90s, Brock DeShane steered Eye for an I Cinema to several successful years in the Denver/Boulder area; in the mid-'90s, Patti Bruck curated Video Visions, a program of experimental video work at the Boulder Public Library; Bruck also initiated and organized numerous visiting artist programs and conferences on independent film through her multiple positions at CU-Boulder in the '90s and 2000s. There were also occasional screenings/sightings of famed visual artist, archivist, and filmmaker Harry Smith and San Francisco filmmaker Nathaniel Dorsky at Naropa University over the years.

Such short-lived cinematic outbursts were common (some funded by the relatively generous arts grants program funded by the Boulder Arts Commission). But, in truth, they were only the tip of the iceberg in terms of people thinking about, watching, and making experimental/independent film locally, even if the results only screened in people's living rooms and back yards.

As the '80s progressed, Brakhage continued to "hold court" in increasingly normalized and, eventually, public ways. Since he'd settled west of Rollinsville in the '60s, he'd hosted hundreds of private salons at his home. Given his wide range of friends and acquaintances, the salons could be quite lively and supplemented his very prolific correspondences with most of the key players in the avant-garde around the world. While Brakhage's active intellectual/social life was not that unusual for an artist of his stature, the circumstances in Boulder allowed for a somewhat more public iteration of these ongoing discussions of life and art. Brakhage's position at the university (and its supportive infrastructure), his divorce from Jane Wodening in the '80s (and Brakhage's subsequent move into Boulder from Rollinsville), along with a particularly dedicated and loyal group of local participants (among them Fuermann, Phil Rowe, Carlos Seegmiller, and John Writer) all conspired to make Brakhage more available. His salons became semi-public, films were

shown in the old Sibell Wolle art building on Sunday evenings, followed by casual yet intense discussions in a nearby classroom. Anyone could show up (as they still can to the "Celebrating Stan" series run by Film Studies Professor Suranjan Ganguly). The rise of extremely portable consumer video cameras allowed for a certain amount of documentation of many of these salons (as well as visits from film artists near and far). Phil Solomon collected quite a bit of this history — home movies of his experimental film family — and, in an email, Fuermann noted the impact on Brakhage's ongoing discussions

> The arrival of Phil Solomon with his video camera rolling I think did influence the dynamics to some degree. You knew you were being recorded so there was extra incentive to sound extra brilliant for posterity. I think Stan liked the camera rolling and honored it also because that is what he did with his family, so he really couldn't complain. Plus, it was another avenue to validate his work, which was always a continuing part of the salon discussions — not just his own but all the filmmakers. But here it was documented

— Stan clearly mapping out how (a particular) hand-painted film was connected to an ancient poem, hieroglyphics, particle physics, and Jungian mythology.[5]

The films screened at the Boedecker Theater in Boulder's Dairy Arts Center for *Celebration! A History of the Visual Arts in Boulder* [6] — a cross-section of local filmmakers with an interest in the subjective — was designed to be representative of a certain kind of sensibility, at once extremely personal and, yet, owing something to the idea that the personal has value.[7] Stan Brakhage stood for many things, particularly in this community (and, at times, contrary to things he might have said before or after), but his allegiance to the intense truth of the subjective never wavered.

The situation of film and video art in 2016 Boulder is still in flux, but some outcomes are more likely than others. As a sort of bookend to this history as I've described it, the recent closure of Cinemalab in Denver marks part of the process of film as celluloid embracing its obsolescence in order to survive otherwise as a fine art medium. At the same time,

Still from Jim Otis, *On Your Own,* 1981.

CU-Boulder's film department, with Kelly Sears, David Gatten, Erin Espelie, and Geoff Marslett joining Jeanne Liotta and Solomon as production professors, is entering a new era of (likely) national prominence. Beyond the university, Robert Schaller has run the Handmade Film Institute, which organizes wilderness retreats that offer students a chance to literally make their own film, since 2003. Assorted regional venues, among them experimental programs in Fort Collins, curated by Jacob Barreras, and Cinema Contra, a Denver series curated by Anthony Buchanan, provide support for the form and screening opportunities for a variety of local filmmakers.

The sound of the projector may be diminished, even lost, in the background noise of the ever-voracious Internet and its insistence on short-term inter/active experiences, but the deep appreciation of moving visual thinking remains in Boulder.

Notes

1 Steve Seid is a well-known film/video curator who co-edited the comprehensive history, Radical Light: Alternative Film and Video in the San Francisco Bay Area 1945-2000 (Berkeley: University of California Press, 2010).

2 All quotes from Don Yannacito are from personal interviews.

3 Woody and Steina Vasulka are early pioneers of video art, producing work since the early 1960s. In 1965, they began showing video at the Whitney Museum and in 1971 founded The Kitchen, a multi-use media theater located in the kitchen of the Mercer Arts Centre in Greenwich Village in New York.

4 Email correspondence, 2016

5 Email correspondence, May 2016.

6 The "Evening of Experimental Film," which took place at the Boedecker Theater in the Dairy Arts Center in December 2016, comprised Dan Board and Luis Valdovino, Patti Bruck, Andy Busti, Michelle Ellsworth, Carl Fuermann, Joel Haertling and Stan Brakhage, Courtney Hoskins, Jim Otis, Mary Beth Reed, Robert Schaller, Philip Solomon, and Stacey Steers.

7 Robert Schaller, for instance, developed a pinhole movie camera to imagine the fluttering moving imagery a bee might see on its peripatetic wanderings; Stacey Steers turned a personal history into an animated allegorical fable; in "On Your Own," Jim Otis reworks the hidden cadences of a ´60s job training film into a rhythmic exploration of language and form. But, as with the basic conceit of this essay, an itemized list of films is less useful than the notion that every artist in the show has a unique and expressive approach to the medium, and an authoritative list of Boulder experimental films and filmmakers is a project for another time.

Still from Robert Schaller, *To the Beach*, n.d., 16mm.

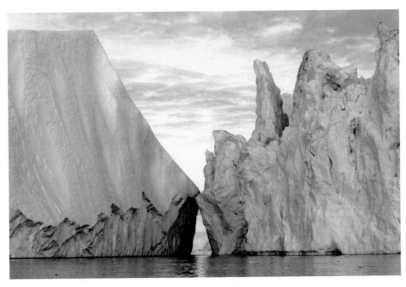

Feature Films
Boulder's Inviting Surroundings for Moviemakers

Heather Perkins

It used to be that if you asked someone about film in Boulder, the first thing that came to mind was *The Shining*, Stanley Kubrick's 1980 masterpiece based on the fiction of Stephen King. But, although King had once lived in Boulder and was inspired by the Stanley Hotel in Estes Park, the movie was not actually filmed there or anywhere nearby.

Nevertheless, Boulder has a rich tradition of movie making for such a small city. The Boulder History Museum curated an exhibit tracking this history in 2012, leading us through the past century with a number of choice anecdotes and Hollywood stars. According to the *Longmont Times Call*, *The Glenn Miller Story* was filmed here in 1954, starring James Stewart and June Allyson, and the movie *Stagecoach*, was filmed at Caribou Ranch near Nederland in 1966. Woody Allen set his 1973 movie *Sleeper* at the modernist Mesa Laboratory of the National Center for Atmospheric Research, designed by I.M. Pei, and at architect Charles Haertling's futuristic residence, The Brenton House.

Catch and Release, a 2006 romantic comedy, directed by Susannah Grant, starred Jennifer Garner and Kevin Smith in a supporting role as a wistful fly fisherman who wrote words of wisdom on Celestial Seasonings tea bags.

The natural world has had a profound impact on filmmaking here, much as the landscape has influenced painters. The Earth itself shows up frequently in the work of Boulder filmmakers, often as a character in addition to just a setting. Boulder's roots as an environmentalist mecca are reflected in movies like Louie Psihoyos' 2009 Oscar-winning *The Cove* (a story about plankton, of all things, as well as the awful plight and mistreatment of dolphins in Japan), and documentaries like *Chasing Ice*, released in 2012, which follows acclaimed environmental photographer James Balog to the Arctic to capture images of the Earth's changing climate.

Among documentarians, Jerry Aronson's short 1978 film, *The Divided Trail: A Native American Odyssey* was nominated for an Academy Award. Ava Hamilton has made several short, important documentaries about Native American issues,

Above: James Balog, "Ilulissat Isfjord, Greenland," 2007, digital chromogenic print on Fuji Crystal Archive paper.

including *Everything Has a Spirit*, examining the lack of protection for indigenous religion and sacred sites.

Adventure filmmaking is a rich genre, and award-winning documentary filmmaker Michael Brown, who among others made *Farther Than the Eye Can See* (2003) and *High Ground* (2012), even started the Adventure Film School to take advantage of Boulder's unique convergence of dramatic landscapes, adventure sports, and expedition documentaries.

Before she left filmmaking to form a non-profit, There with Care, to help sick children, Paula DuPré Pessman, among other accomplishments, was a producer on *Harry Potter and the Sorcerer's Stone* (2001).

Sisters Robin and Kathy Beeck put Nederland on the map with the 2003 film, *Grandpa's in the Tuff Shed*, which investigates with comedic precision the history of Bredo Morstol and his family's efforts (now the town of Nederland's efforts) to keep him cryogenically frozen until advancements in medicine can bring him back into consciousness. The film was so successful that the Beeck sisters created a sequel with renowned documentarian, Michael Moore, and in 2004 went on to found the Boulder International Film Festival, BIFF, which often spotlights films that go on to receive incredible acclaim including Oscar nods and wins.

Numerous other film festivals call Boulder home, as well: The Boulder Jewish Film Festival, the Italian American Film Festival USA, the Moondance International Film Festival (billed as the "American Cannes of film festivals"), and, of course, the Adventure Film Festival. A number of local venues and film series have survived the rise of home theaters, and, while down from the 1970s heyday of twenty-seven venues in town, still serve the local film community. The Boedecker Theater in the Dairy Arts Center and local Cinemark theaters currently screen a variety of films in diverse genres, while the First Person Cinema continues to thrive, begun in 1955, as the world's longest running avant-garde film screening program.

The Boulder Film Commission has worked to encourage filmmakers of all stripes to pursue their projects here. The combination of dramatic landscapes and Boulder's uniquely talented creative class has proven quite a draw for filmmakers. In 2014, *MovieMaker Magazine* listed Boulder in "Best Places to Live and Work as a Moviemaker."

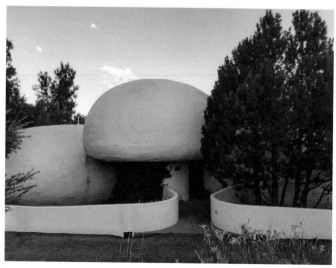

Charles Haertling (1928-1984), a prominent Boulder architect, designed the Brenton House in 1969. Photo by Collin Heng-Patton.

Luis Eades (1923-2014), "Transoceanic 1," 1980, color lithograph, edition 40. Courtesy of Shark's Ink.

Daniel Friedlander (1945-2012), "Isotope Breaakfast," 2008, clay tiles mounted and framed. Courtesy of Diane Rosenthal.

Shark's Ink
Magic from a Master Printmaker

Collin Heng-Patton

Listening to master printmaker Bud Shark talk about his long and laborious relationship with the art of printmaking is inspiring. Shark is a self-proclaimed collaborator, a master who has devoted his life to nurturing a curiosity into a full-blown passion. He is the founder and, with his wife Barbara, co-owner of Shark's Ink, a collaborative print studio specializing in fine art lithography. The Sharks began with a loan, a Griffin lithography press, and a workshop in the heart of Boulder. Since then, Shark and company have relocated to their studio in Lyons, Colorado, which has provided artists the likes of John Buck and Enrique Chagoya with a truly immersive experience.

Shark received his BA from the University of Wisconsin, where he first discovered the process of lithography. He carried this interest further at the University of New Mexico, where he earned his master's in lithography and met one of his mentors, Garo Antreasian. Antreasian arranged for Shark to spend a summer at the Tamarind Lithography Workshop, Inc., one

of the few lithography studios in the United States, in the 1960s. Shark moved to Los Angeles, and gained formal experience working at TLW – a studio that stresses the importance of collaboration and building a strong working relationship between artist and printer. With this experience, he and Barbara moved on to London, where Bud worked as a printmaker for two publishing companies, Editions Alecto and Petersberg Press.

When the Sharks returned to the States, landing in Boulder, Bud was burned out from printmaking. With a loan and support from family, he bought a press, determined to open a print shop that would allow him to operate on his own terms. In 1976, Bud and Barbara founded Shark's Lithography, Ltd Colorado, on Bluff Street. The organization began by printing on commission for galleries and artists. A former assistant introduced Shark to Red Grooms; both were artists-in-residence at Anderson Ranch in Snowmass. The work Grooms produced with Shark helped encourage

Above: Barbara Shark, "Lunch at Greens," 2008, oil on canvas. (Portrait of Bud and Barbara Shark.)

Barbara Takenaga, "Angel (Little Egypt) State I," 2007, color lithograph with gold metallic powder, edition 15. Courtesy of Shark's Ink.

Shark's Ink to transition from commissioned projects to the invitation-only, publishing work they do now.

Hundreds of artists, including many who live or have lived in Boulder – among them Suzanne Anker, Teresa Booth Brown, Matthew Christie, Evan Colbert, Luis Eades, Jim Johnson, Clark Richert, Ana María Hernando, Betty Woodman and Barbara Takenaga – have crossed Shark's threshold. The variety of work is staggering, from Don Ed Hardy's tattoo imagery (he created the Shark's logo) to Jane Hammond's full-scale, three-dimensional sarcophagus, "Spells and Incantations."

In 1998, the Sharks moved to Lyons, where they created a studio and an artist residency. Escaping into the foothills of the Rocky Mountains, artists immerse themselves for weeks at a time. The one-on-one collaborations with this print genius, created within a welcoming environment situated in a wild and beautiful landscape, are truly magical.

Artists of Pattern and Paradox
The Criss-Cross Collective

Jack Collom

As a Boulder poet in the 1960s, I was invited along with some others to read as part of a larger art show at Drop City, a nationally known artists' community located near Trinidad, Colorado. It was a great occasion. Drop City was filled with dwellers, visitors, all active in the arts. The geodesic domes had been carefully built from car parts — after Buckminster Fuller's patterned directions. Agriculture was taking place, ecological considerations were taken seriously, solar energy was being implemented. Talk of revolutionary aesthetic and social movements filled the air. And — we (mostly they) were *doing* it! Heads, hearts, bowels, feet, and ideals all involved. These were exciting times.

In 1974, the five Drop City founders, Gene Bernofsky, JoAnn Bernofsky, Richard Kallweit, Charles DiJulio, and Clark Richert, all artists and filmmakers, regrouped in Boulder and formed the Criss-Cross Arts Collective. Criss-Cross's purpose was to function in a "synergetic" interaction between peers, creating experimental artistic innovation, utilizing, in part, the stress of opposites. Criss-Cross grew to be an influential artists' cooperative — mostly painters — that focused on pattern and structure issues, and it eventually became associated with the '70s art movement called "P&D" (Pattern and Decoration). Between 1974 and 1980, Criss-Cross participation expanded to include artists from throughout the United States. The group established a critically acclaimed art magazine, *Criss-Cross Art Communications*, which was distributed nationally. Their work was featured in exhibits throughout North America.

Above: George Woodman, "Parma," 1979, acrylic on canvas. Collection of Tom Dugan and Karen Ripley Dugan.

Clark Richert, "I.C.E." (detail), 1977, acrylic on canvas.

George Woodman, in describing the group during these times writes

> These are artists of paradox … Like in chess or tennis, the force of patterning is related to channeling tension into the rules of acceptable moves. Renunciation and power are linked together. The work of patternists often is pervaded by a strange atmosphere of sensuality and harshness.[1]

To put it another way, there's a thinking-feeling gap between the mechanical predictability of rules and the unforeseeable richness of actual perception of pattern.

Woodman also comments on two of the local galleries where the Criss-Crossers exhibited — Denver's Spark and Boulder's Edge — as displaying "provocative and interesting works in this metropolitan area" and he mentions similar aesthetics in the hands of twelve-tone composers. He concludes with a mention of Leonardo's force coming from a (words by Watter Pater) "yoking together of curiosity and desire for beauty."[2]

Richard Kallweit, "Escher's Ladder," 1984, laser cut plywood.

Celebration! A History of the Visual Arts in Boulder at the Dairy Arts Center featured work of six then-Boulder-based Criss-Cross artists: DiJulio, Kallweit, Marilyn Nelson, Richert, Woodman, and Fred Worden. Criss-Cross lives on, albeit no longer a formal group. Five of the six are still active in art-making across the country — Kallweit in Connecticut, Nelson in Arkansas, Richert in Colorado, Woodman in New York, and Worden in Maryland. DiJulio, who died in 2013, continued making art throughout his life and career in New York and Colorado.

Following is an anonymous acrostic about the synergy tension in modern art, particularly Pattern, which expresses some of the regularity/irregularity "battles" of the art energy of this dynamic group.

P erhaps
A
T ry at
T he
E ssential hard & soft
R eality of
"N owhere"

❖ ❖ ❖

Notes

1 From an unattributed article, "Pattern," by George Woodman, c. 1979, provided by Clark Richert.
2 Ibid.

Marilyn Nelson, "Untitled," 1979, acrylic on canvas. Collection of the City of Boulder.

Charles DiJulio (1941-2013), "Reconstruction with Accuracy," 1976, acrylic on canvas. Collection of Elizabeth DiJulio.

PORTRAIT OF A BELOVED BOULDER ARTIST
ESTA CLEVENGER
(1939 - 2003)

Jane Wodening

Esta had a laugh that set everyone laughing around her. It was a laugh that danced and rang with the joy of life. Her singing voice was like that, too, warm, joyous, and fulsome. She sang folk songs with her guitar and if she was ever broke and the weather was nice, she could sing on the street and make an impressive amount of money in a couple of hours.

Esta's love and understanding of animals glows through her paintings. She studied Art at the University of Colorado-Boulder so that she could learn how to more clearly show the beauty and heart of animals. After graduating in Art, she wanted to study Psychology so that she could understand the animals even better, but the Psychology department at that time had no sympathy for such an application of their studies so she dropped out of graduate school.

When I first met Esta, she was living in a little cabin up Sunshine Canyon and the great thing in her life was her horse. At that time, we lived part-way up Four-Mile canyon and sometimes Esta would visit us on her horse and we would talk about animals. This was a great and amazing horse and the bond between the two of them was palpable and deep. When that horse died, Esta bought a little house on the edge of Boulder where she lived for the rest of her life.

At one point, Esta fell in love with another singer and they headed to New York City to get discovered as folk singers. Esta hurled everything into this dream but halfway there, they fought and he dropped her off, penniless, at the side of the road. She never wanted to talk about it.

Above: Esta Clevenger and her dog, Badger, portrayed on the cover of *Ode Banjo* catalog, 1964.
The company is still making banjos in Boulder and is now known as Ome Banjos.

Eventually, she managed to get back to Boulder but with a permanent weakness to her thyroid that took away her considerable beauty, but left her with all of her love of animals, her voice, her laugh, and her ability to paint.

Although Esta came from a wealthy family in Hershey, Pennsylvania, she avoided wealth and loved the underdog always. If she saw a wounded dog or bird at the side of the road, she'd stop and take it to her friend the veterinarian to see if it could be healed and released. She got jobs as janitor or kitchen help in a fast-food restaurant. Her favorite work, though, was cleaning the stables, where she could find animals that needed help and she'd take care of them. She built a chicken house and fenced in some of her yard so that she could take care of derelict domestic birds. Once, she was driving past the egg factory and saw a chicken floundering below the structure. She caught her and took her home. It was a big cleaning job and also the chicken had to learn to stand up, but she eventually became a happy hen. Esta would often go to cattle auctions and paint the animals there. At one of these auctions, she acquired a little lamb that no one wanted and raised him as a pet. He loved to ride in the car and even when he got big (he got very big indeed), he would squeeze into and fill up her little economy car and startled many a driver as they rode around together.

And always, she was painting, painting, but she seldom mentioned it.

The job she loved most of all, a volunteer job, was in the stables of The Abbey of St. Walburga on Baseline Road, where the nuns let her take care of the calves they were raising to sell as prime organic beef. She raised them from birth, kept their straw clean, petted them, washed and combed them, took care of their illnesses with careful nursing, and saw them off at the auction. Naturally, their meat tasted much better than that of any other calves in all of the Rocky Mountains and the nuns of St. Walburga Abbey became famous for the amazing quality of their beef. Once I asked her, "how can you care for those calves when you know they'll die soon?" and her answer was, "Their lives are short, but they're happy; they're really happy for their whole lives!"

❖ ❖ ❖

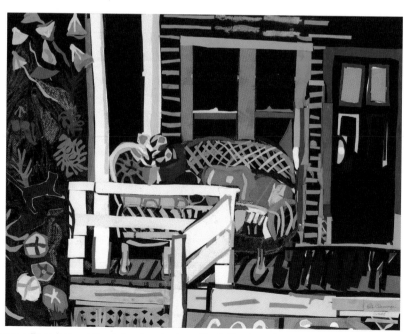

Esta Clevenger, "Suzy's Front Porch," n.d., mixed media. Collection of Tom Dugan and Karen Ripley Dugan.

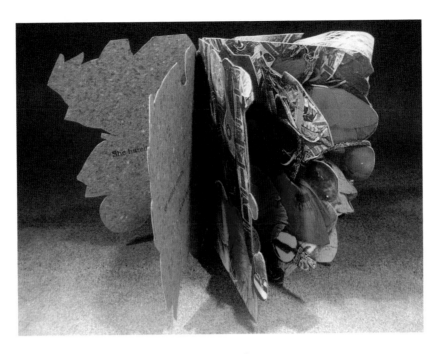

Always a Book Town
A History of Book Arts in Boulder

Jane Dalrymple-Hollo

From small presses to books-as-sculpture, from calligraphy to letterpress and type design, Boulder artists have long been innovators in the many facets of the essentially indefinable genre we call "Book Arts." A quick search in Wikipedia lists four categories: Artists Books = works of art in the form of a book; Book Illustration = illustration in a book; Book Design = the art of designing a book; and Bookbinding = the process of creating a book. The first definition entails the historical blending of fine printing and bookbinding with the rapidly evolving "democratization" of contemporary art and publishing, beginning with the Russian Futurists[1] and filtered through "Fluxus"[2] and beyond. The idea behind this type of "Artist's Book" is to somehow challenge the very idea of "what is a book?" and often results in works that do not look or act like traditional books.

During her tenure (1983-1991) as Special Collections Librarian at the University of Colorado-Boulder's Norlin Library, Nora Quinlan assembled an exquisite and still-growing collection of book arts, book objects, and exemplars of small press publications, many produced in Boulder, which she promoted with exhibitions, lectures, and handle-with-care white-gloves Open Houses. Letterpress printing was another of Nora's passions, which is how she and the late J.K. Emery, then Director of CU Publications, came to refurbish a vintage Chandler and Price platen press donated to the university by a group of bibliophile friends, renaming it "The Eves Press" in honor of its location beneath the eves of the old part of Norlin Library. Enter Brian Allen, a graphic and type designer now based in Austin, Texas, and Julia Seko, still a driving force in Boulder's Book Arts scene, and the Boulder Book Arts League was born. A small

Above: Clare Chanler Forster, "*Sometimes*," 1985, color Xerography, handmade paper.

cadre of enthusiasts led classes open to anyone interested in printing and bookmaking until 1996, when Norlin Library announced that it could no longer house the press. Almost ten years later, with donations of time and money from friends, many of whom met at CU Special Collections soirees, the Book Arts League, along with the Eves Press and several other pieces of vintage printing equipment orphaned by "obsolescence," found permanent homes in another vintage treasure, the Ewing Farm in Lafayette, Colorado.

Laurie Doctor, *"Chance Marks,"* 2016, paper, gouache, sumi ink, walnut ink, linen thread, embroidery thread.

Among the treasures in CU Special Collections are pieces by Clare Chanler Forster (1928-1992), whose work exemplifies the challenge-the-paradigm definition of "Book Arts." Forster's works were created to function like books, but eschewing text, they could also be described as kinetic sculptures activated by human hands, inviting the participant to take an intimate journey from one page to the next, however varied the pages may be in shape and "content."

Calligraphy is a cousin to book arts, and Barbara Bash, a world-class calligrapher and children's book artist now living in the Hudson Valley, is noted for her printed fliers, posters, and works of fine art that came to exemplify the graphic style of small, eccentric Naropa Institute before it was accredited and evolved into Naropa University. Bash, along with Laurie Doctor, another master calligrapher and beloved teacher; and the late, great Boulder polymath, Susan Edwards (1943-2008), founded and taught classes and workshops

in an, unfortunately, short-lived Book Arts program at Naropa.

Yet always emphasizing the tangible "embodied" nature of good writing, Naropa's Writing and Poetics Department adopted several vintage presses over time, all with pedigrees in the closely knit poetry world.[3] Collectively known as Kavyayantra Press, these repurposed warriors are housed in a cottage on the Naropa campus named after the late mystic artist and filmmaker, Harry Smith. Hundreds of broadsides, pamphlets, and Artists Books have been printed there in collaboration with students under the guidance of Naropa faculty, Julia Seko, Brad O'Sullivan, and visiting printers and Book Artists, who continue to lead week-long printing workshops during the annual Naropa Summer Writing Program.

Boulder is also home to many successful authors and/or illustrators of children's books, botanical books, comic books, and graphic novels, of which, sadly, only a small fraction can be represented in any retrospective. And small press publications, not necessarily letterpress, have been a hallmark of the Boulder literary scene for decades.

Too numerous to count, some examples that have come, gone, or still remain, are Dead Metaphor Press, edited by the late Richard Wilmarth; Rocky Ledge Editions, followed by Erudite Fangs, both edited by Anne Waldman; Rodent Press, edited by Matt and Sarah Corey; baksun books, edited by Jennifer Heath; Smokeproof Press, edited by Brad O'Sullivan; Potato Clock Editions, edited by "The

School of Continuation," consisting of Mark DuCharme, Laura Wright, Patrick Pritchett, and Anselm Hollo; Laocoon Press, edited by Randy Roark; Treehouse Press, edited by Tree Bernstein; Monkey Puzzle Press, edited by Nate Jordan; and LuNaPoLiS, edited by Joseph Braun and Indigo Deany. Poet Jack Collom's 1960s-70s journal, *the*, published work by many of the leading avant-garde poets in America. It was stapled and Xeroxed while Collom worked at Boulder's IBM factory.

Then there are comic books and increasingly popular graphic novels. In 1997, a stimulating exhibition at the Boulder Museum of Contemporary Art, co-curated by Cydney Payton and Barbara Shark, featured nationally and internationally renowned artists, such as Philip Guston, as well as some from Boulder, and Denver, including Sarah C. Bell and Bill Amundson. Titled *Art and Provocation: Images from Rebels*, the exhibit examined parallels between fine art and comic art, exploring their shared visual languages as well as aspects that distinguished one from the other.

This was followed in 1998 by an exhibit co-curated by Bell and Matt McKown titled *Black & White & Read All Over*, that featured original work by seventeen of Boulder's comic-

Invitation from a 1998 exhibition, *Black and White and Read All Over*, featuring seventeen of Boulder's many comic book artists and cartoonists resident at the time.

book artists and cartoonists at Axis Mundi Gallery. Sadly, Axis Mundi, a cooperative for emerging artists, closed, and most of the artists have moved from Boulder, thanks to rising costs of living, thus diminishing the city's reputation as a national center for comic artists and cartoonists.

A Caldecott Honor is among the most prestigious recognitions for the writing and illustration of children's literature in the United States, and at least two artist/authors living in Boulder have been thus celebrated. Steve Jenkins writes books that draw young readers in with his hauntingly beautiful and distinctly original collaged illustrations, and Janet Stevens anthropomorphizes a broad array of animal species into vivid characters that critics have lauded throughout her career.

Known primarily as a painter, Laura Marshall has also illustrated several children's books, including Ursula LeGuin's *Fire and Stone*, and *The Girl Who Changed her Fate*, Marshall's retelling of a Greek folktale.

Tree Bernstein, *A Poet's Alphabet: 26 Poets/26 Poems*, Treehouse Press, Boulder, 2000, archival board, rubber stamped with ink, limited edition of 226.

From Anne Ophelia T. Dowden, *Look at a Flower,*
Crowell, c. 1963.

In the realm of informational books, Lisa
Gardiner offers delightful science education to
children. And there is Anne Ophelia Dowden
(1907-2007), whose exquisitely beautiful
botanical paintings were so influential that she
is affectionately known as the "grandmother"
of botanical artists in the United States.
Dowden grew up in Boulder, lived in the eastern
United States for most of her life, then returned
to Boulder late in life, where she died at the age
of 99. Among the many books she authored
and/or illustrated are at least two botanical
books for young people, *Look at a Flower,* and
with author Jessica Kerr, *Shakespeare's Flowers.*

Artist and photographer Mia Semingson left a
tenure-track position in CU's Department of
Art and Art History, where she taught Book
Arts and alternative-process photography, to
become the owner-operator of Two Hands
Paperie, a shop on Pearl Street, just west of
the mall. Two Hands began in 1993, as a small
bindery, and has expanded to carry hundreds of
journals, notecards, calendars, and decorative
papers, as well as offer classes that teach new
skills to both aspiring and accomplished Book
Artists, thus increasing a list that is becoming
far too long to capture.

In a world which seems dominated by
electronics, Book Artists continue to thrive in
Boulder … now and always a book town.

❖ ❖ ❖

Notes

1 Inspired by Italian artist Filippo Marinetti's Futurist
 Manifesto (1908), the Futurists were among the first
 artists to experiment with Abstract painting although
 the movement was rooted in poetry and typography.
 First inspired by the "Calligrammes" of Guillaume
 Apollinaire, wherein the lettering or type was arranged
 in ways intended to parallel the meaning conveyed by
 the text, typography and book design became fertile
 ground for avant-garde experimentation, particularly
 among the Russian Futurists.
2 The movement known as Fluxus was strongly influenced
 by the "chance" methods of Marcel Duchamp
 and composer John Cage, and was seminal in the
 subsequent (and continuing) re-defining of "what is
 art?"
3 The original press at Kavyayantra was used by renowned
 Language poet, Lyn Hejinian, to do most of the fifty
 chapbooks under her Tuumba Press imprint. Hejinian
 sold her printshop to David Sheidlower and in around
 1992, David offered the equipment to the Jack Kerouac
 School of Disembodied Poetics at Naropa.

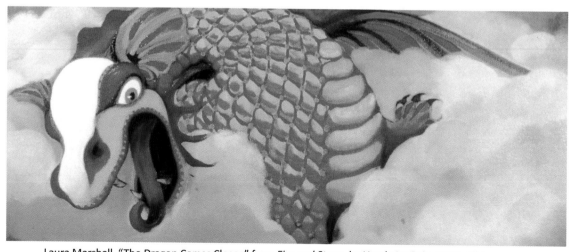

Laura Marshall, "The Dragon Comes Closer," from *Fire and Stone,* by Ursula Le Guin, 1989, oil on canvas.

An Adventure in Confluences,
Or "Stilling the Whirlpools of the Mind"
The Visual Arts at Naropa

Laura Marshall

In 1974, Chogyam Trungpa, Rinpoche, a meditation teacher from Tibet, founded the Naropa Institute. The founding of Naropa was part of a larger cultural movement that was gathering strength between the 1950s and 1970s. Even as United States warplanes were bombing Southeast Asia, seeds of new sensibilities were germinating in American culture, and influences of Tibetan, Chinese, and Japanese culture began to emerge in the work of American artists, including the composer John Cage, and poets Gary Snyder, Pat Donegan, and Allen Ginsberg. Indirectly, ripples of these stirring influences could be discerned in the stillness of Mark Rothko's paintings, and in Robert Motherwell's series of paintings, *Elegy to the Spanish Republic*, the shapes of which suggest the traces left by a giant, ink-laden Chinese paintbrush. In its early years Naropa was borne forward by the momentum of these currents. Focused primarily on the arts and humanities, Naropa was founded on a vision of a place where Buddhism and the intellectual culture of the West could meet and engage in an ongoing reciprocal exchange. In this way, a rich confluence of artistic streams took place at Naropa.

From the outset, meditation practice has been at the core of Naropa's curriculum. The aim of contemplative practices is to affect a synchronization of mind and body; at Naropa this synthesizing influence continues to inform the approach to teaching and learning alike.

Above: Calligrapher Barbara Bash and the late rhetorician Susan Edwards perform at Naropa Institute in the 1980s. Edwards told stories or lectured, while Bash drew spontaneous calligraphy with a huge brush.

This approach has made it possible to study academic subjects from different perspectives, and thereby to get to the essence of things, both Eastern and Western. Thus, what can be found at Naropa is a departure from the strictures – and conceits – of a Eurocentric approach to visual art, not only brought about by the influence of artists immersed in Asian traditions, but in American-born artists whose work is informed by contemplative experience.

As might be expected in a college named after a 10th-century Indian saint, classes at Naropa were offered in traditional arts of Asia such as *ikebana* — Japanese flower arranging, *chado* — the Way of Tea, and in martial arts — including *Aikido* and *Tai Chi Chuan*. Courses were taught in Buddhist philosophies of art, and in Chinese, Tibetan, Japanese calligraphy, and the Tibetan tradition of *thangka* painting.

Originally from India, thangkas are religious paintings, an inscription of the iconographic counterpart of the written teachings of Buddhism. Unlike a fresco on the wall of a monastery, thangka paintings can be rolled and carried around — an advantage in the nomadic culture of Tibet, where monks traveled widely in order to teach. Thangka painting was first taught at Naropa by Tenzin Yongdu Rongae and his sons, who found their way to Boulder after leaving Tibet in 1959.

Chinese born artist Ed Young, best known for his award-winning picture books for children, introduced Naropa students to written Chinese characters in 1980, and since the late 1990s, Harrison Xinshi Tu, a Chinese calligrapher whose work is recognized in the U.S, China, Korea, and Malaysia, has taught Chinese calligraphy.

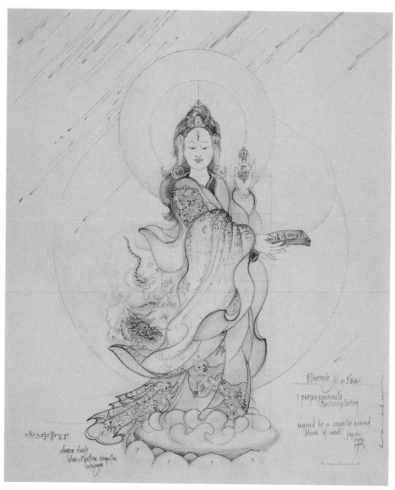

Cynthia Moku, "Prajnaparamita Contemplating," n.d., graphite and colored pencil on paper.

American artists who have attained mastery in traditional artistic disciplines of Asia have joined the Naropa faculty over the years: Sanje Eliot and Cynthia Moku taught thangka painting after the Rongae family returned to India. The paintings of Moku, who was originally trained in the Western tradition, reflect an adherence to the formal discipline of traditional

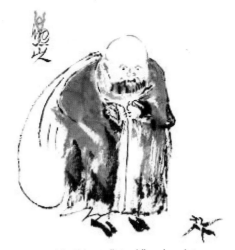

Keith Abbott, "Monk", n.d., print.

thangka painting, yet are at the same time highly innovative. Her work, which is included in the collection of the Denver Art Museum, is a unique synthesis of traditional and modern sensibilities and methods.

The program of visual arts in Naropa was summed up under the rubric of "Dharma Art." *Dharma* is a general term referring to the Buddhist teachings; thus Dharma Art can be understood as a visual component of verbal and written teachings. At Naropa, Dharma Art became more than that; it became an extension of the contemplative practices at Naropa's core, a way of deepening the relationship between an artist and the world. While courses in Buddhist art and iconography were included in Naropa's curriculum from the beginning, the intended approach was, in Trungpa's words, "an art which springs from a certain state of mind on the part of the artist."[1] Thus, while traditional art forms were being taught by artists from both Asia and America, during the 1990s more American artists joined the faculty of Naropa, teaching courses that at first glance seemed to belong in the curriculum of any conventional visual arts program: drawing, painting, sculpture, photography, calligraphy, art history. Yet there was a difference in the way these courses were taught, for they were informed by an awareness of body, mind, and environment

— a mindfulness — that comes of the contemplative experiences of the teachers. Joan Anderson, who taught painting at Naropa during the 1990s and early 2000s, says that she has been "indelibly imprinted as an artist and human by Buddhist meditation and retreat practice."[2] Her husband, Robert Spellman, also a teacher at Naropa, describes the practice of mindfulness meditation as "a central mode of inquiry."[3] Although contemplative practice shaped the teaching of Western traditional art forms, the results do not necessarily reflect traditional Eastern art, and do not seek to imitate it.

Barbara Bash is an American artist whose work bears the influence of contemplative practice. The courses she taught in Western calligraphy, beginning in 1980, complemented those that were being offered in Tibetan and Chinese calligraphy. Her intention was to "work with the texture of the alphabet and its surrounding space." Today, Bash's picture books are widely known, many of them published by Sierra Club Books, and she continues to offer workshops in giant brush calligraphy. Naropa's Book Arts program developed out of the courses she taught, enriched and carried on by the contributions of Laurie Doctor and Susan Edwards (1943-2008), who also taught Rhetoric in the writing program.

Also in the early years of Naropa, art historian José Argüelles (1939-2011), author of *Mandala* and *The Transformative Vision*, taught "Art: a Global Approach," a course in which art history was explored as "a globally interrelated process," one that complemented Naropa's courses in World Music and Poetics. I was privileged to continue teaching courses in World Art in the 1990s and 2000s.

Joan Anderson, "Red Star Ancestors" (detail), 2006, acrylic, gold leaf, stitching on canvas, double-sided.

In addition to Anderson — who, before retiring to teach privately in 2008, taught painting and a class called "The Contemplative Artist" — and Spellman, who at this writing continues to teach drawing and watercolor painting, novelist Keith Abbott taught brush painting, Caroline Hinkley offered courses in photography and a class in film history. With Michael Newhall and Sue Hammond-West, I taught "Figure Drawing." Tyler Alpern teaches painting, while Marcia Usow taught "Pottery from the Earth." In keeping with Naropa's ecological concerns, Jill Powers teaches "Environmental Art."

The practice of art at Naropa becomes a form of mindfulness practice in itself. Many Boulder artists, trained in the Western tradition, have taught their métier at Naropa, informed by the contemplative tradition, which is itself a way of seeing, with the artist less of a heroic outsider, than a person seeking ways to become part of the world they are observing with care and attention. In this way, they are carrying on a tradition that might best be described as that of the philosopher-artist.

In 1999, the Naropa Institute became a university; in the School of the Arts, one of its five schools (others are Psychology, Poetics, Humanities and Interdisciplinary Studies, and Natural and Social Sciences), Naropa's teachers continue the reciprocal confluence of East and West, the coming together of contemplative and artistic practice, what the 4th-century Indian sage, Patanjali called a "stilling of the whirlpools of the mind."

Notes

1 Much of the material presented here is drawn from a number of early Naropa catalogs, in which quotations were largely unattributed.
2 From Joan Anderson's website http://www. joanandersonart.com.
3 From Robert Spellman's website http://robertspellman. com.

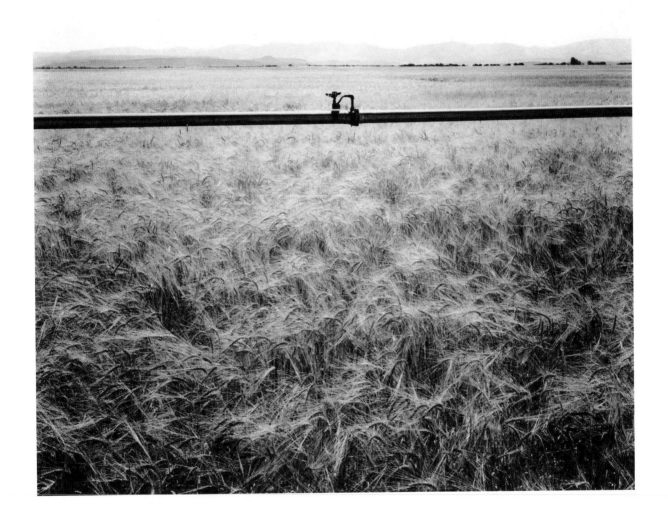

Charles Roitz (1935-2012), "The Way Home: Idaho 1979," c. 1980, silver gelatin print. Collection of Carla Roitz.

Vidie Lange (1932-2016), "Wisconsin Window VI," c. 1970s, hand-colored black-and-white silver print.
Collection of Elisabeth Relin.

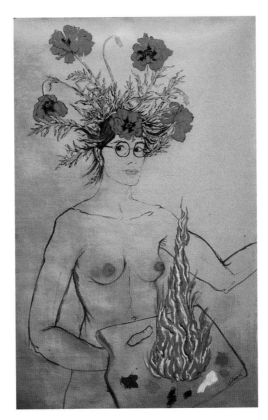

A Shared Historical Moment
Front Range Women in the Visual Arts

Fran Metzger

It was our time: the 1970s. We were university students, studying to be artists and teachers, and we were women. We looked around and what we saw needed changing. We saw that women artists were still not recognized as significant voices in the contemporary creative, artistic, and societal dialogue of the day. We sought to change that by forming Front Range Women in the Visual Arts, a small but passionate group – Michele Amateau Amato, Sally Elliott, Jaci Fischer, Helen Barchilon Redman and myself -- whose goal was to take down gender-based barriers and create opportunity for women artists.

> *They are connected primarily by their ongoing commitment to making art and a shared historical moment upon which they can look back with pride.* — Lucy R. Lippard[1]

We began out of a need to connect, to communicate, to study, and to exchange ideas with other women artists. We demanded to be seen as professionals and as worthy contributors, as our male counterparts had been for centuries. In growing and learning as women artists we discovered we weren't the first. We discovered the rich heritage of women artists in all eras of human history, but unknown to us in the 20th century.

> *Front Range stands as a model of action and accomplishment. This model of action signifies a unique group identity, one that is important to 20th-century women's art history and to the feminist movement that fueled its beginnings. As a group dedicated to promoting opportunity and recognition for women in the arts while honoring individual art production from a variety of aesthetic viewpoints, styles, and media, Front Range Women in the Visual*

Above: Helen Barchilon Redman, "Artist Aflame," 1982, oil. Collection of Faith Stone.

Arts stands as a living legacy for Colorado, its history, and its people, just as it does for women artists everywhere — Margo Espenlaub[2]

The women of Front Range gained inspiration from each other, from our many exhibitions, and from other women artists who came from universities and art collectives around the country. Our group was based on non-hierarchal leadership, shared responsibility, supportive feedback, and openness. We came from multiple viewpoints — socially, educationally, historically — but all were celebrated.

> *They have succeeded where much larger and more powerful institutions have failed, creating greater opportunities for women in academia, museums, and the gallery system. In forty years they have facilitated dramatic institutional shifts, as well as the evolution of how women commune with and support each other.* — William Biety[3]

We see hopeful signs today that the seeds Front Range Women planted all those years ago are bearing fruit. There have been significant changes in the position of women artists at universities, in galleries, and in museums across the country. We take pride in the role we played in those shifts and look forward to the future.

> *Regardless of what the feminist movement looks like or is called today, it behooves everyone to remember that we stand on the shoulders of women like the members of FRWVA, who invested so much on our behalf, and that of future generations.* — Jennifer Heath[4]

Notes

1. Lucy R. Lippard, "Front Range/ Far Range" in *Elbows and Tea Leaves, Front Range Women in the Visual Arts (1974-2000)*, (Boulder, CO: Boulder Museum of Contemporary Art, 2000), 13
2. Margo Espenlaub, "Modeling Action for a Decade: Front Range Women in the Visual Arts" in *Elbows and Tea Leaves*, 19
3. William Biety, "Curator's Statement," *Transit of Venus: Four Decades of Front Range Women in the Visual Arts* (Denver, CO: Redline Gallery, 2014), 2
4. Jennifer Heath, "Venus Rises Back Home on the Range," *Transit of Venus*, 6.

Fran Metzger, "Winter, Colorado," 2013.

The Essence of Art as Activism

Carol Kliger

The term "activist art" can be broadly applied to artist- and community-initiated projects and, by and large, is not tied to the traditional art world nor to construction-oriented public art. Most activist projects do not result in commodities to be bought as objects of beauty, status symbols, corporate embellishments, or investments. Most activist art occurs outside the sanctioned art spaces of galleries, sculpture gardens, museums, or publicly funded constructions. Most occur in non-traditional locations such as the subways of New York City, the banks of Boulder Creek, or the skid row area of Los Angeles. The audience for activist art can be nontraditional as well.[1]

Activist and construction-oriented public art differ most often in their content. The content of activist art is wide-ranging and complex; as the lines between political, social, economic, and environmental issues become intertwined and blurred.[2] Activist projects tackle subjects such as reproductive rights, AIDS, or the environmental havoc created or condoned by government agencies. They center on specific concerns of a community, on a community's self-perception, or bear witness to the forgotten history or unrecognized contributions of a community or a people.

From Billboards to Graffiti

Activist art often makes use of advertising and mass media. In 1990, artist John Craig Freeman and the environmentalist group Greenpeace made use of existing billboards along Route 93 near the entrance of Rocky Flats Nuclear Weapons Plant, the sole producer of plutonium in the United States. With strong visual images and words, the billboards urged immediate closure of the plant and to "make a statement

John Craig Freeman, "Operation Greenrun," 1990.
These billboards spell out, "Today / we made / a 250,000 year / commitment (not pictured).

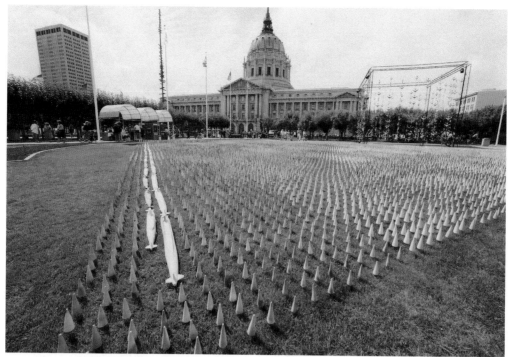

Barbara Donachy, "Amber Waves of Grain," 1983, 35,000 small clay cones, each representing a nuclear warhead or missile in the United States nuclear arsenal. Interspersed are models of long-range bombers, jet fighters, and submarines for delivering the deadly force. The installation has been displayed around the U.S., and is here shown in San Francisco.

against nuclear war" to "convince decision makers … that the Cold War must stop here … and now."[3] Unfortunately, controversy overshadowed the billboards' message, when an environmental group, Citizens Against Billboards on Highway 93, complained vigorously and the media turned its focus from the nuclear issue to the fight. Freeman's images were torn down only six months after they were unveiled.

Activist projects sometimes take the form of guerrilla action or they can manifest in ways that create the possibility of interaction between an audience and subject,

situation, or place. Some become permanent structures, others are temporary and quickly made (making public reaction to controversial subject matter less likely). Whether through community murals, the mass media, guerrilla actions, performance, or interactive pieces, activist art manifests in ways not necessarily associated with art or the art world.

Direct Response to the World's Woes

Artists become involved in activist public art for a variety of reasons. While some participate in private studio and activist work simultaneously, others deliberately choose, as activist artists, to

On August 6, 1985, on the 40th anniversary of the atomic bomb explosion over Hiroshima, Japan, Boulderites awoke to find images painted with non-permanent whitewash resembling the remnants of human beings near ground zero who were vaporized, leaving only their shadows. The Boulder Shadow Project was organized by Bunny Pfau, who recruited artists and others to pose for and outline the figures throughout Boulder during the very early hours of the morning.

separate themselves from the art world. They do this because they find the continuing "quest of career advancement through shows, reviews and sales to be unfulfilling."[4] Instead, these artists are more interested in responding to pertinent issues and reaching non-traditional, often specific, audiences outside the confines of the art world. And instead of being restricted to the imposed, rigid, pressured, or drawn-out time lines of construction-oriented projects, activist projects can be initiated by an "internal response to an external situation" in a timely manner.[5]

For the most part, activist artists work outside the world of galleries and museums. They conceptualize, organize, bring into being, and fund projects, often using donated materials and working without pay.[6] They sometimes act as problem solvers and even as prophets.[7]

Because activist art is so directly tied to audience and issue, it can function in a number of ways that art which addresses formal artistic concerns usually cannot. Activist art at its best represents the unrepresented, gives voice to those who are unseen, examines difficult and complex issues, raises questions, generates dialogue, educates, and seeks change.[8]

Sometimes activist art and studio art coincide in utilizing common values.

In the cold month of January 1992, Los Angeles activist artist, John Malpede — who has spent many years working with homeless individuals, seeking to educate the public and social agencies about the issues of homelessness — came to Boulder, under the umbrella of the Colorado Dance Festival, which created the first Boulder Homeless Awareness Week. Recruiting the homeless, regardless of addiction, literacy, or mental illness from LA's Skid Row, Malpede had shaped a workshop he called Los Angeles Poverty Department – LAPD – which met twice weekly. Over the years, through media coverage, awards, and travel, LAPD's audience grew. Wherever LAPD went on tour, including Boulder, they added one or more scenes about homelessness, performances that involved local homeless people as extras.[9] In Boulder there were regular theatrical performances and a performance in a laundromat (where the homeless often gather to keep warm). These performances allowed the general public to become aware of the devastating effects of poverty, isolation, and homelessness. Boulder Homeless Awareness Week challenged Boulder's citizenry and government to look more closely at how homelessness in Boulder affects many diverse population groups. The dance festival staff brought together social service agencies to co-develop the event.[10]

The following year, in February 1993, the Colorado Dance Festival again produced Boulder Homeless Awareness Week and, in the second year, through the Emergency Family Assistance Association, an art show featuring

Hank Brusselback, from his artist book, *Crying Presidents*, 2003.

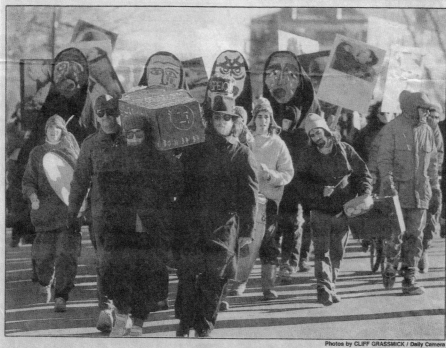

HUNDREDS IN BOULDER RALLY FOR PEACE

Photos by CLIFF GRASSMICK / Daily Camera

ON THE MARCH: People carrying pro-peace and anti-war signs march down Broadway on their way to the Downtown Mall in Boulder on Saturday. The march began at the University of Colorado Memorial Center fountain. Below, Christopher Collom of Boulder listens during a rally prior to the march.

In 1991, an activist group calling itself Damage Control marched as "The Wailing Women" during a rally against the Persian Gulf War.

work by homeless children was created, along with a mini-documentary, spearheaded by Fairview High School students, featuring interviews with runaway/homeless youth at Attention Homes.

The Importance of Process in Activist Art

"Artistic process" is the term that traditionally refers to the process a studio artist goes through during the conceptualization, development, and creation of work. In the area of activist art, there are often two processes that occur simultaneously between a project's conception and fruition. The internal artistic process of both activist and studio artists develops in response to the manipulation of materials, accidents or mistakes, critical self-analysis of past and present work, and response from others. A matured artistic process results in a vocabulary, sensibility, and manner of working that clearly belong to a particular artist. The work of an artist can grow and vary widely

over the years and still retain the distinct mark of that artist. This holds true for the activist, as well as for the studio artist.

In some respects, it may seem like a contradiction that an activist artist's private vision and personal working process, which grows over time in a manner unique to that artist, can result in public art. However, an activist artist can develop a working process that is very much her own, and, at the same time, respond to and include others. It is almost as though the activist artist adds the public to a piece, be they participants or audience, in the same way a studio artist would add new material. The development of a matured artistic process allows the activist artist to maintain the artistic integrity of a project and still respond to concerns and influences of the public.

Yet there are clear differences between the artistic process of studio artists and that of

activist artists. Developing an activist process begins with the definition of a working group. Some activists choose to work alone or with one or two other artists. Some small groups include non-artists in their core. Damage Control (Five Women Over 40) was a Boulder-based activist art group comprising two writers, two visual artists, and a psychologist. The group formed in 1991 in reaction to the Persian Gulf War.

"We're all good friends and all of us are fairly political people," psychologist Anne Hockmeyer said. "Damage Control" started when we were sitting around talking about what to do about the war." The group, named by writer Lucy R. Lippard, chose to do two guerrilla theater pieces. One, enacted on the Pearl Street Mall, was called "The Bushes Take You for a Ride." Two of the group's members wore masks and paraded as George and Barbara Bush, driving up and down the mall in a portable cardboard car, especially made for the piece by artist Kristine Smock. When the Bush's car ran low on gas, they stopped at the gas tank for a refill. The tank was a wounded soldier; the gas was blood.

Damage Control also created "The Wailing Women," huge cardboard and cloth replicas of mourning women dressed in black veils. They regularly led dirges in the midst of anti-war marches in Boulder, appeared at an exhibit at the Boulder Artists Gallery called *No Show*, featuring local artists, poets, and musicians against the war, and wherever else their presence seemed appropriate. In those cases – not unlike LAPD's open-ended engagement with the homeless wherever they traveled or the Colorado Dance Festival's recruitment as activists of whole communities and social service agencies to be their working group — Damage Control's core of five expanded to as many as fifty, with others enlisted to carry

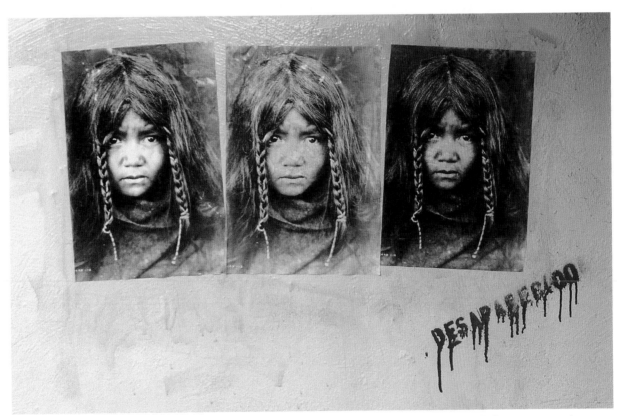

This image of a Native American child was photographed by Edward Curtis, c. 1906. A highly skilled anonymous painter replicated her on the wall of a Boulder underpass. Nearby were paintings of eagles presumably by the same artist, but only the girl was painted over with opaque gray paint, perhaps by city authorities. Sometime later, these posters appeared where the painting had been, along with the word *desaparecido*, Spanish for *disappeared*. Photo: Laura Marshall

Two-year-old Zachary Garcia, captured on the front page of the February 26-28, 1993 Colorado Daily, adds his artwork to a community mural at the Boulder Artists Gallery created in conjunction with Boulder Homeless Awareness Week, produced by the Colorado Dance Festival and Emergency Family Assistance.

coffins, beat drums, or hold large placards depicting the faces of war victims, civilians, and soldiers alike. Damage Control's interests went beyond the Persian Gulf and they dealt with environmental devastation, military recruitment, and news censorship, among other issues. As with most activist art projects, this requires research, careful development and a clear definition of goals and audience.

Public artists define community in reference to the development of a project for a specific site, neighborhood, or city. There are times, however, when an activist artist may define subject first and then define audience on the basis of that subject. Will the project then attempt to raise issues, pose questions, or educate? Will the aim be to memorialize an event? Will the goal be to promote a community's pride and cohesiveness? Or will the project encourage activism through direct action? If the goals of a project are unclear, the project may be ineffective or even backfire.

Once goals are clarified, an activist artist or group must decide what methods will promote those goals and reach the audience. What form will the project take? Performance? Guerrilla action? Billboards? Community murals? What imagery and materials should be used? If text will accompany the imagery, how will it read, and what typeface will be used? What will be the size, timing, and location of the project? What will the tone of the project be: challenging, playful, reactive, confrontational, hostile, humorous, stern, or official?

None of this process occurs in any particular order. A working group may form in reaction to a particular issue and only later seek out and define new topics of interest. A working group may have a specific goal in mind and develop a project around that goal. Or a non-art community may define issues relevant to that community, and in doing so spur an artist within the community into action. It is

also possible for an artist to have a developed, predominant style and tone of working that can then be applied to many issues in a variety of ways. No matter what the order, an activist artist's working process most often needs to include the definition of working group, topic and issues, community audience, goals, imagery, and tone.

Options, Choices, Freedom

The realm of activist art contains a myriad of options for the studio artist who wishes to engage with the public. Unlike construction-oriented projects, activist projects are initiated and developed by the artist. Instead of waiting for an agency to develop and fund a suitable public project, an artist can develop her own public project based on persona, political, and artistic interests. An artist can choose a community to be involved with, form a working group, decide what issues to respond to, and choose to use particular methods and materials. In this way, a studio artist can gain experience defining, responding to, and working with a community and an audience.

❖ ❖ ❖

Mark Bueno poses with his concrete and glass sculpture, "Nobody Builds Walls Better Than Me," created for *Crossing Borders*, a juried group art exhibition at the Dairy Arts Center that explored immigration issues in conjunction with One Action 2016: Arts and Immigration Project.

Notes

1 This essay is excerpted – and somewhat updated -- from Carol Kliger, *A Public Art Primer for Artists of the Boulder-Denver Area* (Boulder, CO: National Endowment for the Arts and Boulder Arts Commission, 1993), chapter 3.

2 Ron Glowen, "Buster Simpson: An Activist Art of Urban Ecology," *Public Art Review*, 2, no. 1 (Spring/Summer 1990), 16.

3 Jason Salzman and Chet Tchozewski, *Daily Camera*, December 3, 1990; Marnie Engel *Daily Camera*, November 13, 1990.

4 Julie Ault, notes from slide presentation, University of Colorado-Boulder Visiting Artist Program, attended by author, January 22, 1992.

5 Ault, January 22, 1992.

6 Ault, January 22, 1992.

7 One example is the 2007 exhibition, *Weather Report: Art and Climate Change,* produced by EcoArts Connections and curated by Lucy R. Lippard, which took place at the Boulder Museum of Contemporary Art. See the following essay outlining a history of EcoArts Connections.

8 Professor Erika Doss, notes from Public Art class at CU-Boulder, attended by author, spring semester, 1991.

9 Events for the first Boulder Homeless Awareness Week included a forum with the mayor, the chief of police and other officials with the general public to discuss homeless in Boulder; tours to the homeless shelter (some city council members had never been); and talk-back sessions with Playback Theatre and local merchants who were upset about homeless people asking for money in front of their stores.

10 With thanks to Victoria Watson and Marda Kirn for providing further information about the activities of LAPD in Boulder and about Boulder Homeless Awareness Week, while it was under their auspices as staff of the Colorado Dance Festival.

Boulder's first Peace Poles, located on either side of Boulder Creek near the main branch of the Boulder Public Library, were installed permanently by the Peace Pole Project.
The poles read "May Peace Prevail" in a variety of languages. Photo: Laura Marshall

One Woman's Efforts to Blaze a New Path for Art in the Era of Climate Change
EcoArts Connections

Nora Rosenthal

EcoArts Connections is perfectly situated to fulfill its mission[1] to find and forge a new role for the arts in the face of climate and global change. It is headquartered in a city with no fewer than five Nobel laureates in science (so far) and the highest population density of climate scientists in the United States.

This new role aims to maintain the highest artistic excellence while stimulating thought, local and global, inspiring self-reflection, and igniting personal transformation and social change. And through it all, EAC strives to help non-art disciplines appreciate the arts as an essential ally and collaborator in addressing some of the most important issues of our time.

All in a day's work for Marda Kirn, who, in 1982 — with Bob Shannon and Felicia Furman — founded the Colorado Dance Festival, one of the most exciting, intellectually and aesthetically invigorating annual events ever to hit Boulder. *The New York Times* named CDF one of the three most important dance festivals in the world. Alas, the festival ended in 2001, but after a short breather, Kirn was active again, this time founding EcoArts with board members Linda Carbone and Karon Kelly from the National Center for Atmospheric Research and the University Corporation for Atmospheric Research.

Above: Melanie Walker and George Peters, "Coal Warm Memorial," 2007, wind installation.
Site specific, created for *Weather Report: Art and Climate Change*.

During its early years, from 2006 to 2008, EAC presented festivals of ten to thirty days as EcoArts, under the fiscal umbrella of the Boulder County Arts Alliance, with as many as twenty-five collaborators at a time, including the Colorado Music Festival, Colorado Shakespeare Festival, Institute of Arctic and Alpine Research and the National Center for Atmospheric Research. In 2009, EcoArts incorporated, changed its name to EcoArts Connections to better reflect its breadth, and shifted from festivals to commissioning, producing, presenting, and/or consulting on artists' projects. In 2010, youth programs were added. They have brought visual art, dance, spoken word/rap, and theatre artists into middle and high schools and after-school programs like Club Mestizo, which brings Denver's renowned Su Teatro company actors to Angevine Middle School in Lafayette. EAC's SCO: Exploring Culture & Opportunities brings actors, graffiti muralists, photographers, and videographers to Boulder Ridge Mobile Home Park in programs for Latino youth and adults.

EAC regularly initiates collaborative arts projects with Indigenous peoples, scientists, social scientists, urban planners, educators, and other entities. Activities have been held in traditional venues (theatres, art and science museums, science centers, libraries, and schools) and non-traditional sites including coal-fired power plants, gardens, wind farms, and the waiting booths of vehicle emissions-testing facilities. In 2011, birdwatchers, local naturalists, scientists, three transportation entities, and eight local and national birding, environmental, and science organizations came together to support *Bird Shift: The Anthropogenic Ornithology of North America*, a multi-media exhibition featured at the University of Colorado Museum of Natural History, on Boulder's Long JUMP buses, at bus stops and on the Internet. "Bird Shift" offered an unconventional approach to exploring how humans are affecting bird life and habitat. A component of *Bird Shift* was "Bus Birding," by EAC-commissioned, Vermont-based artist Brian Collier. It took place at thirteen bus stops, on six buses.

Jane McMahan, "Arapaho Glacier: What Goes Around Comes Around," 2007, Arapahoe Glacier ice, glass, steel, refrigeration equipment, solar panels, batteries, aluminum screen, pump, hose, Boulder Creek water. Site specific artwork created for *Weather Report: Art and Climate Change*. McMahan worked with Dr. Tad Pfeffer of INSTAAR (Institute of Arctic and Alpine Research) at the University of Colorado-Boulder.

Mary Miss – with Peter W. Birkeland and Sheila Murphy — "Connect the Dots: Mapping the High Water, Hazards, and History of Boulder Creek," 2007, mixed media. Site specific artwork created for *Weather Report: Art and Climate Change*.

In Colorado, Seattle, Indianapolis, New York City, and Washington, D.C., EAC arts activities have included visual art, dance, theatre, film, poetry, and music. In Boulder, in 2007, EAC commissioned *Weather Report: Art and Climate Change*, curated by Lucy R. Lippard, and co-presented with the Boulder Museum of Contemporary Art. *Weather Report* featured fifty-one artists from the United States and abroad, and was one of the first art-and-climate-change exhibitions in the world. It also proved to be a prescient exhibition, with displays such as New York artist Mary Miss's "Connect the Dots: Mapping the High Water, Hazards, and History of Boulder Creek" created in collaboration with retired CU geologist Peter W. Birkeland and U.S. Geological Survey hydrologist Sheila Murphy, a powerful foreshadowing of the

September 2013 flash flooding in Boulder (exacerbated by wildfires) that killed at least three people and destroyed much property.[2]

Los Angeles-based artist Kim Abeles, who had participated in *Weather Report*, created *the invisible connectedness of things*, an art, science, and, again, transportation project, though this time, the exhibit took place in the waiting booths of AirCare Colorado (Boulder's auto emissions testing facility), as well as NCAR, Manhattan Middle School, and at the exhibition's hub, the CU Museum of Natural History. Abeles brought together lichens, buses, an art/science scavenger hunt, smog collector plates — made from particulate matter in the polluted air by placing the plates outdoors for varying lengths of time — created by eighty middle-school students, a self-guided "lichen tour" via bus, panels, talks, as well as the exhibit.

When EAC commissions visiting artist projects, it works closely with the artists, pairing them with scientists, naturalists, and other Boulder-based experts to offer inspiration and information for the creation and/or implementation of the artists' work. Whenever possible, the pairings are based on "the point of wonder," the question(s) that the artist or scientist is wondering about and wants to or is already exploring. Thus, both are explorers along the same path, coming at questions and discoveries from different but equal vantage points, and avoiding anxieties about stereotypes, such as that artists are "more creative" than scientists, or that scientists will expect artists to do the math (these are just a few of many misconceptions). To complement the resulting science-informed, sustainability-focused, arts-expressed works, as it did with *Bird Shift/Bus Birding*, for example, EAC often invites additional collaborators to "wrap" thematically related activities and events around the artist's work, to enhance and anchor it in the community.

As with visiting artists, EAC finds scientists and others to collaborate with Boulder-based artists such as performance artist/choreographer Michelle Ellsworth, teamed with global change biologist Rob Guralnick. Both were CU faculty members at the time and their partnership resulted in a second iteration of *Preparation for the Obsolescence of the Y Chromosome*, the first having taken place at the Museum of Contemporary Art-Denver. For Guralnick, "seeing how [Michelle Ellsworth] has taken our conversations and the science behind them and turned them into verbal and physical poetry has been one of the most rewarding experiences of my career."

In 2016, EAC collaborated with the National Oceanic and Atmospheric Administration to co-commission two Colorado artists (Michael Theodore and Jeanne Liotta) to create 6-minute films/visual presentations for Science on a Sphere®, a 6-foot in diameter globe and visual display system that typically displays science images. Thanks to Theodore, Liotta, and NOAA scientist Shilpi Gupta, this collaboration with EAC is opening an entirely new platform for artists that has the potential for being displayed on more than one-hundred-and-twenty SOS® globes installed in museums, science centers and other locations worldwide, reaching more than 33 million people annually.

As she did with the legendary Colorado Dance Festival, Kirn has brought massive media attention to EcoArts Connections, with coverage in local, regional, and national outlets, including *The New York Times*, *Art in America*, and *Dance Magazine*. The result of not only her Herculean efforts — but also her inventiveness, her brilliant new ideas, her pursuit of excellence, and her determination to enlighten and educate — is the bringing of more than 10,500 people annually to EAC activists, reaching as many as 100,000 a year.

Very little, even in a unique city like Boulder, can match this fundamentally one-woman endeavor.

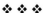

Notes

1 The mission of EcoArts Connections is "to bring the arts together with science, social justice, and other fields to inspire sustainable living and to forge a new role for the arts in the face of global change."

2 In his essay, "Boulder Flooding: Remembering Warnings from *Weather Report*," (Climate Storytellers, September 14, 2013, http://www.climatestorytellers.org/stories/subhankar-banerjee-boulder-flooding/), Subankar Banerjee, another artist who'd participated in the exhibit, wrote of the devastating effects of climate change on Colorado, praising *Weather Report's* prescience and lamenting the continuing slow progress by the U.S. government "to take any meaningful action on climate change. Will the death and devastation from this week's flood in Colorado simply pass us by as a mere spectacle?"

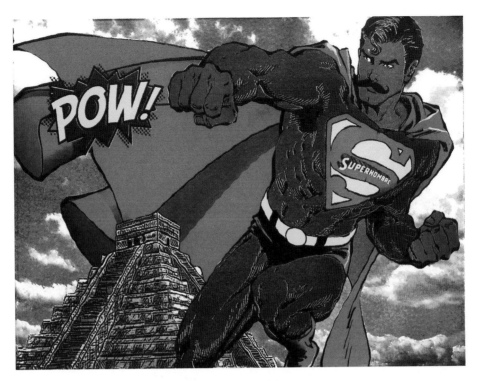

Diversity in Boulder Arts

Thirteen Voices

Editor's Note: *Diversity has long been on the minds of Boulderites, particularly those who belong to frequently overlooked minority groups.* Celebration! A History of the Visual Arts in Boulder *is concerned not only with the past, but with the future. Issues of diversity arise as an essential part of any discussion about who we are and where we are going.*

We compiled a range of questions to elicit a range of views about diversity in various arts disciplines and invited thirty-five people to comment. Thirteen replied. We are very grateful.

Some improvised, others followed the questionnaire, which was intended as a starting point and to stimulate thinking. Some respondents chose to remain anonymous. We have abridged the responses in consideration of space, but we did our best not to tamper with or weaken the contributors' voices.

1. *What is your racial or ethnic background?*
2. *How long have you lived or did you live in Boulder and outlying communities?*
3. *If you have moved away from Boulder, are there reasons specific to diversity or its lack that motivated your move?*
4. *How long have you been an artist here and what particularly prejudicial experiences/ personal challenges have you faced with organizations in Boulder?*
5. *What is it like to live in a place that is dominated by white privilege?*
6. *How difficult has it been to show your work or practice your craft?*
7. *What is your personal experience of diversity in the arts here in Boulder, personally, professionally, and as a spectator?*
8. *As an artist or arts spectator, what do you feel is missing in arts presentations/productions/ exhibitions in Boulder that might better represent diverse points of view and cultures?*

Above: Anthony Ortega, "Super Hombre," 2015, lithograph.

9. *Do you travel to other cities — such as Denver — to experience arts that you may prefer or relate to more than what is offered in Boulder?*
10. *Are there historically propagated racial stereotypes that affect your work — that limit what you feel you can produce or how much you can say and how often you can say it? Do you think that these stereotypes affect how artists — both from minority and dominant cultures — are trained?*
11. *How does your racial, ethnic, and/or gender identity affect how you produce artwork? Can you describe how you believe it is viewed by the masses?*
12. *Do you acknowledge and use your heritage and racial or gender identity in your art? Or do you choose not to highlight your heritage in order to enhance your acceptance? Is there a middle ground?*
13. *Does making art of any type give you agency and empowerment?*
14. *What are your hopes for diversity in Boulder in the future and what ideas might you have to improve this challenging situation?*

We begin with a psychologist, Glenda Russell, who, along with Dr. Andrea Iglesias, is a founding principal in North Star Project, a group that uses implicit attitudes as a guide to undoing bias and creating personal and organizational change.[1]

Glenda Russell: Psychologist

When I consider the presence of various forms of oppression or stigma in Boulder, I am struck by how much of it exists on a subtle and even unintended level. That is not to say that people in marginalized groups do not encounter overt, <u>explicit</u> forms of prejudice and discrimination; they undoubtedly do — and far more frequently than many of us would suspect. But people in marginalized groups here generally encounter more <u>implicit</u> bias — bias that causes people to wonder: *What was that? Did she really say what I think she said? I think he thought that was a compliment, but it wasn't at all a compliment for me!*

Statements, questions, and behaviors that carry implicit bias typically begin with no negative intent on the part of the actor, but they can carry a very negative impact for members of marginalized groups.

Many of us grew up in an era that offered us the misguided ideal of so-called "color-blindness" — pretending not to notice or discuss the differences among us. Who would have guessed that there is no such thing as color-blindness? Who could have imagined that efforts to be and appear color-blind set us up for incorporating and passing on oppressive thoughts and actions? Who would have known that our only way out of these implicit biases is through them — learning about them and challenging them?

Who might have known, then, that we carry within us the power to change the world?

George Rivera: Visual artist, art critic, curator

I am a Chicano/Mexican American professor at the University of Colorado-Boulder and have been at the university since 1971. I teach in the Department of Art & Art History, and I specialize my research/creative work on Art, Race, and Ethnicity in American Society. I am an artist, an art critic, and an international curator.

During my forty-five years in Boulder, I have only been able to curate two Chicano/Mexican American exhibitions in Boulder — at the CU Art Museum and the Dairy Arts Center.

The basic problem is that the Boulder art scene considers art by racial and ethnic minority members to be lacking in quality — the same old argument directed at minority artists that Lucy R. Lippard noted in her 1990 book, *Mixed Blessings*. In essence, the White art bubble in Boulder cannot tolerate difference and diversity, and it therefore abhors what it terms art about "identity politics." Acceptance as an artist in Boulder can only happen if racial and ethnic minority identifiers are eliminated from the artwork. In other words, be like White artists.

Therefore, I do not think that any public funds should be allocated to art museums and galleries in Boulder unless inclusion and respect for diversity is demonstrated. Boulder needs to catch up with the rest of the nation by recognizing that demographics in the United States are changing. It needs a comprehensive plan to serve a neglected minority population that will comprise 51 percent of the United States population by 2050. Apartheid in the Boulder art world is not the answer. The arts future of Boulder mandates more inclusive directions.

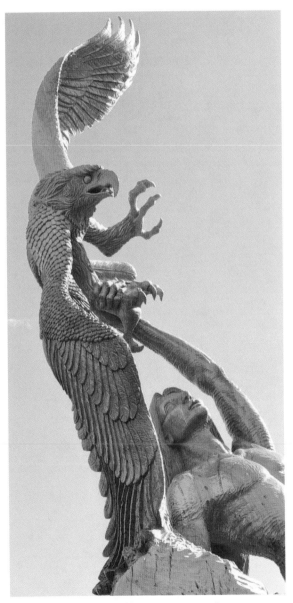

Eddie Running Wolf, "Eagle Catcher," 2010, 2nd and Niwot streets, Niwot.

Gesel Mason: Performer, choreographer

I use dance and performance as a vehicle to shift perspectives and examine the human condition. What do we share or keep secret? How do we live, love, and persevere? What can we learn from each other, despite our differences? Dance is the lens through which I interrogate the self and the world. Whether it's examining the definition of "Black Dance," or illuminating perspectives around female sexual expression, I seek to stimulate dialogue, reveal the invisible, and catalyze transformation, no matter how slight. In my own work and in the work of others, I am drawn to the process of naming, claiming, subverting, and disrupting cultural identities through performance.

Boulder's homogeneous population can make it difficult to find the bodies I need — for my work and in the audience — to achieve my aim to challenge and bridge difference. I often "import" artists for my projects, to reflect a multiplicity of bodies, cultures, and backgrounds, and I seek to perform in more culturally diverse spaces that allow for richer dialogue and interaction.

My African-American heritage and culture is undeniably present. In performance, I am cognizant of the historical, social, and cultural implications on the work, yet it is not all of who I am or what I am interested in exploring. In my collaborations with Tim O'Donnell, a contact improvisation practitioner whose cultural background as a white male stands in stark contrast to my own dance and cultural identity, we have been cultivating a practice that allows our divergent aesthetics and techniques to inform each other and emphasize where our values and interests intersect.

Alan O'Hashi: Filmmaker

(NOTE: Mr. O'Hashi's responses largely follow the questionnaire. Please refer to it above.)
1. Third generation Japanese American.
2. Twenty-five years, *más o menos*.
4. An artist since 2001. No prejudicial experiences as an artist.

5. If you can't beat 'em, join 'em. I've been on the outside looking in and inside looking out. I prefer to be on the inside and be a gatekeeper.

6. Not difficult [to show work or practice craft].

7. Artists in Boulder largely reflect the demographic, mostly white, some others, but that's to be expected.

8. Diverse points of view are looked at as "add-ons," as opposed to integrating diverse points of view into the way things are done. Groups and individuals could stand some cultural competency training.

9. Boulder thinks it's at the center of the universe — including the arts universe, which is light years from the truth. Boulder is a medium-sized town with an art community. It's too small to be really exceptional and big enough to crowd out "hobby" artists.

14. Not really hopeful [for diversity in Boulder's future], beyond the typical reactionary responses. Look at the power structure here [in 2016]: there are a few women involved, but the City Council, County Commissioners are mostly white men. They make political appointments to boards and commissions and tend to pick white people. there are very few people of color who apply for those boards and commissions. There's no way to develop leadership in diverse communities. They seem to better like to rabble rouse from the outside looking in. As I mentioned, I'm more interested in being on the inside looking out and being a good gatekeeper.

Firyal Alshalabi: Writer

As a resident of Boulder since 1975, I have witnessed the little quiet town I so loved grow larger and busier with time. Coming from an Arabic ethnic background, where diversity is commonplace and wide ranged, it was interesting to observe how the community here is dominated by white privilege. Minorities are usually patted on the back and made to feel welcome, but left at a polite distance from the main action.

There is a large Arab community in Boulder, yet throughout the forty years I've lived here there has been very little in the visual arts that represents them. It's either because the majority of them are not in the arts, or because they are overlooked. From personal experience during the last two decades, I have faced many obstacles and was given the cold shoulder when I attempted to exhibit an art show by well-known Arab artists, rendering my efforts fruitless.

My writing, which always deals with my ethnicity and cultural background, has received a similar treatment, not only in Boulder but nationwide. I wonder if I would have better luck if I gave a negative picture of Arabs and Muslims like most published authors do, but I'd rather not find out taking that path!

Carmen Reina-Nelson: Dancer, teacher

I am originally from Guatemala, living in Boulder since 1990. I have also lived for long periods in Canada, Costa Rica, Panamá, and Spain. I am very proud of my heritage and racial identity.

I introduced Boulder to the popular dances of Latin America, in 1990, when there were no other influences of Latin American culture here. My experiences were both rewarding and difficult. Many in the Boulder arts community helped me. Although my dances were not well known, I was well-received in both the Anglo and Latino populations. Indeed, I formed one of the first Latin communities in town. But I was taken advantage of by some well-established dance companies and some dance institutions that quickly realized the dances I taught were a good way to make money or attract the public. I was naïve not to realize I was a token for diversity. Sometimes my name was added to grant proposals without my knowledge. I did not have a point of reference to help me realize I was being taken advantage of. Grants are still given primarily to "White Companies: White Privilege." There were no sources of information for people coming

from a different culture. We never had access to rental space and were unable to present our work in big venues, where well-established companies had a monopoly. I felt too intimidated to ask.

Artists of color are now numerous in Boulder. There has been improvement in the arts, but there is still a tendency here to see popular arts as inferior. Popular festivals — African, Brazilian — popular dances — Hip Hop, the various Latin dances – attract many people, but are not respected as they deserve. Preference is still given to ballet, the Shakespeare Festival, and other Eurocentric "high" art forms. I applaud when there are festivals that honor other cultures.

Our town is rich in sports and self-centered activities like yoga and meditation, which is good, but there are few joyous concerts and public presentations (often free) that I see in other cities. There are too many rules in Boulder.

Alphonse Keasley: Actor

(NOTE: Dr. Keasley's responses largely follow the questionnaire. Please refer to it above.)

1. African American.

3. I have worked in Boulder and Denver [since 1974]. While I do not perform on stage as much anymore, I do work with a production company in Boulder and some readers' theatre/new play productions.

4. I have been fortunate to have performed as often as I have wanted. I have worked with community theatre, then the University Theatre stage, then with Colorado Shakespeare Festival, and ultimately the Denver Center Theatre Company, where I earned my Actors' Equity card to become a professional actor. Very few have had such great fortune.

5. Because I have been teaching [about white privilege] for years, I have developed a repertoire of direct responses to those who are unaware of their privileged behavior. The hardest part is when institutional and cultural domination is at work.

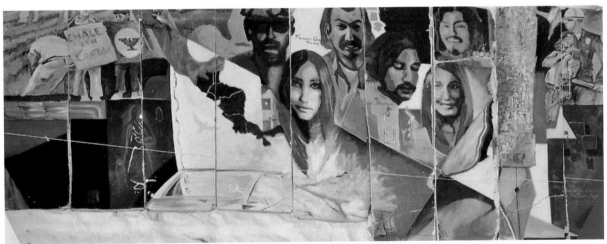

LOS SEIS DE BOULDER

Some visual artists of today's Chicano/Latino community credit the environment of the University of Colorado's student activism in the 1970s for inspiring their crafts. In addition to anti-draft and Viet Nam War protests, there were rallies and riots against deep discrimination toward Mexican Americans at the State Capitol, in high schools, and elsewhere. Denver's most recognized organizing effort was the Crusade for Justice Movement, under the leadership of Corky Gonzales. In Boulder, a new voice was being heard through United Mexican American Students. Of the 247 Latino students attending CU in 1973, those who majored in Fine Arts were among the first contemporary artists in Colorado's Indigenous Chicano/Latino art communities.

In 1974, there were two brutal car bombings that killed six, mostly students – Reyes Martinez, Neva Romero, Una Jaakola, Florencio Granado, and Heriberto Teran. They became known as *Los Seis de* Boulder and their deaths unleashed a torrent of Chicano activism and unrest not seen before in the county. No one was ever indicted for the crimes. The incident profoundly influenced the work of the CU art students, such as Daniel and Maruca Salazar, Mike Garcia, Jerry Jaramillo, and others, further shaping their professional pursuits. After graduation, they left Boulder to find opportunities elsewhere. Those who followed comprise a creative class of color – skin color – are alive and thriving throughout Boulder County, even as they frequently remain overlooked or invisible.

The mural by Pedro Romero pictured above depicts *Los Seis de* Boulder and is housed at Colorado State University-Pueblo.
-– Benita Duran

7. I am working on developing a theatre company in Boulder that features African American playwrights. I would like Boulder to be a destination community for performers of color. This will help initiate a community of actors/performers of color [and thus may improve the challenging situation of diversity in Boulder].

9. I travel to New York, London, and South Africa [where I experience art].

12. As an actor capable of spanning the range of the art, I bring my heritage with me to all that I do, but also work within the world the playwright has created. So, when it is appropriate to bring my heritage to the role, I do not hesitate.

13. Agency and empowerment [from making art], most definitely!

Melanie Yazzie: Visual Artist

As a printmaker, painter, and sculptor, my work draws upon my rich Diné (Navajo) cultural heritage. My work hopes to follow the Diné dictum, "walk in beauty," literally, creating beauty and harmony.

I have worked and lived in Boulder County since 2006. I studied here in graduate school from 1991 to 1993, then pursued work in New Mexico and Arizona, before returning in 2006. I have been exhibited widely in the United States and abroad. I travel around the world to connect with other Indigenous peoples, to dialogue about Indigenous cultural practices, language, song, storytelling, and survival. As an artist, I try to serve as an agent of change by encouraging others to learn about social, cultural, and political phenomena shaping the contemporary lives of Native peoples worldwide. And as part of that change, I strive to create safe, non-toxic methods of printmaking to replace commonly used toxic chemicals.

The Boulder community seems very guarded. Nevertheless, I find that Boulder organizations are making more of an effort nowadays to be inclusive. This is good. I have been finding non-natives who understand what it means to be a friend to our community, who come with cultural gifts that are signs of friendship and understanding.

Yet many who run things in Boulder are part of the powerful, privileged class. People of the Other are rarely hired to be directors of art spaces, staff members, or even asked to serve on boards. When these few spots are given to People of the Other, they are often given no support as representatives of Other communities. It's confusing for them.

I feel there could be more diverse exhibition offerings. Exhibits I've curated have been received very well. This is great! But I often lack funds to make super-amazing projects happen and, frequently, I, personally, have to help with shipping costs for Native American artists who live out of state. I teach summer school so that I can use my earnings to make exhibitions and projects happen.

Melanie Yazzie, "When We Came," 2016, two-panel acrylic painting on wood.

It is hard to have to prove to granting agencies how worthy a project highlighting diversity really is and how it would benefit everyone. I believe there should be an exhibition focused on Native People every year in Boulder, funded by the city! It's needed to show the community that we are important and that we matter. And bringing in nationally known artists is important to help local artists stand out. This is what I have been trying to focus on of late.

The writer Lucy R. Lippard brought diversity to my graduate school, and that helped me excel. She brought visiting artists from various backgrounds who spoke the truth I needed to hear. My work incorporates both personal experiences and events and symbols from Diné culture. But I do not speak for everyone in my community, just for myself.

Yes, it is hard to live in Boulder. My husband and I choose to live outside the city, largely due to the cost of living, but we have also found more diversity elsewhere and are therefore more comfortable.

Donna Mejia: Dancer, teacher

My effort to study my own multi-ethnic Creole heritage (African, First Nation Indigenous, Spanish, Jewish, French, and more) fueled my artistic career as a transnational fusion dance artist. I galvanize a hybrid format of North African, Arabian, West African, American, Mediterranean, and South American dance traditions. Thirty years ago, this willful commingling of cultural material would have been regarded as a violation of sacrosanct territory; a destructive polluting and eroding of traditional forms. I received many lectures in my youth, regarding the importance of preserving and transferring cultural forms to future participants with attentive detail to accuracy in translation.

I still value preservationist efforts, but I am no longer a purist. I am part of a social/art movement engaging in thoughtful remix experiments. I deliberately, unapologetically seek common denominators between various traditions. My movement practices are complemented and inspired by a devoted study of identity formation, migration, dynamics, cultural appropriation and ethics, privilege and hegemonic practices, ethical anthropology, gender coding, and socio-political/economic histories. If these colliding influences can coexist harmoniously within me as a multi-ethnic being, then they can certainly do so in the outer world, too.

I lived in Boulder for twelve years as a young artist, left, and returned in 2012. I have been fortunate to experience tremendous enthusiasm as I traverse the world with my dance performances, lectures, and classes, then return to our community. Yet I observe audience members unsure of how to discuss the work I present, hesitant to ask questions that will reveal their lack of familiarity with international source material. Dance is a gateway to learning another culture, but the next progressive layer of engagement requires a disruption of our unexamined biases, misinformed assumptions, and racist attitudes.

Boulder is a city that celebrates possibilities in diversity, but is communally unsure of how to proceed toward the deeper challenges of dismantling racism. That is because the next step is highly personal, impacted by our individual experience in the world. This dynamic is further complicated each year by the mass infusion of new transplants to our university community. Perhaps starting over each fall creates a type of collective fatigue that renders us less willing to problem-solve with vigor.

Let us not give up on ourselves. Let us learn not just to tolerate difference in our community, but to coexist joyfully and adventurously. Let us not treat our common humanity as a disposable condition of economic, social, gender, or geographic circumstance. Let us find ways to

truly reach and know each other as participants in a universe of wildly manifold reflections. I know I am not alone in trying. If you're looking for a dance partner in that process of discovery, please count me in.

Daniel Escalante: Folk Artist

I have been, among other things, a Chicano Folk Artist who lived in Boulder County from 1971 until about 2011. In 1979, my family and I moved to Taos, New Mexico, temporarily, where I learned from Taos artists how to make decorated folk art furniture in a Northern New Mexican style. I moved to Nederland during the early '80s, where I created decorated folk art furniture for about ten years. My work was represented by the Boulder-based Maclaren Markowitz Gallery and six others throughout the Southwest. Creating decorated furniture was my source of income, but it was also a very personal exploration and expression of my own identity as well as an incredible opportunity to learn about cultures other than my own. I discovered that folk art is a global language.

In addition to creating art, I co-founded the Nederland Arts and Humanities Board, served as a member of the Boulder County Scientific and Cultural Facilities District Advisory Board, was a member of the founding board of the Dairy Arts Center, and was employed by the renowned Colorado Dance Festival to support its sincere efforts to be more inclusive.

All these experiences provided me with a unique perspective of the art world in Boulder County and convinced me that while inclusiveness was possible, it was not valued and practiced widely. During the '70s, '80s and '90s, most arts and community organizations in the area did not actively seek to include ethnic representation on their boards, staff, and volunteers. While people of color were sometimes recruited, they usually resigned after a relatively short period. People would often throw up their hands and say, "We tried, but 'they' weren't interested or committed enough." The dominant culture almost always expected people of color to adjust to the organization's standard way of operating, not

David Garcia Ocelotl, "Struggle of Tonanzin Colorado," 2014, The Dairy Arts Center, gift of the Americas Latino EcoFestival.
Photo: Collin Heng-Patton.

"Unity Project," 1998, by Mario Miguel Echevarria and Susan Dailey, in Longmont, a neighborhood-based artwork, using the faces, hands and ieas of the Kensington Park neighbors to make a statement in concrete that memorializes past events of that took place in the community.

acknowledging how Eurocentric that standard was. They seemed unwilling to meet people of color halfway. And to top it off, members of the dominant culture often felt betrayed because people of color didn't appreciate their recruitment efforts. To me this is a classic example of entitlement and abuse of white privilege.

There were racial stereotypes that affected many Chicano artists and other artists of color. For example, the buying public seemed most interested in "Colorful Mexican" expression, rather than what artists may have wanted to express. Consequently, if you wanted to make a living as an artist, you had to consider what the public expected of you, even if it was based on stereotypes. This seriously impeded authentic creative expression and did not contribute to the breaking down of stereotypes in the art world. It seemed to me that white artists didn't have to deal with this problem.

Fortunately, my only training as an artist was working with folk artists in Taos, who didn't much care what the public wanted to buy. They were carrying on generations-old traditions that were largely based on religious icons, and what functional piece was needed in the church or home. Consequently, folk

artists considered function and form before "marketability." For example, a classic *taramita* (three-legged stool) was beautiful to behold and a wonder of simple construction, but it was, first and foremost, functional. So what I did not expect when I started was that some buyers would find that the furniture contributed to their personal healing processes, or that it made an unexpected connection to their own ancestry. My furniture evolved into a hybrid of traditional and contemporary art. Fortunately, I found several galleries that understood what I was doing and wanted to represent my work.

Maclaren Markowitz Gallery appreciated my sense of identity as a Chicano and the work I was doing. They shared their white privilege and position of power in the arts community by exhibiting such artists as Tony Ortega, Lydia Garcia, Amado Peña, myself, and many others. They even helped me raise scholarship funds for young artists of color who wanted to pursue careers in the arts. The gallery was the exception in Boulder, not the rule.

After many battles around diversity and inclusiveness I moved to Taos, because I wanted to live in a smaller, rural community, where expression of cultural identity was more understood and valued.

Norma Johnson: Poet

Living in Boulder County, my eyes are always on signs of diversity. Of course, there are all kinds of diversity, from gender, age, and ability, to race, ethnicity, religion, and more. As a black middle-aged woman, I particularly notice color …and the lack of it.

Well, of course there is "white." Plenty of it. But a lot of folks don't consider that it's a color or a race, it's considered normal. Consequently, being non-white is an abnormality. Those perspectives have definitely influenced my life here.

My spoken-word poetry about race specifically evolved from my racial experiences in Boulder. While white people seem to look at my experiences as racial "incidents," what I began to express in my writing was that rather than "incidents," race is a *way of life*. It has more to do with how we personally experience the influences, stories, history, and attitudes of our dominant white culture. And that is so for all of us. ALL of us are in the story of race.

Attitudes of whiteness and dominance were affronts in most arenas of my life here, from walking in my neighborhood to the various venues, businesses, organizations, and institutions I associate with. I directed a black youth group and witnessed, firsthand, the effects of racism on our youth in Boulder.

Most of my dear, loving white friends and associates could not seem to comprehend that my life was an almost daily navigation of race. The preference or perhaps default of choice was to somehow imagine that their white lives reflected what they wanted to see as my life. But it just didn't work that way.

So, after yet another racial "incident" and innocent denial by my white friends that this doesn't happen in Boulder, there came a day when I surely thought I was going to lose it … my mind that is. It took everything I had not to blow up all that accumulated ugly at my white friends and any other white folks who happened to be in my vicinity.

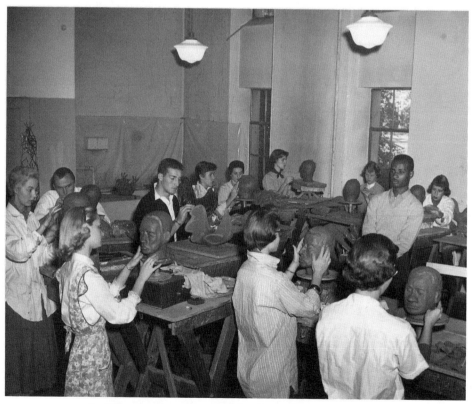

An African American man models in a CU art class. Date unknown.
Courtesy of University of Colorado-Boulder, Archives, Photolab Collection.

That's when I knew something had to give or I would personally be on a self-destructive track. How do you explain to white people an experience of race?

That night I prayed long and hard. You know that kind of prayer you put your all into? When it feels like your life is on the line and you've come to the end of a very short rope and there's nothing left to pull yourself up with? I don't know if I was desperate, but I was so very exhausted and weary. I carry the burden of race, while my white friends just get to be "white."

I felt exhausted deep in my bones. It was a generational deep, a historical deep, a cultural deep. I called on the ancestors to help me understand what to do to remain living among so many who remain sleepwalking in their dream and my nightmare of race. I fell into a weighted sleep, lulled with weariness and a faint anticipation of unpromised hope.

In the middle of that night, I awoke fully. A surge of electrifying movement was traversing through my body. I HAD TO WRITE! That is all I knew. I had to write!

I found my way to my computer, opened a new document and wrote and wrote until the words came to their end. It was my first poem about race, "A Poem for My White Friends: I Didn't Tell You." In it, I shared the experiences of everyday racism, some of which can be understood under the term now known as "micro-aggressions." It refers to the kind of racial cultural norms inflicted on people of color on a daily basis, likening it to enduring continual and accumulative paper cuts throughout your day and your life. They are not dominant enough to bring attention, but you're bleeding just the same.

That one poem began a deeper level of addressing race, for both myself and my friends. Eventually, as I allowed it to go more public, it became a tool shared throughout the country and used by diversity educators to help address the dynamics of race in our culture.

I've since gone on to create a video and CD collection of *Poems for My White Friends*.

Being able to address race through my art has truly been a godsend. I don't think I could have expressed this kind of depth and personal experience any other way. And I've been able to collaborate with other performance artists. Poetry became my own personal healing tool and an offering of healing and opportunity for others.

Fact is, we've all been living in race. So what does that look like in your own life? In your relationships? In the history and current face of family and community? What do you know about the history and presence of whiteness and race?

Our passion elevates the best of our humanness and reveals our connection to the divine. Let the juices flow through you to reveal, articulate, envision, empower something of meaning regarding race in your life, in your family, in your organization, in your business, in your school, in your faith community. Following our passion is an act of freedom that inspires others toward their freedom too.

What I learned through my poems is that I have no idea what I can influence but words and acts articulated through the heart speak to other hearts. Eventually, we have a room full of speaking hearts, a community of speaking hearts, a nation of speaking hearts. That's when we see each other in a different light, a bigger and more profuse light that includes all of us in its radiance.

Nikhil Mankekar: Musician and City of Boulder Human Rights Commissioner

I am an artist, musician, and Boulder native, the first Indian and Sikh American to serve on any City of Boulder board or commission.

Artists and arts organizations from underrepresented communities are essential to a rich, culturally diverse and thriving Boulder arts community. Artists from underrepresented communities can address their own unique experiences in a way that only they can, being

more honest about realities and potentially resulting in the breakdown of stereotypes long propagated by the mainstream. Their unique culture and point of view can result in entirely different expressions of creativity from the majority population. Isn't that what the creative arts are all about?

However, institutional bias and systems of privilege in Boulder can result in lack of access to, education in, and support for the artistic and the creative pursuits of people from underrepresented communities. This lack of culturally relevant arts education and support for these emerging minority artists makes Boulder have a far less rich and vibrant creative arts community overall. It can also cause cultural appropriation by the majority population. These issues, combined with Boulder's growing income inequality and lack of affordable housing, studio, and office space, have resulted in artists and arts organizations being pushed out of Boulder and into Denver and surrounding cities. They also disproportionately impact underrepresented and minority communities and have a detrimental effect on our creative arts community as a whole. For instance, the closing of most small to mid-sized music venues in Boulder, over the past decade, has resulted in young bands and musical acts not having anywhere to develop and grow.[2] Their only option to be in supportive, creative communities is to move to surrounding cities, such as Denver. African, Asian, South Asian-Indian, and Latino dance and music groups have also moved their education and performance spaces to Denver, due to lack of affordability and community support in Boulder.

Cultural equity is a necessity for the long-term sustainability and resilience of our Boulder arts community.

❖ ❖ ❖

Notes

1 In 2014, the Community Foundation of Boulder County established The BRAVO Fund, to improve the quality of life for Latino communities throughout Boulder County and to cultivate philanthropy within the Latino community and others for that purpose. Among the many institutions, activist and educational, that the Foundation is committed to serving are arts organizations, such as the Longmont Museum & Cultural Center and Motus Theater-Community Conversations on Immigration.

2 Boulder was once a hotbed of music. The 2001 film, *Sweet Lunacy: A Brief History of Rock in Boulder*, by Leland Rucker and Don Chapman, produced by Boulder City Channel 8 and funded by the Boulder Arts Commission, describes a time when Boulder nurtured musicians from a variety of ethnic and racial backgrounds, such as the Freddi-Henchi Band, Earth, Wind, and Fire, and renowned blues musician, Otis Taylor, who still lives here.

Ava Hamilton and Gabriele Dech, still from *Everything has a Spirit*, 1992, VHS.

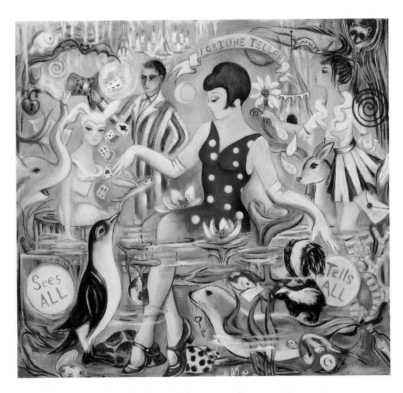

Longmont's Rich Visual Arts History

Lisa Truesdale

Once sleepy Longmont has definitely awakened in the past few decades, especially where the arts are concerned. Everywhere you look, there's a gallery, a statue, an interactive art piece, a colorful mural, or an arts-related event.

It hasn't always been this way; Longmont's founders in 1870 were all about agriculture. But as the population swelled in the 1960s (thanks, IBM) and again in the '90s (hello, technology boom), the city grew and changed, gradually adding more and more cultural opportunities for both artists and patrons of the arts. Today, the thriving city of more than 90,000 is home to many celebrated cultural arts programs and attractions that draw visitors from all over the state and beyond.

1936: Longmont Museum & Cultural Center

Although the Longmont Museum was established in 1936, the first exhibits — mostly about, you guessed it, agricultural history —

weren't ready for public viewing until four years later. The museum's first location was inside the carriage house at the historic 1892 Callahan House at Third and Terry streets, and it moved around to a number of different locations over the next thirty years. In 1970, the museum switched from private status to a division of the city's government. After several years in two locations on Kimbark Street, the museum finally found a permanent home, opening in 2002 in a sleek, brand-new facility in south Longmont at 400 Quail Road. The new museum, funded by a $5 million bond issue and a $1 million gift from the Bill and Lila Stewart family, was further expanded in 2015, thanks to a capital campaign and more funding from the Stewarts. The 11,000-square-foot addition includes a new two-hundred-and-fifty-seat Stewart Auditorium, the glass-walled Swan Atrium, and the Kaiser Permanente Education Center.

Above: Zoa Ace, *"Fortune Teller,"* 2016, oil on canvas.

The Longmont Museum hosts permanent and changing interactive exhibits focusing on agriculture, history, science, and art; educational programs; arts classes and summer camps for children; a film series; a variety of performances; and a huge, month-long Day of the Dead celebration that attracts visitors from all over the country.

Longmont is also home to two other museums, both maintained by Boulder County: the Agricultural Heritage Center, an early-1900s farmstead that focuses on Longmont's agricultural history from about 1900 to 1925, and the Dougherty Museum, a vast collection of vintage automobiles and antique farm equipment.

1985: Longmont Council for the Arts/Arts Longmont

Longmont Council for the Arts was founded in 1985 as a community resource for local artists and cultural arts organizations, providing marketing, education, fundraising, grant-

Two young people dressed in Indigenous costumes with their faces painted as *calaveras* (skulls) for Día de Los Muertos, a traditional Mexican festival, celebrated annually at the Longmont Museum.

writing, and administrative support. LCA was instrumental in getting Longmont's popular thrice-yearly ArtWalk off the ground and helped develop the non-profit Firehouse Art Center. LCA later opened its own gallery, the Muse Gallery, on Main Street. In 2015, LCA changed its name to Arts Longmont, also renaming the Muse Gallery as Arts Longmont Gallery. Arts Longmont oversees the gallery, which has dozens of resident artists, and sponsors a variety of popular community programs including Arts & Ales at Left Hand Brewing, the Longmont Studio Tour, and Friday Afternoon Concerts & Art Shows.

1987: Firehouse Art Center

In 1987, the LCA and the Arts Studio, Inc., joined forces to renovate Longmont's historic 1907 firehouse on 4th Avenue into a non-profit art center, with space for exhibitions, classes, and events. It was known as the Old Firehouse

Alvin Gregorio, "A place for your things," 2012, acrylic on wood.

Art Center until 2013, when the gallery dropped "old" from its name to better reflect the contemporary nature of its exhibitions. The Firehouse, also called FAC, hosts changing exhibits, resident artists, Poetry Nights, First Friday film showings, a Catrina Ball and other events to celebrate Day of the Dead, and a number of special events all year long. For the past two years, the Firehouse and Arts Longmont have also collaborated on FRESH, a project that brings together local artists, farms, and chefs to create exhibitions and programs that celebrate "the culture of agriculture in Longmont."

1987: Art in Public Places

AIPP, established in 1987, is a city-affiliated department funded by a 1 percent levy on most capital-improvement projects of more than $50,000. AIPP's extensive public-art collection includes more than fifty permanent pieces of art around Longmont, including two large gateway projects that welcome visitors, plus special projects like Shock Art (painted electrical boxes) and Art on the Move (rotating works that get switched out each summer). A good portion of AIPP's yearly budget also goes toward maintaining the existing pieces in the collection to ensure that they last for years to come. Upcoming AIPP projects include artwork atop the pedestals on the new bridge along Main Street, and "Rejuvenation," a large-scale piece to commemorate the city's resiliency following the devastating 2013 flood. The permanent works in AIPP's collection are included on the city's colorful bike map.

2014: Certified Creative District

In 2014, Downtown Longmont was awarded formal designation as a Certified Creative District, one of only twelve in the state of Colorado at the time. The purpose of such districts, as administered by Colorado Creative Industries, is "to enhance cultural and economic vitality and serve as a focal point of community identity." Downtown Longmont

boasts more than forty arts and entertainment destinations, and more than a dozen of those are thriving galleries.

From galleries and museums, to regular art-related events like Second Fridays and ArtWalk, to public art pieces just about everywhere you look, Longmont truly has something for everyone when it comes to visual arts. And although Longmont's history doesn't extend quite as far back as Boulder's, Longmont's residents are proud of their visual arts.

They have every reason to be.

Bunky Echo-Hawk, *"When a Woman Loves a Man,"* 2012, oil on canvas. Private collection.

Wanda Matthews (1930-2001), "Mountaintown 4 Alpenglow," 1983, intaglio print.
Collection of the First Congregational Church. of Boulder.

Portraits of Boulder Artists
by Boulder Artists

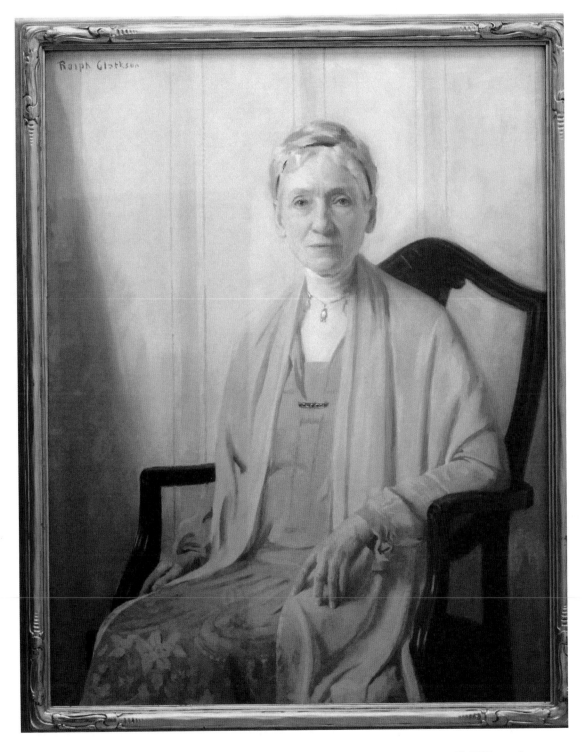

Ralph Clarkson, American (1861 - 1942) "Jean Sherwood" n.d. Oil paint on canvas 40"x30" framed.
Boulder Historical Society, 2012.002.009 © Boulder History Museum/Museum of Boulder

Left to right, top row:
"Portrait of Sue Robinson," Margaretta Gilboy, 1976; "Madame E," Claire Evans (self-portrait), 2003; "The Photographer," Barbara Shark (George Woodman), 1997.
Left to right, middle row:
"Kenny: Free Form DJ," Helen Barchilon Redman, (Kenny Weissberg), 1973; "Bearing: Pregnant Self Portrait," Helen Barchilon Redman, 1964; "Paul: Homage to Morocco," Helen Barchilon Redman (Paul Barchilon), 1992.
Left to right bottom row:
"On the Ferry," Barbara Shark (Jim Logan, Sherry Wiggins, Bud Shark), 2006; "Polly Addison," Margaretta Gilboy, 1999.

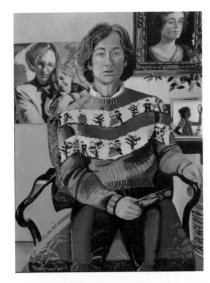

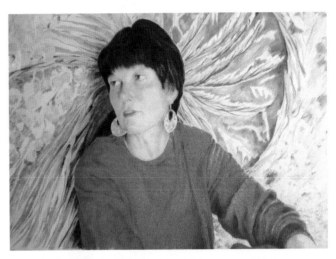
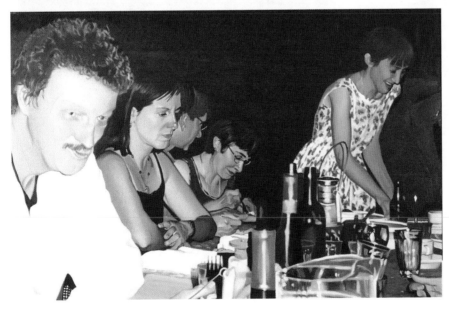

Left to right, top row:
"Balancing Act," Linda Lowry (self-portrait), 1995; "Self Portrait with Fire," Virginia Johnson, 1992-93; "Caroline Starns Douglas," Bonney Miller Forbes, 1979.
Left to right, middle row:
"Pink Hat," Barbara Shark (Betty Woodman), 1997; "Sally," Fran Metzger (Sally Elliott), 1990.
Left to right, bottom row:
"Dessert on Blue Mountain Road II," Barbara Shark (Jack Collom, Ana María Hernando, Jim Logan, Margaretta Gilboy, Roseanne Colachis) 2002; "Paint Brush Halo – Patricia Bramsen," Susan Albers, 2000.

Artists at the Abbey

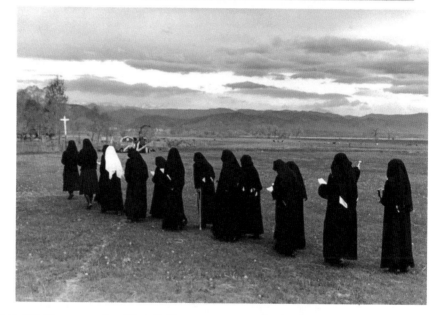

In 1935, three sisters from a small Roman Catholic community of Benedictine nuns were sent from Eichstätt, Germany, to a then-remote farm on South Boulder Road. It became the Abbey of St. Walburga.

In the 1980s, two notable Boulder artists, photographer Valari Jack and painter Esta Clevenger, were inspired to make highly personal and contrasting art, documenting the daily lives of these women religious.

In 1992, the Abbey moved to Virginia Dale, north of Fort Collins. The original church, Sacred Heart of Mary, remains, as does a cemetery where the first nuns to arrive here are buried.

Esta Clevenger, who worked as a farm hand at the Abbey, died in 2003. A profile of her life is featured on page 67.

Valari Jack moved from Boulder to England then to Bellingham, Washington, but returns to Colorado periodically to visit with the Sisters of St. Walburga.

❖ ❖ ❖

Photographs by Valari Jack, "Milking," "Skateboard," "Sunrise Processional," 1988, silver gelatin prints. Collection of the City of Boulder.
Painting top row right: Esta Clevenger, Untitled, 1989, acrylic on canvas. Collection of Jim and Meg Lorio.
Painting middle row left: Esta Clevenger, untitled, 1993, acrylic. Collection of Jim and Meg Lorio.
Painting bottom row left: Esta Clevenger, Untitled, n.d., acrylic on canvas. Collection of Felicia Furman.

The CU Art Museum
Its Distinguished Past and New Horizons

Jade Gutierrez

Boasting more than 8,000 square feet of gallery display space, 3,500 square feet of storage, and over 8,500 art works from around the globe spanning 10,000 years of history, the University of Colorado Art Museum is, in many ways, the beating heart of Boulder's arts community. But it was not always what it is today. Its beginnings, six-plus decades ago, illustrate dedication and a long-term commitment to the arts and the outstanding devotion of individuals who strove to create the facility and collection that exists today.[1]

The collection began in 1939 as a teaching tool for university students. The Carnegie Fund[2] provided the Department of Art and Art History with the means to purchase and accession works of art. Long before the museum was created, a vast collection of historic and contemporary works of art were already being accumulated by the department. Some of these early accessions include an incredible collection of 18th-century Italian and French drawings and etchings. Even after the galleries and museum were established, the Carnegie Fund continued to support purchasing important art work for the galleries, ranging from Francisco de Goya to Don Ed Hardy. This outstanding collection became the foundation

for the University of Colorado Art Galleries and later the CU Art Museum.

While this collection was being slowly amassed over the 20th century and stored in the attics of the Sibell Wolle Fine Arts Building, the University of Colorado Art Galleries hired its first director and curator of the collection in 1975. Jeanie Weiffenbach brought vision and cutting-edge art to the galleries with exhibitions by up-and-coming artists such as Theodora Skipitares, Eric Fischl, and Martha Rosler. Across the next ten years, Weiffenbach brought serious recognition to the galleries and increased the exhibition budget by 700 percent to $40,000.[3] She also connected with collectors Polly and Mark Addison, now among the galleries' biggest supporters. In 1991, the Addisons gave approximately one hundred prints to the galleries, including works by Roy Lichtenstein, Robert Longo, Fritz Scholder, John Buck, H.C. Westermann, Robert Rauschenberg, and Chuck Close, thus establishing the Polly and Mark Addison Collection, comprising some of the most significant works in CU's permanent collection.

The University of Colorado Art Galleries was emerging as a destination and institution, yet the huge collection of historic artwork

Above: Garrison Roots, "I'm Not a Racist," 2001, painting on paper with decals. Courtesy of Veronica Munive.

Art exhibition at the Henderson Art Gallery, 1960s, University of Colorado-Boulder, Archives Photolab Collection.

that had been growing since the 1940s was gradually degrading in the building's hot, dry attics. Much of the art was curling, flaking, and yellowing. There was no other storage space nor was there climate control, and there was no funding to conserve it. Around 1985, Weiffenbach showed Jennifer Heath, an editor at the *Colorado Daily*, the disintegration of the collection, which varied from prints by 18th-century English artist William Hogarth to life-size cutouts by outsider artist Howard Finster. Heath and reporter M.S. Mason further investigated and wrote an exposé of this sad situation, which caught the attention

of Elizabeth D. Gee, wife of then-CU President, Gordon Gee. An art lover and collector, Gee took it upon herself to save the collection. She greeted the challenge with urgency and devotion, raising sizable funds to begin the project. Weiffenbach was able to hire conservators to begin repairing the neglected collection and to build climate-controlled storage.

It took some years before the collection was in a condition to be exhibited. Susan Krane became CU Art Galleries director in 1996, and at last could curate the first proud exhibitions of the permanent collection, including a show

Sibell Wolle Building, date unknown, University of Colorado-Boulder Archives, Photolab.

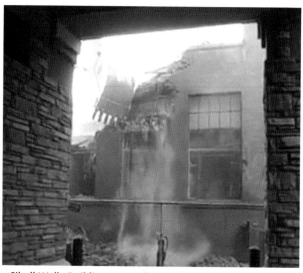

Sibell Wolle Building meets the wrecking ball, J. Gluckstern, untitled film footage, screen shot, 2008, sd videoframe.

Deborah Haynes, "Cantos for (This) Place," from a series of 36, 2006-2009, mixed media.

of Vietnamese dragon ceramics and Edo-period Japanese prints (1603-1868). During Krane's five years at CU, she was able to increase the galleries' budget to $400,000, and instituted an active program of cross-disciplinary public educational events and of special exhibitions, most organized in-house. One of the shows she curated in 2000, *Out of Order: Mapping Social Space* — which included artists Andreas Gursky, Guillermo Kuitca, and Mark Lombardi — toured nationally. Krane brought a new level of professionalism to the galleries, presenting traveling exhibits from across the country including the solo exhibition, *Lesley Dill: A Ten Year Survey,* in 2001. For this show, Krane worked with students from the art and dance departments to create collaborative performances with Dill, a practice that reflects

the ever-present goal of interdisciplinary collaboration across the university campus.

But the Sibell Wolle Fine Arts Building was in bad shape, unsuitable for housing or displaying art. Something needed to change. Krane began floating the idea for a new building. In collaboration with Mark Addison, Alan Rudy, then-Art Department Chair Deborah Haynes, and many other campus and community members, Krane played a major role in the development of the conceptual design, planning, and capital campaign for a new Visual Arts Complex. When she left the museum in 2001, the project was established and on its way toward becoming a reality.[4] In 2002, Lisa Tamaris Becker took over as the director of the galleries. One of her first initiatives was to change the name of

Teresa Booth Brown, "Jacket, Bag, Dress, Watch, Ring," 2014, color lithograph/digital/collage, edition 25. Courtesy of Shark's Ink.

the galleries to the CU Art Museum, thus shifting the galleries' public image to that of a collecting and permanent institution. It had, after all, always been a collecting institution with educational and community connecting goals at its heart, but these goals could not be fully realized without the necessary facilities to nurture the collection and provide access to it. Becker made every effort to realize Krane's original vision of a state-of-the-arts facility. During her decade as director, Becker was able to increase grants, philanthropic contributions, and bequests by $3.2 million. She worked with campus and state leaders to break ground for a new Visual Arts Complex that would include today's CU Art Museum facility.

However, building a new museum was fourteenth on the list of campus construction priorities, so there was no telling when ground would actually be broken. As luck would have it, a health-and-safety inspection of the Sibell Wolle Fine Arts Building led the CU Student Government to advocate for the Visual Arts Complex to be moved to the top of the list. Construction began in 2007, the year before one of the worst economic recessions the United States had ever experienced, forcing many other sites that needed rebuilding to be put on hold indefinitely.

The new facility needed to become a vital player in creating a university culture where art, creativity, intercultural understanding, and

research advance all disciplines in contribution to the community.⁵ Stephen Martonis, exhibitions manager at the CU Art Museum, was part of the team developing the plan for the new facility. He spent a significant amount of time researching other university museums, ultimately modeling the CU design after the Tang Teaching Museum and Art Galleries at Skidmore College in Saratoga Springs, New York. As at Tang, CU's staff want teaching to be incorporated into the fabric of the museum, a practice becoming increasingly common in U.S. museums. One goal for the CU Art Museum was a center where professors could book classrooms to study objects with their students and where independent researchers were welcomed and encouraged.

Functionality of space was also key. The Sibell Wolle building had one multi-purpose room. The new building has both fabrication and framing rooms so that all exhibitions can be shaped in-house, reducing costs and emphasizing the permanent collection. The storage space was also designed to both house the already comprehensive collection and to allow room for future growth.

State-of-the-art security and climate control systems allow the museum to borrow world-class traveling shows, such as the 2016 *Shakespeare's First Folio* exhibition of original manuscripts, for which museums in Colorado had to compete.

So what does the future hold for the CU Art Museum? Current director Sandra Firmin has big plans. She describes the history of collecting and teaching at the museum as its core, defining values. Only a few years into her job, Firmin began expanding on these values, seeking new ways to diversify the staff, goals, and strategies for city and university involvement. An exciting initiative, which started with Becker, has been to acquire the so-called "Sharkive," seven hundred limited-edition prints encompassing forty years of printmaking collaborations between internationally renowned artists and Shark's Ink of Lyons, Colorado, including prints made with many Boulder artists such as Teresa Booth Brown, Luis Eades, Evan Colbert, Ana María Hernando, and Barbara Takenaga, as well with international art stars such as Robert Kushner, Yvonne

Evan Colbert, "Eye Candy," 2011, color lithograph, edition 20. Courtesy of Shark's Ink.

Jacquette, William T. Wiley, Mildred Howard, and Betty Woodman (whose career began in Boulder). The Bebe & Crosby Kemper Foundation has committed a generous sum toward the acquisition and is spearheading the effort to add the Sharkive to the CU Art Museum's already prestigious collection.

There are few university art museums like CU's that boast the sort of comprehensive collection that includes everything from contemporary video and sound art to Roman coins and glass. The CU Art Museum with its diverse collection, devoted staff, and state-of-the-arts building, make it one of the top university museums in the nation.[6] It is a gem in the heart of the Boulder community, a university museum that, during its long history, has enriched all of campus and all of Boulder.

❖ ❖ ❖

Notes

1 The author wishes to thank Stephen Martonis, Susan Krane, Jennifer Heath, Mark Addison, Sandra Firmin, Bud and Barbara Shark, and Pedro Caceres.

2 The Carnegie Corporation of New York was established by industrialist Andrew Carnegie in 1911 "to promote the advancement and diffusion of knowledge and understanding." The Carnegie Corporation has helped to establish and endow a variety of institutions, including Carnegie libraries that were built in towns throughout the United States, which otherwise might not have had access. Boulder's Carnegie was its original library, built in 1906 with $15,000 donated by Carnegie with the agreement from the city that $1,500 would be set aside each year to maintain the building and the collection. Boulderites liked to refer to their town as the "Athens of the West," therefore architect Thomas McLaren patterned the building on Pine Street after a small Greek temple that had been unearthed in 1905 near Athens. https://boulderlibrary.org/services/local-history/carnegie-our-history/

3 Dubin, Zan. "Jeanie Weiffenbach Brings Vision and Cutting-Edge Taste to UCI's Art Gallery - Latimes." *Los Angeles Times*. March 16, 1999.

4 "CU Art Galleries Director Accepts Position In Arizona." *News Center*, June 27, 2001. http://www.colorado.edu/news/releases/2001/06/27/cu-art-galleries-director-accepts-position-arizona.

5 This is the mission statement of the CU Art Museum currently on view at the CU Art Museum website. http://www.colorado.edu/cuartmuseum/

6 CollegeRank.net. "College Rank Names The 50 Best College Art Museums." Accessed August 7, 2016. http://www.prnewswire.com/news-releases/college-rank-names-the-50-best-college-art-museums-300238713.html.

Mark Amerika, *Filmtext 2.0*, looped network art. In 2000, another digital piece by Amerika was selected for exhibition in the Whitney Biennal of American Art.

From a Tumultuous Past Toward an Exhilarating Future
Boulder Museum of Contemporary Art

Collin Heng-Patton

In 1972, the Boulder Art Center opened in a Victorian house on Pine Street, determined to enlarge the scope of the city's art scene. It was time. Movements to revitalize the downtown Boulder area were beginning to take hold, large corporations like IBM and Ball Aerospace had moved into town, and the population was exploding. The 1968 Pearl Street Happening, initiated by architect Carl A. Worthington, brought thousands into the heart of the city for one of Boulder's first open-air public art exhibitions, produced by Fine Arts Department graduate students up The Hill at the University of Colorado. Reactions to the event proved that Boulder was still divided about what some perceived to be hippie displays and gatherings. Public support for the arts, especially contemporary art rife with experimentation, was relatively weak among most of the community.

There was, however, an enclave of artists and bohemians working to take Boulder in a new direction.

The Boulder Art Association was founded in 1923, and, in 1926, the Boulder Artists Guild was born. Their aim was to support artists and they flourished. The guild imported traveling exhibitions, as well as offering community art classes. In 1937, the guild was forced to disband but began working informally as the Creative Interest Group during World War II. In 1968, the Boulder Artists Guild reorganized into the Boulder Art Association, planting the seeds of what would soon become the Boulder Art Center, which took up residence at 1305 Pine Street, fashioning a kind of arts collective, exhibiting the works of students and gallery organizers, as well as local and regional artists.[1]

Above: Dan Boord and Luis Valdovino, *Tree of Forgetting*, 2009, HD video.

The mandates of both the original Boulder Artists Guild and the newly formed Boulder Art Center were to introduce the community to the benefits of art, but the BAC went a step further by attempting to expand the definition of what that art could represent. The old house on Pine Street was a refuge for artists who wanted to experiment, who wanted to exhibit large, abstract works. This diverged from the painterly landscapes, portraits, and still lifes favored by many artists in the region. As the collective became a more cohesive whole, the Pine Street location began to feel much smaller. It was time to find a new, more serious, space. In 1976, the BAC opened its doors at 1750 13th Street, in the old City Storage and Transfer Building, where decade by decade it has grown to be a centering force in the Boulder visual arts community.

The BAC opened its new doors intending to showcase the performing and exhibiting arts in every medium, as well as offer classes, workshops, and special events. Due in part to a generous lease from the city for $1 a year, the center was able to hit the ground running. At the time, the Boulder art market was saturated with plenty of for-profit galleries, but the BAC was one of the first non-profit exhibition halls. All proceeds from sales went directly to the artists. And two years after it opened its doors on 13th Street, in 1978, the BAC was able to hire its first paid director, Karen Hodge (later Karen Ripley Dugan).

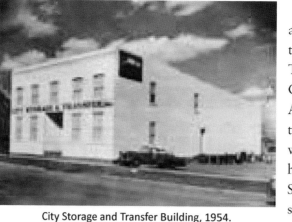

City Storage and Transfer Building, 1954.
Courtesy of the Carnegie Branch Library for Local History.

One of Hodge's first acts as director was to re-name the BAC. The change to Boulder Center for the Visual Arts was symbolic of the transformation Hodge would institute during her time as director. She had a vision for the space that would make the museum a Boulder landmark for years to come. The purpose of the BCVA, she told the *Daily Camera* in 1981, "will be to demystify art for the average viewer, to make art community-accessible and to debunk the myth that art is a privilege expressly for the elite."

BCVA assistant director Janis Stahlhut went on: "I see people interested in art other than Western. They're more contemporary and daring, they are beginning to move away from the classical trends people feel so safe with. There's a mystique about artists that they're not human, but they are. They buy gas for their cars and most of them have both ears, too."

The BCVA would be a space for artists who dared question what it meant to make art. Hodge and Stahlhut worked tirelessly to expand it into a place where anyone, even those intimidated by the arts, could come and dip their toes into something new and exciting. Their effort to humanize the act of exhibiting artists appeared to be working: by the end of 1981, there had been 30,000 visitors.

Even as the art center's popularity was steadily growing, financial support for the institution was increasingly difficult to find. After five years of operation, the

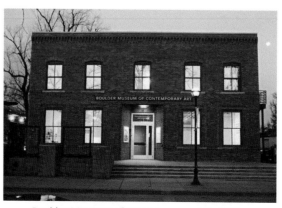

Boulder Museum of Contemporary Art, 2014.
Courtesy of BMoCA.

Rebecca DiDomenico, "Whirl" (detail), 2002, fabric, thread, metal mesh, glass.

budget had swelled from $12,000 to $70,000 in private donations, memberships, and grants from the City of Boulder as well as the National Endowment for the Arts.[2] Growth was excellent, but as the BCVA became more organized and relied more and more on city money, they diverged from the direction under which it was originally founded. They took fewer risks, with exhibits that revolved around quilting and local folk art rather than exploratory artists. While that appealed to many citizens, it became increasingly difficult to pinpoint exactly what the art center was trying to achieve, and that confusion ultimately attracted less funding.

To their credit, Hodge and Stahlhut were up against a wall, trying firmly to establish an art center in a community that by 1985 had voted down three measures which would have funded and helped to renovate potential cultural spaces throughout the city. It didn't help that the overall mood toward new, cutting-edge art in Colorado at the time was characterized by something of an aesthetic war between strongly conservative and determinedly innovative interests. Artist and Art History Professor at Colorado State University, Bill Amundson, claimed that, at the time, "there were three types of art popular in Colorado: Western art of the Remington and Russell variety, Santa Fe emanations, and soft, carpet-matching, sofa-sized abstractions."

Hodge and her associates faced an uphill battle against a community

Sherry Hart, "Once in a Blue Moon," 1986, beads and horn.

that seemed, for the most part, indifferent to placing Boulder in a national conversation about the future of the arts. Their ability not only to maintain the art center, but also to keep producing interesting exhibitions, despite an unstable budget, is a testament to their unwavering courage and perseverance. After years of fluctuating stability, in 1985, the BCVA aimed to place itself squarely in the public eye with its most daring show to date. *Naked* was a photography exhibit co-curated by BCVA and CU which aimed to "dispel preconceived, mainstream cultural notions of how the nude body is used in art." The exhibition made local news and brought in thousands. If not for the resolve of these determined women, there would be no BMoCA today.

By 1987, it became clear that BCVA was here to stay. Expansion became the next goal. Hodge and her associates united with Boulder artists Sherry Hart and Rebecca DiDomenico with the goal of raising enough money to renovate the upstairs portion of the building. The upper rooms would be used as an exhibit space for Boulder artists. Together, they raised $17,000 of the $40,000 goal, but were unfortunately cut short when it became clear that updates to the building's sprinkler system would raise the cost of renovations to roughly $100,000. As if that weren't rough enough, due to budget cuts under the Reagan administration, the BCVA's annual NEA grant was cut off.

Hodge left her post as the art center's guiding light in 1989. In a tribute to her, BCVA publicist, Ina Russell, told the *Camera*, "You can't underestimate Karen's influence; her personality has definitely shaped the development and direction of the BCVA." And eminent Boulder collector and curator Mark Addison noted, "[the BCVA and Karen] are inextricably tied."

Jon Friedman, previously director of the Cochise Fine Arts Center in Bisbee, Arizona, was chosen to take Hodge's place. During his tenure at Cochise, he boosted membership from nearly zero to more than 500 and presided over a budget that jumped from zero to $80,000 in three years. His first act as BCVA director was to change the name back to the Boulder Art Center. He aimed to return to the roots of the institution with the primary goal of reclaiming grant money from the NEA. But many of the original staff did not warm to this plan and by December 1989 had resigned. With the loss of most of its personnel and various disagreements over Friedman's ambitious exhibition schedule, the art center was forced into hiatus until the following February, when it reopened with exhibitions by Arizona artists Jim Waid and Phillip Estrada.

But the big buzz was an upcoming James Turrell exhibit. Turrell, known internationally for massive installations concerned with light and space, would be a huge draw for the BAC,

Martha Russo, "allay" (detail), 2016. Courtesy of Boulder Museum of Contemporary Art. Photo © Jeff Wells.

but cost was going to be a large factor and speculation swelled as people wondered where an organization whose recent history had been marked by deep lack of funds would find the money for the required construction, let alone Turrell's fee. Nonetheless, the exhibit opened on March 30, 1990, featuring three installations, the most notable of which, "Pleiades," had visitors enter a dark room, where they lost all sense of visual perception until a dim red light appeared.

The exhibit came with mixed reviews. Many were honored to have hosted such a renowned artist in Boulder, even as they were concerned about how much money had actually been spent on the exhibit. Tensions erupted between Friedman and the BAC board, which pressed the director to resign on the grounds that he had submitted an unapproved budget and for exceeding the money allotted to him for the Turrell exhibit. On April 12, 1990, the Board, expecting Friedman to resign, held an open meeting with the museum's membership. But Friedman did not resign and many BAC members came to his defense, arguing that the board was unreasonably forcing him to leave. Accusations flew back and forth; the board voted to fire Friedman; lawsuits ensued; the controversy continued for weeks.

The scandal forced the BAC to define its bylaws and clearly state the roles of the board of directors, the executive director, dues-paying members, and members of the community. Perhaps the largest question that arose was what the director's role should be. Friedman had acted more as a passionate curator in bringing the Turrell exhibit to Boulder than the board had expected of him. They saw his responsibility as caring first and foremost for the organization's financial well-being. When Friedman left, Don Hobbs stepped in as interim and organized a series of fundraisers that helped pull the art center out of debt and back on track.

Ana María Hernando, "Por los ojos se me escapan," 2014, oil on wood.

In 1991, Cydney Payton became the first long-term director to succeed a line of interims. She would redefine the vision of the art center and was essential in expanding its direction, as well as enlarging the useable area around the building. As one of her first acts, she negotiated an extension of the $1-a-year lease from the city for ninety-nine years. She then proceeded to change the institution's name to the Boulder Museum of Contemporary Art, causing a chain reaction among art centers in Colorado, which rebranded the content they would host in their gallery spaces and, following Payton's lead, put more emphasis on experimental exhibitions. Among the myriad prestigious artists Payton showed were Lynda Bengalis, David Wojnarowicz (the first museum exhibition after his passing), George Woodman and Joe Brainard. Alongside City Manager Tim Honey, Payton also initiated the siting of the Dushanbe Teahouse next to the museum.[3]

Payton left BMoCA to reconstruct Denver's Museum of Contemporary Art and after a transition period in the early 00s, Joan Markowitz and Penny Barnow took over as co-executive directors and continued to take the museum to new heights. Among the notable

artists shown at BMoCA during their five-year tenure (with associate curator Kirsten Gerdes Stoltz) were James Surls, Halim Al-Karim, Emmi Whitehorse, Traci Krumm, Ana María Hernando, and filmmakers Stacey Steers, and Dan Boord and Luis Valdovino.

Across its history, BMoCA has established itself as essential to the Boulder community. In 2010, David Dadone took over as executive director and chief curator. According to Dadone, BMoCA's current mission "is to be a catalyst for creative experiences through the exploration of significant art of our time, as well as fostering interactive and participatory experiences with art for visitors."[4] BMoCA's recent roster has included artists Martha Russo, Daniel Pitin, Tim Schwartz, Alvin Gregorio, Barbara Shark, Stephen Batura, and a host of others, often cutting edge, always energizing.

Under Dadone's leadership, BMoCA's outreach has been extraordinary with programs, for instance, that reached nearly 14,000 young people in 2015. In that same year, nearly 40,000 visitors attended the museum and its programs. BMoCA touches children throughout the region, as well as marginalized communities, and collaborates with other organizations such as the University of Colorado's Macky Auditorium, where BMoCA curates exhibitions, with, among others, the work of Gayle Crites and Margaret Neumann. Its wide array of projects includes MediaLive, a week-long international new media festival and an international artist residency with Rebecca DiDomenico's Swoon Art House.

Through all its incarnations, BAC/BCVA/ BMoCA has always looked to the future with fresh plans for enlarging its already vast scope.[5]

❖ ❖ ❖

Notes

1 http://boulderartassociation.org/about.html, July 14, 2016. See also in this volume, "Shaping Boulder's Aesthetic: A Brief History," by Carol Taylor, and "Women at Work: The Visual Arts in Boulder Prior to 1950," by Kirk T. Ambrose.
2 Grants from the National Endowment for the Arts were critical in aiding the survival of regional institutions such as the BCVA. Rooted in a community that, at the time, did little to support the arts, NEA grants allowed small museums to grow and remain independent.
3 Interview with Cydney Payton, email, March 29, 2016.
4 Interview with David Dadone, email, June 29, 2016.
5 This essay was written using articles sourced from the *Boulder Daily Camera* archives at the Carnegie Branch Library for Local History.

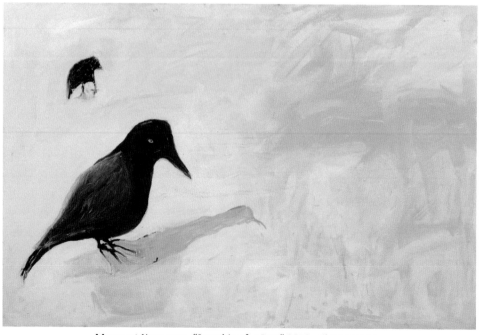

Margaret Neumann, "Searching for Rye," 2012, oil on canvas.

BAG
A Genesis Story

Tree Bernstein

The Boulder Artists Gallery, known as BAG, was an art space that grew out of a magical summer in 1983. Steven Weitzman, known locally as the Tree Sculptor, needed a place to carve an enormous cottonwood stump into a 30-foot eagle for the Crossroads Mall. He landed his big bird at the corner of 9th and Canyon, where the old bus station was waiting to be demolished. The offices at the bus station were empty and the light was good; perhaps other artists could use the space. It was Steven's idea to create a community art space — but he was on deadline with the eagle and suggested I organize it. He said, "Tree, you should be the Stationmaster." Which is how The Station Terminal Art Space came to be one summer.

The only criteria for free rent at The Station were that you had to show up and work, otherwise your "office" would be given to another artist. Local paint stores donated paint and three murals went up in quick succession by Ken Bernstein, Ted Ringer, and Michael Wojczuk. New exhibits opened every Friday night. Wine and cheese shops in the neighborhood donated refreshments for our openings. Everyone wanted to be a part of it.

While Steven worked in the parking lot carving "Treegle," inside the terminal, Jerry Downs assembled seven-foot tall photo collages. Down the hall, John Aaron's ceramic Hotel Boulderado grew so big that the door had to be removed and a chunk of the wall chainsawed to get it out. Meanwhile, two recent University of Colorado-Boulder art school grads, Michael Criswald and Kevan Krasnoff, used the roof for their open-air atelier. Other established artists joined us: Jerry Wingren was one, and Bill Vielehr, Irene Delka McCray, Robert Bellows, Sherry Hart, Rebecca DiDomenico, and Cha Cha all came to play.

The Station was the community's gift to itself. We did not pay rent or insurance. A homeless guy who slept in a car in the parking

Above: Boulder Artists Gallery, *What's a Bag?* exhibition, n.d. Photo by Jerry Downs.

Irene Delka McCray, "Mother Without Father," 2015, oil on canvas.

lot was our security. At the end of the summer we celebrated the last show with the Wrecking Ball. Steven's eagle flew off to Crossroads Mall. The walls came down, and condos went up. It was the end of the line for The Station Terminal Art Space. The party was over, but no one wanted to go home.

The next chapter of the story has more than one version and involves the Boulder Center for the Visual Arts, now the Boulder Museum of Contemporary Art.

A delegation of us petitioned for a Boulder "artists' gallery in the building's unfinished attic. We raised a boatload of money for the

Steven Weitzman and friends take the "Treegle" to Crossroads Mall, c. 1983.

remodel project. Then, well, that was a long time ago; misunderstandings ensued. The Station artists went rogue and incorporated as a non-profit. We opened a gallery in North Boulder before it became NoBo. Our first show was art made from brown paper grocery bags. We called ourselves BAG — Boulder Artists Gallery. (No possessive before the last s for our gang.)

Cha Cha, untitled dragon bench at the Dairy Arts Center, n.d., steel and flagstone.

But … folks couldn't find us in our North Boulder warehouse. It seemed so far away. We moved into a smaller space near Pearl Street, and had monthly art shows and poetry readings for a couple of years. Others, like artists Nancy Robertson and Linda Arline Ellis, took charge; that's how we set it up, we wanted constant renewal of the Board. The entire adventure lasted about ten years before BAG folded. Such is the ephemeral nature of art spaces.

However, for one magical summer, The Station was Boulder's most vibrant art destination — perhaps because we all knew it was terminal.

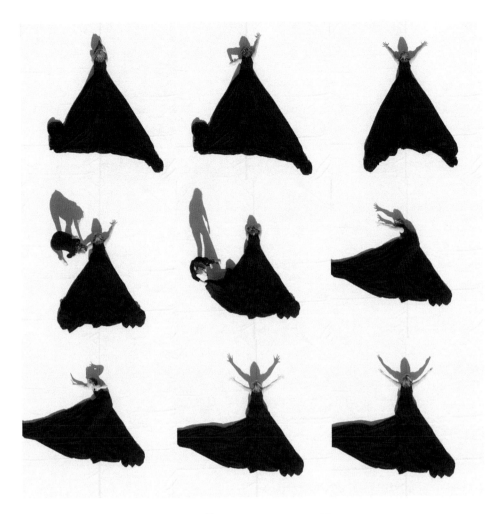

From Milk House to Art House
The Dairy Arts Center

Collin Heng-Patton

Walking into the lobby of the newly renovated Dairy Arts Center, it is difficult to imagine that it was once an abandoned milk processing plant with nothing but the smell of sour milk perfuming the air. The Dairy today would likely be an apartment complex if not for the foresight of a handful of art lovers. These visionaries, among them Russ Wiltse, Margi Ness, Anita Schwartz, and Marda Kirn, had the courage to dream in the potential, and what they envisioned was a multi-disciplined arts community and working space. Support for the arts in Boulder was only just beginning to gain

ground. The Boulder Center for the Visual Arts (now the Boulder Museum of Contemporary Art), was the only exhibition space in town for artwork that pushed the boundaries past the conventional. The original vision of the Dairy was to create a space where artists from different disciplines, including the avant garde, could unite, collaborate, and simultaneously engage with the community.

So how did a dairy become the Dairy? In 1970, the local Watts-Hardy Dairy Company broke ground on a new milk processing plant and distribution center at 26th and Walnut. In 1983,

Above: Sherry Wiggins, "Performing the Drawing / Realizar o Desenho," 2015.

Sinton Dairy Foods Company bought the Watts-Hardy Dairy to edge out competition. But by 1986 Sinton downsized, moving operations out of the building, ending home milk delivery in Boulder, and leaving the building vacant. At this time, local support for the arts was dismal. A series of proposed city initiatives in 1970, 1980, and 1984 would have invested money in such cultural institutions as the Boulder Theater and the BCVA, and could have supported the construction of a new cultural center, but they were overwhelmingly voted down. Frustrated by the lack of support for arts in Boulder, a group called VisualEyes decided to put together a one-night show comprised of art, performance, and music in order to showcase the best the city had to offer. The show was so special because its creation was organic, it grew from the minds and talents of Boulder citizens and artists alike. VisualEyes brought together the community, including those voters.

This one-night show blossomed into an annual weekend-long festival and after four years with over 5,000 people in attendance, the group felt it necessary to find a space to call home. In 1987, Wiltse, a video artist, headed a subcommittee on behalf of VisualEyes in search of a performance space for the next year's event. Sinton Dairy Foods Company had just vacated their building and put it up for sale, marketing it as office space for

Sally Elliott, "To Bulgaria with Love," 2002, gouache.

$2.2 million dollars. Despite the building's prime location, a low economy made it difficult to sell — but a perfect opportunity for a wandering arts group.

Imagine opening the doors to the cavernous shell of the dairy for the first time as Wiltse did when he went to tour it in 1987. The space is enormous and dark. Faint shadows play on the cold cement floor. Fiery excitement mingles with a touch of despair and the sickly smell of sour milk permeates the air. A swirl of hopes, dreams, and fears projects onto the shapeless darkness until the industrial lights finally flicker to a dim hum. It becomes apparent how filthy the place is from floor to ceiling. The roof leaks into a lake-sized puddle in the middle of the main room, and an adjacent space is covered with pigeon droppings. The basement is a black abyss with an ancient boiler that seems ready to explode any second. The building had been gutted of any sellable materials and left to rot.

Wiltse was undeterred. In his imagination, the grim place was transformed into an artists' community with offices, studio and performance spaces, a coffee bar, and a lobby where performers and patrons could meet one another and commune in their shared love of the arts. His inspiration was the Torpedo Factory in Alexandria, Virginia, which, as the name suggests, was an old missile factory that had been gutted and transformed into a residency program where artists could create

and community members could visit to see works in progress. Wiltse had a vision of what the dairy could be at a time when a majority of the town did not believe a large-scale art center would be feasible, let alone welcome, within city limits. But he persevered and contacted the vice president of Sinton. He and VisualEyes got permission to use the building for their show with the added bonus that it would be rent-free except for any utilities used by the group.

The minute Wiltse set foot inside the second time, his original vision expanded drastically. He rebranded this new arts building as the Flatiron Center for the Arts. He then reached out to the Boulder County Art Association, the Boulder International Chamber Players, and Marda Kirn, founder, with Bob Shannon and Felicia Furman, of the Colorado Dance Festival, to be the first resident organizations of the building. At this point, they were all squatters, taking up space in a building that could be sold at any moment. Having set one foot on the ground, it was time for the newly formed board of the FCA to keep the flame alive and raise enough money to buy it. Together they cleaned the building to make it habitable and began planning. Jump Start for the Arts was a 10-day fundraising event that showcased a different art discipline each day and brought enough money into the FCA to keep it running on a slightly more solid foundation.

The best way to spread awareness about the burgeoning FCA was by showcasing the success of

resident organizations. Russ Wiltse invited CDF to become the FCA's first tenant. By the time they moved into the new building, the dance festival had an international reputation as one of the top three dance festivals in the world. This month-long event brought national and international artists to Boulder to teach and perform. The organization was able to transform the northeast corner of the building into functional office space, thanks to in-kind donations of paint, carpet, and furniture. Wiltse and other FCA board members could then tour potential funders through CDF's offices as an example of what the rest of the building could become with theatres, galleries, and studio spaces. Having affordable office space helped the CDF thrive administratively and artistically. Among the programs created through CDF were the Mile-High Tap Festival and Great Tap Reunion that brought many of the world's greatest rhythm tap dancers to Boulder. Dances of the Spirit, another CDF program, was a three-year project that explored the relationship between dance, spirituality, and the environment. This was one of the first performances, at least in the Colorado area, to connect natural human movement and dance to an awareness of climate change. The autonomy given to resident organizations spurred and encouraged conversation and excitement about the new arts center and the state of the world both in and out of Boulder.

Jim Lorio, "Wood-Fired Pot # 1," 2010, stoneware.

Paul Gillis, "I Forgive You My Sins," 2011, oil on canvas.

In 1993, the city agreed to help the FCA buy the building after they'd successfully raised $450,000 to help them split the cost. Wiltse and company organized the sale of a portion of the property (the section littered with pigeon droppings) to developers looking to build apartments on the land. This brought the cost of the building down to a more affordable level. Once the space was firmly secured, the board decided to renovate and rebrand and that is when it became simply, the Dairy.

"The Dairy now isn't as wild as it was then," Wiltse said. "We wanted to be able to take buckets of paint and fling it around on the walls. I had this vision that people would work together and put on shows, come into the central lobby, have coffee, and talk about ideas."

But he found that one of the most difficult tasks in running the Dairy seemed to be creating a space for artists to work and collaborate freely while simultaneously navigating the bureaucracy inherent in operating an official enterprise.

Nobody understood this struggle better than the Dairy's first official director, Margi Ness. In 1995, Wiltse returned to his artistic roots and left Ness to head the operation. By the time she took over, there were eight organizations renting space and tensions were running high. Early inhabitants of the Dairy had made renovations, however, they were minimal, just enough to keep the building running. Many of the organizations like Space for Dance had to paint the walls and re-do the floors. Ness and Anita Schwartz, who joined in 1995, struggled to figure out how to keep rent affordable but still make enough money to pay Dairy staff, let alone keep the place running. Not a simple job. The two found themselves not only administering the Dairy, but also landscaping, and marketing each organization occupying the building. They started "Fresh from the Dairy," a radio show that promoted upcoming events and the activities of resident organizations, many still virtually unknown to the public. The place bustled. In one room, artists Melanie Walker and George Peters created their generously eccentric installations, while in the next, Space for Dance staged raves to raise money for programming. The Dairy grew exponentially in the late '90s and early '00s and, as a result, has truly established itself as a chief supporter of the Boulder performing arts scene.

A portion of that growth has come from narrowing the scope of what the Dairy would represent. In the beginning, there was a collective agreement that the Dairy would be a place where artists could collaborate and have affordable studio space. However, many of the early artists felt even the affordable rent was too much and that it should be reduced due to the fact that the Dairy was, respectfully, a shambles. The artists and organizations that took up residence had to figure out how to maintain their autonomy while creating programming that would excite the whole community. Gradually, the studio space format was phased out to make room for larger, more established organizations such as the Boulder Philharmonic and the Parlando School of Music. The Dairy had plunged into debt as a result of costly renovations and these groups could not only afford to pay higher rent but could contribute substantial sums of money to constructing their own performance spaces. Moreover, music and dance performances were more accessible to a community still wary of contemporary visual arts. Thus the Dairy was forced to shape itself around what would allow it to survive.

In the time since its foundation, the Dairy has begun to curate its own performances rather than simply provide space. Since 1987, three performance theaters and the 60-seat Boedecker Theater for film have been constructed. In 2014,

Amos Zubrow, "Girl on Bicycle," 2008. Zubrow's found-steel sculpture was part of the Dairy Art Center's 2013 exhibition, *Art of the Bicycle*. Photo Gayl Gray.

Boulder voted in favor of ballot measure 2A, a three year 0.3 percent sales tax increase that would raise approximately $27.6 million for arts and community organizations. This has helped the Dairy complete its most recent renovation of the performance theaters and the front lobby of the building. There are fewer resident organizations today than in the past, however the Dairy's current director, Bill Obermeier – who oversaw the sophisticated renovation by architect Stephen Sparn of Sopher/Sparn Architects — believes this has encouraged the growth and flexibility of Boulder's performing arts. A balance of solidness and fresh excitement.

The Dairy is already competitive with various art centers across the Denver metro area. The 42,000-square-foot building has allowed for versatility in performance and exhibition space that not many other art centers around can claim. The Gordon Gamm Theater, a 250-seat venue, and the Grace Gamm Theater, a 116-seat venue, both state-of-the-art performance halls, along with the reconfigured Carsen Theater offer patrons a variety of artistic experiences. What it lacks in larger 500-seat-plus performance venues, such as the Lincoln Center in Fort Collins, or the Arvada Center, it makes up in the diversity of its performances.

Freshly face-lifted visual art spaces include the McMahon, Polly Addison and Hand-Rudy galleries, along

with the MacMillan Family Lobby. In the spirit of community, the Dairy's galleries have traditionally focused primarily on displaying the work of a rich variety of local and regional artists — among them Garrison Roots, Sally Elliott, Antonette Rosato, and Jim Lorio, many curated by Charmain Schuh — along with group exhibitions, such as *Veterans Speak* in November 2015 curated by Stephanie Rudy, Mary Horrocks and Sally Elliott (with related performances by 3rd Law Dance/Theater); the hugely popular *Art of the Bike*, the annual Boulder Valley School District exhibit; a portion of the historically important 2009 *Ditch Project — 150 Years of Ditches: Boulder's Constructed Landscape*, curated by Elizabeth Black and Bob Crifasi, a water resource specialist for City of Boulder Open Space and Mountain Parks, crowded with historical memorabilia and the interpretive work of thirty-five Boulder artists; and in 2016,

Crossing Borders, art about the immigration experience and issues surrounding immigration in the U.S., curated by Rebecca Cuscaden.

In 2016, the Dairy could boast 250,000 experiences with the arts through theater, music, dance, visual art, cinema, and classes. Not only that, but the renovations have allowed for the creation of music and dance studios for nearly 2,000 students of Boulder Ballet and Parlando School of the Arts. The original spirit of the Dairy, of creativity and collaboration, first imagined by Russ Wiltse, is alive in the potential of the many different spaces occupied by so many different arts organizations. The Dairy Arts Center is a hub for culture and community interaction and a stunning example of what can happen when a few dreamers come together in search of a brighter artistic future.

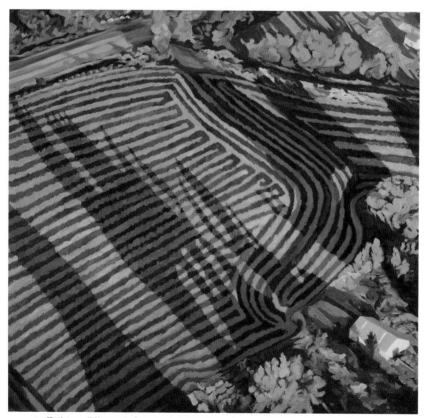

Buff Elting, "Illusion of Order," 2006. Elting is one of thirty-four local artists to participate in *The Ditch Project*, a community art event that took place at the Dairy Arts Center, the Boulder Public Library and Central Park in 2009.

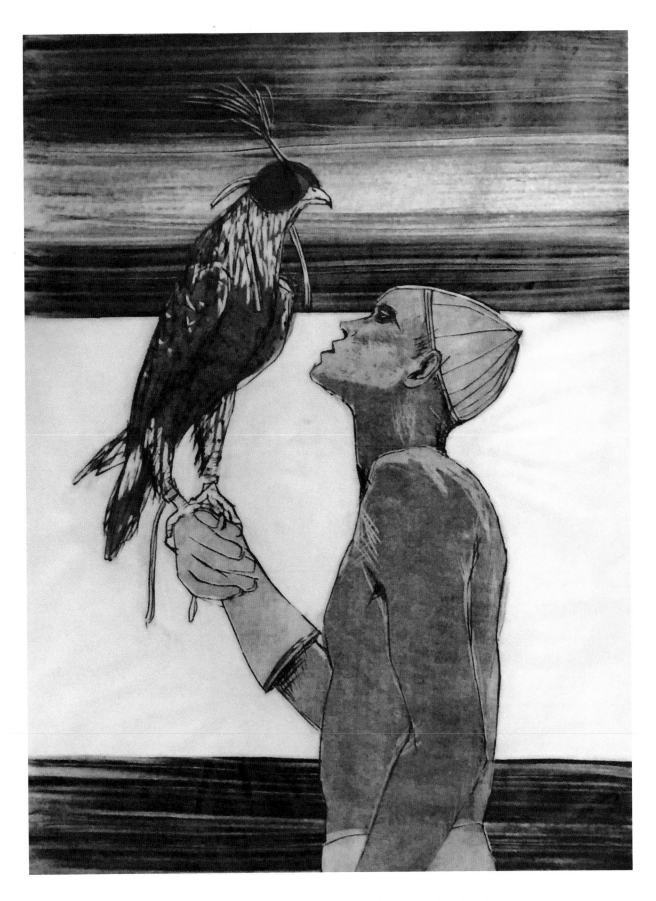

Joe B. Ardourel (1931-2015), "Falcon and Falconer," 1964, woodcut, intaglio print.

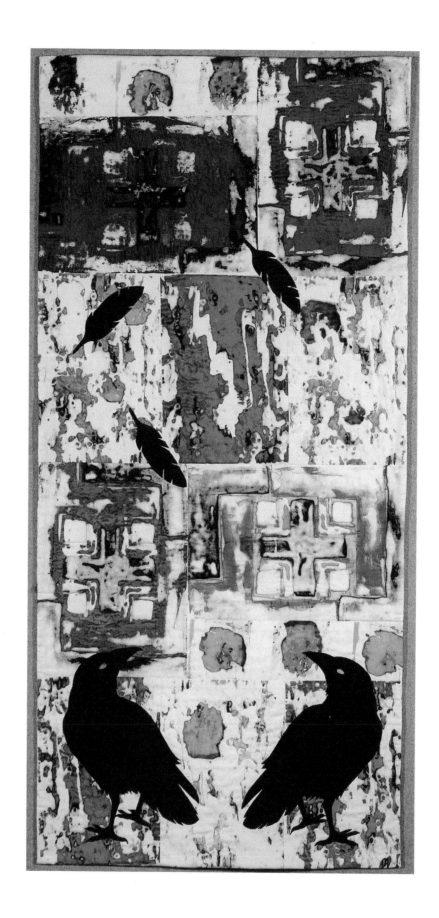

Mary Rowan Quinn (1954-2014), "Winter Ravens," 2009, fiber.

The Eyes Have It
A History of Visual Eyes

Kathy Mackin

In 1985, artist Kevan Krasnoff and producer Don Hobbs planned an event to attract both artists and art lovers. It was a time when local artists accused Boulder of being a deep void, with limited opportunities and venues for exhibiting their work. Then as now, Boulder was loaded with talent looking for an outlet and similarly loaded with people looking for a good reason to get together and enjoy the arts. Krasnoff's and Hobbs' idea was to create an arena for local artists and to make art more approachable and fun for art lovers.

It worked!

The first event took place in spring 1986 and was called "Art Beyond the Vacuum," a clear reference to the empty space artists felt they had fallen into. Fourteen Boulder artists participated in the event located in a vacant upstairs space in the downtown Exeter building at 1050 Walnut Street. It was only a one-night run, but with 700 attendees, the artists considered it a success.

The following spring, the event was held again in the Exeter building and renamed "Eyes." This time there was double the space, more than double the artists, and support from local businesses. This was fast becoming a huge art party, with catered food, live music, and more than 2,000 attendees. The event lasted the entire weekend. The unique ambiance and the idea of a "class art extravaganza" was catching on and becoming a real opportunity for artists to discuss and show their work. Local press coverage was favorable. In the short space of a year, the organizing group had grown and now called itself "Visual Shift," a loose coalition of artists, patrons, and dedicated friends.

Their contagious enthusiasm was motivated by goals as broad and diverse as the people involved. Their declared objectives were to uncover the vast amount of talent right here at home; to attract guests who might not otherwise attend art events in town; to make the arts lively and fun; and to build a long-term commitment to Boulder as a nationally recognized art center.

Prior exhibitions had been invitational and there had been concern about the erratic quality of the work. So in 1988, art entries were juried. And the group wanted to enlighten Boulderites

Above: John Haertling, Visual Eyes announcement logo, n.d., drawing.

about the expanse and volume of visual arts genres being created locally. Participating artists included university art professors, realists, traditionalists, and artists on the cutting edge. They were painters, photographers, sculptors, ceramists, glass workers, papermakers, and more. Artists priced their own work and Visual Shift, a non-profit, collected no commission. At last, artists were getting the support they needed and the opportunity to expose their work to the public. And attendees were enjoying themselves, too, entertained by the lively events, as well as opportunities to interact with artists.

Visual Shift evolved into "Visual Eyes" and the annual bash continued for two more years, now at the East Park Tech Center at Arapahoe Avenue and 33rd Street. With 40,000 square feet, there was room for a hundred artists – seventy-five visual, twenty-five video. Opening night now included a champagne ball, featuring Big Band music. The second night, a "Cultural Blast" featured both live music and performance art. Add to that a choreographed show of outrageous hair sculptures dubbed "Culture Shock" and it's no wonder the *Daily Camera* described Visual Eyes as "a kind of Bolder Boulder of art." The entire long weekend was organized by volunteers and supported by local businesses and individuals.

Five years later, this artistic energy coalesced around a new idea, Open Studios, brought to town by Gary Zeff. Many of the artists were primed and ready, now skilled with hanging, pricing, and selling their own artwork.

Kevan Krasnoff, "Blue Waunder" (detail), 2000, acrylic on canvas.

Open Studios
A Win-Win Proposition

Brenda Niemand

Open Studios was an idea whose time had come: It was the mid-'90s, and Boulder had a large community of artists but precious few art galleries. Persuading the artists to open their studios for a couple of weekends in the fall would facilitate a connection with the public. Artists would gain welcome exposure for their work, the studio tourists would meet the artists in a friendly and non-intimidating environment, and everyone would benefit from the experience. In the process, some art might change hands. In hindsight, it seems a no-brainer, but it took a zealous persuader and organizer to get it off the ground. Gary Zeff, then recently retired from a marketing career with Eastman Kodak and an enthusiastic woodworker, used as a model the successful Santa Cruz, California, Open Studios. He organized Boulder's Open Studios in 1994

and launched the Fall Artists Tour the next year with 84 artists. From the beginning, the non-profit has relied for its success on an army of volunteers and a dedicated board of directors; nonetheless, Zeff's own art-making had to take a back seat as he focused his energies on nurturing the operation for its first fourteen years.

Open Studios quickly became one of the city's most beloved events. When the familiar yellow signs bloom in yards all over town during the first two weekends of October, Boulderites are ready and waiting. The kick-off reception, traditionally held at Boulder Public Library, is thronged with artists and tour participants. The number of artists on the tour averages 125, a group selected by jury. Each artist has one piece exhibited in the library, which displays them all for a few weeks preceding the event.

Above: Caroline Douglas, "Lady of Enchantment," 2010, salt-fired stoneware.

For the first twenty years, a large printed map was sold so tourists knew where to find each studio. In 2016, a free phone app provided the map and all the pertinent information. On tour days everyone sets off in a buzz of excitement and anticipation: parents with kids in tow (or the other way around), lone participants, clots of friends, bikers — art lovers and collectors, as well as the uninitiated who are out to learn about how art is made. The tour participants are driven by curiosity, the hunt for exciting new talent, the chance to revisit favorite artists, or just the sheer delight that an afternoon of looking at art can bring. Thousands of people repeat this ritual year after year; it has become as symbolic of autumn pleasures as football games and golden aspens.

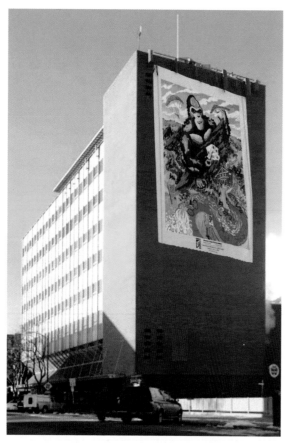

This paint-by-numbers gorilla, created by artist George Good, was a 2004 fundraiser for Open Studios, a community project unfurled on the Colorado Building at 14th and Walnut streets. The Guinness Book of World Records named it the largest paint-by-numbers in the United States at the time.

The participating artists are the key to the enormous popularity of the fall studio tour. Making art is what artists do; showing and selling their art doesn't necessarily come easily. But they are also typically passionate about their work, and eager to share why and how they create it. Agreeing to open their studios for two weekends each fall is a win-win proposition. An artist's work may be seen by hundreds of people, and the touring visitors have an art experience that is up close and personal. If a purchase is made, it's hard to know which side is more thrilled.

Over the years, Open Studios created a number of fun special events. The one most fondly remembered was the enormous paint-by-numbers spoof that was unfurled on the wall of a downtown office building in the fall of 2004, to mark the tenth anniversary of the organization's founding. The fundraising project began in July with a (top secret) 19-by-25-inch pastel by Open Studios artist George Good, which was sent to a company that specialized in turning artwork into a paint-by-numbers painting. The huge work was divided into twenty-five pieces, each 5-by-6 feet, which were printed on vinyl sheets by Circle Graphics, a Longmont billboard printer. The panels, along with jars of the specific colors of house paint required for each, were distributed to local companies who had paid $300 per panel. Their employees, clients, customers, family, and friends (an estimated 800 total) diligently filled in the numbered spaces, having no idea what the finished image would turn out to be. When all the panels were completed, they were returned to Circle Graphics to be reassembled. The result was a huge vinyl "canvas" — at that time, the largest paint-by-number in the United States, according to Guinness World Records! It was unfurled on the north side of the Colorado Building (14th and Walnut Streets), and the image (gasp!) was revealed — a gloriously giant gorilla swinging from the Flatirons!

Gary Zeff, "Ode to Scobie," 2013, ash, oak, bronze.

Founder Gary Zeff recalls another attention-grabbing fundraiser that involved fire hydrants. Dog owners were recruited to sponsor a Pearl Street fire hydrant. Each hydrant was then assigned to an Open Studios artist, who transformed it into a work of art. People voted for their favorite, and the winning artist, the sponsor, and the dog were photographed together in front of a firetruck. Boulderites were so enamored of their artsy fire hydrants that when it came time to fulfill the promise to the city to repaint them, the artists restoring the standard hydrant green took a lot of flak from citizens who strongly preferred the more creative paint jobs.

The idea of artists painting cars was an example of how Zeff tried to ensure that a sponsor's business would be actively promoted. He persuaded Pollard Autos at the intersection of Pearl and 30th streets to provide a car that artists would cover in a wild design to promote Open Studios. One artist provided the design, which was realized with the help of numerous other painters. The car was then parked right at the corner, where many motorists would see it each day. Sometimes the car was driven around town to promote the event, and the dealership.

Zeff was a tireless advocate for Open Studios, a bulldog with a good idea, an indomitable force when it came to squeezing money or support from donors. He was also a terrific judge of character and built a board of directors who shared his vision and brought diverse and invaluable talents. First in was Howard Bernstein, a Boulder lawyer who "got" the idea that Open Studios would benefit the artists but that it was also about educating the public; he made that argument to the IRS when he successfully filed for 501(c)(3) non-profit status for Open Studios.

Photographer Chris Brown, another volunteer of note, has participated in countless Open Studios and also served on the board.

Jerrie Hurd, "Rocket to the Moon," n.d., photograph.

It was he, who, in 2005, convinced nineteen Open Studios artists to donate art to the non-profit Boulder Shelter for the Homeless. A veritable army of other Boulder artists are studio tour regulars or alums, including Susan Albers, Joe Ardourel (1931-2015), Elizabeth Black, Cha Cha, Amy Guion Clay, Gayle Crites, Rebecca DiDomenico, Caroline Douglas, Sally Eckert, Claire Evans, David Grojean, Jerrie Hurd, Kevan Krasnoff, Ann Luce, Sibylla Mathews, Gerda Rovetch, Bunny Rosenthal Rubin, Judith Trager, John Waugh, and Virginia Wood.

Chris Brown, "Aspen Grove, V-PAN," 1993, Photography: film capture; Ultrachrome inkjet print.

Over the years, a number of events were designed exclusively to meet the needs and interests of Open Studios artists. These have included free winter workshops or guest speakers on such topics as promotion and marketing; how to photograph artwork; and instruction in various art media. Such activities that focused on the artists helped build camaraderie among them as they learned the basics of the business of art.

Some Open Studios initiatives have been ongoing. Art education, both formal and informal, has always been part of the organization's mission. From the beginning, artists on the fall tour were strongly encouraged to provide something educational — a demonstration, a project for kids and/or adults, whatever might engage or involve the curious visitor. Many people who tour the studios want seriously to understand the process the artist uses to achieve his creations, and the studio atmosphere is right for asking questions without feeling embarrassed or intimidated.

A more formal commitment to education is Education Links (EdLinks), a program that sends Open Studios artists into the schools to lend assistance in the classrooms to enhance art education and inspire the students. This program began in 2000, in response to budget restraints and other pressures that resulted in public schools reducing the time and staff for teaching art and music. Each artist provides up to five classroom hours for instruction, projects, demonstrations, etc. The art teachers are excited to work with professional artists, and the kids are thrilled by the exposure to new ways to make art.

Open Studios moved into early education in 2008 when it bought Clementine Studio, an art school for kids. It was located in the Steelyards on 30th Street and offered drop-in summer camps and after-school and school-break programs. Occasionally adult classes were held in the same location. Soon after the acquisition,

Julie Maren, "Rabbit Test, "2006. Oil, graphite, liquid metal on wood.

Open Studios changed its name to OpenArts to reflect the broader scope of its undertakings, with the Open Studios fall tour remaining the mainstay of the organization. Under the amazing director and teacher Lisa Holub, Clementine Studio gained an enthusiastic following, but it struggled to be financially stable. It moved to a location at 2590 Valmont and then, a few years later, to space in the Pine Street Church at 13th Street in downtown Boulder.

In summer 2015, Clementine Studio began a transition from its Pine Street home to a mobile platform that will allow it to take art education to children of all socioeconomic strata, including those who don't otherwise have such opportunities. The Mobile Art Lab will allow Clementine also to take its unique process-oriented art education to facilities that serve the disabled and the elderly. Reaching a broader constituency through this targeted delivery system could contribute to closing the achievement gap, lowering barriers for the disabled, nurturing the elderly, and increasing the number of individuals who appreciate the critical value of art in life.

After Zeff retired in 2008, his hired successor proved in short order to be a poor fit, and board member Kathleen Sears valiantly stepped forward and volunteered to serve until a permanent executive director was found. Jane Saltzman took the reins early in 2009, so her tenure as executive director (unluckily) coincided with the Great Recession. Finding financial equilibrium became even more challenging, but she brought new energy and tried fresh tactics. By this time, OpenArts had moved its offices to Rembrandt Yard on Spruce Street, with an agreement to curate art for the galleries on two floors. This provided a handsome year-round space for showing the art of Open Studios artists, with exposure to the general public. Saltzman and subsequent executive directors have hung a new show several times a year, opening each with a public reception.

Annual benefit parties begun by Saltzman continued under her successors, Bill Capsalis, a former chair of the OpenArts board (2012–14), and Stephen DeNorscia (2015). Those fundraisers, such as the amazing Beatnik-themed bash of 2013, were all swell parties,

Gerda Rovetch, "Philosophical Ex-Dancer," n.d., print of a collage. Collection of Sibylla Mathews.

with terrific buzz and rave reviews (if you include enough artists, the party is bound to be a success!), but none was able to produce a bountiful addition to the bottom line.

The 2014 Open Studios fall tour was notable for two firsts, both occasioned by the death of longtime Open Studios artist Scott Reuman, who had died in 2012. A free screening of *Scott Reuman and the Wave of Improbability*, a documentary tribute to the artist, took place in the Boulder Public Library's Canyon Theater. Following the film, the inaugural Scott Reuman Award for Artistic Excellence was awarded to Boulder sculptor Jerry Wingren. The $4,000 award recognizes an artist who has demonstrated an absolute mastery of his/her craft. A foundation established in Reuman's memory has guaranteed the continuance of the annual award for ten years.

In 2016, Open Studios reverted to its original moniker and has been revisiting its vision, goals, and strategies. The arts environment has significantly changed since Zeff founded the organization. The citizens have indeed become more aware of art and the importance of encouraging it in our community and in our lives; they have come to understand that art is critical to our well-being, and that making it or viewing it offers a unique kind of pleasure. A goodly number of the early Open Studios participants have become successful artists, making a living with their art, and many of them have inspired younger or newer artists through their support, teaching, and encouragement.

Of course, after two decades, the organization also faces new challenges. One is directly related to the very success of the

studio tour concept, which has been copied in several neighboring towns. Imitation may be the sincerest form of flattery, but it's also a source of competition — for artists, audience, and funding. Another worrying factor is the rise of rents and cost of living in Boulder, which increasingly drives artists to find affordable studio space elsewhere. The future of the visual arts in Boulder may depend on what kind of support the city offers — for example, whether it decides to provide low-cost studio spaces for artists.

Lastly, the cultural health of the city today is stronger than ever: Boulder is home to more than 130 registered non-profit cultural organizations, and creative professionals living and working in Boulder make up nearly 9 percent of the population. However, in 2016, funding for all the arts has not grown nearly as fast as the number of funding seekers. Competition is stiff for audiences, too, since art lovers are also likely to seek out music, dance, and theatre. And there are still only twenty-four hours in the day. But these are good problems to have!

Cultural organizations, like businesses, must be continuously inventive and flexible as they adapt to leaner budgets and new challenges. Open Studios will increasingly embrace the option of operating on a virtual basis and with a lighter footprint (e.g., replacing the printed tour map with a free app and recreating Clementine on a mobile platform). Fortunately, Open Studios has a huge advantage in its constituency of artists: they are bright, optimistic, enthusiastic, and best of all, creative. It's their nature to think outside the box, to color outside the lines. We can't know exactly what the future will look like, but it will be beautiful — and the road trip will be an exciting and fun adventure.

Amy Guion Clay, "Crossing Over Chasms," 2008, encaustic and oil on panel.

This commissioned 1974 untitled sculpture by Kim Field (1945-1977) was first located at the corner of Baseline and Broadway, and was a source of bitter controversy. It was eventually relocated to Airport Road and, at the end of 2014, was deaccessioned by the city and removed. Photo: Gayl Gray.

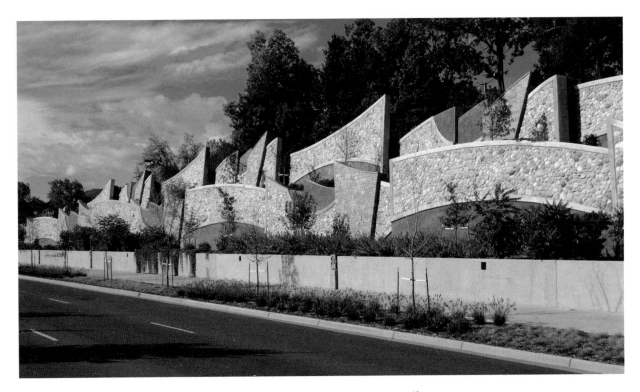

Getting to Yes (and Beyond):
Skirmishes and Compromises in Boulder Public Art

Dinah Zeiger

A 2014 squabble over the proposed "YES!" sculpture in front of the main Boulder Public Library wasn't the first time public art felt the backlash of the community's ire. One of the most vehement episodes occurred in 1937 when curvaceous nude sculptures depicting Minerva, goddess of wisdom, and Jupiter, god of power and strength, were installed over the main entrance to Boulder High School. A school board member called them "hideous monstrosities" and demanded their removal. Police directed traffic around the school as people flocked to stare. Letters flooded the pages of the *Daily Camera*, some pro but mostly con, and the school board contemplated their removal. One letter opined that the pair were "a comfort to all fat persons"; another suggested Minnie needed a "brassiere." Eventually, it all blew over, and the sculptures

remain in place today.[1] And that's perhaps the lesson to be learned about public art: Someone always objects, but does that mean it should be rejected?

These recurring commotions raise questions about why some public art projects fail. One simple explanation lies in the audience for public art, who, unlike traditional art patrons, are not self-selecting. Carol Kliger observes that artworks may be sited on a corner next to work or in a neighborhood park, forcing contact that may be unwanted.[2] To the public, it smacks of a power-grab by officials or experts. As Erika Doss, art historian and former member of the Boulder Arts Commission and University of Colorado faculty, points out: "Many feel marginalized by what they perceive as an unaccountable, self-referential group of experts: Those in the public art industry but

Above: Airworks (Melanie Walker and George Peters) and Ken Bernstein, "StrataVarious," 28th Street and Colorado, Boulder.

also city managers and politicians who claim to speak for 'the people' yet seem willfully detached from real-life public concerns."[3]

The relationship between artists and communities has shifted across recent decades, as the former have become more attuned to specific needs and desires and less inclined to see their creations as entirely autonomous interpretations.[4] Multiple controversies in many places show that excluding the public from the selection process incenses the community, which may consider public art a luxury and question its costs.[5] When an artist's personal aesthetic takes precedence, the public usually reacts, funding comes under attack, and the piece is threatened. As Kliger notes, an artist's disregard for the public may result in beautiful but uncomfortable benches or alterations to established traffic patterns that inconvenience residents.[6] Dismissing such concerns or belittling public appreciation of such functional artworks ignores the fundamental basis of their appeal, Doss says. They do more than give the public what it wants: "They encourage the public to imagine a social and cultural possibility — the formation of community."[7]

How We Remember the Past

Public art in Boulder before the 1970s fell mainly in the realm of memorial sculpture, much of which remains on view around town, from the Boulder County Courthouse lawn facing the Pearl Street Mall, to Columbia Cemetery at 9th and Pleasant streets, to the façade of Boulder High School. Veneration is usually the purpose of public monuments, often financed with money raised by public-spirited individuals or groups. A century ago, the Women's Relief Corps, an auxiliary of the Boulder chapter of the Grand Army of the Republic Civil War veterans group, collected $1,600 to buy the "Soldier at Parade Rest" monument, now standing in front of the county courthouse. At its unveiling in 1914, Eliza Gardner, a veteran's widow, spoke of those it honored: "They made us a nation," she said, referring to the named dead. "May the principles of truth, honor, and justice be so instilled in the minds of coming generations.

Such monuments furnish concrete evidence of the past, albeit recording a particular way of remembering it.[9] They reflect the common history and political culture of their times,

The bas reliefs on the Boulder High School façade designed by Glen Huntington in 1937 depict the Roman Gods Jupiter and Minerva and caused the first public art controversy in Boulder. Today, they are treasured and affectionately called Jake and Minnie. Huntington also designed the Boulder County Courthouse, whose images extol the city's mining and agricultural history. Photos: Laura Marshall.

whether celebrating civic ideals of progress and virtue or evoking memories of wars and other disasters. We continue to honor these monuments because they help us make sense of our present and remind us of how we got here, thus anchoring and uniting us as a community.[10] What cannot be ignored, however, is that these memorials — while evoking a sense of unity and order — were and remain partisan and often contested.

Boulder, remembered by many as a mining supply and farm town, changed rapidly after the Second World War as an influx of new residents boosted the population from 20,000 in 1950 to 72,000 in 1972. By 1963, Crossroads Mall, presently the site of the Twenty Ninth Street retail district, ushered in a new era. Merchants flocked to the fashionable indoor shopping mall, which transformed a pasture but left vacant land and buildings downtown. In 1967, a shift began when the city council authorized its first growth plan, Boulder Tomorrow, Inc.[11] Priority No. 1: Preserve the mountain backdrop by buying up land for an open space program, funded by a 1 percent sales tax.[12]

The Boulder Tomorrow plan included a greenbelt program for new parkways embellished with art. Only a year before, the National Endowment for the Arts had established its Art in Public Places program with the goal of helping finance and commission public art projects nationwide. Discussions began locally about developing a public art master plan. In 1968, Mayor Robert Knecht appointed a committee of "five Boulder men to study use of sculpture in the city and study the design of its public facilities," chaired by architect Carl Worthington, a member of the city planning board.[13] The committee incorporated as the non-profit citizen group Aesthetic Action, Inc., and included local activists, artists, and architects — among them Charles Haertling, Neal and Gretchen King,

Bill Vielehr, and Worthington. A city council resolution, approved in 1972, commended Aesthetic Action's master plan for "beautifying Boulder with sculpture," and directed the city to use it to begin developing a community-wide design plan.[14]

Boulder's Checkered Relationship with Public Art

Not waiting for city action, Aesthetic Action launched the first public art project — a 60-foot-high Cor-ten steel abstract sculpture commissioned in 1974 — and set the stage for much of what unfolded over the next four decades. The pushback started almost from the moment the huge steel structure appeared on an island at the intersection of Broadway and Baseline. Aesthetic Action had raised $5,000; the city contributed another $5,000;[15] and the group issued a call for entries. Six sculptors applied, and after months of discussion, the group selected local sculptor Kim [Kimbrough] Field. The design they chose, from among ten Field submitted, was not his favorite, nor was it a darling of the public. Within months, a group of citizens had formed the "Committee to Recall the Sculpture at Broadway and Baseline."[16]

The site — a grassy triangle in a busy intersection cluttered with power poles and wires — had a "hardcore industrial feeling," and the piece itself was meant to "emphasize the movement at the intersection" said Worthington.[17] The public, however, responded that the site was too small for the size of the sculpture, and its size distracted drivers at such a busy spot.[18] There had been no particular effort to include the public in the selection of the work or the site. Years later, Bill Vielehr, a member of Aesthetic Action and a sculptor himself, admitted that "a lot of groundwork wasn't done in getting the public more involved in art appreciation." Experienced from inside, he said, the piece "creates its own environment" and probably would have been better suited to a pedestrian area.[19]

Within three years, the sculpture began to deteriorate. Although it had always been intended to rust, the welder hired by the city to patch it up offered to dismantle it "for nothing,"[20] because of its condition. The city's director of transportation said his engineers had "noticed" structural weaknesses when its Broadway-Baseline Improvement Project started in March 1977. Thus began a nearly decade-long discussion about what to do with the sculpture: Should it be dismantled, removed, or restored? Karen Hodge Ripley [Dugan], then director of the Boulder Center for the Visual Arts, said the sculpture had "given Boulder a bad feeling about public art in general," because it "had not been cared for."[21] She suggested that, if it could be removed, "maybe Boulder's attitude toward public art can be softened somewhat."

Things came to a head in 1986 when a truck careened into the sculpture delivering "a knock-out punch to an artwork many Boulderites love to hate." One witness to the accident "suggested that the truck be left there as a permanent part of it."[22] In addition to being a perceived eyesore, it had become a public safety issue. The Transportation Department, which already had embarked on the redesign and widening of the Broadway-Baseline intersection, said it needed to remove the neglected sculpture.[23]

Marcelee Gralapp, then Boulder Library director, said the problem with the Field sculpture was that it "doesn't really belong to anyone, and no department wants to spend money from their limited budgets on maintenance. Maintenance arrangements need a city council fix."[24] The BAC allocated $10,000 to move and repair the sculpture, relocating it to a site at the Boulder Municipal Airport.[25] In 2014, the city removed it when the land was sold and returned it to Field's widow.[26] Some residents, like James Hough, writing in the *Daily Camera*, considered the deaccessioning of the untitled work and its ultimate destruction to be "a disgrace" and "an insult."[27]

The saga of the Field sculpture encapsulates several issues that have dogged Boulder's public art efforts for decades: Where should the money

A mysterious artist -- perhaps one calling himself "Gravity Glue" -- regularly created these extraordinary stacked rocks, known as cairns, in Boulder Creek, much to the delight of passersby. In May 2015, "Gravity Glue," aka Michael Grab, was threatened with ticketing by an overzealous police officer, but City Attorney Tom Carr decided prosecution was not possible. The beloved cairns have since virtually disappeared. Photo: Laura Marshall

come from to maintain, as well as commission, public art? How, and by whom, will selections be made? And where will artworks be placed? The Boulder Arts Commission, created by the city council in 1979, consisted of five city council-appointed citizens whose job was to make decisions about two grant programs. The commissioners knew they needed policies to guide the selection and siting of artworks, but the BAC was locked in a delicate dance with several city departments. Its primary partner, Parks and Recreation, controlled specific pieces of land and had funding available for artwork,[28] while the city council held the purse strings, financing programs from the general fund budget.

Yoshikawa, "Correspondence," 1986, marble, Charles Haertling Sculpture Garden, 9th Street and Canyon Boulevard.

The Big NO!

Working in tandem with the Parks and Recreation Advisory Board and the Library Board, which housed the city's arts division (now the Boulder Office of Arts + Culture), the BAC rolled out its first big public art effort in 1982 — a plan for a sculpture garden at 9th and Canyon, formally designated the Charles A. Haertling Sculpture Park in 1985. They needed $100,000, half of which they hoped would be funded by a NEA Art in Public Places grant of $50,000 to be matched by private funds raised in Boulder. Parks and Recreation chipped in $30,000 from its capital improvement budget to begin renovation and development of the Boulder Creek Trail from a city dump formerly on that site. However, the parks budget could fund only the landscaping and bike paths, so the arts commission agreed to be "facilitators for creative people [and] to collect proposals" to develop the one-and-a-half-acre sculpture garden.[29]

To raise the additional funds, a group of citizens, including five members of the BAC, formed the Boulder Arts Foundation to, according to the *Daily Camera*, allow people "to make contributions to a project they are interested in." The final player in the sculpture garden design was the artist, to be selected by a panel of five experts comprising two local residents — a University of Colorado-Boulder curator and a local lawyer and art collector —and three nationally known art figures.[30] Public meetings were held, although few outsiders attended. After considering more than 200 artists, including local submissions, the panel selected New York sculptor Andrea Blum.[31] The *Daily Camera* weighed in with an editorial advising caution because development of the site

> requires the cooperation of many people, including the city administration, a private arts foundation, local citizens who feel strongly about art and the New York artist who has been selected to create the sculpture park itself. . . . The major problem is that art by committee seldom produces art. It represents so many compromises and tradeoffs that the result pleases almost no one.[32]

Opposition to Blum flared almost immediately. Some local artists felt snubbed by the choice of an East Coast sculptor, which the selection committee had deemed necessary in order to develop "a major important site" in Boulder supported by the NEA, thus lifting it out of the realm of "provincial questions," the *Daily Camera* reported. BAC chair Jeanne Manning defended the choice: The panel wanted "an artist capable of 'working with

the site, instead of just plunking something down.'"[33] Nor did Blum do herself any favors on her first visit to town, telling an audience: "What I like to do is take a dull place and turn it into a changed area."[34]

That all occurred even before Blum unveiled a scale model of "Three Pavilions," consisting of three 8-foot-high cast-concrete structures: One, a small spare room with benches; one, a circular platform that could be walked on; and the third, a large high-sided bench. The public was dismayed. They called Blum "arrogant," said the sculptures looked like "an outdoor lavatory," declared there was "no beauty in concrete," and lamented that the work "didn't reflect the Flatirons [or] the community."[35] The *Daily Camera* polled its readers, and 90 percent voted "NO!" (as the newspaper's headline read) on accepting Blum's proposal.[36] Blum agreed to modify some aspects of the proposed sculptures due to safety concerns, but a local developer, Stephen Tebo, threatened a ballot initiative if the arts commission and the parks board refused to reverse their conditional approval for the piece. In the end, the park board, which had the final say, bowed to "community opposition" and withdrew approval.[37]

In the aftermath, Manning pointed out that none of the opponents had attended any of the commission meetings. Although the panel "had expected disagreement" she said, they hadn't "expected hostility."[38] That's because,

Melissa Gordon, Untitled, 2012, Euclid Avenue/16th Street Pedestrian tunnel. Photo: Gayl Gray.

Kristine Smock, Skunk Creek, Broadway-Baseline Underpass. Photo: Collin Heng-Patton.

one irate speaker said at a city council hearing, the public thought the commission "would do the right thing. We no longer trust you in a way we did when we didn't come," he said.[39]

The failure of the "Three Pavilions" proposal led in 1984 to a reassessment of the selection process by the arts commission and the parks board: In the future, the BAC would make "decisions based on the compatibility of the piece with the recreational function, historic character, and natural features [of the site, and] on the sculpture's representation of a broad variety of tastes" within the community.[40] The Parks and Recreation Advisory Board would hereafter consider "safety, maintenance, and site suitability." And, there would be plenty of opportunity for public input at each stage of the process. The big change was that *artworks* rather than *artists* were chosen, based on models or sketches submitted for joint review by the BAC and the parks board.[41] Kliger, writing in 1993, observed that public reaction to the Blum selection affected Boulder's public art long-term. The commission and the parks board had made "a good-faith effort" to bring public art to Boulder, but

Maria Neary and Ken Bernstein, "African Patterns," 2010, 30ᵗʰ Street. Photo: Gayl Gray.

their efforts resulted in tremendous controversy and the embarrassing cancellation of a large project. In response, they have become very cautious, attempting to make every effort to please a greater segment of the Boulder public. Granted, the new selection process . . . has resulted in much less controversy. However, the selected pieces have not been any more site-specific or public than Andrea Blum's piece. In fact, oftentimes the artistic quality of the chosen pieces has been poor to just plain innocuous.[42]

The BAC and the parks board had envisioned a curated sculpture garden — which Blum's proposed work would anchor — where new works would be added to harmonize with the site as it developed. Instead, Boulder found itself in the embarrassing position of returning the NEA grant funds, with a sculpture garden that many now view as a collection of "plop art" placed without due consideration.

Counting on Functional Art

The arts commission responded to the Blum debacle by renewing efforts to find a permanent funding source. Percent-for-art programs gained steam nationwide during the 1980s, and the Boulder Arts Commission floated numerous proposals although, until 2015, it never got city council approval for permanent funding. Within months of rejecting the Blum sculpture,

Ken Bernstein, "Goose Creek Mural," 2011, 30ᵗʰ Street and Mapleton Avenue. Photo: Gayl Gray.

the BAC and the parks board began meeting with the city council to draft an Art in the Park ordinance, adopted in 1985, which set aside 1 percent of annual revenues for art in all Parks and Recreation capital projects. A later 0.15 percent sales tax increase approved by voters in 1993 allocated 4 percent to the arts; when renewed in 1998, city council doubled the arts allocation.[43]

The Transportation Department, which had found that murals on pedestrian/bike tunnels "greatly reduced graffiti and the need for repainting," also joined forces with BAC. The new director, Dave Baskett, wanted to find "appropriate sculptures" for the city's medians, because landscaping was "ineffective and expensive" and, in a town with a high rate of population turnover, "sculptures were beneficial as landmarks."[44] Baskett recommended his department and BAC establish a cooperative sculpture selection process.

Donna Gartenmann, manager of Boulder's arts programs from 1988-2010, credited these partnerships with "how, without a dedicated budget, we moved public art forward."[45] Throughout the 1990s, the arts commission and its departmental partners — later including Public Works, Greenways, and others — added murals to city pools, sculptures to traffic circles, and benches and memorials in city parks. And they also grappled with thorny issues like liability and maintenance and how to handle public donations of artworks, which required aesthetic decisions as well as determining where to place them and how to preserve them.

In an effort to provide leadership and resources, BAC produced its first Cultural Master Plan in 1992 to provide "a blueprint for maximizing cultural resources."[46] It partnered with the Arts and Humanities Assembly of Boulder (now the Boulder County Arts Alliance) to support funding for advocacy and education and created alliances between the arts and business communities. Links were further strengthened in 2000 when the updated Boulder Valley Comprehensive Plan included policies directing the city and county to incorporate artistic elements in public projects whenever possible.[47] An updated 2005 Cultural Master Plan addressed a variety of issues, from venues to public engagement, to the perennial need for dedicated funding.

The big lift came in the late 1990s as Boulder dealt with housing and traffic issues resulting from its burgeoning population, when various transportation and development budgets became a major source of funding for public art. The Twenty-Eighth Street Project (1999-2013) established the pattern, remaking U.S. Highway 36, which becomes 28th Street as it passes the University of Colorado campus on the west. As Boulder's gateway, planners thought it should reveal the city's unique qualities. So, in addition to necessary improvements — new bridges, removal of telephone poles, better lighting, and improved

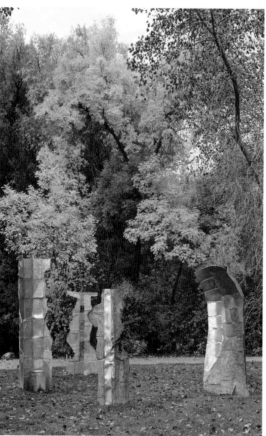

Bill Vielehr (1945-2014), "Human Glyph," 2001, 3-D drawings, cast wax and fabricated aluminum. Photo: Gayl Gray.

Randi Sue Eyre, Spruce Pool mural. Photo: Gayl Gray.

pedestrian and bike access — it needed to be welcoming. Turns out the money for art was under their noses. The project had budgeted for steel for railings and concrete for pedestrian tunnels and retaining walls and sidewalks. City planners calculated the engineering, logistics, and materials costs, and the remaining balance "was pretty much what we could offer an artist as a stipend," Gartenmann said.[48]

Gartenmann credits the success of the Twenty-Eighth Street Project for "opening doors to other projects," as planners realized they could incorporate aesthetics into their budgets.[49] The upshot was a series of projects and master plans specifically linked to public art — a 2009 City of Boulder Transit Village Area Public Art Master Plan; a 2008 Parks and Recreation Public Art Policy; and a Pedestrian and Bicycle Information Center case study. The latter demonstrated Twenty-Eighth Street's "uses [of] functional art, water-wise landscaping and improved signage and landmarks to draw pedestrians, bus riders, and bicyclists . . . between work, school, shops, and home."[50] What these plans have in common is a shared understanding of the centrality of public participation in the selection, not only of each work, but where each was placed and how it might affect the people who used these various locations.

George Peters, one of many artists who worked on these projects, said the process can test your patience: They "come together over a long time and are large in scale. You need to understand the process" and have other projects in the works, he said.[51] The Twenty-Eighth Street Project process involved a design committee talking with multiple communities, from business owners and college students, to bus and bike riders, to motorists and local residents. Once several designs were agreed to, the parties reconvened to hash out likes and dislikes, arriving at a final master plan. Many don't consider these works as public art; rather, they look at them as "merely aesthetic" decoration on a bridge or underpass or bus stop. Yet, this kind of community dialogue, asking the artist to respond to a specific site and surveying the desires of the people who use it, in effect creates the resulting artwork and often transforms public attitudes.[52]

That's why it's so difficult to explain the failure of the "YES!" sculpture in 2014: The lengthy work on Twenty-Eighth Street and other projects had succeeded based on a community collaborative model. The selection process for "YES!" — part of a renovation of the main library — adhered to guidelines spelled out

A mural showing wolves decorates the wall of an underpass along Boulder Creek.
A search did not reveal the name of the artist. Photo: Laura Marshall

in the city's 2008 Interim Public Art Policy, requiring a selection panel comprising local art experts, review of the process by the library and arts commissions and approval by the city manager. The panel chose "YES!" proposed by artists Rosario Marquardt & Roberto Behar [R&R Studios] of Miami, from 367 applications. The sculpture featured four bright red, free-standing aluminum letters, with inner lighting visible through perforations in the surface. It was to be installed outside the curved glass wall north of the library's main entrance.

The artists said YES! reflected their interpretation of Boulder's "free-spirited personality," and panel and BAC member Felicia Furman said she thought the public would find it "totally accessible" and would "make you smile."[53] Not everyone smiled, according to the *Daily Camera*'s headline the next day: "Some Boulder residents just say no to big red 'YES!" The objections ranged from the font and color of the letters, to the cost — $150,000, money banked from unclaimed arts commission funds, not all of which was allocated to the sculpture — to the artists, who weren't local. Others worried the size of

the letters would obscure the view of Boulder Creek.[54]

It didn't appear to be a widespread revolt. The *Daily Camera* reporter's interviews totaled "more than a dozen library patrons" in a story three days after the announcement,[55] and the city's public relations office received phone calls from "somewhere between 100 and 150 people" complaining about the piece.[56] Still, it was déjà vu all over again, echoing many of the same objections in 1983 to Andrea Blum's "Three Pavilions." Two weeks after the selection, the city council called a halt. "The 'YES!' artwork will not move forward as planned," city manager Jane Brautigam said, and the city's public art policy would be revised "to fully achieve the community's vision for public art."[57]

Getting to Yes: The Community Cultural Plan

The Community Cultural Plan, already in the works in 2014, became the vehicle for rethinking the selection of public art, beginning with a series of workshops and panel discussions.[58] Matt Chasansky, hired in 2013 as Arts + Culture manager, hoped the process would reveal how best to find out what the community wanted. He started at the "conceptual level" designating

several specific locations and soliciting ideas from the public before any plans were made or artists chosen. The challenge involved striking a balance between "really populist" works and a "curated collection that generates interest and notoriety," Chasansky said. Throughout 2015, Arts + Culture sponsored numerous public forums, culminating in a variety of temporary installations and interactive events that appeared to please the public.[59] The resulting Community Cultural Plan, presented to the city council in November, "reflected the priorities and goals expressed by Boulder residents and artists," Chasansky said.[60] The plan promised to "reinvent" the public art program, emphasizing extensive public interaction in the process of selecting artworks, with the goal of "variety and diversity, not necessarily popular taste."[61]

Significantly, the plan also called for quadrupling spending on the arts by 2024, financed by a new dedicated tax — if voters and the city council agreed. It would replace the temporary 0.3 cent-per-dollar increase in the city's sales-and-use tax passed in 2014 designated for Community, Culture, and Safety. Most of those funds were earmarked for capital improvements over the three-year life of the increase, but $600,000 was set aside for public art.[62] That effectively doubled Arts

+ Culture's 2016 grant funds to $450,000 and added $50,000 for programming and a new employee.[63] The cultural plan also proposed that the city "investigate alternative sources, such as a dedicated tax or fee or mandates on private development," as well as public capital improvement projects.[64] It estimated that annual funding would increase to $1.3 million by 2018, rising to $2 million by 2024, if voters approve a ballot initiative in 2017.

What set this cultural plan apart from earlier efforts was its emphasis on "civic dialogue" that acknowledges the arts' impact on the economy, the environment and the diversity of the community. Earlier cultural plans had included policies and guidelines for engaging the public in the selection process, but the 2015 plan broadened outreach to the very beginning point, discovering the local community's wants and needs. Only after this contact is complete does the search for the aesthetic object begin. As the plan notes: "Great public art programs are a balance between the process and the results," and officials and public alike need "to be confident in this measure of success." In the end, all must recognize that "no work of art will be universally loved."

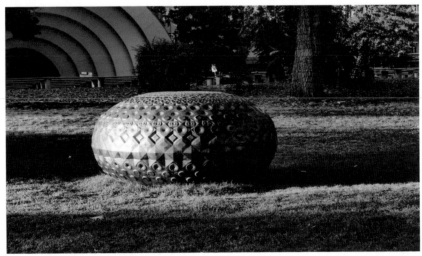

"TORUS," by Mars-1, aka Mario Martinez, n.d., temporary sculpture in Central Park. On loan to the City of Boulder from the Alexander Chambers Gallery. Photo: Laura Marshall

Notes

1 Silvia Pettem, "Boulder County History: 'Minnie and Jake' stirred controversy at Boulder High," *Daily Camera*, Sept. 9, 2000.

2 Carol Kliger, *A Public Art Primer for Artists of the Boulder-Denver Area.* Funded by grants from Neodata Endowment for the Arts and Humanities, and the Boulder Arts Commission, an agency of the Boulder City Council, 1993. 9.

3 Erika Doss, *Spirit Poles and Flying Pigs: Public Art and Cultural Democracy in American Communities* (Washington, D.C.: Smithsonian Press, 1995), 21.

4 Kliger, *A Public Art Primer.*

5 Doss, *Spirit Poles*, 2.

6 Kliger, *A Public Art Primer*, 10.

7 Doss, *American Art*, 79.

8 Sylvia Pettem, "Boulder County History: Courthouse statue honors Civil War soldiers," *Daily Camera*, June 6, 2002.

9 Joan Tumblety, *Memory and History: Understanding Memory as Source and Subject* (London: Routledge, 2013), 2.

10 Greg Dickinson, Carole Blair, Brian L. Ott, *Places of Public Memory* (Tuscaloosa, AL: U Alabama Press, 2010), 6.

11 Boulder City Council Resolution No. 29, Series of 1967.

12 Personal interview, Carl Worthington, March 19, 2016.

13 Boulder City Council minutes, 1968.

14 Boulder City Council Resolution No. 64, Series of 1972.

15 Steve Hoffman "'The Sculpture' is rusting away," *Daily Camera*, May 28, 1977.

16 Jennifer Heath, "Friends remember creator of controversial sculpture," *The Sunday Camera*, April 6, 1986

17 Worthington, personal conversation, March 19, 2016.

18 Sally McGrath, "Panel takes no action on moving, removing intersection sculpture," *Daily Camera*, May 13, 1986.

19 Charlie Brennan, "Unpopular sculpture may get new home for art lovers' sake," *Rocky Mountain News*, March 14, 1986.

20 Hoffman, *Daily Camera*, May 28, 1977

21 McGrath, *Daily Camera*, May 13, 1986.

22 Brennan, *Rocky Mountain News*, March 14, 1986.

23 Boulder Arts Commission meeting minutes.

24 Ibid.

25 Juliet Wittman, "Move it, panel says of sculpture," *Daily Camera*, May 22, 1986.

26 Boulder Arts Commission meeting minutes, September 2014. In addition to the cost of restoring it, experts noted its poor condition and cited safety issues after several decades of general neglect by the city. Janet Heimer, Field's widow, asked about relocating the piece, but both Parks and Recreation and Transportation had turned it down for their managed lands.

27 Mitchell Byers. "Boulder removes 41-year-old sculpture from Airport Road, *Daily Camera*, August 26, 2015; James Hough, "Destroying Sculpture is a Disgrace to Boulder," *Daily Camera*, Sept. 4, 2015.

28 Telephone interview with Donna Gartenmann, March 15, 2016.

29 Boulder Arts Commission meeting minutes, 16 June 1982.

30 Larry Caldwell, "9 Residents Form Arts Foundation: Sculpture Garden Is First Project," *Daily Camera*, December 5, 1982.

31 Doss, *Spirit Poles*, 64.

32 "Easy Does It on Sculpture Garden," *Daily Camera*, December 20, 1982.

33 Donna Joy Newman, "Snub Upsets Boulder Artists," *Daily Camera*, December 8, 1982.

34 Donna Joy Newman, "New York Sculptor Picked for City Art Project," *Daily Camera*, December 10, 1982.

35 Boulder Arts Commission meeting minutes, May 18, 1983. Mike Stone, "Planned artworks for Boulder called 'Outhouses,'" *Rocky Mountain News*, May 16, 1983.

36 Donna Joy Newman, "NO! Sculpture Poll's Overwhelming Verdict Proves Art Has Become Boulder's Latest Conversation Piece," *Daily Camera*, May 1, 1983.

37 Mike Stone, "Public ire topples sculpture plan for Boulder Park," *Rocky Mountain News*, June 22, 1983.

38 Stone, "Planned artworks."

39 Mike Stone, "'Too late' to block sculpture at Boulder park," *Rocky Mountain News*, 20 May 1983.

40 Kliger, *A Public Art Primer*, 15.

41 Brighid Kelly, "Council to decide on guidelines for city art selection," *Daily Camera*, April 3, 1984.

42 Ibid.

43 Gartenmann, March 15, 2016.

44 Boulder Arts Commission meeting minutes, September 19, 1984.

45 Gartenmann, March 15, 2016.

46 Boulder *Arts Commission, Cultural Master Plan, Update 2005*, 7.

47 Ibid., 12.

48 Telephone interview with Donna Gartenmann, April 15, 2016.

49 Gartenmann, April 15, 2016.

50 "28th Street Multi-Modal Improvements," PBIC Case Study – Boulder, CO. n.d. 1.

51 Telephone interview with George Peters, April 12, 2016.

52 Mark Hutchinson, "Four Stages of Public Art," Third Text 16: 4, 429-438, 2002.

53 "Public Art Project Selection Announced for Main Boulder Public Library Renovation," press release, City of Boulder, April 22, 2014.

54 Alex Burness, "Library art is in the books, but critics have a word or two," *Denver Post*, from *Daily Camera*, April 25, 2014.

55 Ibid.

56 Erica Meltzer, "Boulder nixes big red 'Yes!' outside library as civic leaders revisit public art process," *Daily Camera*, May 5, 2014.

57 Ibid.

58 Erica Meltzer, "Boulder 'sets stage' for public art after 'YES!' rejection," *Daily Camera*, July 24, 2014.

59 "Boulder 'Public Displays of Affection' grant winners surprise passers-by with flowers," *Daily Camera*, September 26, 2014.

60 Erica Meltzer, "Boulder artists push for plan to fund, support public art," *Daily Camera*, November 16, 2015.

61 City of Boulder Library & Arts Department, Office of Arts + Culture, *Community Cultural Plan*, November 17, 2015. 22.

62 Ballot Title for Issue 2A, "Temporary Tax Increase for Community, Culture and Safety," Ordinance No. 7983, adopted August 19, 2014.

63 Meltzer, "Boulder artists push," November 16, 2015.

64 Community Cultural Plan, November 17, 2015. 57.

Charles Moone (d. 2010), "Re/Opening," 1998, oil pastel. Collection of Sally Elliott.

Suzy Roesler (1942-1999), Untitled, 1978, acrylic on paper. Collection of Margaret Neumann.

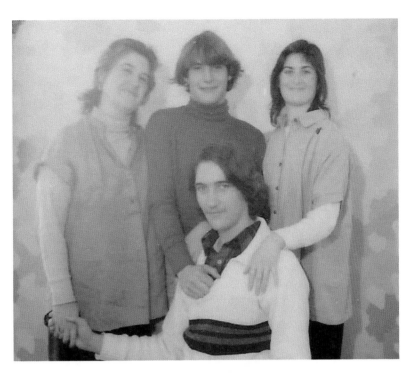

The Queen Bee of Boulder Culture
A Tribute to Karen Ripley Dugan
1939-2015

Jennifer Heath

When a potentially splendid, potentially harebrained idea like creating a community-wide series of events to celebrate Boulder's art history arises, the first person to call would naturally be Karen Ripley Dugan. Without her, much of what we can appreciate about the city today might not even exist.

So, in 2014, Karen was the first to join the curatorial and steering committee for *Celebration! A History of the Visual Arts in Boulder* (HOVAB). Despite her fragile health, she worked diligently to help us identify artists, venues, funders, and more. She knew everyone and had strong, deep bonds with hundreds of people all over the country. This is likely because, as her friend artist Priscilla Cohan said, "she took the time to know people and care about their environments. She was what I

love most about Boulder. Entrepreneurial spirit. Awake. Curious. A most generous friend and mentor. It was a pleasure to see how important her friendships were to her."[1]

In the too-brief period she worked with our little HOVAB committee, Karen was often in dire pain, but never once did she give up on her commitment; never once did she complain. She was always smiling.

Indeed, Karen Ripley Dugan was probably born smiling — on November 11, 1939 in New Jersey. In 1957, she came west to attend the University of Colorado-Boulder. She said that when she crested the hill overlooking Boulder, she knew this was "the place" and that she would never return to the East Coast.

Boulder suited her profoundly independent spirit. "With all due respect, I say that she

Above: Karen Ripley Dugan with her children (clockwise), Derek, Nike, and Rafael VanArsdale, 1981, posing in front of George Woodman's Criss-Cross painting, "Parma." Photo by Cheri Belz.

possessed an unadulterated hippie spirit, she had a keen interest in literature, philosophy, poetry and in the weird and beautiful," Cohan said. "She was fierce and unruly."

At CU, Karen married Robert VanArsdale and had three children, daughter Nike and sons Rafael and Derek. "Much of her life was rooted in her children," Derek's wife Melissa VanArsdale said. "They share love of culture, from dance to fine art. Even Nike's wardrobe is like a painting, where she expresses her lively personality with colors that seem to dance to her own beat, as did Karen. Raphael embraced the spiritual side of Karen. They both emit the light of a higher presence that guides them. And for Derek, it's his passion for gardening."

The first time VanArsdale met Karen, "No sooner were we introduced, than Karen was directing me in the kitchen to chop fresh vegetables from her garden. I quickly learned that Karen was the mastermind of direction. And one could never simply bow out of their assigned task. Prepping meals to pulling weeds, these became the norm for our visits. She quickly realized that my thumbs are not green — I could not distinguish a weed from a vegetable or flower. That didn't end my days in her garden: Karen simply changed my role by directing me to cut fresh flowers."

When our HOVAB committee met at Karen's beautiful house, I somehow ended up making cucumber sandwiches under Karen's supervision. Doing so sent me back to my childhood and my mother's tea gatherings (thank heavens Karen didn't also direct me to polish the silver!). The sandwiches were terrific — I've been making them every summer since. No one else I know in Boulder serves cucumber sandwiches, so I wondered if they were perhaps a throwback to Karen's youth, her debutante

days in New Jersey, her early education at Rosemary Hall Boarding School, where — no surprise — she was thought to be a natural leader.

Karen's second marriage was to Jerry Hodge and together they established the Sun Sign Center, which served as a gallery and all-around art center. "The woman I knew was always involved in a creative endeavor," Cohan said. "Writing a book, a story, beading, painting, gardening, collaborating. She surrounded herself with beauty and wished no less for anyone else."

Karen initiated numerous citywide summer art festials, including Artfeast. Martin and Taffy Kim Poster Collection, "Artfeast," n.d., poster. Courtesy of Boulder History Museum/Museum of Boulder.

After a second divorce, Karen returned to CU, where she completed a degree in Humanities. She spent the rest of her life promoting and advocating for the arts. "Karen was devout about the value of art to a community. Culture was her love and passion," Cohan remembered.

In 1978, Karen became the first paid director of the Boulder Arts Center and renamed it the Boulder Center for the Visual Arts (now the Boulder Museum of Contemporary Art). "One of the most memorable Boulder Arts Commission meetings in my 23-year journey with the City of Boulder was a joint meeting with the commission and the BCVA," Donna Gartenmann, retired BAC director, said.

"I was new to the Boulder art scene and had only held my position for a couple of months. The tension in the room was high. All these years later I can't tell you what the tensions were, but I can tell you that I was transfixed as this force of nature spoke so ardently and eloquently about the mission and importance of the BCVA. This was my introduction to Karen. Over the next two decades, it was my privilege to work beside one of Boulder's most devoted arts supporters."

One who regularly wrangled with Karen was photographer Richard Varnes: "I worked/fought/laughed with Karen in 'Arts' affairs as I was liaison (from the Boulder Arts Commission) to the BCVA Board in the 1980s. Karen could be infuriating. She defined the combative Scorpio. Yet she was a powerful and positive force on the Boulder art scene, especially in the 'hay day' of the visual arts (before so many artists left town to find affordable studio space)."

Karen embraced many boards and commissions, "sharing her vast experience with them," Gartenmann said. "There were too many to name and no limit to her passion." Her numerous honors included a *Daily Camera* Pacesetter Award and the Boulder Chamber of Commerce's Women Who Light Up the Community Award.

Once the BCVA was solidly established,[2] Karen retired. "Karen planned to spend time writing, Gartenmann said. "It didn't take long before she realized she had so much more to offer to the arts community. Marcelee Gralapp, then Boulder Public Library Director, brought Karen on board and handed her the baton to expand the library's cultural programming. Karen took the concert series to new highs. The film program became a city treasure. The Canyon Gallery was and still is one of the best venues to experience local and national artists. Performances for the literary arts, dance, children's programs, and community issues all became part of Karen's vision for community offerings. She believed everyone had the right to experience the arts, and the free programming at the library was her vehicle."

"Perhaps our best and easiest collaboration came in the later 1990s to the early 2000s,

BOULDER ARTISTS' GUILD RETROSPECTIVE

A HALF CENTURY OF ART

1925 - 1978

NOVEMBER 9 - DECEMBER 3
Reception: Wednesday, Nov. 8, 7-9 p.m.

BOULDER ARTS CENTER, 1750 13th Street, Boulder, Colorado 80302
Tuesday - Sunday 12-4:30 p.m. Closed Monday.

This retrospective took place in the first year that Karen took over the Boulder Art Center as its first paid director. Martin and Taffy Kim Poster Collection, "Boulder Artists' Guild Retrospective," n.d., poster. Courtesy of Boulder History Museum/Museum of Boulder.

when I was Director of Channel 8 and Karen was Director of Cultural Programming at the library," Varnes said. "Together we presented, recorded, and broadcast many fine concerts."

"She was a shrewd supervisor and director," Ina Russell, a former coworker told the *Daily Camera*. "She knew how to invest people in tasks that they normally would flee from. She knew how to make them think that they were something valuable — and, in fact, they were. Kind of a wizard in that way."[3]

John Tayer, Boulder Chamber CEO, echoed Russell: "I worked with Karen on her various connivings to bring art to the Boulder community. And I was fortunate to get to know her creativity and her strategic mind — but also what a wonderful human being she was, for all of us."[4]

Emblazoned on Karen's library office door, instead of her name, were the words "Queen Bee of Cultural Programming."

It took a certain combination of imperiousness, determination, and ardor to uphold Boulder's reputation as an arts-friendly city (an "arts destination," as some have been fond of claiming), when, in fact, the city has, since the 1990s, become increasingly challenging for artists to live in and make art.

"Just looking at statistics," Tayer told the *Camera* in 2015, "we know that Boulder is a community that appreciates art and culture, but it doesn't make as significant an investment in those areas as you would see in other communities that are similarly respectful of the arts. Karen worked tirelessly to bring resources to the arts community that were appropriate for, and respectful of, the talent that we have available to us."[5]

"The 'Queen Bee,'" Gartenmann said, "opened the door for so many who would otherwise be unable to experience the arts. I often wonder how many people became life-long arts patrons because of Karen. For that, we are forever grateful."

Thus, her commitment to *Celebration! A History of the Visual Arts in Boulder*, which came to fruition a little more than a year after her death in 2015. Thus, Karen's devotion to the exquisite exhibition — her final one — that she curated for HOVAB at the library's Canyon Gallery. Much of the artwork displayed in HOVAB's eighteen venues — including George Woodman's majestic Criss-Cross painting, "Parma" — was loaned from from Karen's collection, at her behest, by Tom Dugan, her partner of many years, who she married in 1992. Right to the last, Karen dedicated herself to illuminating and bringing Boulder arts forward.

"It is impossible to narrow her story into a singular event," Cohan said. "It would be the equivalent of trying to describe a garden by pointing out a single flower.

"She was a star. In my mind, the star on the side of Flagstaff mountain that shines during the winter is Karen's star. It was not built for her or by her, but she inspired that kind of big-hearted beauty."

"When Karen and I started dating and getting to know each other better," Tom Dugan recalled, "she told me that she was from another star. I wasn't sure what to make of that

The annual Boulder Star on Flagstaff Mountain was first lit in December 1947. It is thought that Karen had the idea in 2002 to commission Gayle Crites to create this first of yearly Flagstaff Star holiday cards.

but she was absolutely sincere. After we decided that surgery on her broken neck was pointless and opted for hospice care, we came home for nearly three weeks. Karen got to enjoy being home and was able to say goodbye to many friends and family. "The day Karen died she told me that something felt radically off and that she wouldn't live long. I asked her if that meant I was going to have to cry soon and she gave me one of her wry smiles and nodded. Once she took her last breath, it felt as if she was quickly gone and finally free of the pain she had to suffer for so many years. I don't know if there is anything that persists after the body gives out, but I can't help but wonder if she was on her way back to her star."

Notes

1 Priscilla Cohan's, Donna Gartenmann's, Richard Varnes' and Tom Dugan's comments came via email in response to my inquiries. Melissa VanArsdale memorialized Karen on Facebook on the first anniversary of her death – July 29, 2016. I spotted her homage and asked to include some of it in this essay. She and her husband Derek very kindly agreed. Tom Dugan's is a portion of his talk at Karen's memorial service in November 2015. I thank them all.
2 See Collin Heng-Patton's essay on page 119 of this volume about BMoCA's history, "From a Tumultuous Past Toward an Exhilarating Future: Boulder Museum of Contemporary Art."
3 Charlie Brennan, "Karen Ripley Remembered as a Passionate Voice for the Arts in Boulder," *Daily Camera*, August 11, 2015.
4 Ibid.
5 Ibid.

Selected Bibliography

Anker, Steve, Kathy Geritz, Steve Seid, eds. *Radical Light: Alternative Film and Video in the San Francisco Bay Area, 1945-2000.* Berkeley: University of California Press, 2010.

Argüelles, José A. *Mandala.* Boulder, CO: Shambhala Publications, 1974.

_____. *The Transformative Vision: Reflections on the Nature and History of Human Expression.* Berkeley & London: Shambhala, 1975.

Beckmann, Max, and Barbara Copeland Buenger. *Self-Portrait in Words: Collected Writings and Statements, 1903-1950.* Chicago: University of Chicago Press, 1997.

Brakhage, Stan, and Robert A. Haller, eds. *Brakhage Scrapbook: Collected Writings, 1964-1980.* New Paltz, NY: Documentext, 1982.

_____. *Gertrude Stein: Meditative Literature and Film.* Boulder, CO: The Graduate School, University of Colorado, 1990.

Coel, Margaret. *Chief Left Hand,* Norman, OK: University of Oklahoma Press, 1981.

Cuba, Stan. *The Denver Artists Guild: Its Founding Members.* Denver, CO: History Colorado, 2015.

Daniel, Joseph. *A Year of Disobedience and a Criticality of Conscience.* Boulder, CO: Story Arts Media, 2013.

Davis, William E. *Glory Colorado! A History of the University of Colorado 1858-1963.* Boulder, CO: Pruett Press, 1965.

Doss, Erika. *Spirit Poles and Flying Pigs: Public Art and Cultural Democracy in American Communities,* Washington, D.C.: Smithsonian Press, 1995.

Eve Drewelowe. Iowa City, IA: University of Iowa School of Art and Art History, 1988.

Elbows and Tea Leaves, Front Range Women in the Visual Arts (1974-2000). Boulder, CO: Boulder Museum of Contemporary Art, 2000.

Nina Felshin, ed. *But is it Art? The Spirit of Art as Activism.* Seattle: Bay Press, 1995.

Gayley, Mary. *The Grand Assembly: The Story of Life at the Colorado Chautauqua.* Boulder, CO: Colorado Chautauqua Association, 2015.

Gray, Gayl. *Vintage and Artistic Homes of Boulder.* Boulder, CO: Johnson Books, 2011.

_____. *Artscape Boulder, CO.* Boulder, CO: Geneva Park Press, 2015.

Kliger, Carol. *A Public Art Primer for Artists of the Boulder-Denver Area.* Boulder, CO: National Endowment for the Arts and Boulder Arts Commission, 1993.

Lippard, Lucy R. *Mixed Blessings: New Art in a Multicultural America.* New York: The New Press, 1990.

_____. *The Lure of the Local: Senses of Place in a Multicentered America.* New York: The New Press, 1998.

Pettem, Sylvia. *Positively Pearl Street: A Chronicle of the Center of Boulder, Colorado.* Ward, CO: The Book Lode, 2007.

_____. *Boulder: A Sense of Time and Place,* Longmont, CO: The Book Lode, 2000.

Sibell Wolle, Muriel. *Stampede to Timberline.* Denver, CO: Sage Books, 1949.

Singerman, Howard. *Art Subjects: Making Artists in the American University.* Berkeley: University of California Press, 1999.

Smith, Phyllis. *A Look at Boulder: From Settlement to City.* Boulder, CO: Pruett Publishing Company, 1981.

Swith, Kirsten. *Painting Professionals: Women Artists & The Development of Modern American Art, 1870-1930.* Chapel Hill: University of North Carolina Press, 2001.

Torrence, Gaylord. *The Plains Indians: Artists of the Earth and Sky.* New York: Skira Rizzoli, 2014.

Transit of Venus: Four Decades of Front Range Women in the Visual Arts. Denver, CO: Redline Gallery, 2014.

Trenton, Patricia, ed. *Independent Spirits: Women Painters of the American West, 1890-1945.* Berkeley: University of California Press, 1995.

Tumblety, Joan. *Memory and History: Understanding Memory as Source and Subject.* London: Routledge, 2013.

Virginia True. Santa Fe, NM: Zaplin Lambert Gallery, 2001.

Visiting Artist Program, 20th Anniversary Show, January 15-February 22, 1992: Celebrating 20 Years of Program Excellence. Boulder, CO: University of Colorado-Boulder, 1992.

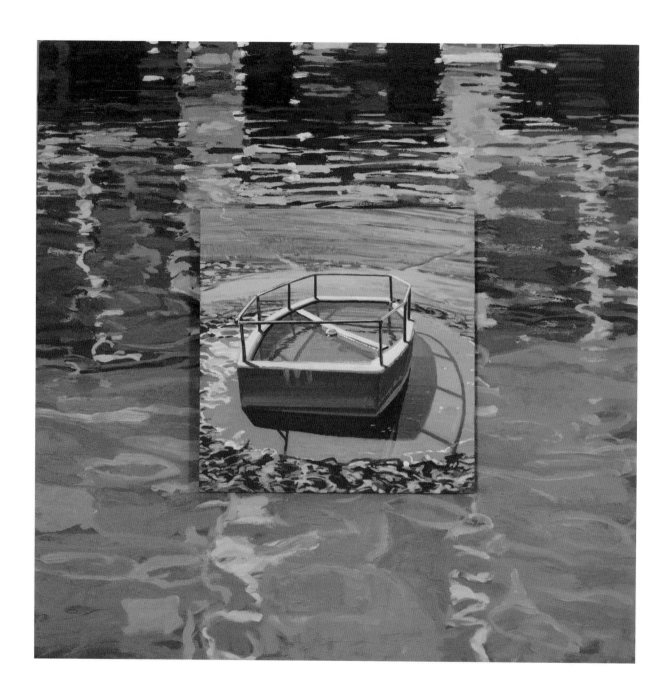

Jim Colbert (1946-2007), "Lost at Sea," 1993, oil on canvas and masonite. Collection of Evan Colbert.

About the
Artists,
Curators,
and
Contributors

Artists' Biographies

KEITH ABBOTT (HOVAB @ Naropa) taught two writing workshops one semester a year at Naropa University from 1989 to 1994. His publications include the novels *Gush, Rhino Ritz,* and *Mordecai of Monterey* and the short story collections, *Harum Scarum, The First Thing Coming,* and *The French Girl.* He studied with visiting Chinese and Japanese *sumi* brush masters and became part of Naropa's Visual Arts faculty in the 1990s, where he taught calligraphy, painting, and drawing.

KEN ABBOTT (HOVAB @ Highland City Club) grew up in Denver and received his MFA in Photography from Yale University in 1987. He was principal photographer for the CU-Boulder Office of Public Relations until 2002, and currently lives in Asheville, NC. Last year he published his first book, *Useful Work: Photographs of Hickory Nut Gap Farm.*

ZOA ACE (HOVAB @ Firehouse Art Center and Mr. Pool Gallery) moved to Boulder from Chicago in 1972 and has lived in Berthoud since 1985. She is represented in the permanent collection of the Denver Art Museum and has been active in the arts both locally and internationally for the past several decades.

ELIZABETH ACOSTA (HOVAB @ Naropa) is an Adjunct Faculty member in the Visual Arts Department at Naropa University, and has been in Boulder since 1995. Her experience spans the fields of education, the arts, healthcare, retail, and design.

POLLY ADDISON (HOVAB @ Canyon Gallery) moved to Boulder in 1953. She received her BA in Fine Arts at CU-Boulder in 1957. She has exhibited at the BCVA and The Dairy Arts Center. She was on an art advisory committee at the DAM and has been a major collector of art with her husband Mark Addison since 1960.

GINA ADAMS (HOVAB @ Naropa) holds a BFA from the Maine College of Art and MFA from the University of Kansas, where she focused on Visual Art, Curatorial Practice, and Critical Theory. Her work is exhibited extensively throughout the U.S. and resides in many public and private collections.

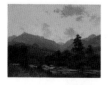

CHARLES PARTRIDGE ADAMS (1858-1942) was a largely self-taught American painter who is widely considered to have been Colorado's finest landscape artist. He is best known for his stunning views of snowy mountain peaks in early morning or sunset light, or wreathed in storm clouds, and for his luminous sunset and twilight paintings of the river bottoms near Denver.

ROBERT ADAMS (HOVAB @ BMoCA) chronicles the American West. He has published more than 25 books of his photographs, is the recipient of Guggenheim and MacArthur Foundation Fellowships, the Hasselblad Foundation Award, the International Award in Photography, and has been elected to the American Academy of Arts and Letters. His work has been exhibited and collected by museums worldwide, such as the Denver Art Museum, the Philadelphia Museum of Art, the J. Paul Getty Museum, the Museo Nacional de Arte Reina Sofía, Madrid, and the Jeu de Paume, Paris.

SUSAN ALBERS (HOVAB @ Rembrandt Yard and First Congregational Church Gallery) came to Boulder in 1974 and found a rent-free studio in an abandoned school house. She has shown art in Boulder galleries, taught painting in public and private schools, as well as in her studio and participated in Open Studios since the late '90s.

TYLER ALPERN (HOVAB @ The Dairy Arts Center and Naropa) has lived in Boulder, painting and teaching art, since 1988. He uses rhythm and patterns in paint to express the wonders of our environment.

MICAELA AMATEAU AMATO (HOVAB @ The Dairy Arts Center) lived in Boulder from 1969 to 1978. She graduated from the CU-Boulder with an MFA. Her solo shows have been reviewed in *Artforum, Art in America*, the *New York Times*, and the *Los Angeles Times*. She has taught feminist art history and studio arts for 38 years, is a professor emerita from Penn State University, and continues to exhibit, curate, and write.

MARK AMERIKA (HOVAB @ The Dairy Arts Center) has exhibited his work internationally at venues such as the Whitney Biennial of American Art, the Denver Art Museum, the Institute of Contemporary Arts in London, the Walker Art Center, and the National Museum of Contemporary Art in Athens, Greece, which hosted his comprehensive retrospective exhibition, *UNREALTIME*. In 2009, Amerika released *Immobilité*, generally considered the first feature-length art film ever shot on a mobile phone. He is a Professor of Art and Art History at CU-Boulder.

JOAN ANDERSON (HOVAB @ Canyon Gallery) is a painter, a meditator, and an educator. She is engaged in drawing, sculpture, textiles, leather, graphic design, and lettering. She teaches painting privately since retiring from many years teaching at Naropa University. She publishes *AnOAn*, her magazine dedicated to the art of the sketchbook.

VICKI ANDERSON (HOVAB @ Canyon Gallery) was welcomed into Boulder's creative niche in 1972. Her clay sculpture led to a Lodestone Gallery partnership and she made many sculptural cloth animal costumes for the Colorado Music Festival. She founded "The Story Gleaner," a performance group for children with after-show art-making workshops at museums, schools, and libraries. Her participatory art has been available at the Denver Art Museum for many years.

SUZANNE ANKER (HOVAB @ Macky Auditorium) was born in Brooklyn, NY, and received her MFA from CU-Boulder, where she also taught. Selected collections include Oakland Art Museum, Denver Art Museum, Williams College Museum of Art and the New York Public Library. Anker lives in New York City.

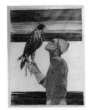

JOE B. ARDOUREL (HOVAB @ Rembrandt Yard) (1931-2015) was born in Boulder, a descendent of early Boulder County settlers. He was largely self-taught, specializing in woodcuts and serigraphs. His work is included in the public collections of the Brooklyn Museum, the Smithsonian Institute, the Dallas Museum of Fine Art, The Boston Public Library, and the U.S. State Department.

JERRY ARONSON (HOVAB @ Boedecker Theater) is an independent filmmaker, producer, director, and film instructor, who has taught filmmaking at Chicago's Columbia College and the University of Illinois and, in 1973, was instrumental in creating the Film Production Department at CU-Boulder. In 2006, he won the CU Award for Teaching. In 1978, his short documentary, *The Divided Trail: A Native American Odyssey* was nominated for an Academy Award. (Image: Buffy St. Marie composing the soundtrack for *The Divided Trail*.)

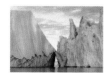

JAMES BALOG (HOVAB @ BMoCA), a Boulder resident since the mid-1970s, has broken new conceptual and artistic ground on one of the most important issues of our era: human modification of our planet's natural systems. His "Extreme Ice Survey" is featured in the award-winning documentary, *Chasing Ice*. He is the author of eight books; his photos have been published in major magazines, including *National Geographic*, and exhibited in museums and galleries worldwide.

PAUL BARCHILON (HOVAB @ The Dairy Arts Center) was born in Boulder in 1965 and specializes in Moroccan art, creating his own patterns that have 1,300 years of tradition behind them. His work is informed both by his childhood visits to Morocco and his heritage as a Sephardic Jew.

BARBARA BASH (HOVAB Book Arts @ Boulder Public Library and Naropa) began her long, award-winning career as a natural history illustrator and writer while living in Boulder, where she taught at Naropa University from 1979 to 1987. Her most recent book is *True Nature: An Illustrated Journal of Four Seasons in Solitude*. She now lives in the Hudson Valley, NY.

JUDY SCHAFER BATTY (HOVAB @ Firehouse Art Center) moved to Longmont in 2012. She began working with stained glass in 1971, after taking an adult education class at the local community college. She works in the original Tiffany style, with copper foil that allows for greater flexibility and a delicacy of line.

BARBARA YATES BEASLEY (HOVAB @ First Congregational Church Gallery) was born in Boulder and raised in the mountain community of Sugarloaf before moving back to Boulder as an adult. Her fascination with animals and a love of fabric and color have guided her artistic career.

SARAH C. BELL (HOVAB Book Arts @ Boulder Public Library) grew up in Boulder's creatively nurturing cradle, going on to publish three of her own books under the title *The Urban Fairytales*. She holds a BFA in Fine Art and an MFA in Illustration, and works as a freelance illustrator in San Francisco.

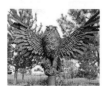

ROBERT BELLOWS (HOVAB Selected Outdoor Art) has been a Boulder sculptor since 1972. Among other things, he makes large scrap-iron sculptures and hand-crated gates. He is self-taught and "always learning." His 8-foot Iron Rooster can be seen in front of Alfalfa's Market at Arapahoe and Broadway. His project to honor war veterans is called The Warriors' Story Field.

ANGELA BELOIAN (HOVAB @ Firehouse Art Center) has contributed to the arts in Longmont since 2001. She was involved in the inaugural Longmont Open Studios. Her designs were used for Art Walk and Rhythm on the River and she has co-curated exhibits at the Firehouse and at Muse Gallery.

LEE BENTLEY (HOVAB @ First Congregational Church Gallery) came to Boulder from Kalamazoo, MI, in 1976. Her first painting exhibition was in Italy in 1973. She holds an MA in Psychology from Naropa University and was an art therapist and a teacher in both Michigan and Colorado. She organized the multicultural mural at San Juan del Centro.

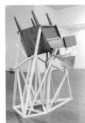

MIKE BERNHARDT (HOVAB @ Firehouse Art Center) earned his MFA in Studio Art from CU-Boulder in 2009. He has lived in Longmont since 2006, making proposal drawings and sculptures about innovation and hopefulness in his home studio. He showed his work at the Firehouse Art Center in 2015 during the Ins & Outs sculpture show.

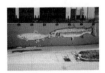

KEN BERNSTEIN (HOVAB Selected Outdoor Art and First Congregational Church Gallery) makes murals, mosaics, paintings, and sculptures that have been chosen for numerous national art-in-public-places projects, and are in private and corporate collections both nationally and internationally. In 2007, he received the Milash Award for Painting and the Federal Highways Administration's Exemplary Human Environment Initiative Award.

TREE BERNSTEIN (HOVAB Book Arts @ Boulder Public Library), see Catalogue Contributors, below.

NORENE BERRY (HOVAB @ First Congregational Church Gallery) was an artist in Boulder for many years before moving to New Mexico in the late 1990s.

ELIZABETH BLACK (HOVAB @ BMoCA; HOVAB @ Rembrandt Yard) and photographer husband Christopher Brown have cultivated beauty in North Boulder for 30 years. A former river guide, Black paints oils, and explores human interaction with stunning western landscapes. She is represented by Mary Williams Fine Art in Boulder and Act One Gallery in Taos.

ANNE BLISS (HOVAB @ First United Methodist Sanctuary Gallery) has been involved with textiles since early childhood. She spins, dyes, weaves, quilts, embroiders, embellishes fabrics, designs clothing, and teaches. She is the author of several books on natural dyeing, including *North American Dye Plants*, is former editor of *Spinoff* magazine and a contributor to many textile arts publications.

BETSY BLUMENTHAL (HOVAB @ First Methodist Sanctuary Gallery) earned an MFA in Textiles from Indiana University and co-authored *Hands on Dyeing*. She has taught many workshops at conferences and elsewhere across the U.S. She uses a rich palette of hand-dyed yarns to create imaginary abstract landscapes. She has received numerous awards for her work over the years. Betsy has lived in Boulder since 1998 and shows her wearable work at the Boulder Arts and Crafts Gallery.

DAN BOORD (HOVAB @ Boedecker Theater, The Dairy Arts Center) is chair of the Critical Media Practices Department at CU-Boulder. Exhibitions: The Museum of Modern Art, New York, NY; Venice Biennale, Venice, Italy, Centre Georges Pompidou, Paris, France; Museo Nacional Centro de Arte Reina Sofia, Madrid, Spain; and Stedelijk Museum, Amsterdam, Holland.

ANA MARIA BOTERO (HOVAB @ Firehouse Art Center) was born in Bogotà, Colombia, where she was an architect until 2001 when life she moved to Florida, where she worked for Vigneault and Hoos Architecture, Inc. In 2005 she moved to Colorado, where she began painting. She had her first art show in 2008 and has shown her work throughout the Front Range and in Vero Beach, Florida, and San Diego, California.

GERRI BRADFORD (HOVAB @ Firehouse Art Center) has lived half her life in Colorado, twenty years in Boulder and twenty-two in Longmont. She is a plein air painter, whose art flourished in Longmont, where she participated in Studio Tours, as well as other local art events.

STAN BRAKHAGE ("Celebrating Stan" @ Atlas Institute, University of Colorado-Boulder) (1933-2003) was one of the most innovative filmmakers in the history of experimental cinema. He grew up in Denver, lived in Boulder for much of his life and taught in Film Studies at CU-Boulder. Brakhage made approximately 350 films in his 52-year-long career, including psychodramas, autobiographical films, Freudian trance films, birth films, song cycles, meditations on light, and hand-painted films, ranging from nine seconds to more than four hours in duration.

PATRICIA BRAMSEN (HOVAB @ Mercury) is a self-taught artist, who, in 1970, was suddenly asked to display her work at a Boulder gallery. She has continually exhibited her paintings at Boulder and Chicago venues ever since. Her work is in numerous private collections.

MARLOW BROOKS (HOVAB @ Naropa) is a calligrapher, painter, Five Element acupuncturist, and healer. She has taught at Naropa University since the 1990s. Her work has exhibited in China, Japan, Korea, Thailand, and Europe. She is the author of *The Way Through* and *Words of the Heart*.

CHRIS BROWN (HOVAB @ Rembrandt Yard) moved to Boulder in 1969 to attend CU-Boulder, where his photography is now part of Colorado Arts in Public Places. His first exhibit in Boulder was in 1974 and he has had more than 100 since. He has been a board member of Open Studios, a member of The Dairy Arts Center's jury committee and participated in various Boulder Open Space and Mountain Parks art workshops.

TERESA BOOTH BROWN (HOVAB @ Macky Auditorium) was born in Portland, Ore., and lived in Boulder from 1993 to 1997, then moved back in 2003. She has been a fellow at the Skowhegan School of Painting and Sculpture, a resident artist at The Anderson Ranch Arts Center (where she is on the faculty) and the Ucross Foundation, as well as a visiting artist at the American Academy in Rome.

PATTI BRUCK (HOVAB @ Boedecker Theater) has taught film production courses at CU-Boulder since 1990. Her acclaimed film *Slippage* won the Best Documentary Award at the Athens Film Festival, Honorable Mention at the Baltimore Film Festival, and was featured on the PBS series "The Independents." She has received numerous grants and fellowships and is a long-term trustee of the internationally renowned Robert Flaherty Documentary Film Seminar and its president since 2002.

HANK BRUSSELBACK (HOVAB Book Arts @ Boulder Public Library and The Dairy Arts Center) received an MFA in Sculpture at CU-Boulder, then taught in that department. He had two solo shows at BMoCA and has exhibited his work throughout the U.S. He has created murals in Boulder, Morazán, El Salvador, and Kingston, Jamaica. In the late '90s, he moved to northern New Mexico.

DIANA BUNNELL (HOVAB @ First United Methodist Sanctuary Gallery) made her first quilt in 1979, depicting the Flatirons. In 2007, she switched to painting. Her works have been displayed in local, national, and international venues such as Quilt National, Visions, and Fabric Gardens (Osaka, Japan).

ANDREW BUSTI (HOVAB @ Boedecker Theater) has been creating handmade films for 15 years. He is the technical advisor and instructor for CU-Boulder Film Studies Department. He is a film facilitator and archivist/preservationist and runs Analogue Industries, LTD. He is also a founding member of Process Reversal, an analog film-based non-profit dedicated to ensuring viability and accessibility of the medium.

JORGE CALDERON (HOVAB @ Canyon Gallery) grew up in a small fishing village on the north coast of Peru and moved to Boulder in 1982. His sculptures combine traditional archetypal elements from his culture with the vision developed through his own life experience. The spirit embodied in his work draws the viewer into deeper connection with an invisible reality.

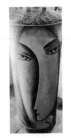

BRUCE CAMPBELL (HOVAB Selected Outdoor Art) finds most of his material on old farms, then combines painting and sculpture to impart an archetypal, ancient quality and a mystic energy to salvaged iron, steel, wood, and stone. His public installations appear in Denver and Boulder. He has been a stage designer in Tennessee and is represented by Envision Gallery in Taos, N.M.

MYRTLE HOFFMAN CAMPBELL (CU Art Museum) (d. 1980s) was born in Columbus, Nebr., and studied with John Vanderpoel at the Chicago Art Institute. She was a member of the Boulder Artists' Guild, the Art Alliance in Philadelphia, and Prairie Watercolor Club. She exhibited her work widely, including in Denver, Kansas City, and Philadelphia.

AMELIA CARLEY (HOVAB @ BMoCA) was born and reared in Colorado. She received a BFA from CU-Boulder in 2009. She received an invitation to TANK Studios in Denver and had a studio there from 2013-15. In the fall of 2015, she relocated to Atlanta to pursue an MFA at Georgia State University. She regularly exhibits locally and nationally.

CHA CHA (HOVAB @ Rembrandt Yard) arrived in Boulder in 1979, straight from Virginia Commonwealth University, with her Communication Arts degree to start her career as a self-employed artist. Throughout the '90s, she evolved from graphic design and calligraphy to handmade paper sculpture and wearable art. She now creates sculptures in steel and makes whimsical fantasy birds in clay.

SCOTT CHAMBERLIN (HOVAB @ The Dairy Arts Center) has taught at CU-Boulder for 30 years in Ceramics, which has been ranked among the top ten ceramics programs nationally for decades.

MARIE CHANNER (HOVAB @ Rembrandt Yard) moved to Boulder in the late 1980s. Her love for horses and the West inspires her horse paintings and landscapes. She also paints flamenco and ballet dancers for galleries in Santa Fe and New York.

DALE CHISMAN (HOVAB @ Mr. Pool Gallery) (1943-2008) received his MFA from CU-Boulder. He was awarded two artist-in-residence grants from the Colorado Council on the Arts and Humanities, an Adolph & Esther Gottlieb Foundation Grant, the AFKEY Award from the Denver Art Museum, and a MacDowell Colony Fellowship. His work has been published in *Art and Architecture*, *The New York Times*, and *The Christian Science Monitor*. His art is in many corporate and public collections, including Chemical Bank and Chase Manhattan Bank in New York; Captiva Collection; US West; American Can Corporation; The Kirkland Museum; CU Art Museum; National Museum of American Art; Denver Art Museum; and the Scottsdale Museum of Contemporary Art.

ALBERT CHONG (HOVAB @ Highland City Club) is a visual artist and professor of Art at CU-Boulder. His works span a range of mediums, including photography, installation art, and sculpture and have contributed to the discourse surrounding issues related to spirituality, race, and identity. He was born in Kingston, Jamaica, W. I., and immigrated to the U.S. in 1977. Select awards include the National Endowment for the Arts, Guggenheim Fellowship, and the Pollock Krasner Foundation Grant. He has represented Jamaica in five international biennials.

MATTHEW CHRISTIE (HOVAB @ Macky Auditorium) was born in Teaneck, N.J., and lives in Denver. He received his BFA from the University of Denver and has been a visiting lecturer at CU-Boulder. He was Artistic Director for Printmaking at Anderson Ranch Arts Center from 1986 to 2010. Selected collections include the University of Nevada/Reno, Boise State University, Museum of Texas Tech University, Lubbock, and McMaster University.

AMY GUION CLAY (HOVAB @ Rembrandt Yard) is a mixed-media artist working in paint, printmaking, animation, and film. She has lived in Boulder for 25 years and has shown her work at Open Studios, The Dairy Arts Center, and various Boulder galleries. She has also exhibited her work internationally in India, Berlin, and London.

JULIE CLEMENT (HOVAB @ Firehouse Art Center) is a yokel (rural) artist who has resided in Longmont for a third of her life. After an accomplished career as a creative director in marketing, she began painting. Major accomplishments include large-scale installations at the Longmont Museum and at The Dairy Arts Center in Boulder. Her art has been exhibited and collected throughout the U.S.

ESTA CLEVENGER (HOVAB @ Canyon Gallery) (1939-2003) was born in Hershey, Pa., came to Boulder to study art at CU, and never left. She was a painter and musician, lived for a while in Sunshine Canyon, and, among her many jobs – janitor, fast-food worker – her favorite is said to have been cleaning the stables and caring for calves at the Abbey of St. Walburga, then located on South Boulder Road.

WENDY CLOUGH (HOVAB @ Rembrandt Yard) received her BA in Art from Middlebury College and her MFA in Painting from CU-Boulder. Originally from New Hampshire, she has lived in Boulder since 1990. Her work is shown in Boulder, Denver, and nationally. She has received grants from both the Arts and Humanities Assembly of Boulder and the Boulder Arts Commission.

JOE CLOWER (HOVAB @ The Dairy Arts Center) moved to Boulder in 1963 to attend graduate school. He received his MFA in 1967 and taught at CU-Boulder for several years. He now lives and works in Denver.

DON COEN (HOVAB @ BMoCA) is a long-time resident of Boulder and grew up on his family's farm in southern Colorado. His paintings, often monumental in size, are inspired by his early years, and depict the spirit of the agricultural production landscape, rural America, and the migrant workers who tend the land. His exhibitions and collections include the Denver Art Museum, Phoenix Art Museum, and the Coors Collection.

PRISCILLA COHAN (HOVAB @ Canyon Gallery) arrived in Boulder in the 1970s and has been immersed in the arts ever since. From her first gallery job at the Lodestone Gallery, she has hopscotched through many local cultural institutions. She works with character in pen, paint, and clay. She has worked in theater design, ceramics, and installation.

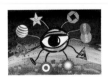

EVAN COLBERT (HOVAB @ Macky Auditorium) was born in Seattle, Wash., and lives in Longmont. He received a BFA from Metropolitan State College of Denver and has been in solo and group exhibitions at BMoCA, the Arvada Center for Visual Arts, and the Detroit Museum of New Art. Selected collections include Arkansas Art Center, Little Rock; Ericksson Radiotelecommunications, Stockholm, Sweden; Auraria Center for Photography.

JIM COLBERT (HOVAB @ BMoCA) (1946-2007) received his MFA from CU-Boulder. He was the recipient of a Colorado Council on the Arts Fellowship. His realistic paintings reflect environmental destruction of the land. His collections include the Denver Art Museum, Children's Hospital Denver, and the City of Arvada. His estate is represented by Robischon Gallery.

ANNETTE COLEMAN (HOVAB @ First Congregational Church Gallery) was born n Denver and reared in Littleton. She was an organizing force for the NoBo Art District in North Boulder from 2004 to 2015 and opened her home studio for First Fridays and Boulder Open Studios more than 90 times, making it a key hub for community engagement and artist connection. She has been affiliated with, among others, the Colorado Women's Caucus for Art and Core New Art Space.

WILL COLLINS (1892-1979) was a noted Boulder-based painter and graphic artist. Originally from Ohio, he received his education at Kansas State University and Columbia University. He moved to Boulder in 1953, where he would come to specialize in scenes of the Colorado high country.

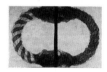

GAYLE CRITES (HOVAB @ BMoCA) has a long association with Boulder galleries and museums. She received her BFA in Printmaking from Colorado State University. An interest in Indigenous world cultures led her artwork to multimedia, incorporating hand-pounded bark and natural pigments. Allentown Art Museum includes two works in its permanent collection, and another is traveling with the International Folk Art Museum and the Bowers Museum. Her work is represented at Chiaroscuro, Santa Fe, and at Goodwin Fine Art, Denver.

KARLA DAKIN (HOVAB @ BMoCA) has lived in Boulder since 1992. Among her projects is "Sky Trapezium," a green roof at MCA/Denver. Growing things, building things, and relishing the entropic and generative qualities of nature are ideal creative means. With an education and background in ceramics, printmaking, and photography, Dakin tends towards accidents, not editions.

JANE DALRYMPLE-HOLLO (HOVAB @ Canyon Gallery and Book Arts @ Boulder Public Library), see HOVAB Associated Curators, below.

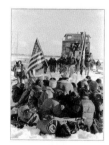

JOSEPH DANIEL (HOVAB @ BMoCA) grew up in Boulder, attended Boulder High School and CU-Boulder. He has been involved in the media arts for over 40 years as a professional photojournalist, filmmaker, and television producer, writer, editor, graphic designer, and publisher. He is the founder and principle of Story Arts Media, a creative agency, has produced three episodic television series and several documentary films, and is widely published as a still photographer. Boulder is still his hometown.

W.F. DANIEL (HOVAB @ Rembrandt Yard) is an internationally collected artist who moved to the Boulder area in 1986. He has painted all over the world, but is invariably drawn back to Colorado. His work has been shown in the Oil Painters of America National Show, American Impressionist Society National Show, Colorado Governor's Art Show, and The Russell at the C. M. Russell Museum.

AJ DAVIS (HOVAB @ Boulder Creative Collective), a.k.a. Project Street Gold, received his BFA in Sculpture from CU-Boulder and studied stone carving in Marble, Colo., and Lawrence, Kans. His work has been shown in Colorado, Australia, Connecticut, and New Zealand, and in public and private collections.

MOLLY DAVIS (HOVAB @ Rembrandt Yard) is primarily an on-site landscape painter working in oil and watercolor. She is also a volunteer for Boulder Open Space in order to protect the land she loves.

NAN DEGROVE (HOVAB @ First Congregational Church Gallery) is an astrologer in Boulder with over 30 years' experience, and a scholar of myth, folklore, and sacred art. She is a visionary painter with special interest in the mystical images of saints and madonnas. In her *Saints* series, she has sought to interpret these as portrayals of Divine Beauty, liberating them from the limiting and sometimes violent narratives of traditional religious context.

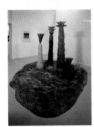

KIM DICKEY (HOVAB @ BMoCA) has lived in Boulder since 1999 and is a professor of Fine Arts at CU-Boulder. She has exhibited in Australia, Denmark, Germany, Japan, Korea, Sweden, Taiwan, the United Kingdom, and in the U.S. at MASS MoCA, Everson Museum of Art, American Craft Museum (now MAD), and MCA Denver, among other venues.

REBECCA DIDOMENICO (HOVAB @ BMoCA) received a BA in English Literature from CU-Boulder. She has exhibited on four continents through the collective Arnauts'. A selected list of her U.S. exhibitions, collections, and publications includes BMoCA; Museum of Contemporary Art, Denver; Denver International Airport; Redline, Denver; *San Francisco Craft & Folk Art Museum*; *Denver Art Museum*; *Artspace*; *Art Papers*; *Artweek*; *The Washington Post*; *Art in America*; and *The New York Times*. She spearheaded The Swoon BMoCA International Artists Residency in Boulder.

CHARLES DIJULIO (HOVAB @ The Dairy Arts Center) (1941-2013) was born in Philadelphia and received an MFA from CU-Boulder. In addition to Boulder, he lived in New York. He was a painter, filmmaker, woodworker, musician, vintner, and more. His works during the era of Criss-Cross were grounded in mathematically based interwoven structures. DiJulio's precision line work visually alludes to his immense craftsmanship.

JANE DILLON (HOVAB @ Canyon Gallery) received her MFA in Ceramics from CU-Boulder, where she also taught as an assistant professor. Her work has been shown in many galleries throughout the U.S. and is held in the collections of Auckland Institute and Museum, Arrowmont School of Art, the University of Tennessee Art Galleries, and the University of Northern Colorado.

KATY DIVER (HOVAB @ Firehouse Art Center) has been a ceramic artist for over 30 years. She has run her own studio in Longmont since 1992, having moved from the East Coast. She has been a member of the Longmont Studio Tour and East Boulder County Artists for 15 years, was an artist-in-residence in the Boulder County School District and teaches from her studio. Her work has shown in many galleries around the country and has been on loan in public art programs in Longmont, Evergreen, and Berthoud.

LAURIE DOCTOR (HOVAB Book Arts @ Boulder Public Library and Naropa) is a painter, calligrapher, and writer whose work is in collections in the U.S. and Europe. Her art is based on language, image, and contemplative practice. She offers classes and lectures internationally in Europe, Canada, and the U.S. She taught painting and calligraphy at Naropa University for more than twenty years. Doctor provided the calligraphy for the HOVAB catalogue cover.

CAROLINE DOUGLAS (HOVAB @ Canyon Gallery) makes figurative sculptures that are evocations of a dream world. Ancient mythology, modern psychology, fairy tales, and dreams fascinate her, as do archetypes, nursery rhymes, and folk tales. She has had numerous exhibitions in the Boulder/Denver area since her arrival in 1976, and her work is in the National Museum for Women in the Arts.

ANNE OPHELIA TODD DOWDEN (HOVAB Book Arts @ Boulder Public Library) (1907-2007) was born in Denver, lived in New York and Boulder, and was a popular and nationally renowned botanical illustrator and author recognized for the anatomical accuracy and beauty of her mainly watercolor paintings. Her career resulted in more than 20 books, many for younger readers. Two of her books won awards from the American Library Association.

JERRY DOWNS (HOVAB @ Highland City Club) is an artist, photographer, and author who called Boulder home from 1969 to 2002. He speaks widely about how to use art and photography for self-discovery. Downs returns to Boulder from San Francisco at least once a year for shows, book signings, talks, and to see family and friends.

EVE DREWELOWE (CU Art Museum) (1899-1989) was born in New Hampton, Iowa, where she grew up the eighth of thirteen children. She attended the University of Iowa-Iowa City, receiving a BA in art in 1923 and an MA in fine art in 1924. During nearly seven decades as an artist, mostly in Boulder, Drewelowe executed more than 1,000 paintings, notable for their wide range of styles, which were exhibited throughout the U.S.

JUDY DUFFIELD (HOVAB @ First United Methodist Sanctuary Gallery) has been in Boulder since the early 2000s, pulled here by mountains, family, and friends. She is deeply involved in the Front Range fiber arts community and has exhibited her work at museums and galleries throughout the Southwest.

MARILYN DUKE (HOVAB @ The Dairy Arts Center) received her MFA from CU-Boulder in 1978, focusing on Landscape Drawing. Drawings of family members had filled many sketchbooks in her early school days, yet, as an adult, seldom drew portraits of people. Today her energies are devoted to portraits of her granddaughter as she grows up.

LUIS EADES (HOVAB @ Macky Auditorium) (1923-2014) was born in Madrid, Spain. He was a professor of painting at CU-Boulder from 1961 to 1986. Selected collections include the Denver Art Museum, the Whitney Museum of American Art, and the Museum of Fine Arts, Houston.

MARIO MIGUEL ECHEVARRIA (HOVAB @ Firehouse Art Center) Mario earned a BFA from the Rhode Island School of Design in 1991, and studied for two semesters in the European Honors Program in Rome. In 1992, Mario worked as graphic designer and illustrator, transitioning in 1995 to the fine arts. He lives and works in Longmont.

BUNKY ECHO-HAWK (HOVAB @ Firehouse Art Center) is a multi-talented artist whose work spans both media and lifestyle. A graduate of the Institute of American Indian Arts, he is a fine artist, graphic designer, photographer, writer, and a non-profit professional. Bunky is a traditional singer and dancer of the Pawnee Nation and an enrolled member of the Yakama Nation.

ROBERT ECKER (HOVAB @ Mercury) joined the CU-Boulder Fine Art Department in 1972, retired in 2001, and is now a full-time artist with numerous solo shows at, among others, the Denver Art Museum, Arvada Center, Pueblo Art Museum, BMoCA, Boulder Library, and the Robischon, William Havu, and Mary Belochi galleries. His work is included in many public and private collections.

SALLY ECKERT (HOVAB @ Rembrandt Yard) has a BFA from Parson's School of Design and studied in Europe, learning egg tempera. She has participated in Open Studios for 20 years. She's president of the non-profit, Boulder Art Matrix. Her mural work has been featured on Channel 9 News.

SUSAN EDWARDS (HOVAB @ Naropa and Book Arts @ Boulder Public Library) (1943-2008) was many things to many people: an artist, teacher, counselor, mentor, student, and dear friend. As an artist, she worked in photography, printmaking, ceramics, poetry and prose, pen and ink, and bookmaking. She taught at Naropa University and CU-Boulder and is remembered for encouraging her students to have precise yet creative thought and expression.

KARMEN EFFENBERGER-THOMPSON (HOVAB Book Arts @ Boulder Public Library) was a longtime Boulder artist before moving to Oregon. She earned her BFA from CU-Boulder and created posters and programs for the Denver Center Theatre Company, the Colorado Shakespeare Festival, and the City of Boulder. She illustrated the children's books, *Meet the Orchestra* and *The Marching Smithereens*, as well as *Cooking in Door County*, by Boulder writer Pauline Wanderer.

GREGORY ELLIS (HOVAB @ Boulder Creative Collective) is a self-taught Boulder artist, who has shown at the Prana Gallery, at Denver's Edge Gallery and at Café Zurich, the Lucy Gallery and ARC Gallery in Albuquerque, N.M.

JACKSON ELLIS (HOVAB @ Boulder Creative Collective), aka, Project Street Gold, received his BFA in Sculpture from CU-Boulder, lives in Lafayette and has exhibited in numerous Boulder and Denver galleries, as well as in Portland, Ore., Black Rock City, Nev., and Paris, France.

SALLY ELLIOTT (HOVAB @ Canyon Gallery), see Curatorial and Steering Committee, below.

SANJE ELLIOTT (HOVAB @ Naropa) has been practicing Tibetan arts since 1974. His first teacher was the American artist, Glen Eddy, and he has studied with numerous Tibetan artists in Darjeeling and Kathmandu. He was the head of the Art Department at Naropa University.

LINDA ARLINE ELLIS (HOVAB @ First Congregational Church Gallery) arrived in Boulder in 1972. After getting a BFAE at CU, she taught Art for Boulder Valley School District and retired after 20 years. Along the way she was co-director of the Boulder Artists Gallery, participated in Open Studios, and her work was featured in numerous shows and publications. She now lives in Santa Fe.

MICHELLE ELLSWORTH (HOVAB @ Boedecker Theater and NCAR) is a professor in CU-Boulder's Theater and Dance Department. Her performance works, video installations, and films have been produced nationally and funded by the National Endowment for the Arts and New England Foundation for the Arts. Her drawings, spreadsheets, and scripts have been published in *CHAIN* and *The Nerve Lantern*. In 2016, she received a Guggenheim Fellowship.

BUFF ELTING (HOVAB @ BMoCA) has been a Boulder resident since 1985. Her art celebrates nature and sense of place and explores the connection between landscape and human development. Elting's work has been exhibited in the U.S. and Europe, including the Autry Museum and the Florence Biennale. She is represented in Denver by Goodwin Fine Art.

DANIEL ESCALANTE is a folk artist who lived in Boulder Country from 1971 to 2011, and for ten of those years, he decorated folk art furniture. His work was represented by the Boulder-based Maclaren Markowitz Gallery and six other galleries throughout the southwest. He is a group facilitator and trainer who has provided services to non-profits, grass roots groups, and many others. His training has focused on inclusiveness, community organizing and leadership. He and his partner Betty operate the Casa Taos Retreat Center in Taos, N.M.

ANI ESPRIELLA (HOVAB @ Firehouse Art Center) is a native of Colombia and grew up in the culturally rich city of Miami. She worked as a singer for 20 years and moved to Longmont in 2003. She paints in oils and pastels and shows her award-winning artwork at Mary Williams Fine Art in Boulder, Arts Longmont Gallery, and Bella Muse Gallery in Ogden, Utah.

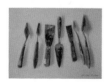

CLAIRE EVANS (HOVAB @ Rembrandt Yard and First Congregational Church Gallery) set up a studio in downtown Boulder in 1975, where she painted portraits. She founded Art Work Space in 1985, which has become Boulder's largest working studio for artists and where she continues to paint and teach.

HUNTER EWEN (HOVAB @ NCAR) is a dramatic composer, educator, and multimedia designer. He composes, teaches, solders, choreographs, and videographs solo and collaborative projects around the world. Ewen works as Instructor of Critical Media Practices, at CU-Boulder, where he teaches music, electronics, and sound practices.

RANDI SUE EYRE (HOVAB Selected Outdoor Tour) (1952-1999) worked as an illustrator and a graphic designer for the *Daily Camera*. She lived in Boulder from 1977 until her death following an accident. Her work is most seen at Spruce Pool, where she created a huge mural.

MIMI FARRELLY (HOVAB @ Firehouse Art Center) has lived in Longmont since 1980, and helped start the Firehouse Art Center, the Longmont Council for the Arts, and the graduate Art Therapy program at Naropa University. In 2003, she spearheaded an art program for persons with mental illness at Longmont's Soft Voices Art Center and is the author of *Spirituality and Art Therapy*.

DIANE STUM FEKETE (HOVAB @ Naropa) Diane Stum Fekete has been an artist and instructor for more than twenty years. She explores the intersection of Western calligraphy and abstract painting, from legible writing to gestural marks creating visual texture. Her work incorporates ink, charcoal, graphite, and acrylics. Fekete came to Boulder in 2010 and exhibits her work locally, nationally, and internationally.

MARCELO FERNANDEZ (HOVAB @ Firehouse Art Center) was born in Chicago, but has lived in Longmont since the late '90s He owns KCP Gallery in downtown Longmont, commissions artwork, and shows his paintings and drawings throughout the area.

E. KIMBROUGH FIELD (HOVAB @ Canyon Gallery) (1945-1977) graduated from Colorado State University in Fine Arts in the late '60s. He moved to Boulder in 1962 and exhibited work at the Gilman Gallery in Chicago, the Don Conrad Mobiles Gallery in San Francisco, as well as throughout Colorado. In 1976, he founded Axe Case Co. where he produced the first hard-shell banjo and guitar cases.

JACI FISCHER (HOVAB @ The Dairy Arts Center) moved to Boulder for graduate school and earned her MFA. She was juried into the first and second Colorado Biennial. Her professional career in both fine art exhibitions and her graphic art work expanded to California and now continues in New Mexico, where she creates a contemporary silver jewelry line.

JO FITSELL (HOVAB @ First United Methodist Sanctuary Gallery), originally from Toronto Canada, is a talented art teacher, who has been in and out of Boulder since 1976. She helped found Front Range Contemporary Quilters in 1988, an organization promoting the art quilt as fine art.

BONNEY FORBES (HOVAB @ The Dairy Arts Center and First Congregational Church Gallery), see HOVAB Associated Curators, below.

JULIANA FORBES (HOVAB @ First Congregational) is a painter and art teacher living in Boulder. Respectful of the ability of art to inform our lives in ways we may not understand, she is interested in artwork that is emotionally evocative before it's intellectually analyzed or categorized. She finds abstract work can achieve this magic.

CHARLES FORSMAN (HOVAB @ BMoCA) is both painter and photographer. He was a professor of Fine Art at CU-Boulder. His landscape works reflect his concern for the environment. He has twice received grants from the National Endowment for the Arts, exhibited widely, and his numerous collections include the Metropolitan Museum of Art, Denver Art Museum, Colorado Historical Society, Phoenix Art Museum, Kemper Art Museum, and Anschutz Corporation. He is represented by Robischon Gallery.

CLARE CHANLER FORSTER (HOVAB Book Arts @ Boulder Public Library) (1928-1992) began her work as a painter in her early twenties after attending the Art Students League of New York and put her love of writing and imagery together into the form of handmade books. Her first works were with early color Xerography in the mid-'70s and involved large scale collages using photographic images produced on the early Xerox color machines, which rendered a grain and texture she worked into her painterly collage. She moved to Boulder in the 1980s with her partner, artist George Peters.

MICHAEL FRANKLIN (HOVAB @ Naropa) came to Boulder in 1997, has practiced and taught in various academic and clinical settings since 1981, and is chair of the art therapy program at Naropa University. The author of numerous articles, Franklin is an international lecturer and founder in 2001 of the Naropa Community Art Studio, a research project training socially engaged artists.

DAN FRIEDLANDER (HOVAB @ Mr. Pool Gallery) (1945-2012) was an economist, an artist, a political activist, a humanist, an environmental activist, a champion of civil rights, an entrepreneur, a cook, a hiker, and a biker. He received his BA from the University of Wisconsin and his Masters in Economics from the University of Chicago. His artistic passion was sculpture and he worked with clay tiles for 20 years, building thousands of sculptural tiles, each hand textured, each unique, and each fired in a solar oven.

CARL FUERMANN (HOVAB @ Boedecker Theater) studied at CU-Boulder during the early '90s and stumbled upon the experimental avant-garde cinema after taking a Super 8 class with Don Yannacito and attending the film salon gatherings of Stan Brakhage. He continues to make films in this style while on the road traveling the world and calls Boulder his home when he returns to rest and catch a breath.

LISA GARDINER (HOVAB Book Arts @ Boulder Public Library), see HOVAB Associated Curators, below.

CAROL GARNAND (HOVAB @ First United Methodist Sanctuary Gallery) has been a passionate silk painter and fiber artist since the early 2000s. She paints, dyes, felts, and sews to create one-of-a-kind art, some of it wearable art. She has lived in Boulder for 30 years.

MARGARETTA GILBOY (HOVAB @ Canyon Gallery) lived and painted in Boulder from 1966 to 1985 and received her MFA from CU-Boulder in 1981. She was a member of Front Range: Women in the Visual Arts and had her first solo show in Denver at the J. Magnin Gallery in 1977. She is represented by Goodwin Fine Arts, Denver.

PAUL GILLIS (HOVAB @ The Dairy Arts Center) lived, worked, and studied in Boulder from 1970-78, when he moved to Denver. He continued to show work in the '80s, '90s and 2000s at BMoCA (then BCVA) and the Boulder Public Library.

LINDA GLIETZ (HOVAB @ Firehouse Art Center) is a Boulder native, 57 years in Boulder County. She studied art at CU-Boulder and began making art full time in the early 2000s. Her work is in many private and public collections, she exhibits frequently locally, regionally, and nationally and was a featured artist on the National Women's Caucus for Art website.

J. GLUCKSTERN (HOVAB @ BMoCA), see Catalogue Contributors, below.

JULIE GOLDEN (HOVAB @ First Congregational Church Gallery) originated a stained glass process in 1988, then built a deep resume of exhibits, gallery representation, and students locally and internationally. She has curated exhibits, opened Artcycle in Boulder, directed the Boulder County Arts Alliance and managed 25 studios at Art Work Space. The book, *Painting with Glass*, features her art process.

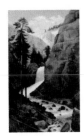

JEANNE GRAY (HOVAB # First United Methodist Sanctuary Gallery) moved to Colorado in 1990. She made an attempt at traditional quilting but said she couldn't make the points match, so instead started improvisational quilting and hasn't turned back.

ELMER P. GREEN (HOVAB @ BMoCA) (1863-1892) was an American artist who died in Boulder of Bright's Disease. There is little information about Green, aside from a letter from a Winnie Mary Sosey (neé Hamm), his sweetheart, who years after his death wished to acknowledge and enhance his artistic importance.

JIM GREEN (HOVAB @ Canyon Gallery) came to Boulder to attend graduate school and lived here for 25 years. He staged his first public art installation in his driveway at age nine. For five cents, neighborhood kids could attempt to grab handfuls of nickels from a large plastic bowl filled with salt water and charged with electricity. The charge was activated with a kick-start from an old motorcycle generator that sent mind-numbing (harmless) jolts as each participant reached for the nickels. Green's interest in playful, interactive work continues today.

ALVIN PAGDANGANAN GREGORIO (HOVAB @ Firehouse Art Center) was born in 1974 and lives and works in Longmont, Boulder, and Los Angeles. His work investigates how local cultures and customs may merge with cultures and customs of ancestors that are passed down through domestic and familial rituals.

DAVID GROJEAN (HOVAB @ Rembrandt Yard) attended American University, where he received his BFA in graphic design. In 1977 he received his MFA from CU and committed himself fully to the art of painting. He has a large working studio in Boulder and shows work throughout the Western U.S.

BRIAN GROSSMAN (HOVAB @ Mr. Pool Gallery) joined the U.C. Coast Guard in 1969, received a BA in English and Fine Arts from CU-Boulder. He began carving in high school, has participated in Open Studios for 9 years and Loveland's Sculpture in the Park for 18. In 2014, he received first place at the National Veterans Creative Arts Festival and in 2015 received the Open Studios Reuman Award.

TERESA HABERKORN (HOVAB @ Rembrandt Yard) moved to Boulder in 2002, where she reserved a studio in Art Work Space and began exhibiting her woodcut prints in Open Studios. She has her own studio in North Boulder where she works, exhibits, and teaches woodcut printmaking.

JOEL HAERTLING (HOVAB @ Boedecker Theater) is a Boulder native who learned about cinema from the Boulder Public Library Film Program, which he has curated since 1999, and the International Film Series at CU-Boulder. Through experimental music-making in the 1980s, he began collaborating with filmmaker Stan Brakhage. His work includes a documentary and e-book on the architecture of his father, architect Charles A. Haertling.

AVA HAMILTON (HOVAB @ Boedecker Theater) has lived in Boulder since 1970 when she came to attend CU. In 1980, she attended the Anthropology Film Center in Santa Fe, N. M. She is a historian, a writer, and a documentarian, lecturer on Arapaho and Native histories and cultures. She has been published in the *Yellow Medicine Review* and the *Global Press*. *Our History, Our Memories* is a documentary work-in-progress about Arapaho People and particularly their time living around Boulder and in Colorado.

JOAN BARTOS HANLEY (HOVAB @ First Congregational Church Gallery) was born in New York, received her MFA at the University of Hawaii in 1967 and studied at the Chicago Art Institute before moving to Boulder in 1970. In 2000, she opened a gallery in La Veta, where she works in both painting and sculpture.

SARAH HANSON (HOVAB @ Mr. Pool Gallery) earned her BFA from the San Francisco Art Institute and is a graduate of the Chicago Academy for the Arts. She manages Meininger Artist Materials in Boulder. Her work has shown at BMoCA, Firehouse Art Center, Foothills Art Center, McNichols Civic Center, and NCAR.

EMMA HARDY (HOVAB @ Canyon Gallery) was born in Lincolnshire, England. She earned a BA in Sculpture at the Wimbledon School of Art in London, and is a practicing sculptor, who has lived and worked in Boulder County since 1994. Her varied works have been displayed at the Shelbourne Museum, Vermont, Denver International Airport, and Burning Man among other places.

SHERRY HART (HOVAB @ The Dairy Arts Center) has lived and breathed art in Boulder for nearly 40 years. She is the founder-director of ArtFarm. Of her early work she writes, "I remember 1979, when seeing hanks of tiny faceted beads, glistening in the sunlight, I was inspired to an innovative 'painting style.' First flat, sewn pieces, then ordinary objects were transformed by their new, symbolic, light-reflective surfaces."

BETSEY HASSRICK (HOVAB @ Firehouse Art Center) moved to Boulder from Pennsylvania in the late 1950s. In Boulder she attended summer art classes and later worked at the Boulder Pottery lab and taught many of the children's pottery classes. Through the children's vision, she says, she learned to express her own. Her work has been shown and sold throughout the Boulder-Denver area.

BOBBIE LOUISE HAWKINS (HOVAB @ Mr. Pool Gallery and Book Arts @ Boulder Public Library) attended art schools in New Mexico and London before the age of 20. She has published more than 30 books of poetry and prose, received a NEA fellowship, toured widely with folksingers and with her own one-woman plays, and launched the Prose program at the Kerouac School of Naropa University, where she taught until her retirement in 2010. She is equally prolific as a visual artist.

DEBORAH HAYNES (HOVAB @ Mercury) lived in Jamestown from 1999 until September 2013. During that period, she served as a professor, department chair, and program director at CU-Boulder. Her *Cantos* may be read as topographical maps and as a visual record of experiences on her Jamestown site.

JEN HERLING (HOVAB @ Boulder Creative Collective) has been an artist in many disciplines. She has a BA in Performance Art from the University of Maryland and performed extensively in New York, Baltimore, San Francisco, and Washington, D.C. Meanwhile, she dabbled in visual art, collaborating with artists throughout her dance career. In 2015, she began painting seriously.

ANA MARÍA HERNANDO (HOVAB @ BMoCA and Macky Auditorium) is from Argentina and based in Boulder since 1995. She has had solo shows at, among others, MCA/Denver, Kemper Museum of Contemporary Art, BMoCA, International Center of Bethlehem, CUAM, and Marfa Contemporary. Selected collections include: The Tweed Museum of Art; Fundación Banco Patricios, Buenos Aires; Argentina, Kemper Museum of Contemporary Art; U.S. Department of State; Art Bank Gallery, and the University of West Virginia.

STEPHANIE HILVITZ (HOVAB @ Firehouse Art Center) moved to Longmont in 1981 and was immediately drawn to the small town feel of the community. She and other "kindred souls" host neighborhood art tours, classes, pop-up art events and gather to share and talk art. She has also been involved with the Firehouse Art Center and the Longmont Museum.

CAROLINE HINKLEY (HOVAB @ Highland City Club) is a photographer and professor of Practice in the Cinematic Arts Department, University of New Mexico-Albuquerque. She holds two MFAs (Claremont Graduate University and California Institute of the Arts), has made multiple treks (pilgrimages) to Tibet, Zanskar, and Ladakh to photograph the remote and sacred landscapes of the Buddhist Himalaya, has held residencies in Iceland, Ireland, and Russia, and, among her grants and fellowships, are a NEA/WESTAF award in photography and the San Francisco Phelan Award for Excellence in Photography.

FRANCES HOAR (CU Art Museum) (1898-1985) was born in Philadelphia and studied at the Pennsylvania Museum School of Industrial Art. After her marriage to artist Frederick C. Trucksess in 1927, she settled in Boulder where she taught at CU. There she and her husband participated in the Prospector Group. She is best known for her western landscapes, often with ghost towns and mining scenes.

SHERE HOLLEMAN (HOVAB @ First Congregational Church Gallery) is interested in the constructed world of imagery, architecture, and thought — how we create frameworks for ourselves in order to bring structure and meaning to existence. Buildings have inspired her work for over 30 years as she paints/records her responses to their forms and how they reflect our needs, ideals, and lives.

J. HADLEY HOOPER (HOVAB Book Arts @ Boulder Public Library) hand-painted *The Room*, a 1991 poem by poet **Jack Collom**, a Boulder resident for 50 years. Hooper is an illustrator and painter in Denver, a groundskeeper, gallery coordinator, and co-owner of Ironton Studios. Her illustration work is represented by Marlene Agency and her paintings can be found at Goodwin Fine Art, Denver.

MARY HORROCKS (HOVAB @ First United Methodist Sanctuary Gallery) worked in graphic design for 30 years. Side-stepping to fine art in 2009 she acted as Project Manager for the Longmont Studio Tour and Lines into Shapes (Art Center of Estes Park) and became Curator of Visual Arts for Boulder's The Dairy Arts Center. She is a free-lance curator and fiber/mixed media artist.

COURTNEY HOSKINS (HOVAB @ Boedecker Theater) is a Colorado native. She attended CU-Boulder from 1995-1999. Her films have been shown at festivals around the world, including the Toronto and New York Film Festivals. She has lived in Paris, New York, and Los Angeles. She currently resides in Boulder.

JERRIE HURD (HOVAB @ Rembrandt Yard) has been photographing and showing her art for 10 years. A novelist who turned to photography later in life, she now considers herself as much a photographer as a writer. She's listed in *Who's Who in America* as both writer and photographer. She lives in Boulder.

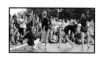

MARK IVINS (HOVAB @ Firehouse Art Center) was born in and grew up in New York City, and began photographing at the age of 12. He is interested in many divergent subjects photographically: community events, such as street fairs, festivals, and parades.

KEN IWAMASA is a retired professor of Fine Arts at CU-Boulder. He has studied the natural world all his life and created art that attempts to reconcile much of the irony/contradictions of our relationship to it. His work has involved many mediums, while he continues to publish fly-tying articles. His novella is titled *Death on the Arkansas River*.

VALARI JACK (HOVAB @ Canyon Gallery) is a portrait and documentary photographer who lived in Boulder, and was involved in photography, for 30 years. The photographs of the Benedictine community of nuns at the Abbey of St. Walburga on South Boulder Road were made over a year's time, recording the seasons both religious and natural, to document their daily lives. The Abbey eventually relocated to a home more remote than burgeoning Boulder County. Some years later, Valari also left Boulder and now lives in Bellingham, WA.

STEVE JENKINS (HOVAB Book Arts @ Boulder Public Library) moved to Boulder from New York City in 1994. He is a graphic designer, illustrator, and author of more than 30 nonfiction picture books for children. He lives with his wife and co-author Robin Page and their youngest son Jamie. Two older children are off on their own.

JIM JOHNSON (HOVAB @ The Dairy Arts Center and Macky Auditorium) taught drawing and painting at CU-Boulder from 1970 to 2005 and developed the department's Computer Imaging Program. He served on the board and curated exhibitions at the then-BCVA (now BMoCA), and has exhibited at the Dairy Arts Center and BMoCA. Selected collections include Minneapolis Institute of Fine Arts, The Museum of Modern Art, New York, Yale University Library, and Tate Library and Archive, London.

VIRGINIA JOHNSON (HOVAB @ The Dairy Arts Center) made art in Boulder in the 1970s, '80s and '90s. Her work is narrative and somewhat surrealistic and the ideas come from everywhere, people and places, objects and events, dreams and the landscape. Many were illustrations for the *Daily Camera*.

ANN JONES (CU Art Museum) (1900-1989) received her BA in 1937 from Colorado State College (now UNC in Greeley), before teaching high school in Iowa and then at Moore College of Art, Philadelphia. In 1942, she received her MA from Colorado State College and then joined the faculty of CU-Boulder in 1943, where she taught until her retirement in 1973. She established the pottery lab at the university and was a member of Boulder Artists Guild, Delta Phi Delta.

JUNIPER BOOKS (HOVAB Book Arts @ Boulder Public Library) based in Boulder, is dedicated to giving people more reasons to buy printed books and keep them forever! The company's founder, **Thatcher Wine**, invented the concept of custom printed book jackets in 2010. Thatcher oversees all art direction, product creation and library curation. Juniper Books has been featured in publications including *The New York Times*, *The Wall Street Journal*, *Vanity Fair*, *Departures*, and *Oprah's Favorite Things*.

RICHARD KALLWEIT (HOVAB @ The Dairy Arts Center) had a studio in North Boulder in 1974, past the Bus Stop Club, in a new warehouse facility that artists were beginning to use as live-in studios, workshops, and rehearsal spaces. There he first developed his 3-D math/art structures, and began using traditional art ideas and concepts to explore mathematics.

ANDY KATZ (HOVAB @ Highland City Club) lived and exhibited in Boulder for many years, where he was a well-known figure. He now travels the globe from the deserts of Namibia to the disappearing Jewish world of Eastern Europe to the rolling hills of the California wine country. His imagery has been featured on the covers of the Doobie Brothers and Dan Fogelberg albums and is featured in museums and galleries worldwide. He has published 12 books.

LLLOYD KAVICH (The Sink) (d. 2013) covered the walls of The Sink on the Hill with comical, irreverent paintings that spared nothing and no one from politics to sex, current events, and angst.

ADMA GREEN KERR (CU Art Museum) (1878-1949) came to Denver in the 1920s, when her work in Chicago and Washington D.C. had already made her a successful regional artist. She lived and worked in Denver until 1934, then moved to Estes Park. There she continued to pursue her interest in Colorado landscapes and share ideas with other regional painters. She was a founding member of the Colorado Artists' Guild, formed in 1928, and exhibited at the Denver Art Museum in 1926, 1936, and 1937. In 1942 she moved to Boulder, where she remained until the end of her life.

MICHAELE KEYES (HOVAB @ Mr. Pool Gallery) has been a Boulder artist since 1971, was trained as a painter but focuses on printing monotypes. She shows at Spark Gallery in Denver and teaches private groups. Her Fine Arts degree is from the University of Denver and she studied at Universidad de las Americas in Mexico City.

MARTIN KIM (HOVAB @ Canyon Gallery) was an eminent Boulder potter and early instructor at the Pottery Lab. From about 1972 to 1986, he collected 179 posters from the streets and building walls of Boulder. The entire collection "is not," Kim wrote, "an exhaustive survey by any means. I began this collection of materials ... in an effort to record evidence of what I believed to be a vital renaissance of culture, and to tell the story of its time." He now lives in Arizona and has displayed his work throughout the Southwest.

GRETCHEN KING (HOVAB @ Canyon Gallery) was born in Minneapolis, and moved to Boulder in 1952 to attend the CU-Boulder, where she received a BA in Fine Arts and English Literature in 1959. She is known for her active support of the arts in Boulder and has been on several boards, including BMoCA and The Boulder Arts Commission.

JOHN KING (HOVAB Selected Outdoor Art) lives and makes art in Lyons. His work is activated by air and flowing water. His main medium is powder-coated steel, but he also uses round, hanging river stones. He has been making kinetic art for 40 years.

CAROL KLIGER (HOVAB @ Mercury), see Catalogue Contributors, below.

KEVAN KRASNOFF (HOVAB @ Rembrandt Yard) moved to boulder in the late '70s, and started painting, with no idea why or where it would lead him. Freedom is addictive, he says. "It's been very dendritic and daily unpredictable."

TOM QUINN KUMPF (HOVAB @ Highland City Club) is an internationally recognized, award-winning photographer, writer, and author who moved to Boulder in 1996. Working primarily in documentary and fine art photography, he quickly experienced the fellowship and shared support of Boulder's artist community. His books, especially *Children of Belfast*, are testaments to that fraternity.

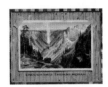

JERRY KUNKEL (HOVAB @ BMoCA) is professor emeritus at CU-Boulder. His own passion for collecting has informed his works, many of which reflect popular culture and art historical references. He has exhibited widely and collections include the Denver Art Museum, Kirkland Museum, Anderson Ranch Art Center, San Francisco MOMA, Kaiser Permanente, and Seattle Art Museum. He is represented by Robischon Gallery.

VIDIE LANGE (HOVAB @ Highland City Club) (1932-2016) came to Boulder from Dubuque, Iowa, in 1969. She studied Video Arts at CU-Boulder. Her photographs are in the collections of the Museum of Fine Arts, Boston, the Library of Congress, and the Chicago Art Institute. She was a member of Front Range Women in the Visual Arts and took part in their 2014 reunion exhibition "Transit of Venus: Four Decades," at Redline in Denver.

VELVET BRANDY LEMAE (HOVAB @ Mercury) is a founding partner and creative director of WORKSHOP8, a multidisciplinary design studio. She holds a BFA Magna Cum Laude from CU-Boulder. Brandy showed regularly from 1994 to 2004 and then took a 12-year hiatus to run her design studio and rear her daughter. She began painting again in 2015.

JEN LEWIN is an internationally renowned light and interactive sculptor who worked in Boulder for 15 years, honing her highly technical medium to fabricate large-scale interactive sculptures that combine light, sound, and motion to encourage community interaction. In 2016, she moved her studio to New York City.

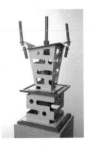

ANDREW LIBERTONE (HOVAB @ Canyon Gallery) moved to Boulder in 1969 to teach sculpture at CU. He studied at Parsons School of Design, San Francisco Art Institute, and Stanford. He left Boulder in 1979 and, while teaching in Denver, co-founded Spark Gallery.

MICHAEL LICHTER (HOVAB @ Highland City Club) began photographing custom bikes and the biker lifestyle after merging passions for photography and custom Harleys in 1977. He has a commercial photography business in Boulder, shooting advertising, corporate, and PR photography, has published more than 1,500 stories and 11 books about motorcycling.

JEANNE LIOTTA (HOVAB @ NCAR) makes films, videos, and other cultural ephemera, often at the intersection of art, science, and natural philosophy. Her award-winning work has been shown at the Whitney Biennial, New York Film Festival, and museums and festivals in the US, Europe, and Asia. She is on the faculties of CU-Boulder and Bard College.

JIM LORIO (HOVAB @ First Congregational Church Gallery) has lived and worked in Boulder, making high fire, functional stoneware and porcelain pottery ever since completing his MFA in Ceramics at CU-Boulder in 1971. He has taught and conducted workshops across the U.S. His work is included in the permanent collections of the Alice C. Sabatini Gallery, Topeka, Kansas, the Vance Kirkland Museum, and the Collection of Katsunari Toyoda, National Museum of Modern Art, Kyoto.

LINDA LOWRY (HOVAB @ The Dairy Arts Center) received her MFA from CU-Boulder and has been painting portraits and interiors since 1987. She is inspired by color, light, design, and the potential for a narrative or ethereal quality in space.

ANN LUCE (HOVAB @ Rembrandt Yard) is the author of the education series, *History Through Art and Architecture*. After moving to Boulder in 1970, she created separate programs for fifty different cultures, both contemporary and ancient. Ann is a prolific artist, and the matriarch of Boulder's Art Work Space.

LUNAMOPOLIS (HOVAB Book Arts @ Boulder Public Library) was founded in Boulder by **Joseph Braun**, **Craig Collier**, and **Indigo Deany**, publishing poetic phenomena and other adventures in space-time. Their monthly journal, *The Lune*, regards poetry as correspondence: each single-author collection is envelope-bound, pre-stamped and ready to mail anywhere in the U.S.

SUE MACDOUGALL (HOVAB @ The Dairy Arts Center) received her BA in Studio Art from Whitman College and her MFA from Claremont Graduate School. She works mainly in pen and ink and graphite, concentrating primarily on landscapes and still-life compositions. Her eyes look east to the plains. She has lived in Boulder for 45 years.

RODDY MACINNES (HOVAB @ Highland City Club) has been teaching photography at the University of Denver since 2001. He is an autobiographical photographer, who has documented his life for four decades. He received an MFA in photography from CU-Boulder, and a BA in photography from Napier University in Edinburgh, Scotland.

MERRILL MAHAFFEY (HOVAB @ BMoCA) Merrill lived in Boulder from 1983-1990 and exhibited with Maclaren Markowitz Gallery from 1984-1996. He organized the artist/patron Green River Trip in 1985, was on the organizing committee for Visual Eyes exhibitions, and served on the board of Boulder Art Center. He moved to New Mexico in 1990.

VIRGINIA MAITLAND (HOVAB @ The Dairy Arts Center) moved to Colorado in 1970 from Philadelphia. She fell in love with Colorado's natural beauty, the sweeping sky, the stunning light. The Western landscape informs her paintings in which she layers transparent sheets of color, creating veils that float above, behind, and through the spaces of the canvas.

TERRY MAKER (HOVAB @ Mr. Pool Gallery) was born in Texas and resides in Denver. She received an MA in Education from Texas Tech University and an MFA in Painting from CU-Boulder. She is known for her 3-D work in both sculpture and installation, exhibiting across the U.S. at, among others, BMoCA, MCA/Denver, Colorado Springs Fine Arts Center, Denver Botanic Gardens, and Cornell DeWitt Gallery in New York City. Selected reviews include *ARTFORUM*, *Art Papers*, *Art in America*, and *The New Art Examiner*.

CARRIE MALDE (HOVAB @ Canyon Gallery) was born in Denver in 1927 and graduated from CU-Boulder in 1948. She taught in Alaska Territorial Schools from 1949-1954 and then returned to Boulder where she received an MFA in 1986. Her work is in charcoal, oil, and oil pastel focusing on landscape in Boulder County.

DOROTHY MANDEL (HOVAB @ First Congregational Church Gallery) (1920-1995) studied general design for four years at the Massachusetts School of Art and lived in Boulder for many years until her death. Her woodcut prints, which have been exhibited across the U.S., are in the permanent collections of many public and corporate collectors, such as the Heard Museum, Museum Ein Harod, Unitarian-Universalist Arts Guild, Tilsa City-County Library Systems, and the University of Kansas.

BERNIE MAREK (HOVAB @ Naropa) (1937-2006) joined Naropa Institute in the early 1970s during the school's inception, and was an instructor in the Department of Art and Somatic Psychology and the Art Therapy Program. He blended meditative practices with visual arts and art therapy.

JULIE MAREN (HOVAB @ Rembrandt Yard) is a Colorado native, who received her BFA from CU-Boulder in 1993. She works as a painter, stone carver, textile designer, and children's book illustrator. Boulder has provided the perfect setting to practice her crafts

MARILYN MARKOWITZ (HOVAB @ First Congregational Church Gallery) (1925-2007) was a prolific artist whose works were inspired by her many travels and the Western landscape. She was known for layered colors and textures. Her work is in many personal and corporate collections, including Scripps Howard, Westin Hotels, and IBM. She received her MA at CU-Boulder, was featured in *American Artist* magazine and was a recipient of the Colorado Governor's Award for Excellence in the Arts.

NANCY MARON (HOVAB @ First Congregational Church Gallery) paints in her Boulder studio, as well as on San Juan Island in the summer. Painting on location allows her to absorb the "sense" of a place. After a successful work career, she turned to sculpture and painting in 1992.

LAURA MARSHALL (HOVAB @ Book Arts, Boulder Public Library, Naropa, and First Congregational Church Gallery), see HOVAB Associated Curators, below.

J. DIANE MARTONIS (HOVAB @ First Congregational Church Gallery) creates cut paper sculptures that relate to memories of growing up in her home state of New York. She moved to Boulder County in 2003 and serves on the board of directors for the Firehouse Art Center in Longmont. She has exhibited her work locally, nationally, and internationally.

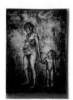

STEPHEN V. MARTONIS (HOVAB @ First Congregational Church Gallery), see HOVAB Associated Curators, below.

SIBYLLA MATHEWS (HOVAB @ Rembrandt Yard) has lived and worked in Boulder, CO for the past thirty-five years exploring many art forms. She studied at the Atlanta Art Institute and the Art Center School in Los Angeles before coming to Boulder in 1978, where she received her degree at CU in Fine Art.

JOHN MATLACK (HOVAB @ BMoCA) received his MFA in Art Practice from the University of California-Berkeley. He has received numerous awards and exhibited widely throughout Colorado and the western states including the MCA/Denver, the Denver Art Museum, Colorado Springs Fine Art Center, Aspen Center for the Arts and Humanities, Yellowstone Art Center, and Berkeley Art Center. Selected collections include the Legislative Services Building, Denver's Art in Public Places Program, The Tweed Museum of Art, and the University of Minnesota.

GENE MATTHEWS (HOVAB @ First Congregational Church Gallery) (1931-2002) received his MFA from the University of Illinois and was awarded the Rome Prize Fellowship at the American Academy in Rome in 1952, 1958 and 1959. His work was exhibited in museums and galleries worldwide. He taught at CU-Boulder until 1996, and in 1985 helped establish the University Visiting Artists Program, becoming its first director, widely acclaimed for bringing national and world artists to the campus.

WANDA MATTHEWS (HOVAB @ First Congregational Church Gallery (1930-2001) received her BFA from Bradley University in 1952 and her MFA degree from the University of Iowa in 1957. After extensive travel in Europe, in 1961, she established a studio in Boulder, where she lived for many years. Her award-winning art is in the permanent collections of institutions such as the Los Angeles County Museum of Art, Boston Public Library, Joslyn Art Museum, Library of Congress, and Neiman Marcus.

IRENE DELKA MCCRAY (HOVAB @ Firehouse Art Center) is an artist and educator. Her paintings and drawings have been exhibited mostly in Colorado, as well as in New Mexico, California, Missouri, Washington D.C., and Arizona. She teaches at Rocky Mountain College of Art and Design in Lakewood and is represented by Sandra Phillips Gallery in Denver.

JANICE MCCULLAGH (HOVAB @ Canyon Gallery) has shown her etchings regularly in juried shows since 2008. She lives in Boulder and works at Open Press in Denver. Her works reside in important collections, including those of Mark and Polly Addison, Alan and Stephanie Rudy, and the Crawford Hotel, Denver Union Station.

JILL MCINTYRE (HOVAB @ Mr. Pool Gallery) came to Boulder in 1979 and found work at the Bagel Bakery. Her plan was to attend Cornell University, but she loved life here, so she chose CU-Boulder instead and earned her BFA in Drawing and Painting. She's been in Boulder ever since, making and sharing art that tries to honor the beauty and emotion of the natural world.

JANE MCMAHAN (HOVAB @ BMoCA and NCAR) is a conceptual artist living in Boulder, who uses photography, video, painting, drawing, and construction in her projects. McMahan's current work explores cycles of construction, deconstruction, and reconstruction as they occur in nature and in the environment, culture, politics, and society. Her work has shown locally, nationally, and internationally.

MARTIE MCMANE (HOVAB @ First Congregational Church Gallery) was the Senior Minister at First Congregational Church Gallery in Boulder from 2000-2016. There she created an Arts Ministry which is now endowed in her name. She began working in pastels in 2006, after receiving a Lily Grant to explore the intersection of spirituality and the arts.

AMY METIER (HOVAB @ Mr. Pool Gallery) has an MFA from CU-Boulder. She lives in Boulder, exhibits at Havu Gallery in Denver and was recently awarded a residency at the American Academy in Rome. Her work is in private and public collections, including the Denver Art Museum and Kirkland Museum. She is on the board of BMoCA.

FRAN METZGER (HOVAB @ The Dairy Arts Center and Canyon Gallery), see HOVAB Associated Curators, below.

NO
IMAGE
AVAILABLE

GWENDOLYN MEUX (CU Art Museum) (1893-1973) studied at Owen's Museum in Sackville, New Brunswick, taught in the Fine Arts Department there and later at the University of Oklahoma. During this early period of her life, she also studied at the art colonies of Provincetown and Santa Fe. She married Arthur Gayle Waldrop in 1925, a journalism professor at CU-Boulder, where Meux taught summer school art classes. One of the founding members of the Boulder Artists Guild in 1925, Meux also wrote and illustrated articles for the Christian Science Monitor and Trail and Timberline, the Colorado Mountain Club's monthly magazine.

CYNTHIA MOKU paints in contemporary western and traditional Asian formats. She has been painting and drawing images of buddhas and historical figures within the tradition of Himalayan Vajrayana Buddhism for more than forty years. Cynthia has served as a faculty member at Naropa University in Boulder, since 1989. During the early 1990's, she designed and launched the University's Bachelor of Arts Degree Program in the Visual Arts, serving as Chair of the Visual Arts Department.

MELODY MONEY (HOVAB @ First United Methodist Sanctuary Gallery) grew up in Colorado, leaving her studies at CU-Boulder to attend art school in California for an extended period. She returned to Boulder in the early 2000s. Her mixed media textiles have been shown nationally.

CHARLES MOONE (HOVAB @ Mercury) (d. 2010) was an artist and professor at CU-Denver for over 30 years until he retired in 1998. His passing was memorialized by his daughter, Quenby Moone, in her collection of essays *Living in Twilight*. Moone's art was largely figural and full of color.

MELINDA MYROW (HOVAB @ Mr. Pool Gallery) came to Boulder from Chicago in 1986. She has exhibited her work at Open Studios, NCAR (and was on NCAR's Art Advisory Committee), and Mary Belochi's "exhibitrek," THE GALLERY.

MARILYN NELSON (HOVAB @ The Dairy Arts Center) was part of the Criss-Cross movement in 1979, canvases investigating hexagonal grid structures defined by scale, color and value shifts. The grid allowed an ordering of individual units to form the tessellated surface of repeated cells. Color was distributed according to number systems. The continual act of counting while painting repetitively was an important function of the process.

MARGARET NEUMANN was born in New York City in 1942 and has lived in Colorado since she was six years old. She received her MFA from the University of Colorado-Boulder in 1969 and has been an artist in Boulder and Denver for thirty-five years.

ELAINE NIXON (HOVAB @ Rembrandt Yard) has been living and weaving in Boulder since the 1960s. The color and texture of her work has captured the attention of numerous clients in hospitals, corporations, and private parties in Colorado, Texas, Arizona, California and she has exhibited in galleries in Boulder, Aspen, Scottsdale, La Jolla, Open Studios, and national juried shows.

BARB OLSON (HOVAB @ First Congregational Church Gallery), see HOVAB Associated Curators, below.

JIM OTIS (HOVAB @ Boedecker Theater) first came to Boulder in 1970 to attend CU, where he studied mathematics and fine arts. He taught filmmaking at CU off and on from 1978 to 1993. He has also worked as data visualizer, game developer, and web designer. Recent projects include large drawings, sculpture, and neoProtoCinema.

CHRIS PEARCE (HOVAB @ BMoCA) is a motion-picture artist, originally from New York City, who moved to Boulder in 1992 to study neuroscience. After discovering experimental filmmaking, he traded the laboratory for the studio. Chris's career in filmmaking has been a slowly forking path away from the curious observation through a microscope and toward the curious creation of motion pictures. His work has shown in film festivals and gallery installations nationally.

DENISE PERRAULT (HOVAB @ First United Methodist Sanctuary Gallery) is a long-time Boulder resident, textile artist, and member of the Boulder Handweavers Guild. She pursued weaving for 12 years until glass seed beadwork consumed her interests. She is the founder and Executive Director of Art Parts, a reuse art supply store.

GEORGE PETERS (HOVAB Book Arts @ The Boulder Public Library and Canyon Gallery) attended the Art Center College of Design in Los Angeles. His 2-D works morphed into 3-D sculptures placed in environmental and installation contexts. Moving to Hawaii further influenced his installation works in large interior spaces, making kites, banners, mechanical kinetic theatre boxes and other experimental sculptural works. He moved to Boulder in the 1980s and, in 2000, created Airworks Studio with his partner Melanie Walker, with whom he creates numerous international public art projects.

TOM POTTER (HOVAB @ First Congregational Church Gallery) taught Ceramics at CU-Boulder until his retirement in 1999. Since then, he has continued to live and work in Boulder. He received his BA in Art Education from Iowa's Cornell College and both an MA and an MFA in Ceramics from the University of Iowa.

JILL POWERS (HOVAB @ Naropa) was a frequent visitor to Boulder until she moved here in 2000. She is an installation artist who works with the aesthetics and science of ecosystems. She founded Naropa University's course in Eco Art, teaches Ephemeral Art, and natural materials. She has exhibited internationally, and her work is in the Lieberman Contemporary Craft Collection and the American Museum of Papermaking.

KAREN POULSON (HOVAB @ Mr. Pool Gallery) moved to Boulder in 1965 and has been painting and exhibiting nationally ever since. She has a continuing interest in prehistory and the marks and remnants left by previous generations linking past and present. Much of her current work is influenced by travel to prehistoric sites in Great Britain, Scandinavia, and the southwestern U.S.

PROJECT (IN)VISIBLE (HOVAB @ Pine Street Church) by One Thousand Design looks at the untold stories of individuals living on the margins in Boulder County. This collection of photography and testimonial reflects stories of struggle and chance, bad luck and tough choices, as well as stories of hope and partnership, risk and strength. The project is led by writer and creative director **Kassia Binkowski**, photographer and filmmaker **AJ Oscarson**, and graphic designer **Katie Malone**, who are working in collaboration with Boulder County and several non-profit agencies to ignite a conversation within our community about action and opportunity.

MARY ROWAN QUINN (HOVAB @ First United Methodist Sanctuary Gallery) (1954-2014) spent her entire life in Boulder. Her art quilts use a contemporary approach, which she called "fiber painting." A prolific artist, her work appeared in the prestigious Quilt National exhibit. She also had a one-woman exhibit at NCAR.

JALALIYYAH QUINN (HOVAB @ Canyon Gallery) received her MFA from CU-Boulder and lived in Boulder from 1974 to 1985. She has held solo exhibitions and taught in the U.S, China, and Liberia, though Boulder remained her home base. Her paintings work with the relationship between art, science, and the Bahá'í writings inviting contemplation. After 19 years abroad, Quinn returned to teach art at Front Range Community College. She now lives in Gallup, N.M.

JEANNE QUINN (HOVAB @ The Dairy Arts Center) earned her BA at Oberlin College; after post-baccalaureate studies in Ceramics at CU-Boulder, she went on to earn her MFA in Ceramics from the University of Washington, exhibits her work internationally, and has taught Ceramics at CU since 1997.

LOUIS RECCHIA (HOVAB @ Firehouse Art Center) moved to Boulder from Chicago in 1972 and has lived in Berthoud since 1985. He is represented in the permanent collection of the Denver Art Museum and has been active in the arts both locally and internationally for the past several decades.

HELEN BARCHILON REDMAN (HOVAB @ The Dairy Arts Center, Canyon Gallery, and First Congregational Church Gallery) spent 26 years in Boulder, receiving her MFA at CU-Boulder in 1963, where she formed her perspective as a feminist and educator. Her art is exhibited internationally and is part of the Brooklyn Museum and Colorado Springs Fine Arts Center collections. She was a founding member of Front Range Women in the Visual Arts.

MARY BETH REED (HOVAB @ Boedecker Theater) lived in Boulder from 1994 until 2004, studying experimental film at CU-Boulder. She received her BFA/BA in Film and Art History in 2000, and in 2001, began teaching film production at CU where she created films combining hand painting, animation, traveling mattes, and hand processing. She now teaches in the Film and Photography Department at Virginia Commonwealth University.

CELESTE REHM (HOVAB @ The Dairy Arts Center) created artwork and taught at CU-Boulder, from 1973 to 2000. She has exhibited widely throughout the U.S.

ELISABETH RELIN (HOVAB @ Highland City Club) began her study of photography with Vidie Lange, who became her friend and mentor. She received her MFA in 1987 at CU-Boulder, studying with Charlie Roitz, Barbara Jo Revelle, and Alex Sweetman. She is currently an associate member of Denver's Spark Gallery.

CLARK RICHERT (HOVAB @ The Dairy Arts Center and Canyon Gallery), see HOVAB Associated Curators, below.

TED RINGER (HOVAB Book Arts @ Boulder Public Library) is a writer, artist, and writing teacher, who has lived in Boulder since 1970. His children's book, *Drawing and Dreaming* is a declaration of creative independence. He is the author of several novels, including, *Born with a Beard*, *Gus Goes West*, and *Get Outta Town*.

NANCY ROBERTSON (HOVAB @ First Congregational Church Gallery) was a long-time Boulder artist and a director of the Boulder Artist Gallery (and particularly praised for her "No Show" exhibit protesting the first Gulf War) until her departure for North Carolina in the mid-1990s.

SUE CAROL ROBINSON (HOVAB @ The Dairy Arts Center) studied Art at the University of New Mexico, where she discovered black-and-white photography. Her MFA is from CU-Boulder, where she explored what emotional effects could happen with oil paints. Her current work is in vivid color.

GREGORY ROBL (HOVAB Book Arts @ Boulder Public Library) draws the themes for his artist books from his travels and creates structures that reflect that content. He moved to Boulder in 1968 and has worked at Norlin Library at CU-Boulder since 1992. He is a member of the Book Arts League.

SUZY ROESLER (HOVAB @ Canyon Gallery) (1942-1999) grew up in Connecticut and attended Middlebury College, where she studied creative writing. She moved to Boulder in 1968 with her husband, John, who was later killed in action in Viet Nam. Her art was shown at the National Gallery in Washington, D.C., the Denver Art Museum, and numerous other galleries around the country, and is in the permanent collections of the Boulder Public Library and Denver Children's Hospital.

CHARLIE ROITZ (HOVAB @ Highland City Club) (1935-2012) grew up in Trinidad, Colorado. He began his career behind the lens after he enlisted as a young man in the US Navy, taking aerial photographs of Hawaii and Alaska, and later founded the photography department at CU-Boulder, where he taught until his retirement in 1991.

JEAN ROLLER (HOVAB @ Canyon Gallery) was born in Colorado and has lived and worked here since. She built shaped canvasses and constructions in the 1970s and box constructions with art historical references beginning in the 1980s. She has shown widely in Colorado.

CHANDLER ROMEO (HOVAB @ BMoCA) lived in Boulder in the 1960s and 1970s and currently lives and works in Denver. Her numerous honors include the Mayor's Award for Excellence in the Arts and the AFKEY Award from the Denver Art Museum's Alliance for Contemporary Art. Romeo has exhibited her work throughout the region, at, among others, the Dairy Arts Center, the Arvada Center for the Arts and Humanities, Foothills Art Center, Colorado Springs Fine Art Center, and the MCA/Denver. Her work is in many private, corporate, and public collections nationwide.

GARRISON ROOTS (HOVAB @ The Dairy Arts Center) (1952-2011) was born in Texas, received his BFA from Massachusetts College of Art in 1979 and his MFA from Washington University in 1981. He began teaching sculpture at CU/Boulder in 1982, became department chair, and led the charge and vision for the new Visual Arts complex on campus. He was known for his large site-specific installations.

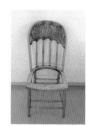

ANTONETTE ("TONI") ROSATO (HOVAB @ The Dairy Arts Center) (1952-2006) began her artistic career in the late 1970s with exhibitions in California, where she obtained her MFA from Claremont Graduate School. She taught sculpture and visual thinking in the Department of Art and Art History until December 2005.

YUMI JANAIRO ROTH (HOVAB @ Mercury) is a professor of sculpture and post-studio practice at CU-Boulder. Her diverse body of work explores ideas of immigration, hybridity, and displacement through discrete objects and site-responsive installations, solo projects as well as collaborations. She has exhibited and participated in artist-in-residencies internationally and received a BA in anthropology from Tufts University, a BFA from the School for the Museum of Fine Arts-Boston and an MFA from the State University of New York-New Paltz.

DISMAS ROTTA (HOVAB @ Mercury) has lived in Boulder since 2000. His work has been exhibited at the Arvada Art Center, The Dairy Arts Center the Firehouse Art Center, Spark Gallery, and Mercury Framing.

GERDA ROVETCH (HOVAB @ Rembrandt Yard) studied art in London with Royal Academicians and the Art Students League, New York. She speaks of her art is "a piece by piece development held together by a strong sense of design and an incorrigibly playful mind."

BUNNY ROSENTHAL RUBIN (HOVAB @ Rembrandt Yard) turned to brushes and paints from weaving to, she says, "reflectively portray nature's world: from above and below the horizon, where earth meets sky, to the momentary gesture of flora, fauna and human form, directly from life and/or from internal sub-conscious sources."

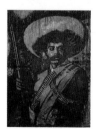

EDDIE RUNNING WOLF (HOVAB @ Firehouse Art Center) is a Boulder-based artist. He is known locally for various public art wood sculptures. He has been working in Boulder County for over 30 years.

MARTHA RUSSO (HOVAB @ Canyon Gallery) moved to Colorado to pursue her MFA at CU-Boulder. Her undergraduate degree in Developmental Biology and Psychology (Princeton University 1985) has been the core of her art making. She is a sculptor and installation artist who uses primarily ceramics materials to make her ideas come alive. She is a member of the social and politically based art collective, Artnauts, has been a Visiting Lecturer at CU, and taught Fine Arts at Rocky Mountain College of Art and Design.

FRANK SAMPSON (HOVAB @ Canyon Gallery) was born on a farm in Edmore, N.D., in 1928. He received his BA from Concordia College, Moorhead, Minnesota, in 1950 and his MFA from the University of Iowa in 1952. He had a Fulbright Scholarship from 1959 to 1961, which he spent in Brussels, Belgium. He taught at CU-Boulder from 1961 to1990 and continues to live and work in Boulder.

LINDA SAPORT (HOVAB Book Arts @ Boulder Public Library) is an illustrator of children's books and a reference librarian at the Boulder Public Library. Her books include *Subira Subira, All the Pretty Little Horses: A Traditional Lullaby, Circles of Hope,* and *The Company of Crows: A Book of Poems.*

ROBERT SCHALLER (HOVAB @ Boedecker Theater) is a filmmaker and composer whose work centers on the integration of film and classical chamber music, handmade pinhole cinematography, handmade emulsion, nature, and dance. He directs the Handmade Film Institute, conducting immersive retreats using photochemical processes as a creative tool for the making of cinematic art.

CHARMAIN SCHUH (HOVAB @ The Dairy Arts Center), see HOVAB Associated Curators, below.

MARYLYNN SCHUMACHER (HOVAB Book Arts @ Boulder Public Library) has been exploring the idea of art and vessel from her first clay class at the Boulder Pottery Lab to her current work exhibited at shows including the Boulder Potters' Guild, Loveland's Sculpture in the Park, and Boulder's Open Studios. "As pottery holds sustenance and books contain ideas," she says, "we each hold our stories, and art contains our soul."

TERRY SEIDEL (HOVAB @ The Dairy Arts Center) was born in North Dakota, is a self-taught artist/sculptor, and was influenced by Native American artists. He came to Boulder in 1978 and established Mr. Pool and Mr. Pool Gallery in 2000.

JULIA SEKO (HOVAB @ Book Arts Boulder Public Library) is a letterpress printer, book artist, and book arts instructor. She is adjunct faculty at Naropa University, where she helped set up the letterpress studio and co-founded the Book Arts League, a non-profit letterpress and book arts organization. Her work is in university and private collections.

MIA SEMINGSON (HOVAB Book Arts @ Boulder Public Library) moved to Colorado in 1998 to pursue her MFA in photography and electronic media. Her work has been exhibited internationally in Colombia, Mexico, Guatemala, and France as well as nationally. Mia taught photography, book arts, and video production at CU-Boulder for 11 years. In 2010, she and her husband, Gerald Trainor, purchased Two Hands Paperie.

BARBARA SHARK (HOVAB @ Canyon Gallery and First Congregational Church Gallery) came to Boulder in 1974 and now lives in Lyons. She received her BFA at the University of New Mexico and her work is in the collections of the Minneapolis Institute of Art, Plains Art Museum, Kaiser Permanente in Boulder and Denver and Denver's University Hospital. In 2010, BMoCA hosted her solo show, Moments In Between, for which a catalogue of the same title was published.

NO
IMAGE
AVAILABLE

JEAN SHERWOOD (CU Art Museum) (1848-1938) was born in Oberlin, Ohio, and received her BA from that town's college. She was an active promoter of the arts in Boulder and Chicago. She was instrumental in spearheading and shepherding many projects, including the Chautauqua, the Blue Bird, the Boulder Art Association, and the Boulder Artists Guild. She was a firm believer in the transformative power of art in all people's lives.

MURIEL SIBELL WOLLE (CU Art Museum) (1897-1977) graduated from the New York School of Fine and Applied Arts (later Parsons) with a degree in costume design and advertising, then taught for a period at the Texas State College for Women in Denton but left to earn a BS in Art Education from New York University. In 1924, she accepted a teaching position at CU-Boulder, becoming department chair in 1927. In 1978, the year after her death, the CU Board of Regents honored Muriel Sibell Wolle by naming the fine arts building after her. She can be credited with making the department what it is today.

DAWN HOWKINSON SIEBEL (HOVAB @ Rembrandt Yard) moved to Boulder from New York City in 1994. "I left in 2010 and miss it still." Boulder, she says, made her a painter. In 2010 she left Boulder to finish "Better Angels: The Firefighters of 9/11." She paints portraits of endangered species.

KRISTINE E. SMOCK (HOVAB Book Arts @ Boulder Public Library, Canyon Gallery, and Selected Outdoor Art) has lived in Boulder since 1979 and has created public art pieces throughout Boulder, as well as in Denver and New Jersey. She has always been drawn to collecting recycled objects, rearranging, painting and rebuilding them. In 2003, she moved to Lyons.

PHILIP SOLOMON (HOVAB @ Boedecker Theater) has been a Professor of Film Studies at CU-Boulder since 1991. He collaborated on three films with Stan Brakhage, who named Solomon's *Remains to be Seen* on his Top Ten Films of All Time list for *Sight and Sound*. Solomon has received numerous awards and prizes, including Oberhausen and Black Maria and a Guggenheim Fellowship. His films have been exhibited in every major venue for experimental film throughout the U.S. and Europe, among them two Whitney Biennials and three one-person shows at MoMA.

ROBERT SPELLMAN (HOVAB @ Canyon Gallery and Naropa) is an artist and teacher on the faculty at Naropa University and an annual invited lecturer for the Dharma Art Masters Series at its Summer Writing Program. Spellman's varied body of work includes subjects from the plant and animal kingdoms as well as machines, skies, fruit, warplanes, and ordinary household implements. His painting, "Helios #11," appears on the cover this book.

STACEY STEERS (HOVAB @ The Boedecker Theater) is a long-time Boulder filmmaker, known for her process-driven, labor-intensive films composed of thousands of handmade works on paper. Steers's animated short films have been screened throughout the U.S. and abroad, and have received multiple awards. She is the recipient of major grants from the Guggenheim Foundation, Creative Capital Foundation, and the American Film Institute.

C. MAXX STEVENS (HOVAB @ The Dairy Arts Center) is an Installation artist of the Seminole / Mvskoke Nation from the Oklahoma region. She received her MFA in 1987 from Indiana University-Bloomington, and has received many awards and honors. In 2012, she had a solo exhibition at the National Museum of the American Indian George Gustav Heye Center in New York.

JANET STEVENS came to Boulder in 1971 to attend CU. Shortly after graduation she began illustrating children's books. Her love of reading, art, and children have combined to create the perfect career. Janet has received numerous book awards, including a prestigious Caldecott Honor.

ISOLDE STEWART (HOVAB @ Canyon Gallery and First United Methodist Church Sanctuary) migrated to Boulder from the east coast in 1975, when Boulder was the mecca of conscious living. In 1983, she discovered the ancient art of creating spiritual icons with everyday household materials. Intuitively, she built her inner consciousness, archetype by archetype, each made manifest in her hands through socks and stuffing: a personal Mystery School of the Mundane.

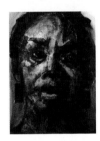

WILLIAM STOER (HOVAB @ Rembrandt Yard) has exhibited at universities, art centers, museums, and galleries. Recent awards include: *Best of Show* - Best of Santa Fe Denver Arts District and Best of Show - Brooklyn Artists Coalition juried by Christiane Paul of the Whitney Museum of Art. He has been painting in Boulder for nine years.

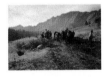

JOSEPH BEVIER STURTEVANT (HOVAB @ BMoCA) (1851-1910), otherwise known as Rocky Mountain Joe, was born in Boston, was a circus performer, an Indian fighter, tourist guide, and storyteller. He arrived in Boulder in 1874, where he established himself as the fledgling town's most distinctive early photographer.

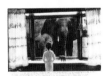

PAULA SUSSMAN (HOVAB @ Rembrandt Yard) makes award-winning work (included in *The History of Photography Collection*, Harvard University Press), dubbed *"fantastical photography"* by a *New York Post* critic, a hyperextension of reality – never a distortion!

WILLIAM S. SUTTON (HOVAB @ Highland City Club) has lived in the mountains west of Boulder, Colorado for 34 years and is a professor at Regis College in Denver. He received his BFA ('78) and MFA ('84) from CU-Boulder. He is the author of *At Home in the West: The Lure of Public Lands*, collaborated with Michael Berman on the Wyoming Grasslands Photographic Project, and is a recipient of a Guggenheim Fellowship.

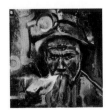

SOPHIA SWEENEY (HOVAB @ Mr. Pool Gallery), born and brought up in Boulder, has been creating art in some form or another for most of her life. She began with painting and drawing, and evolved to using primarily house paint and oil on plywood.

ALEX SWEETMAN (HOVAB @ Highland City Club) studied literature and film at New ork University. He received his MFA from the State University of New York-Buffalo in 1975. He teaches photography and the history of photography and has had over 100 national and international exhibitions and over 30 collaborative and solo shows. He has worked to build the finest collections of the visual literature of photography in the world in Special Collections, CU's Norlin Library.

STEVE SWINK (HOVAB Book Arts @ Boulder Public Library) (1952-2007) was the first employee, in 1974, at Mile High Comics, the first comic book store in Boulder. He returned to his hometown of Baltimore in 1981 to run Geppi's Harbor Place mall store for several years, then returned to Boulder and worked for Alfalfa's grocery, all the while making art and raising children. He also managed Time Warp Comics, now Boulder's only comic-book haven.

BARBARA TAKENAGA (HOVAB @ Macky Auditorium) lived in Colorado for more than 17 years, now lives in New York City, and is a professor of Art at Williams College. Selected collections include: Ackland Art Museum, University of North Carolina, Chapel Hill, DeCordova Museum, Library of Congress, Pennsylvania Academy of Fine Art, and San Jose Museum of Art.

HARRIET PECK TAYLOR (HOVAB Book Arts @ Boulder Public Library) is an award-winning author and illustrator of children's picture books as well as a long-time Boulder resident and artist. She is a graduate of CU with a BFA in Fine Arts. A critic one said of her art that "it pays tribute to a beautiful world."

THEA LELE POTTERY (HOVAB @ Canyon Gallery) **Thea Tenenbaum** grew up on Mapleton Hill and attended Mapleton School, Casey, Boulder High, and CU. She began making pottery in 1970, interned with Betty Woodman, taught pottery at Boulder's Firehouse Studio and helped in the foundation of the Boulder Arts and Crafts Cooperative. **Raffaele Malferrari** started decorating some of the ceramics in 1980, when he and Thea were living in Italy. In 1985, they moved back to Boulder and have been local potters ever since.

MICHAEL THEODORE (HOVAB @ NCAR) has presented his works in the U.S., Europe, Latin America, and Asia. He is on the faculty of CU-Boulder's College of Music, Department of Art and Art History, and director of the ATLAS Institute's Center for Media, Arts, and Performance. His degrees are from Amherst College, Yale, and University of California-San Diego.

SEAN TIFFANY (HOVAB Book Arts @ Boulder Public Library) moved to Boulder in the spring of 1996 having grown up on a small island off the coast of Maine and studying illustration and cartooning in northern New Jersey. He has been a working artist and illustrator for decades. His project, *Oilcan Drive*, a rock-and-roll adventure, combines a web comic, print comics, videos, and music.

JUDITH TRAGER (HOVAB @ Rembrandt Yard) has been a studio artist and teacher in Boulder since the early '90s, and an Open Studios artist since 2000. She is a member of the Visual Arts Committee of the Dairy Arts Center.

VIRGINIA TRUE (CU Art Museum) (1900-1989) painter and teacher, was born in St. Louis, Mo., and grew up there and in Hannibal, where she attended high school. In 1918, she enrolled in the John Herron Art Institute at Indianapolis and, winning scholarships for three years, was a pupil of William Forsyth. She taught at CU-Boulder from the late 1920s until 1942, when she became head of the Home Economics Department at Cornell University.

STEFKA TRUSZ (HOVAB @ Mercury) moved to Boulder in 2000, where the peace, pace, fellow artists, and nature at her doorstep inspired her work. A document scanner pushed her to take photographs without a camera. Her art has been exhibited at The Dairy Arts Center, the Boulder Public Library, and at NoBo Art District.

HARRISON TU (HOVAB @ Naropa) has created numerous works of calligraphy, many of which have been selected for exhibition in the U.S., Japan, Korea, and Singapore. In these, and other international exhibitions, Mr. Tu has received high recognition and strong reviews.

TONY UMILE (HOVAB @ Firehouse Art Center) first came to Boulder as a CU student in 1955, and has lived in Longmont since 1973. She has been taking photographs since she was a teenager.

LUIS VALDOVINO (HOVAB @ Boedecker Theater) is a professor in the Art & Art History Department at CU-Boulder. His exhibitions include the Museum of Modern Art, New York; Venice Biennale; Centre Georges Pompidou, Paris; Museo Nacional Centro de Arte Reina Sofia, Madrid; and Stedelijk Museum, Amsterdam.

RICHARD VAN PELT (HOVAB @ Highland City Club) was born in Seattle and saw Boulder for the first time in 1946, when his father's car crested the hill at Legion Park on Arapahoe Road. "Through the windshield was framed a community, lying low in the valley of this special place. This was, to my memory, my earliest appreciation of place, and it was beautiful." Van Pelt received his MFA from CU in 1978.

MATILDA VANDERPOEL (CU Art Museum) (1862-1950) studied at Chicago's School of the Art Institute, one of six students graduating in 1891. She taught there, beginning 1909, while her brother served as director. Originally from Holland, Vanderpoel painted pastel portraits, landscapes, and flowers. She was one of Jean Sherwood's "Bluebirds" (Chicago working women who vacationed each year in Boulder and Gold Hill) and two wall murals in the "Bluebird Cottage" at 1215 Baseline are credited to her. In 1923 she moved into a Gold Hill cabin with her brother and his wife. Affectionately called "Auntie Till" by the locals, she returned every summer for 20 years.

BECKY VANDERSLICE (HOVAB @ First United Methodist Sanctuary Gallery), a genetic researcher, came to Boulder in 1970. At retirement she explored hand weaving, focusing on incorporating optic fiber, electroluminescent wire and micro controlled LED's. She was project leader and creator of "Luminescence," a woven metal installation with 2000 digitally controlled LEDs, at The Dairy Arts Center in Boulder in 2014.

RICHARD VARNES (HOVAB @ Canyon Gallery) is a photographer who lived in Boulder from 1967 to 2009 and is best known for his intimate portraits of the Boulder Community. His largest project: *Icons of My Tribe: A Year at the Mall* was featured as a solo exhibition at the Boulder Center for the Visual Arts and remains a poignant look at our modern rituals of worship.

BILL VIELEHR (HOVAB @ Canyon Gallery and Selected Outdoor Art) (1945-2014) was born in Chicago, but spent most of his life in Boulder, where he became a prolific sculptor, working out of a tin shed on West Pearl Street. His work is in San Francisco's Embarcadero, Denver's Cherry Creek Plaza, the Albuquerque Public Library, the Boulder Reservoir, Boulder Public Library and in the Charles Haertling Sculpture Garden. He was a co-founder and president of the Boulder International Film Festival, creator of "The Vielehr," a handmade, 9-inch-tall award he produced each year for BIFF winners, such as Shirley MacLaine, Alec Baldwin, Martin Sheen, and William H. Macy.

KATE VILLARREAL (HOVAB @ Firehouse Art Center) earned her BFA at The Kansas City Art Institute. She teaches Ceramics at Boulder High School and believes that an active artist makes a better art teacher. She maintains a home studio and shows her work throughout the Front Range.

MARK VILLARREAL (HOVAB @ Mr. Pool Gallery) graduated from The Kansas City Art Institute in 1982 with a BFA in Painting and moved to Boulder that spring. He has lived in Boulder, Lafayette, Longmont, and Berthoud, and his work has been shown in Boulder, Denver, Santa Fe, Aspen, Pueblo, and Brooklyn, N.Y. He is represented by Goodwin Fine Art, Denver.

BETH WALD (HOVAB @ Highland City Club) is an award-winning documentary photographer who creates compelling visual narratives exploring the rich diversity of natural environments and traditional cultures under threat around the world. Her wide-ranging career has taken her to remote corners of the world for many publications including National Geographic, Smithsonian, Outside and many others. When not on assignment, she lives in Boulder.

MELANIE WALKER (HOVAB @ Highland City Club) attended San Francisco State University (BA) and Florida State University (MFA). Her awards include an NEA Visual Arts Fellowship, Colorado Council on the Arts Fellowship, and an Aaron Siskind Award. She teaches in the Media Arts Area at CU-Boulder and has work in several collections including LACMA, Center for Creative Photography, Princeton Art Museum, and SF MoMA.

CAROL WATKINS (HOVAB @ First United Methodist Sanctuary Gallery) arrived in Boulder in 1991 and embraced quilting soon afterward. Content is communicated through digital print on fabric and thread painting. Her quilts are in the First Presbyterian Church sanctuary, CU Folsom Field, and in private collections.

JOHN WAUGH (HOVAB @ Rembrandt Yard) was born in Boulder and mentored by Boulder photographers Ev Long and Don Look, among others. His first solo exhibition took place at the Glenwood Springs Center for the Arts in 1998, and he has been a professional motorsports photographer from 2000.

LIZA WEEMS (HOVAB @ First Congregational Church Gallery) has lived in Boulder since 1975. She studied photography at CU-Boulder and at Anderson Ranch Arts Center in Snowmass. As a photography educator, she established the darkroom at September School in 1992, and established the photography department at New Vista High School where she taught photography from 1997-2004 and in the fall of 2009. As a photographer, Liza has exhibited her work in the U.S. and Europe.

STEVEN WEITZMAN (HOVAB Selected Outdoor Art) lived in Boulder in the 1970s and '80s, created the "Treegle," which stood for many years in the Crossroads Shopping Mall and the bust of Chief Lefthand at the Boulder County Courthouse. Eventually, he moved to Brentwood, Md., where he works on private commissions, site-specific public art installations, major highway installations, and urban development projects.

DOUG WEST (HOVAB @ Canyon Gallery) moved from Santa Fe to Boulder in the 1980s and maintained a studio here for seven years. He exhibited his serigraphs at the Albatross Gallery before it became Maclaren Markowitz. Boulder, he says, had a keystone influence in consolidating his career as an artist.

SUE HAMMOND WEST (HOVAB @ Naropa) is a painter/mixed-media artist who combines art-making with the energy of Buddhism and yoga philosophy. She came to Boulder in 1995 and teaches at Naropa University, where she researches contemporary and ecstatic art forms and how to infuse art with a palpable haunting presence. She has exhibited at Beacon Street Gallery/Chicago and the University of Notre Dame Isis Gallery.

SHERRY WIGGINS (HOVAB @ Canyon Gallery) came to Boulder in 1970. She is a multi-disciplinary artist, cultural organizer, and contributing writer. Her work is reflective, often participatory, and rooted within cultural difference, spiritual transformation, social justice, and women's issues. National and international exhibitions include venues in China, India, Korea, Mexico, the Middle East, South America, and the U.S. She is a founding member of 6+, a women's art collective, which facilitates exhibitions, publications, and workshops among women artists internationally. She holds BFA and MFA degrees from CU-Boulder.

JERRY WINGREN (HOVAB @ Canyon Gallery, Mr. Pool, and Selected Outdoor Art) was reared in southeastern Alaska and entered the University of Washington in 1959 to study Scandinavian and German language and literature. He was awarded a Fulbright scholarship to study German drama at the University of Bremen. There he began an apprenticeship in stone sculpture. In Heidelberg, Wingren studied Origami with Hiromi Hoshiko. He has exhibited widely in the U.S. and Europe in private galleries and art museums, including the Atlanta Sculptural Arts Museum, the Denver Art Museum, and the Kleine Orangerie in Berlin. His works are found in private and public collections in the U.S., Germany, Norway, Sweden, Italy, Spain, and Japan.

MICHAEL WOJCZUK (HOVAB @ First Congregational Church Gallery and Selected Outdoor Art) came to Boulder in 1980 with his young family seeking a life as an artist and poet. He painted murals in Boulder and around the U.S. in the 1980s and '90s and has taught elementary public school art since 1998. His work includes a Jack Kerouac Conference poster, a Japan painting series, 100 sketches of Catalonia, Spain, and the Art Tarot.

NURIT WOLF (HOVAB @ Highland City Club) was born, reared, and educated in Israel, where her father taught her photography when she was 10. She moved to Boulder in 1968, has exhibited here (including Open Studios) and beyond. Three of her photographs are in the permanent collection of the Denver Art Museum.

LYNN WOLFE (HOVAB @ First Congregational) was born and raised in Nebraska, studied art in Paris and painting with Max Beckmann in Germany. He has exhibited at New York's Metropolitan Museum of Art, among others. He taught Painting and Sculpture in Nebraska, Alaska, Hawaii, and at CU for 30 years.

JOAN WOLFER (HOVAB @ First United Methodist Sanctuary Gallery) moved to Boulder in 1988. Her fiber art has been exhibited in invitational and juried shows in the U.S., appeared in books and magazines, and is in private collections.

VIRGINIA WOOD (HOVAB @ Rembrandt Yard) was born in Columbia, S.C., and majored in Fine Art at the University of South Carolina, followed by three years at the Art Students League in New York City. She moved to Boulder in 1975. Her paintings grew from realism to abstraction with emphasis on color, and simultaneously moved back to horse and landscape imagery.

BETTY WOODMAN (HOVAB @ Macky Auditorium and Canyon Gallery) was a professor of Art at CU-Boulder from 1978 to 1998 and was famous in Boulder for her ceramics sales, as well as her initiation in 1954 of the Pottery Lab, a community learning center that continues to thrive. She now lives in New York City and Italy. In 2006, New York's Metropolitan Museum of Art honored her with a retrospective exhibition. Selected collections include: Museum of Fine Arts, Boston; Metropolitan Museum of Art, New York; Museum of Modern Art, New York; Smithsonian Institute; and London's Victoria and Albert Museum.

GEORGE WOODMAN (HOVAB @ The Dairy Arts Center and Highland City Club) is a photographer and painter, who received one of the first NEA fellowships in 1967. His work is in the collections of New York's Museum of Modern Art, the Guggenheim Museum and the Whitney Museum of American Art. He is professor emeritus at CU-Boulder, where he taught painting and the philosophy of art. He now divides his life between New York City and Antella, Italy.

JENNIFER WOODS (HOVAB @ First Congregational Church Gallery) lived in Boulder from 1973 to 1999. Over the years she has explored many art forms including fiber arts, jewelry design, painting, sculpture and CAD drafting and design. Jennifer now lives in New Mexico.

FRED WORDEN (HOVAB @ The Dairy Arts Center) focused on intermittent projection as the source of cinema's primordial powers during his years as a Boulder filmmaker. Bursts of light followed by equal moments of darkness delivered at a speed to overwhelm the eyes and induce the perception of a continuous light/time rectangle – out of this perceptual dynamic come many of the so-called illusions of cinema.

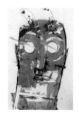

NEIL MACKAY YARNAL (HOVAB @ Boulder Creative Collective) lives in Nederland. He earned his BFA in Illustration from Ringling College of Art and Design. He is a Brand Illustrator at Emerson Stone, a local design agency, and works with global clients, as well as startups. As an illustrator, he uses color theory, traditional illustration techniques and anthropology, which differs greatly from his other work.

MELANIE YAZZIE (HOVAB @ BMoCA and BMOCA Present Box) is of the Salt Water Clan and Bitter Water Clan of the Diné People of northeastern Arizona. She is professor of Art and Head of Printmaking at CU-Boulder. Her works belong to many collections, including the Anchorage Museum of History & Art, the Art Museum of Missoula, the Australian National Gallery & the Kennedy Museum of Art. She has exhibited nationally and internationally in places such as Alaska, California, New Mexico, New York, Florida, New Zealand, France, Russia, Canada, Bulgaria, Northern Ireland, and South Africa. She takes part in collaborative art projects with indigenous artists in New Zealand, Siberia, Australia, Canada, Mexico and Japan.

YOSHIKAWA (HOVAB Selected Outdoor Art) is a Japanese American stone sculptor born in Osaka. He returned to Japan to work in the stone quarries after graduating with a BFA from CU-Boulder. He has received numerous awards for his artwork, which can be found in many collections, as public art throughout the United States and in Japan, as well as in commercial spaces and residential gardens.

SHERRY WATERWORTH YOUNG (HOVAB @ First Congregational Church Gallery) came to Boulder in 2011. She has been drawing all her life, studied art in college and taken several painting workshops, though for the most part she is self-taught. She paints mainly in oils and tries to capture all colors in nature.

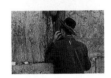

RANDALL ZAHN (HOVAB @ First Congregational Church Gallery) has been sharing photography, digital illustration, writing, and painting with the general public in Boulder since 1980. In addition to exhibiting his work locally and internationally, he supports the art community as a Master Printmaker.

GARY ZEFF (HOVAB @ Canyon Gallery) moved to Boulder in 1994, where he wanted to accomplish two things: find a way to use his marketing experience to help visual artists present their work by engaging the community in the artistic process, and continue his woodturning. He founded Open Studios, which was the successful culmination of these efforts.

CHARLOTTE ZIEBARTH (HOVAB @ First United Methodist Church Gallery) came to Boulder from Montana in 1966 to attend CU, earned her PhD, and taught at the University of Calgary, before she returned in 1976 to pursue weaving as a studio artist. She took up art quilting in 1994, has work in public collections and is the author of *Artistic Photo Quilts*.

CHARLOTTE ZINK (HOVAB @ Firehouse Art Center) was born and raised in New Orleans, came west in 1987, and earned a BA in Studio Arts and Art Education from CU-Boulder. She and her husband, Ben, create and exhibit their art throughout the Front Range, including the permanent collections of Denver Public Schools, Children's Hospital, Sky Ridge Hospital, City of Greeley, and City of Longmont's Art in Public Places programs.

AMOS ZUBROW (HOVAB Selected Outdoor Art) is a professional welder and blacksmith, the proprietor of Iron Rose Forge and Welding. In 2013, his "Girl on a Bicycle" was featured in the Dairy Arts Center's *Art of the Bicycle* exhibition.

Steering and Curatorial Committee Biographies

KAREN RIPLEY DUGAN (1939-2015) worked first in Boulder at the Sun Sign, an art supply and craft store she owned with her husband. She then became the first paid and longest employed (12 years) director of the Boulder Center for the Visual Arts, now BMoCA. In 1992, she moved to the Boulder Public Library as Director of Cultural Programs. She worked there until the end of 2005, when she retired. Working in the arts was often difficult, she said, but something she loved doing. *Celebration! A History of the Visual Arts in Boulder* is dedicated to her memory.

Karen Ripley Dugan curated HOVAB @ Canyon Gallery: *A Lasting Legacy.*

SALLY ELLIOTT has been exhibiting locally and nationally as an artist for more than 30 years. She was a founding member of Front Range Women in the Visual Arts and in June/July 2000, she helped organize a major anniversary exhibition at BMoCA. She is a long-time member of Denver's Spark Cooperative Gallery, where she exhibits yearly. She was awarded a residency at the Virginia Center for the Creative Arts, a fellowship from the Colorado Council on the Arts, a Boulder Arts Commission Grant, and was named an associate at the Rocky Mountain Women's Institute. She has been a visiting artist/lecturer at colleges and universities across the U.S. and from 1999 to 2011 she was on the Drawing and Painting faculty at CU-Boulder, where she was named Professor of the Year in 2006. Her art is in numerous private and public collections, including IBM, United Airlines, Kenyon College, Front Range Community College, and Kaiser Permanente.

Sally Elliott curated HOVAB @ The Dairy Arts Center, and liaised with curators for HOVAB @ Naropa, HOVAB @ Firehouse Art Center: *Local Folk*, and HOVAB @ First Congregational Church Gallery, *Sumptuous Spirits / Sumptuous Locals.* She co-curated HOVAB @ Canyon Gallery: *A Lasting Legacy,* and HOVAB @ Mr. Pool Gallery: *Objects and Abstractions.*

JENNIFER HEATH (Chair) is an award-winning independent scholar, curator, and cultural journalist. Her honors include the Donald Sutherland Award for Investigative Reporting, which she won with M.S. Mason for an exposé about the plight of CU-Boulder's Permanent Collection and thus began preventing it from gradual destruction. Heath's many international touring exhibitions include *Water, Water Everywhere: Paean to a Vanishing Resource* (the first in a climate-change trilogy); *The Veil: Visible & Invisible Spaces*; *Black Velvet: The Art We Love to Hate,* and *The Map is Not the Territory: Parallel Paths— Palestinians, Native Americans, Irish* the foundational exhibition for a series of art shows about peace, justice, and reconciliation. Heath is the author/ editor of 12 books of fiction and non-fiction, including *On the Edge of Dream: The Women of Celtic Myth and Legend* (Penguin, 1998), *The Echoing Green: The Garden in Myth and Memory* (Penguin, 2000), *The Scimitar and the Veil: Extraordinary Women of Islam* (Paulist Press, 2004), *The Veil: Women Writers on its History, Lore, and Politics* (University of California Press, 2008), *Land of the Unconquerable*: *The Lives of Contemporary Afghan Women*, with Ashraf Zahedi (UC Press, 2011), and *Children of Afghanistan: The Path to Peace,* also with Zahedi (University of Texas Press, 2014). She has lived in Boulder since 1975.

Jennifer Heath conceived HOVAB, is curator-at-large and catalogue editor.

KEVIN KELLEY (Treasurer) is Senior Vice President of Investments for Wells Fargo Advisors. His background includes politics, finance, and community service. He spent five years as a Legislative Assistant to a senior U.S. Congressman, followed by five years in Federal Relations for the City of Boston. He was a Financial Advisor with E.F. Hutton and Merrill Lynch before joining Wells Fargo Advisors in Boulder. He has served on the boards of The Community Foundation Serving Boulder County, Attention Homes, and the Colorado Chautauqua Association. He's been active with his church as a trustee, treasurer, and Sunday School teacher.

KATHY MACKIN has lived and been active in the arts in Boulder since 1976. She co-owned a gallery in downtown Boulder and has actively supported the community and the arts through a wide range of fundraising projects. She has extensive experience promoting artists' careers through her company, Kathy Mackin Fine Arts, LLC. She was Board President of Boulder County Arts Alliance (SBAA), and Board Member of the Colorado Business Community for the Arts (CBCA) for more than six years. In 2005, at the request of Senator Mark Udall, she judged the U.S. Congressional High School Arts Competition. She studied Art History at CU-Boulder and has been an active docent and member of the Educational Council at the Denver Art Museum since 2004.

Kathy Mackin co-curated HOVAB Open Studios @ Rembrandt Yard: *People, Places, and Things,* and liaised with curators for HOVAB @ Naropa and HOVAB @ NCAR: *EcoArts Connections.*

JOAN MARKOWITZ was born in New York and has resided in Boulder since 1978. She received her BA from Hunter College and her MA from CU-Boulder. She is a former gallery owner, curator of the virtual Women of the West Museum, and was co-executive director/senior curator of BMoCA from 2005 to 2010. She is an independent curator.

Joan Markowitz curated HOVAB @ BMoCA: *Evolving Visions of a Changing Landscape* and HOVAB @ Macky Auditorium: *Shark's Ink.*

Associated Curators' and Partners' Biographies

ADDRIENNE AMATO (HOVAB @ Boulder Creative Collective) is co-founder of The Boulder Creative Collective and co-director of The BCC: Warehouse. She received her BFA from Rocky Mountain College of Art & Design and her MFA from Pratt Institute. She has exhibited nationally and internationally and has worked at Rule Gallery (Denver), the Rubin Museum of Art (New York City), and the Museum of Fine Arts (Boston). Born in Cleveland, she has lived in Boulder since 2012.

KIRK T. AMBROSE (CU Art Museum – *Pioneers: Women Artists in Boulder, 1898-1950*) is professor and Chair of the Department of Art and Art History at CU-Boulder. In addition to many articles, book chapters, and reviews, he is author of three books on medieval art. His projects include a study of blindness and art. He presently serves as editor-in-chief of *The Art Bulletin*, the journal of record for art historians in the U.S.

KASSIA BINKOWSKI (HOVAB @ Pine Street Church) is a writer, photographer and creative director with extensive experience working in and collaborating with marginalized communities around the world. Having spent five years in the non-profit industry, she understands how these organizations measure their impact, the fundraising trends through which they survive, and the complex community dynamics in which they operate. She and photographer/filmmaker AJ Oscarson and graphic designer Katie Malone comprise One Thousand Design.

REBECCA CUSCADEN is visual arts curator at the Dairy Arts Center. She holds dual BA degrees in Art History/Archaeology and Psychology (University of Missouri), and an MA in Art History and Museum Studies (University of Chicago). She previously worked at the Hyde Park Art Center and interned at the Oriental Institute Museum, both in Chicago, and serves on the exhibitions jury at the Firehouse Art Center.

JANE DALRYMPLE-HOLLO (HOVAB @ Mr. Pool Gallery and Book Arts @ Boulder Public Library) is originally from Mississippi and has lived in Boulder since 1990. Inspired by 20th-century Modernism, her paintings waver between abstraction and surrealism, exploring tensions between 2-D surfaces and an implied 3-D depth. Her collection, *Between the Lines*, was presented in 2015 at Naropa University's Lincoln Gallery.

STEPHEN DENORSCIA (HOVAB Open Studios @ Rembrandt Yard) was the executive director of Open Studios and has an extensive background in non-profit marketing, program direction, graphic design, and events coordination. Prior to joining Open Studios in 2010, he served as the executive director for Ringing Rocks Foundation in Sedona, Ariz., and as marketing manager for Montalvo Art Center in Saratoga, Calif. His own work is interactive, fully immersive, and experiential, often created for festivals such as Burning Man, Apogaea, and Arise Music Fest.

NICOLE DIAL-KAY earned her MA in Art History from CU-Boulder, another MA in Museum Studies from the University of Missouri, and her BA in Art History from Southern Illinois University. Her experience includes public program design for the Denver Art Museum; a government-funded Educator and Public Programs residency at Native-run Alaskan museums; Community Engagement and Education Associate at the Saint Louis Art Museum; and multiple roles in the Saint Louis contemporary art world. Nicole joined BMoCA's staff as Education Coordinator in 2014. She was previously the curatorial assistant at the CU Art Museum.

BONNEY FORBES (HOVAB @ First Congregational Church Gallery) has always been passionate about fabric and paying homage to women's timeless traditions of handwork in all forms. Growing up in Chicago, the Art Institute was extremely influential. Studying Art History in Europe was life-changing. She earned a BA in Art History and Art Education from Hope College in Holland and in 1973 entered CU-Boulder to study Fine Art Photography and its history. Her love of photographic processes continues in collage and the creation of her images.

LISA GARDINER (HOVAB @ NCAR) is a scientist, writer, and illustrator. At the UCAR Center for Science Education, she creates educational experiences via websites, exhibits, classroom activities, comics, and books. She holds a PhD in Geology from the University of Georgia, a BA from Smith College, and an MFA in nonfiction writing from Goucher College.

MARDEE GOFF is the curator at BMoCA. Goff holds an MA from the Courtauld Institute of Art, London, and a BA in Art History from CU-Boulder. She has worked for art institutions, organizations, and private collections in the U.S. and abroad including: Biennial of the Americas, Denver; The Royal Academy of Arts, London; National Gallery, London; the Denver Art Museum; and the Peggy Guggenheim Collection in Venice.

SURANJAN GANGULY ("Celebrating Stan") received his PhD from Purdue University and is a faculty member in the Film Studies Program at CU-Boulder, where he was chair from 2000 to 2005. He is the recipient of the Marinus Smith Teaching Award and offers a wide range of courses which focus primarily on poetic cinema and the poetics of cinema, drawing on the aesthetic, cultural, and philosophical contexts of European and Asian film. He is the author of *Satyajit Ray: In Search of the Modern* and recently edited Stan Brakhage's interviews for the University Press of Mississippi, to be published in 2017. His critical essays have appeared in *Sight and Sound*, *Film Criticism*, *East-West Film Journal*, *The Journal of Commonwealth Literature*, *South Asian Cinema Journal*, and *Asian Cinema*.

JADE GUTIERREZ (HOVAB Visiting Artists) is an MA candidate at CU-Boulder studying Latin American and Native North American Art History. She explores how religion and spirituality manifest in colonial clothing and the impact of a global trade network on the visual cultures of the Andes.

MARDA KIRN (HOVAB @ NCAR) is the founding director of EcoArts Connections, a not-for-profit organization that brings together science, arts, and other fields to increase awareness of global change and inspire sustainable living. EAC commissions, produces, and presents performances, exhibits, talks, tours, conference activities, youth programs, and other events. Among her awards are the Colorado Governor's Award for Excellence in the Arts, the first CU Creative Climate Communication Prize, and the Dairy Arts Center Honors. Kirn has been a speaker/panelist and/or consultant for organizations in the U.S., Europe, Australia, Latin America, and India.

JAIME KOPKE is the Program, Events & Outreach Manager at Boulder Public Library, where her work focuses on designing collaborative programming with the local community.

LAURA MARSHALL (HOVAB @ Canyon Gallery, and First Congregational Church Gallery) holds a PhD in Mythological Studies, and studied painting and drawing in Italy and the U.S. Since 1980 she has worked in Boulder as a painter, picture-book illustrator, photographer, and teacher. She hosted international music programming at KGNU for more than 20 years, and taught World Art and Drawing at Naropa University. Marshall designed the HOVAB catalogue.

STEPHEN V. MARTONIS (CU Art Museum — *Pioneers: Women Artists in Boulder, 1898-1950*) was raised in rural western New York in the village of Silver Creek. He received a BFA in Painting from the State University of New York at Fredonia and a Master of Fine Arts degree in Sculpture from West Virginia University. He resides in Longmont and is the exhibitions manager for the CU Art Museum and a Lecturer in the Department of Art & Art History at CU-Boulder.

FRAN METZGER (HOVAB @ The Dairy Arts Center) arrived in Boulder in the summer of 1966. Access to a large university and an innovative art department set her course for a career of teaching, as well as making and exhibiting her art work. Along the way, her dedication to women artists and their creative work became a focus and she became one of the founding members of Front Range Women in the Visual Arts. Her women artist friends, her artistic expression, and the beauty and location of Boulder, in many ways her muse, are inextricably bound to one another.

LAURIE BRITTON NEWELL (HOVAB @ Highland City Club) is a curator who works across contemporary art, craft, and design in Europe and the U.S. She worked as a curator of Contemporary Programmes at London's Victoria and Albert Museum between 2002 and 2014, and curated numerous acclaimed exhibitions. She teaches curatorial studies at CU-Boulder and independently curates exhibitions and events for diverse clients and institutions. She writes regularly about contemporary creative practice for catalogues and magazines.

BARB OLSON (HOVAB @ First United Methodist Church Sanctuary Gallery) is a fiber artist specializing in layered, stitched, and painted works of art. She has permanent art at Boulder Community Hospital; the Children's Hospital Chapel in Aurora; CU's Earth Sciences Map Department; and the First United Methodist Church. She is a graduate of Boulder High School and has lived in the community since 1980.

JESSICA KOOIMAN PARKER (HOVAB @ Firehouse Art Center) has a BFA from the University of Wisconsin-Stout. Her passion is local contemporary art. She started as a volunteer at the Firehouse Art Center in March 2012 and became its executive director/curator. By 2016, she had worked with more than 156 artists, curated 12 exhibitions, and produced more than 58 shows.

CLARK RICHERT (HOVAB @ The Dairy Arts Center) attended CU-Boulder and in 1963 joined with several artists to found Drop City, a geodesic artist community in southern Colorado. Out of Drop City evolved Criss-Cross, a Boulder artists' collective associated with the "pattern and decoration" movement of the 1970s. Currently working with "quasi" structural systems, Richert exhibits at Rule and Gildar galleries in Denver, and is a professor at the Rocky Mountain College of Art & Design.

KELLY COPE RUSSACK (HOVAB@ Boulder Creative Collective) is co-founder of The Boulder Creative Collective and co-director of The BCC: Warehouse. Kelly received her BA in English and Art History from the University of Utah. She taught at the secondary school level and also has a background in educational development. She is dedicated to enriching and expanding the Front Range art community. Raised in coastal Maine, she has lived in Boulder since 2010.

LISA RUTHERFORD (HOVAB @ Mercury) graduated from CU-Boulder with a BFA in Painting and Photography. She has worked in many art-related fields including museum installation, professional photographic printing, and, since 1996, has been owner and curator of Mercury Framing Gallery, where, as of 2016, she had curated more than 80 shows, exclusively devoted to Boulder artists. She has juried Boulder Open Studios, done portfolio reviews, and privately consulted with local artists preparing for exhibits.

CHARMAIN SCHUH (HOVAB @ Naropa) received her MFA from CU-Boulder and has been involved in the Colorado art scene as an artist and museum professional since 1983. Her museum background includes director, curator, exhibition designer, and grants writer. She has worked at prominent arts organizations, such as the Denver Art Museum, the Arvada Center for the Arts and Humanities, and The Dairy Arts Center, as well as Naropa University.

CINDY SEPUCHA (HOVAB Open Studios @ Rembrandt Yard) has been a professional visual artist since 1997, working as a mural artist and more recently as a gallery artist. She has been an active volunteer and fundraiser for various non-profit organizations, including Open Studios, where she served on the board of directors for one year before taking the helm as executive director in April 2016.

ELLIE SWENSSON is a community builder and event curator, who holds an MFA from Naropa University. She works as the Program and Content Director for Boulder's historic Highland City Club, co-curates the monthly reading series, Bouldering Poets, and recently launched Boulder Writers Warehouse, a writers' residency, in collaboration with Boulder Creative Collective.

MANDY VINK is the Public Art Coordinator for the City of Boulder. Prior to this position she oversaw many public art projects for the City of Denver, including Denver International Airport's Hotel and Transit Center commissions. In addition, she has a variety of gallery experience, including Denver's Walker Fine Arts. She serves on the Denver Art Museum Contemporaries Board.

GLENN WEBB (HOVAB @ Boedecker Theater) has been the manager of The Boedecker Theater since its opening in 2011. Previously, he mostly worked in the performing arts/entertainment business, whether as production manager at the Boulder Theater for a decade, or touring sound engineer for various Grammy Award or Tony Award winners. He was technical director at Chautauqua Auditorium in the '80s, and archivist for the Conference on World Affairs.

Contributors' Biographies

MARK ADDISON has been looking at, talking about, and learning about Boulder artists for more than 50 years. He has been active with BMoCA and the CU Art Museum and taught Contemporary Art History at CU-Boulder. He and his wife, artist Polly Addison, have collected works by nearly 60 Boulder artists – some now gone to museums.

FIRYAL ALSHALABI writes historical fiction for young adults. Her children's books are written and published in Arabic. Several won prestigious awards. In 2004, she received Boulder's Annual Multicultural Award, Building Bridges in the Arts.

KIRK T. AMBROSE, see HOVAB Associated Curators, above.

TREE BERNSTEIN lived in Boulder for over 20 years. She is a graduate of the Jack Kerouac School of Disembodied Poetics at Naropa University, and has taught literature and writing at the Brooks Institute in California since the mid-2000s. She serves as a volunteer teacher in the Peace Corps, Cambodia, is a founder of Boulder Artists Gallery, and publisher of Treehouse Press.

JACK COLLOM has an MA in English from CU-Denver and is the author of 25 volumes of poetry. His books from Teachers & Writers Collaborative are staples of the writings-by-children world. He pioneered college-level ecology literature classes, establishing "Eco-Lit" at Naropa University 25 years ago. He's taught children and adults for nearly 40 years and is the recipient of two NEA Fellowships, a Foundation for Contemporary Arts Poetry Award and the 2013 Colorado Book Award for his collection, *Second Nature* (Instance Press).

DANIEL ESCALANTE, see Artists' Bios, above.

JADE GUTIERREZ, see HOVAB Associated Curators, above.

JANE DALRYMPLE-HOLLO, see HOVAB Associated Curators, above.

BENITA DURAN is a 5th generation Colorado native raised in Pueblo and now a longtime resident of Boulder. She has extensive professional expertise in community engagement and organizational capacity building, government affairs, and workforce development arenas – in public, non-profit, and private sectors – in Colorado and throughout the southwest. She is self-employed as a community relations and government affairs consultant.

J. GLUCKSTERN holds an MFA from CU-Boulder and currently teaches there and at the Art Institute of Colorado. His films and film-related works have been shown in Korea, Mexico, and throughout the U.S.. He's received numerous grants, awards, and commissions, including a fellowship from the Robert Flaherty Film Seminar in 2006.

JENNIFER HEATH, see Curatorial and Steering Committee, above.

COLLIN HENG-PATTON graduated cum laude from CU-Boulder with dual degrees in Sociology and English Literature. He has since worked as an assistant to artist Ana María Hernando and curator Jennifer Heath of Baksun Books and Arts. While working for Heath, Collin produced a website for an international art show, *"The Map is Not the Territory,"* and designed two books for poet Jack Collom.

NORMA JOHNSON is a facilitator who brings her 30-plus years as healer, poet/writer, performing artist, speaker, and consultant to the quest for social justice. She inspires awareness and connection by bridging community dialogues and relationships. Norma's artistic background inspires her unique presentation form. Her poetry about race is being used by educators across the U.S. to inspire awareness and discussion about race, privilege, and class. She is the author of the video and CD collection, *Poems for my White Friends*.

ALPHONSE KEASLEY has been part of Boulder's theatre community since 1974. He achieved his professional artist status when he became an Actors' Equity and a SAG-AFTRA performer at the turn of the millennium. His interest in visual arts came to life with his first arts appreciation course, later as an international traveler, and most recently as a member of the Boulder County Arts Alliance.

CAROL KLIGER received her MFA from CU-Boulder, and has been awarded art residencies at the Kohler Arts Industry Program and the Ucross Foundation, as well as teaching residencies with Colorado Council on the Arts. She has exhibited at BMoCA, the Denver Art Museum, Chicago's New Art Forms Exposition on Navy Pier, and the Women's Museum in Washington D.C. She maintains a studio in Boulder.

KATHY MACKIN, see Curatorial and Steering Committee, above.

JOAN MARKOWITZ, see Curatorial and Steering Committee, above.

LAURA MARSHALL, see HOVAB Associated Curators, above.

GESEL MASON is a choreographer, performer, educator, and arts facilitator. She is Artistic Director for Gesel Mason Performance Projects and an assistant professor at CU-Boulder. She was a member of Liz Lerman Dance Exchange and Ralph Lemon/Cross Performance Projects

NIKHIL MANKEKAR is a Boulder native, lifelong artist, and virtuoso musician. He is the creative director for Naked Sunrise and has appeared in *Spin Magazine*. He graduated valedictorian of his class at CU-Boulder, where he received the Chancellor's Recognition Award, and was named Outstanding Graduate of the Leeds School of Business. He serves on the City of Boulder Human Relations Commission, where he is the first Indian and Sikh American to be appointed to any city Board or Commission.

DONNA MEJIA is an assistant professor at CU-Boulder in the Theatre and Dance Department and Gender and Ethnic Studies, a choreographer, scholar, director, and performer specializing in contemporary dance, traditions of the African and Arab Diaspora, and emerging fusion traditions in Transnational Electronica. She was a faculty member at Colorado College and director of the Colorado College International Summer Dance Festival and managing director of CU-Boulder's award-winning Harambee African Dance Ensemble.

FRAN METZGER, see HOVAB Associated Curators, above.

BRENDA NIEMAND moved to Boulder 20 years ago from New York City, where she had worked as an editor for various publishers and non-profit organizations. Now retired, she indulges a longtime interest in art and serves on the boards of Open Studios and the CU Art Museum.

ALAN O'HASHI is executive director and producer for Boulder Community Media, working with community-based media producers, organizations, and socially responsible businesses to develop their content via the written word, electronic and new media, and the visual and performing arts in a culturally competent manner.

CARMEN REINA-NELSON, a native of Guatemala, introduced Boulder to the popular dances and culture of Latin America. For 25 years, she taught dance classes, performed regularly with her Grupo Macondo, sponsored visits by inspiring teachers and served as Latin American Projects Coordinator for local festivals. She is a community activist, promoting positive change through growth, both as individuals and as a society. She believes "dance is meant to nurture the spirit rather than the ego."

GEORGE RIVERA received his PhD in Sociology from the State University of New York in 1972. He is a professor in the Department of Art & Art History at CU-Boulder and a Fulbright Scholar, whose life's work is archived in "The George Rivera Papers" at the Benson Library at the University of Texas-Austin. He has published articles in national and international journals and has had exhibitions in Bosnia, Brazil, Bulgaria, Canada, Chile, China, Colombia, Germany, Guatemala, Hungary, Mexico, Palestine, Peru, Russia, Spain, and throughout the U.S. In addition to being an artist, Rivera is an art critic and curator.

GLENDA RUSSELL is a psychologist who has worked as a psychotherapist, researcher, teacher, activist, community historian, and busker. Since 1974, she has documented the psychological impact of anti-LGBTQ politics in Colorado, and is the author of two books and scores of journal articles and book chapters.

LISA TRUESDALE is a freelance writer, based in Longmont, who contributes regularly to regional, national, and international publications on home, garden, travel, healthy living, art, and other topics. She spent 6 years on Longmont's Art in Public Places committee, serving as chair her final year.

CAROL TAYLOR earned her BA in Sociology from the University of California-Berkeley, her MA in Librarianship from the University of Denver and recently completed a certificate program at the National Archives in Washington, D.C. She was librarian at the *Daily Camera* for nearly a decade where she nurtured her interest in local history while preserving and maintaining the 75-year collection of clippings, photographs, and ephemera and writing a column, "From the Archives." *She has written a column on Boulder County history for the Camera* since 2008. Her local history interests include social justice, women in Boulder County, University Hill, mid-century modern architects, and Boulder's regional historical artists.

JANE WODENING has written works from many perspectives on various subject: wilderness and wildness, nature and human nature, animals and their lives, life in solitude, also on having intimate experience and understanding of artists, always searching for deeper comprehension of things that are and things that happen. Her titles range from *Lump Gulch Tales* and *From the Book of Legends* to *Living Up There, Wolf Dictionary,* and *Brakhage's Childhood.*

MELANIE YAZZIE, see Artists' Bios, above.

DINAH ZEIGER is a former journalist, researcher and retired professor of Art History and Media Law. She is currently archiving the papers of the Western States Arts Federation, an arm of the National Endowment for the Arts.

ABOUT BAKSUN BOOKS & ARTS

The mission of Baksun Books & Arts (fiscally sponsored by the Boulder County Arts Alliance) is to produce imaginative projects, publish books of poetry and prose, and curate touring art exhibitions primarily on behalf of social and environmental justice, accompanied by comprehensive exhibition catalogues.

Baksun attempts to approach and examine issues from as many creative and interactive angles as possible in the firm conviction that the arts can influence lasting change.

Baksun was founded by Jennifer Heath in 1992 as a small press dedicated to de-commodifying the word and in 1994 began creating educational art exhibitions as well. It has reached thousands, of all ages, through diverse activities in museums, galleries, grassroots organizations, neighborhoods, schools, children's groups, libraries, and the Internet.

Baksun is dedicated to bringing people together to find strategies for confronting today's issues, illustrating and contextualizing them to highlight the beauty of our natural and cultural gifts and resources, and to heal. The arts not only "speak truth to power," but uphold that truth and carry it forward.

❖ ❖ ❖

Exhibition Checklist

HOVAB Book Arts @ Boulder Public Library
September 19-December 29, 2016
Curators: Jennifer Heath and Jane Dalrymple-Hollo, with special thanks to Mandy Vink, Public Art Manager

ADRIENNE ADAMS, illustrator
AILEEN FISHER, author
from **Where Does Everyone Go?**
Triptych
1973
illustration boards
29" x 21"
Courtesy of the City of Boulder

BARBARA BASH
from **In the Heart of the Village
the World of the Indian Banyan Tree**
1996
Gouache
16"x20"

SARAH C. BELL
**La Niña, Love Story and Stuff & Things,
The Urban Fairy Tales**, Books, 1, 2, 3
Baksun Books
2012

TREE BERNSTEIN
A Poet's Alphabet: 26 Poets/26 Poems (x2)
Limited edition of 226
Treehouse Press, Boulder
2000
Archival board, rubber stamped with ink
5"x5"x5"

JOSEPH BRAUN, CRAIG COLLIER, AND INDIGO DEANY
What's This, Reed Bye
LuNaMoPoLiS, Vol. I, No. 5
17 pages, with mailing envelope and postage stamp
2015
8.5"x5.5" each

HANK BRUSSELBACK
Crying Presidents
2003
Archival board, digital prints
Closed: 6"x 4-3/4"
Open 6"x4-3/4"x48"

JANE DALRYMPLE-HOLLO
"Alphabet: A Game Without Rules"
1998
Book board, cloth, blank puzzle, wooden blocks,
knobs, marbles, watercolor paper, acrylic paint
Box: 6 1/4"x x7 1/4"x9 1/4"
"Game Board," open: 7 1/2"x59 1/4"
Display width variable

LAURIE DOCTOR
Chance Marks
2016
Paper, gouache, sumi ink, walnut ink, linen thread, embroidery thread
closed: 3.5" x 5"
open: 6.75" x 5"

ANNE OPHELIA T. DOWDEN
illustrator
Jessica Kerr, author
Shakespeare's Flowers
Thomas R. Crowell
1969

SUSAN HOLLELY EDWARDS
"Automatic Writing"
n.d.
Paper and ink
13½"x16 framed
Private Collection

KARMEN EFFENBERGER-THOMPSON
"Gertrude and Alice"
c. 1977
Lithograph
14½"x12½"
Courtesy of Pauline Wanderer

ATI FORBERG
Untitled
1961
Colored pencil on paper
21"x23"
Collection of the City of Boulder

CLARE CHANLER FORSTER
She Hated the Thought
1985
Color xerography, handmade paper
8.5" x 10 "

CLARE CHANLER FORSTER
She Read at A Snail's Pace
1986
Color xerography, handmade paper
8" x 10"

CLARE CHANLER FORSTER
Sometimes
1988
Color xerography, handmade paper

LISA GARDINER
"The Principal's Office"
2010
Digital painting, Giclee print
18"x21"

J. HADLEY HOOPER
The Room: A Poem by Jack Collom
Baksun Books
14 gouache paintings on watercolor paper
Cloth-covered archival portfolio box
17½"x12"x1½"
Private Collection

BOBBIE LOUISE HAWKINS
Bijou Books: **Sensible Plainness – One Hundred Poems Selected by Anne Waldman;
Bitter Sweet – One Hundred Poems Selected by Anselm Hollo;
Fragrant Trappings – One Hundred Poems Selected by Lucia Berlin**
Rodent Press
Three "pocket books," 4 3/4"x3 1/4" each
1995

STEVE JENKINS
from **Never Smile at a Monkey**
Cut-and torn-paper collage
2009
18"x18"

STEVE JENKINS
"Sea Lions"
from *The Animal Book*
2014
Cut-paper collage
16"x16"

STEVE JENKINS
"Nautilus and Halibut"
from *Eye to Eye*
2012
Cut-paper collage
24"x16" framed

JUNIPER BOOKS
"Russian Literature Book Set"
2014
Paper and cloth,
8.5"x5.25"x12.5"

LAURA MARSHALL
"Eleni Persuades Her Fate"
from *The Girl Who Changed her Fate*
1990
Oil on canvas
11"x19"

TONY ORTEGA, illustrator
GEORGE RIVERA, author
**Who Am I? Family Adventures of Cholo, *Vato and Pano*
*¿Quien Soy Yo? Aventuras Familiares de Cholo, Vato y Pano***
[Publisher Unknown]
ca2004

GEORGE PETERS
"Opening Books"
Two units
1987 - remade 2016
paper, enamel, string, wire
5›10»x22» each

TED RINGER
Drawing and Dreaming
Wonderful World Publishing
2011

LINDA SAPORT
from **Subira, Subira**
1999
pastel
20" x 28"
Collection of the City of Boulder

MARYLYNN SCHUMACHER
"Illuminated Teapot"
1996
Red clay
12"x 5"x10.5"

MARYLYNN SCHUMACHER and SUSAN EDWARDS
"Blue Mosque Teapot"
1997
Red clay
12"x6"x13"

MARYLYNN SCHUMACHER
"Seek"
2015
Ceramic
9"x 3x25"

MARYLYNN SCHUMACHER
"Solace"
2015
Ceramic
10"x14"x13"

JULIA SEKO
with Naropa Summer Writing Program students
"Paper Wall"
2008
Letterpress printed: mixed media
Closed: 12" x 6 ¾"
Open: 17 1/2" x 6" x 12"

JULIA SEKO
with VIVIAN JEAN
Poem by Saadi Youssef, translation by Khaled Mattawa
Created as part of the Al-Mutanabbi Street Book Project.
Freedom
2012
Letterpress printed: mixed media
5 ½" x 5"

JULIA SEKO
with Donald Guravich, Jeffrey Pethybridge, Anne Waldman
"Braided River Book"
2015
Letterpress printed: mixed media
Closed: 6 ½"x6 ½"
Open: 9 ½"x9 ½"x6

MIA SEMINGSON
"39+: What Comes Around Goes Around
A Year of Photographs"
Book #2 of 12,
2009-2010
Closed: 5.25"x5.5"x1.5"
Open: 5.25"x13'4"

KRISTINE SMOCK, illustrator
JENNIFER HEATH, author
SuperColón: Admiral of the Ocean Sea
Baksun Books
1992

BARBARA STONE
"Storyteller"
1994
colored pencil on paper
19" x 16"
Collection of the City of Boulder

STEVE SWINK
The Steve Swink Library cover
Time Warp Comics Group
2008
Digital Print on Gatorboard
11"x17"

HARRIET PECK TAYLOR
"Coyote Makes an Arrow Ladder"
1992
Batik painting on cotton
29"x30"

SEAN TIFFANY
Oil Can Drive -Track 3, page 21
2015
Digital print on Gatorboard
15"x15"

❖ ❖ ❖

CU Art Museum
Pioneers: Women Artists in Boulder 1898-1950
September 16, 2016-February 4, 2017
Curators: Kirk Ambrose and Stephen V. Martonis
Partial, full list not provided

MYRTLE HOFFMAN CAMPBELL
American (1886-1978)
"Old Spanish Mission"
c. 1948
Watercolor on paper
29"x36" framed
Collection of Deborah and Warren Wadsworth
© Estate of Myrtle Hoffman Campbell and Deborah and Warren Wadsworth

RALPH CLARKSON, American (1861-1942)
"Jean Sherwood"
n.d.
Oil on canvas
40"x30" framed
Boulder Historical Society,
2012.002.009
© Boulder History Museum/Museum of Boulder

EVE DREWELOWE, American (1899-1988)
"The Tetons—Wyoming"
1936
Oil on canvas
32"x38" composition
Gift of Mary Rogers Thoms, CU Art Museum,
University of Colorado Boulder, 85.1744
Photo: Jeff Wells, © CU Art Museum, University of Colorado Boulder

FRANCES HOAR, American (1898-1985)
"Earth Forms"
1933
Watercolor on paper
16"x20"
Collection Kirkland Museum of Fine & Decorative Art, Denver, 1981.0223, © Kirkland Museum of Fine & Decorative Art.

ANN JONES, American (1905-1989)
"Flatirons"
1983
Watercolor on paper
8 ¼"x11 1/8"
Gift of Helen Davis, Collection Kirkland Museum of Fine & Decorative Art, Denver, 2006.1290
© Kirkland Museum of Fine & Decorative Art

ADMA GREEN KERR,
American (1878 – 1949)
Untitled
n.d.
Oil on canvas and foam core
30"x36"
Courtesy and © The Wilson Family Collection

GWENDOLYN MEUX
"White Church, Ward, Colorado"
n.d.
Oil
19"x22"
25" x 28" in original frame
Collection of Otis and Carol Taylor

FREDERICK CLEMENT TRUCKSESS,
American (1895-1997)
"Juniper and Rocks"
1959
Pen and ink on paper
20 3/8"x14 1/8" composition
Gift of Fay S. Carter, CU Art Museum, University of Colorado Boulder, 88.19.07
© CU Art Museum, University of Colorado Boulder

VIRGINIA TRUE (1900-1989)
"Rocks and Trees"
after 1934
Oil on canvas board
13 3/8" x 11 ½"
Collection Kirkland Museum of Fine & Decorative Art, Denver, 2011.0218
© Kirkland Museum of Fine & Decorative Art

MATILDA VANDERPOEL, Dutch
(1862-1950)
"A Young Artist"
n.d.
Pastel on paper
17"x13" framed
Harriett & Wendell Harris, 01.20.1
Photo: Boulder History Museum/ Museum of Boulder, © Vanderpoel Family

MURIEL SIBELL WOLLE,
American (1898-1977)
"Leadville Stumptown"
1934 | 1968
Sanguine (red chalk) and black crayon on paper
26 9/16"x18 13/16"
Gift of Mr. Hart D. Gilchrist, CU Art Museum, University of Colorado Boulder, 94.06.01
© CU Art Museum, University of Colorado Boulder.

❖ ❖ ❖

HOVAB @ BMoCA
Evolving Visions of Land and Landscape
September 29, 2016-January 15, 2017
Curator: Joan Markowitz

ROBERT ADAMS
"Wheat Stubble, South of Thurman"
1965
Silver gelatin print
15"x16"
Collection of Chuck Forsman

ROBERT ADAMS
"North of Keota, Colorado"
1973
Silver gelatin print
15"x16"
Collection of Chuck Forsman

JAMES BALOG
"Ilulissat Isfjord, Greenland"
2007
Digital chromogenic print on Fuji Crystal Archive paper
50"x33"

MAX BECKMANN,
German (1884-1950)
"Boulder-Rocky Landscape"
1949
Oil on canvas / reproduction
Original 55¼"x361/8" / Reproduction size variable
Saint Louis Art Museum, Bequest of Morton D. May 865:1983
© 2016 Artists Rights Society (ARS), New York, NY / VG Bild-Kunst, Bonn

ELIZABETH BLACK
"Isabella and Jim Ascend, Longs Peak, 1873"
2008
Oil on watercolor paper
21"x27"

AMELIA CARLEY
"Lost Miners of a Dream Canyon"
Sign and documentation of outdoor installation
2013
Wood, acrylic paint, rocks, photography, nature
Variable size

DON COEN
"Manuel "
from the Migrant series
2001-2010
Airbrush acrylic and pencil on canvas
7'x10'

JIM COLBERT
"River Move Our Thoughts (Colorado River at Dotsero)"
1995
Oil on canvas
28"x97"
Courtesy of Robischon Gallery

GAYLE CRITES
"Simpatico"
2013
Brush & ink drawing, cochineal natural pigment, tea and coffee on Mexican amate handmade bark paper
37" x 61" framed

KARLA DAKIN
"Fuzzy Balls Relate #1"
"Fuzzy Balls Relate #2"
"Fuzzy Balls Relate #3"
1985
AP etching on paper
17 3/8" x 41"

KARLA DAKIN
2 Planters
18" "cubes," containing "plants"

JOSEPH DANIEL
"On the Tracks at Rocky Flats"
from *A Year of Disobedience*
(2nd Edition, Story Arts Media, 2013)
1978
35mm Tri-X Film
Size variable

JOSEPH DANIEL
A Criticality of Conscience
2013
Film on DVD
Looped - 14 minutes single-play

KIM DICKEY
"Mirage"
2000
Glazed stoneware, painted plaster
96"x 128"
Photograph: 40"x30"
Helium sign: "4"x20"

REBECCA DiDOMENICO
"Whirl"
2002
Fabric, thread, metal mesh, glass
4'x7'x1'

EVE DREWELOWE
"Faces and Findings: The Past in the Present"
1982
35.75"x42.25"
Collection of the City of Boulder

BUFF ELTING
"Illusion of Order"
2006
Oil on canvas
60"x64"

CHUCK FORSMAN
"Sacred Cows"
2011
Oil on panel
51¼"x85-3/4"
Courtesy of Robischon Gallery

J. GLUCKSTERN
"lyons, co, 10-10-13"
2013
Shot on 16mm
Looped, 3 minutes single play

J. GLUCKSTERN
"From the Ashes"
2010
Shot on 16mm
looped, 5 minutes single play

ELMER P. GREEN,
American (c. 1863-1892)
"Boulder Falls"
1891
Oil on canvas
60 1/8"x 36"
Gift of Mrs. Myrtle Lyon Lombard & Mrs. Olive Sosey Hoge from the collection of Winnie Mary Hamm Sosey, CU Art Museum, University of Colorado Boulder, 69.404.01
Photo: Jeff Wells / CU Art Museum

ANA MARÍA HERNANDO
"Amarillo para la Ñusta" (Yellow for the Ñusta)
2016
Silk, organza, synthetic fabric, steel pins, acrylic wool, tulle
105"x90"x60" approximate
Courtesy of the artist and Robischon Gallery

JERRY KUNKEL
"Enough Said (Thomas Moran)"
2011
Oil on canvas
36"x46"
Courtesy of Robischon Gallery

JERRY KUNKEL
"Albert Bierstadt on Thomas Cole 2"
2012
Oil on canvas
36"x42"
Courtesy of Robischon Gallery

MERRILL MAHAFFEY
"Bear Creek Schist"
1990
Acrylic
18"x24"

JANE McMAHAN
"Collapse"
2013
6 looped video projections, honeycomb, bees, wood, sound
Film produced with Robert Kittla

JOHN MATLACK
"Landfill"
1998
Mixed media on Masonite
60"x60"

CHRIS PEARCE
"Wood Water Run"
2013
16mm
Looped, 3:00 minutes single play

CHANDLER ROMEO
"Oasis: Evolution"
2015-2016
Ceramic
Dimensions variable

CHANDLER ROMEO
"Sections IX"
2013-2016
Ceramic
Dimensions are variable

JOSEPH BEVIER STURTEVANT
"J.B. Sturtevant's Photo Gallery"
c. 1885
Original gelatin silver print/ digital reproduction
16"x20"
Courtesy of Art Source International

JOSEPH BEVIER STURTEVANT
Variety of postcards
c. late 19th, early 20th centuries
Originals gelatin silver prints/ digital reproductions
Variable sizes
Courtesy of Art Source International

MELANIE YAZZIE
"When We Came"
2016
Two-panel acrylic painting on wood
30"x86"

❖ ❖ ❖

HOVAB @ BMoCA
Visiting Artists
September 29, 2016 - January 15, 2017
Curator: Jade Gutierrez, with Valerie Albicker, Jennifer Heath, and Brandon Miller

"Visiting Artists to University of Colorado-Boulder from 1940s to the Present"
2016
Looped PowerPoint Slide Show
Courtesy of University of Colorado-Boulder Center for Humanities and the Arts and the University of Colorado-Boulder Art and Art History Department Visiting Artist Program

❖ ❖ ❖

HOVAB @ Highland City Club
Peripheral Landscapes in Photography
September 29-December 1, 2016
Curator: Laurie Britton Newell

KEN ABBOTT
"Invocation at an anti-coal mining rally, Whitesville, WV., February 2009"
2009
Archival ink print on cotton rag paper.
17"x21"

ALBERT CHONG
"Man in the Falls"
2009
Archival Inkjet print
40"x10"

CAROLINE HINKLEY
"Glacier Walk, Iceland"
2014
Digital Ink Jet Print
16"X20"

ANDY KATZ
"Cuernavaca Flower Market"
n.d.
Archival color print
18"x22" framed
Private Collection

TOM QUINN KUMPF
"The Prayer: Easter Monday,
Ormeau Bridge, Belfast, Northern
Ireland"
1997
Silver gelatin fiber-based photographic
print
6/25
16x20"

VIDIE LANGE
"Wisconsin Window VI"
c. 1970s
Hand-colored black-and-white silver
print
20"x24"
Collection of Elisabeth Relin

MICHAEL LICHTER
"Ready for Takeoff.
Bonneville Salt Flats, Utah, 2006"
2006
Pigment ink print
mounted on wood
30"x45"

RODDY MACINNES
"Wave #35, Lincoln City, Oregon"
2015
Archival digital photograph
by a North Dakota woman in 1917
15"x45"

ELISABETH RELIN
"Feet"
2013
Inkjet print
12¾" x 105/8"

CHARLES ROITZ
"The Way Home: Idaho 1979"
c. 1980
Black and white photograph
from silver negative
28"x22"
Collection of Carla Roitz

WILLIAM S. SUTTON
"Dead Horse. Johnson County, Wyoming"
2014
5/40
Inkjet print.
18.1"x33.2"

ALEX SWEETMAN
"Puzzling Landscape"
2015
Ilford Exhibition fiber paper printed
with Epsom Archival inks from a scanned
panoramic 35mm color negative
13"x24"

RICHARD VAN PELT
"Flatiron Gravel, 55th Street"
n.d.
Pizography on Hahnemuhle paper
15"x15" framed

BETH WALD
"Kyrgyz woman with baby yaks,
Afghan Pamirs, 2004"
2010
Lumira archival photographic print
20"x24"

MELANIE WALKER
"Fall"
2010
Metal transfer
20"x30"x5"

NURIT WOLF
"Spectacular Simplicity,"
Shell Beach, Australia
2005
35mm silver print
30"x24"

GEORGE WOODMAN
Untitled
1993
31.5"x24"
Private Collection

❖ ❖ ❖

Atlas Institute, CU
Celebrating Stan
October 2, November 6, December
4, 2016
Curator: Suranjan Ganguly

FILMS OF STAN BRAKHAGE
Screenings variable

❖ ❖ ❖

HOVAB @ The Dairy Arts Center
September 29-November 27, 2016
Curator: Sally Elliott

MARK AMERIKA
Filmtext 2.0
Looped network art

PAUL BARCHILON
"Timurid Ten-Step"
2009
Glazed earthenware
16"x16"x2"

SCOTT CHAMBERLIN
"glava"
2016
Glazed ceramic and wood
48"x20"x20"

JOE CLOWER
Untitled
2014
Watercolor
15"X18"

BONNEY FORBES
"Ode to my Grandmother"
1979
Collage
24"x32"

PAUL GILLIS
"I Forgive You My Sins"
2011
Oil on canvas
48"x44"

SHERRY HART
"Once in a Blue Moon"
1986
Beads and horn
21"x12"x6"

SHERRY HART
"In Light and Mint"
1987
Beads, lantern
16"x81/2"x61/2"

JENNIFER HEATH, ET AL
"Activism: Art for Change in Boulder"
2016
Power point transferred to MP4 video
Looped, 10 minute single play

JIM JOHNSON
"The Adventure of the Dancing Men"
1980
Oil on canvas
46"x46"

VIRGINIA JOHNSON
"Painting My Datsun"
1982
Colored pencil on paper
16"x20"

LINDA LOWRY
"Molly and the Piano"
2006
Oil on canvas
32"x24"

SUE MACDOUGALL
"Roots"
2003
Graphite on paper
19"x22"

VIRGINIA MAITLAND
"Annunciation"
1997
Acrylic and photos
42"x54"

JEANNE QUINN
"Rorschach Curtain"
2006
Porcelain, acrylic paint, wire and pins
35"x51"x3"
Collection of Patricia Ammann

CELESTE REHM
"Taking the Law into Your Own Horns"
2000
Oil on canvas
38"x28"

SUE ROBINSON
"The Altar of Which I Am the Center"
2009
Oil on canvas
30"x40"

GARRISON ROOTS
"I'm Not a Racist"
2001
Painting on paper with decals
30.5"x16.5"
Courtesy of Veronica Munive

ANTONETTE ROSATO
"Altered Chair"
from The World So Far As I Know It
c. 2003
Wood
35"x22"x17"
Collection of Deborah Haynes

TERRY SEIDEL
"Torso"
2001
Swimming pool plaster
26"x18"x8"

CHARMAIN SCHUH
"Smokey"
2015
Digital print
16"x20"

C. MAXX STEVENS
"Iron Lung"
2011
Collagraph print on parchment paper
30"x21"

❖ ❖ ❖

HOVAB @ The Dairy Arts Center
*Front Range Women in the Visual
Arts Founders*
September 29-November 27, 2016
Curator: Fran Metzger

MICHELE AMATEAU AMATO
"Fan Dance"
1978
6 lithographs on folded paper, rainbow
roll printing
36" x variable widths

SALLY ELLIOTT
"Earth Particle Series #3"
1988
Mixed media
32"x32"

JACI FISCHER
"Hillside"
1974
Graphite and mixed media
26"x34"

FRAN METZGER
"Pinedale"
1976
Colored pencil
30"x36"

HELEN BARCHILON REDMAN
"Artist Aflame"
1982
Oil
48"x34"
Collection of Faith Stone

❖ ❖ ❖

HOVAB @ The Dairy Arts Center
Criss-Cross Collective
September 29-November 27, 2016
Curator: Clark Richert

CHARLES DIJULIO
"Reconstruction with Accuracy"
1976
Acrylic on canvas
28 1/4"x23 3/4"
Collection of Elizabeth DiJulio

RICHARD KALLWEIT
"Escher's Ladder"
1984
Laser-cut plywood
12"x12"x12"

MARILYN NELSON
Untitled
1979
Acrylic on canvas
66"x66"
Collection of the City of Boulder

CLARK RICHERT
"I.C.E."
1977
Acrylic on canvas
70"x70"
Collection of Hannah Richert

GEORGE WOODMAN
"Parma"
1979
Acrylic on canvas
7'x7'
Collection of Tom and Karen Ripley
Dugan

FRED WORDEN
Amongst the Persuaded
2004
Looped film on DVD
23 minutes, single play

❖ ❖ ❖

Boulder Creative Collective
Messy Vitality
October 8-November 5, 2016
Curators: Addrienne Amato and Kelly
Cope Russack

PROJECT STREET GOLD
"Street Gold"
Cast Bronze Spray Paint Can
7.5"x2.5"x2.5"

NEIL MACKAY YARNAL
"Objectifying Objects"
2015
Acrylic, ink & credit cards
16"x22"

JEN HERLING
"Japanese Girl"
2015
Mixed media
24"x24"

GREG ELLIS
"The Milk Drinker"
2015
Oil on Canvas
48"x48"

❖ ❖ ❖

HOVAB @ Boedecker Theater
The Visual Art of Boulder Filmmakers
October 11, November 15, and December 13, 2016
Curators: Glenn Webb and Jennifer Heath, with special thanks to J. Gluckstern and Don Yannacito

JERRY ARONSON
The Divided Trail: A Native American Odyssey
1978
Film to DVD
33 minutes

DAN BOORD & LUIS VALDOVINO
Tree of Forgetting
2009
HD video
8:43

PATTI BRUCK
House of Hazards
2009
16mm
9 minutes

ANDREW BUSTI
26 Pulse Wrought (Films for Rewinds), Vol I- "Windows for Recursive Triangulation"
2014
16mm
3:15

ANDREW BUSTI
26 Pulse Wrought (Films for Rewinds), Vol III- "Parallel Beams or The Ineffable Inefficiency of Words"
2015
16mm
2:06

MICHELLE ELLSWORTH
In There
2005
Video
7:07

CARL FUERMANN
Dhá Cheann Déag
2016
Digital HD
6:30

JOEL HAERTLING and STAN BRAKHAGE
Song of the Mushroom
2002
16mm
3 minutes

AVA HAMILTON
Indians for Indians
2005
DVD
11 minutes

AVA HAMILTON and GABRIELE DECH
Everything has a Spirit
1992
VHS transferred to DVD
30 minutes

COURTNEY HOSKINS
Snowbird
2001
16mm
5:40

JIM OTIS
On Your Own
1981
B&W, optical sound
2 minutes

JIM OTIS
Gridrose
1981
B&W, silent, Computer generated
2 minutes

JIM OTIS
Common Knowledge
2002
Color, optical sound
2 minutes

JIM OTIS
The Last Bite
2003
B&W, optical sound
2 minutes

MARY BETH REED
Floating Under a Honey Tree
1999
16mm
4 minutes

ROBERT SCHALLER
My Life as a Bee
2002
16mm
5 minutes

ROBERT SCHALLER
Triptych
1996
16mm
3 minutes

PHILIP SOLOMON
Psalm IV: "Valley of the Shadow"
2013
HD Digital
7:30

STACEY STEERS
Phantom Canyon
2006
35mm
10 minutes

❖ ❖ ❖

HOVAB @ Firehouse Art Center
Local Folk
September 29-November 6, 2016
Curator: Jessica Kooiman Parker

ZOE ACE
"Fortune Teller"
2016
Oil on canvas
44"x47"

JUDY SCHAFER BATTY
"Feather"
2015
Stained glass
16"x35"

ANGELA BELOIAN
"Autumn's Infatuation with Spring"
2008
Ink and latex on found fabrics
54"x42"

MIKE BERNHARDT
"Of the Deep"
2015
Walnut, cherry, basswood, maple, redwood, pine, sawdust
30"x30"x6"

ANA MARÍA BOTERO
"Looking South"
2014
Acrylic on canvas
36"x36"

GERRI BRADFORD
"Affolter Cabin View from Pond in Old Mill Park"
2016
Oil on canvas
11"x14"

KATY DIVER
"Midnight Garden"
2015
Clay
6'x18"

BUNKY ECHO-HAWK
"When a Woman Loves a Man"
2012
Oil on canvas
36"x60"
Private collection

ANI ESPRIELLA
"Dance with Me"
2015
Oil on canvas
20"x16"

MIMI FARRELLY
"Midsummer Reverie"
2015
Oil on canvas
36"x36"

MARCELO FERNANDEZ
"Our Lady of Guadalupe"
2015
Pastels on paper
18"x24"

LINDA GLEITZ
"Immigration 1"
2016
Oil on canvas
36"x36"

BETSEY HASSRICK
Girl in Swing
1987
Clay
15"x8¼"

MARK IVINS
"Dancers"
2014
Photographic print on Kodak Pro Endura paper
48"x22"

IRENE DELKA MCCRAY
"Mother Without Father"
2015
Oil
52"x72"

LOUIS RECCHIA
"Pyramid"
2016
Mixed media
54"x28"

EDDIE RUNNING WOLF
"Emiliano Zapata"
2013
Mixed media
4'x4'
Private collection

TONY UMILE
"Sandstone Ranch, April 2001"
2001
Photography
11"x14"

KATE VILLARREAL
"Pods"
2014
Terracotta clay, Majolica glaze
4"x5"

CHARLOTTE ZINK
"Goddess"
2014
Steel and clay
60"x27"x24"

❖ ❖ ❖

HOVAB @ NCAR
EcoArts Connections
September 29, 2016-January 31, 2017
Curators: Lisa Gardiner and Marda Kirn

KIM ABELES
"the invisible connectedness of things"
2012
Mixed media
Sizes variable

KIM ABELES
"Shared Skies"
2014
Mixed media
Sizes variable

BRIAN COLLIER
"Bus Birding"
from *Bird Shift: The Anthropogenic Ornithology of North America*
2011
Interior bus signs, mixed media
2'4"x11'

REBECCA DIDOMENICO
"Intentional Mutation"
2007
Transparency emulsions mounted on Plexiglas, glass marbles
Full work: 11'x42"x 2.5'

MICHELLE ELLSWORTH
Preparations for the Obsolescence of the Y Chromosome
Excerpts
2011
Video
Looped, 6 minutes single play

JEANNE LIOTTA
SOON It Would Be Too Hot
2014
HD Video
Looped, 6:38 single play

JANE MCMAHAN
"Arapaho Glacier: What Goes Around Comes Around"
2007
Photographic documentation
Original: Arapaho Glacier ice, glass, steel, refrigeration equipment, solar panels, batteries, aluminum screen, aluminum screen, pump, hose, Boulder Creek water
Ice box: 72"x32"
Solar frame: 6'x10'

MARY MISS
"Connect the Dots: Mapping the High Water, Hazards, and History of Boulder Creek"
2007
Photographic documentation
Original: Mixed media
Variable sizes

AVIVA RAHMANI
"Trigger Points, Tipping Points"
2007
Photographic documentation
Original: DVD presentation and 12 digital prints
13"x19" each

KRISTINE SMOCK
"Our Lady of Transformation and Renewable Energy"
2007
Photographic documentation
Original: steel, recycled materials, solar panels, soil
8'x3'x3'

MICHAEL THEODORE and HUNTER EWEN
Meander
2014
Video
Looped, 4:48 single play

MELANIE WALKER & GEORGE PETERS
"Coal Warm Memorial"
Wind Installation
2007
Photographic documentation
Original: Mixed media
Variable – 30'-50'

SHERRY WIGGINS
"Carbon Portraits"
2007
Photographic documentation
Original: 3 billboards - digital prints mounted on plywood
3'x6' each

❖ ❖ ❖

HOVAB @ Mercury
September 29-November 30, 2016
Curator: Lisa Rutherford

PATRICIA BRAMSEN
"Gerund"
1998
Acrylic on Canvas
14"x18"

ROBERT ECKER
"The Ecology of Time"
2010
Acrylic on Wood
12"x12"

DEBORAH HAYNES
"Cantos for (This) Place"
one image from series of 36
2006-2009
Mixed media
11"x15"

CAROL KLIGER
"Cut Pushed Tiles"
2010
Porcelain
12"x5.5"x1.75"

VELVET B. LEMAE
"Stockings"
2015
Acrylic on canvas
18"x30"

CHARLES MOONE
"Re/Opening"
1998
Oil pastel
10"x14"

YUMI JANAIRO ROTH
"Exceptional Homesite"
2012
Archival digital prints
16"x12"

DISMAS ROTTA
"Kurosawa's Forest"
2008
Marble dust and plaster on wood board
with French colored pencils
13.25"x13.25"

STEFKA TRUSZ
"Female Unfolding"
2015
Scanography
20"x20"

❖ ❖ ❖

HOVAB @ Pine Street Church
Project (In)visible
September 29-November 29, 2016
Curator: Kassia Binkowski

ONE THOUSAND DESIGN
30 portraits featuring the faces of
Boulder County's untold stories
2016
Print photography
30"x30"

❖ ❖ ❖

**HOVAB @ First Congregational
Church Gallery**
*Sumptuous Spirits /
Sumptuous Locals*
September 29-November 28 2016
Curators: Bonney Forbes, Sally Elliott,
Jennifer Heath, and Jane Dalrymple-
Hollo, with special thanks to Mandy
Vink and Laura Marshall

POLLY ADDISON
"Mother with Her Father, Husband,
and Sons"
1985
Oil on canvas
4'x3'

SUSAN ALBERS
"Paint Brush Halo - Patricia Bramsen"
2000
Acrylic
16"x20"

TYLER ALPERN
"Down the Snowy Driveway"
2014
Oil on canvas
42"x48"

BARBARA YATES BEASLEY
"Birds in Flight"
2012
Fabric collage
29"x36"

SARAH C. BELL
"Kiss Me, I'm a Writer – Portrait of
Jenny"
c. 1990
Ink on paper
8"x10"

LEE BENTLEY
"Portrait of Anthony"
1996
Acrylic on illustration board
28"x21"

KEN BERNSTEIN
"Resilience"
n.d.
Oil on canvas
16"x20"

NORENE BERRY
"St. Libertata"
1992
Velvet, toy animals, acrylic on paper,
crystal, shards, wood, cardboard
20"x14"
Private Collection

ANNETTE COLEMAN
"Temptation Redemption"
2006
Mixed media, encaustic, heated canvas
30"x30"

MICHAEL CONTI
*The Unruly Mystic: Saint Hildegard of
Bingen*
2013
Video
65 minutes

NAN DEGROVE
"St. Marina—The Mystic Rose"
2012
Oil on canvas
18"x20"

NAN DEGROVE
"Virgin of Guadalupe with Pomegranate"
2012
Oil on canvas
16"x20"

NAN DEGROVE
"St. Bridget with Sacred Datura"
2015
Oil on canvas
16"x20"

MARILYN DUKE
"Isabel"
n.d.
2013 pastel on paper
18"x17"

LINDA ELLIS
"Horizons"
triptych
2015
Colored pencil on found tin
14"x9" each

CLAIRE EVANS
"Madame E"
2003
Oil on canvas
26"x32"

BONNEY MILLER FORBES
"Caroline Starns Douglas"
1979
Cyanotype photograph
24"x25"

JULIANA FORBES
Untitled
2016
Rice paper, acrylics and wax on board
11"x14.5"

MARGARETTA GILBOY
"Portrait of Sue Robinson"
1976
Oil on canvas
60"x42"
Collection of Margaretta Gilboy

MARGARETTA GILBOY
"Polly Addison"
1999
Oil on canvas
30"x36"

JULIE GOLDEN
"Opening Wider"
2015
Stained glass
12"x12"x1"

JOAN BARTOS HANLEY
"Carin and Kirsten"
1968
Pastel
36x43"
Collection of Patricia Bramsen

SHERE HOLLEMAN
"House Unravels"
1997
Mixed media on birch panel
30"x24"

VIRGINIA JOHNSON
"Self Portrait with Fire"
n.d.
Oil on canvas
18"x17"

JIM LORIO
"Wood-Fired Pot # 1"
2010
Stoneware
15"x15"

JIM LORIO
"Wood-Fired Pot # 2"
2010
Stoneware
16"x10"

JIM LORIO
"Wood-Fired Pot # 3"
2001
Stoneware
11"x6"

LINDA LOWRY
"Balancing Act"
1995
Oil on canvas
40"X30"

DOROTHY MANDEL
"In the Ruts of the Highway"
n.d.
Woodblock print
19"x15½"
Collection of Sibylla Mathews

MARILYN MARKOWITZ
"Mountain Climber"
1974
Mixed Media
31"x37.5"
Private Collection

NANCY MARON
"Sunshine Canyon II"
1998
Oil on canvas
18"x24"

LAURA MARSHALL
"Green Tara"
2000
Offset print
30"x20"

DIANE MARTONIS
"Afterward I, Afterward II,
Afterward III"
All 2015
All cut paper
All 10"x10"x2"

STEPHEN V. MARTONIS
"Son: Verso"
2013
Beeswax and burlap
36"x24"

GENE MATTHEWS
"Utterances 2"
1997
Acrylic, oil, and enamel on paper over
canvas
7'10"x6'5"
Collection of the First Congregational
Church of Boulder

GENE MATTHEWS
"Forum 2"
1990
Enamel and acrylic
7'10"x6'5"
Collection of the First Congregational
Church of Boulder

WANDA MATTHEWS
"Mountaintown 4 Alpenglow"
1983
Intaglio print
27"x23"
Collection of the First Congregational
Church of Boulder

MARTIE MCMANE
"Solitude"
2015
Pastel
11"x14"
Collection of Jennifer and Terry Tierney

FRAN METZGER
"Sally"
1990
Colored pencil on paper
18x37.5"
Collection of Sally Elliott

BARB OLSON
"Scattering Leaves"
2003
Fabrics, paint, stitching
28"x59"

BARB OLSON
"Tea Bag Dress"
n.d.
Paper, cloth, stitching
36"x57"

TOM POTTER
"Vorta IV"
1985
Earthenware
31"x31"x3"
Collection of Lucas and Heidi Potter

TOM POTTER
"Inclination Chair"
from the alignment series
1985
Earthenware
30"x20"x2"

HELEN BARCHILON REDMAN
"Jacques Barchilon"
1968
Oil on canvas
59"x47"
Collection of Paul Barchilon

HELEN BARCHILON REDMAN
"Kenny: Free Form DJ"
1973
Oil on canvas
71"x44"

HELEN BARCHILON REDMAN
"Paul: Homage to Morocco"
1992
Acrylic on canvas
66"x34"
Collection of Paul Barchilon

ROLAND REISS
"BOLDER Valley"
n.d.
Pen and Ink
28.5 X 34.51969

NANCY ROBERTSON
"Goddess House"
c. 1993
Wood, gouache, paper, steel,
beads, fetishes
12"x10"
Private Collection

BARBARA SHARK
"The Photographer"
1997
Oil on canvas
36"x36"

BARBARA SHARK
"The Pink Hat II"
1997
Oil on canvas
30"x42"

BARBARA SHARK
"Dessert on Blue Mountain Road II"
2002
Oil on canvas
42"x64"

BARBARA SHARK
"On the Ferry"
2006
Oil on canvas
44"x60"

BARBARA SHARK
"Lunch at Greens"
2008
Oil on canvas
18"x40"

LIZA WEEMS
"Woman On a Train"
2010
Giclee print
16"x20"

MICHAEL WOJCZUK
"Inspiration"
from the *Art Tarot*
2010
Watercolor
11"x14½"

MICHAEL WOJCZUK
"Patience"
from the *Art Tarot*
2010
Watercolor
11"x14½"

MICHAEL WOJCZUK
"Seeking"
from the *Art Tarot*
2010
Watercolor
11"x14½"

LYNN WOLFE
"Spanish Dagger"
1985
Acrylic on canvas
3'x10"x3'

JENNIFER WOODS
"Shireen"
1980
Acrylic on canvas
32"x25.5"

SHERRY WATERWORTH YOUNG
"End of Summer Sunflowers"
2011
Oil painting
25-5/8"x21-5/8"

RANDALL ZAHN
"Here to Pray"
2000
Photography
16"x20"

❖ ❖ ❖

HOVAB @ Mr. Pool Gallery
Objects and Abstractions
September 29-December 29, 2016
Curators: Terry Seidel, Sally Elliott and
Jane Dalrymple-Hollo

ZOA ACE
"Martini with Olive"
2010
Medium unspecified
20"x20"
Collection of Jill McIntyre

DALE CHISMAN
"Indian Rope Trick"
c. 2000
Medium unspecified
60"x60"
Private Collection

DALE CHISMAN
Untitled
c. 2000
Medium unspecified
60"x60"
Private Collection

BRIAN GROSSMAN
"Styro II"
2015
Bronze
16"x12"x12"

SARAH HANSON
"Chromosphere Capture"
2013
Mixed Media
14"x17"

SARAH HANSON
"Aurelian Aura"
2015
Mixed Media
14"x17"

BOBBIE LOUISE HAWKINS
"New Day"
n.d.
Paper and glue
22"x18"

MICHAELE KEYES
"Black on White"
2015
Monotype
42"x29"

PRESLEY LA FOUNTAIN
"Wind Warrior"
2014
Italian Alabaster
n.s.

TERRY MAKER
"Twelve"
2006
Plastic baskets, religious documents,
resin
23"x34.5" 2.5"

JILL MCINTYRE
"Thanks to Delacroix and Lorca"
2004
pastel
22"x30"

AMY METIER
"Red Kelly One"
Monotype Chine Collé
2015
36.5"x36.5"

MELINDA MYROW
"Ampersand"
2008
Acrylic and graphite on polypropylene
paper
mounted on wood panel
40"x13"x2

MELINDA MYROW
"Hot Pursuit"
2008
Acrylic and graphite on polypropylene
paper
mounted on wood panel
40"x13"x2

MELINDA MYROW
"The Happening"
2008
Acrylic and graphite on polypropylene
paper
mounted on wood panel
40"x13"x2

MARGARET NEUMANN
"Searching for Rye"
2012
Oil on canvas
68"x48"
Private Collection

MARGARET NEUMANN
"Wave"
2012
Oil Paint
n.s.
Private Collectioin

KAREN POULSON
"Portal with Blue"
2013
acrylic on canvas
36"x36"

TERRY SEIDEL
"Ann's Bird"
2002
Soapstone
n.s.

SOPHIA SWEENEY
"Coal Miner"
2010
Oil and housepaint on plywood
4'x4'

SOPHIA SWEENEY
"Aung San Suu Kyi"
2010
Oil and housepaint on plywood
4'x4'

MARK VILLARREAL
"Koko"
n.d.
Oil on panel
28"x36"

MARK VILLARREAL
"Chelsea Bridge no. 2"
n.d.
Oil on panel
60"x40"

JERRY WINGREN
"Alabaster Study for Interiors"
2009
Colorado Alabaster
7.5"x7.75"x12

JERRY WINGREN
"Alabaster Interior #11"
2012
Colorado Alabaster
7"x7.75"x10"

❖ ❖ ❖

HOVAB Open Studios @ Rembrandt Yard
People, Places, and Things
September 29-October 29, 2016
Curators: Kathy Mackin and Stephen
DeNorscia with Cindy Sepucha

SUSAN ALBERS
"Single Baobab Tree"
2004
Acrylic paint, imitation gold leaf
30"x40"

JOE B. ARDOUREL
"Falcon and Falconer"
1964
Wood cut, intaglio print
37"x 30"

ELIZABETH BLACK
"11:30 AM, Downstream
from Saddle Canyon, Mile 47,
On the Grand"
2012
Oil on panel
30"x30"

CHRIS BROWN
"Aspen Grove, V-PAN"
1993
Film capture; Ultrachrome
inkjet print.
30"x60"

CHA CHA
"What Boundaries?"
2004
Forged steel, patina, pigment, epoxy
24 ½"x14 ½"x2 ½"

MARIE CHANNER
"She Danced"
2013
Giclee on canvas
40"x40"

AMY GUION CLAY
"Crossing Over Chasms"
2008
Encaustic and oil on panel
36"x36"x3"

WENDY CLOUGH
"Singing a Golden Wisdom"
2005
Oil, gold leaf, ink and muslin on board
20"x36"

W.F. DANIEL
"River of Sky"
2014
Oil on linen
38"x32"

MOLLY DAVIS
"Sunset on Open Space"
2015
Oil on Canvas
36"x36"

SALLY ECKERT
"Flying - The Grand Canyon"
2015
Egg tempera and oil glazes
24"x36"

CLAIRE EVANS
"Polly's Palette Knives"
2009
Oil on canvas
12"x19"

DAVID GROJEAN
"Mystic Square Purple Series"
2009
Mixed media
20"x20"

THERESA HABERKORN
"Morning Light"
2014
Woodblock print
31"x25"

JERRIE HURD
"Rocket to the Moon"
n.d.
Photograph
18"x22"

KEVAN KRASNOFF
"Blue Waunder"
2000
Acrylic on canvas
40"x52"

ANN LUCE
"Mexico"
1945
Oil
30.5"x37"

JULIE MAREN
"Rabbit Test"
2006
Oil, graphite, liquid metal on wood
24"x24"

SIBYLLA MATHEWS
"Rhino Rump"
1978
Intaglio print
16"x18"
Collection of Mark and Polly Addison

ELAINE NIXON
"Oriental Red Poppies"
2015
Handwoven tapestry
32"x36"

GERDA ROVETCH
"Philosophical Ex-Dancer"
n.d.
Print of a collage
16"x12"
Collection of Sibylla Mathews

BUNNY ROSENTHAL RUBIN
"Where Earth Meets Sky"
n.d.
Oil
34"x29"

DAWN HOWKINSON SIEBEL
"Paul & Viola, 1897"
2004
Oil and collage on wood panel
4"x14"x1.5"

WILLIAM STOER
"Thea 4"
2015
Acrylic on canvas
60"x40"

PAULA SUSSMAN
"Elephants Outside My Window…"
2010
Hand-colored silver print
25"x30"

JUDITH TRAGER
"Corn Maiden Triptych"
2015
Fiber
34"x31"

JOHN WAUGH
"Fresco in the Cathedral du St. Julien"
2006
Photography
22"x28"

VIRGINIA WOOD
"Turnaround"
c. 1990
Acrylic on rag paper
22"x30"

❖ ❖ ❖

HOVAB @ Canyon Gallery
A Lasting Legacy
October 15-December 21, 2016
Curators: Karen Ripley Dugan, with Sally Elliott, Jennifer Heath, and Laura Marshall, with special thanks to Mandy Vink

POLLY ADDISON
"Climbing the Maiden"
1985
Mixed media on paper
22"x28"

JOAN ANDERSON
Red Star Ancestors: "Star Lake"
2006
Acrylic, gold leaf, stitching on canvas, double-sided
Armature: oak and steel, neodymium magnets
72"x48" overall

JOAN ANDERSON
Red Star Ancestors: "Ursa"
2006
Acrylic, gold leaf, stitching on canvas, double-sided
Armature: pine and steel, neodymium magnets
75.5"x60" overall

JOAN ANDERSON
Red Star Ancestors: "Heart"
2006
Acrylic, gold leaf, stitching on canvas, double-sided
Armature: pine and steel, neodymium magnets
80"x49" overall

JOAN ANDERSON
Red Star Ancestors: "Saltire"
2006
acrylic, gold leaf, stitching on canvas, double-sided.
Armature: pine and steel, neodymium magnets
80"x41" overall

JOAN ANDERSON
Red Star Ancestors: "Magician"
2006
Acrylic, gold leaf, stitching on canvas, double-sided
Armature: oak and steel, neodymium magnets
80"x68" overall

JOAN ANDERSON
Red Star Ancestors: "Diamond"
2006
Acrylic, gold leaf, stitching on canvas, double-sided
Armature: pine and steel, neodymium magnets
73"x48" overall

VICKI ANDERSON
"Ink Feathers"
2005
Ink on paper
38"x32"

JORGE CALDERON
"Pacha Mama"
c. 1986
Granite
25"x39"

ESTA CLEVENGER
Untitled
1993
Acrylic
12"x20"
Collection of Jim and Meg Lorio

ESTA CLEVENGER
Untitled
1989
Acrylic
19" x 25"
Collection of Jim and Meg Lorio

ESTA CLEVENGER
Untitled
c. 1988
Acrylic
13 ¼"x10"
Collection of Felicia Furman

ESTA CLEVENGER
"Suzy's Front Porch"
n.d.
Mixed media
23"x28"
Collection of Tom Dugan and Karen Ripley Dugan

PRISCILLA COHAN
"The High Priestess"
2012
Acrylic on board
20"x46"

PRISCILLA COHAN
"No One"
2012
Acrylic on board
20"x46"

JANE DILLON
Untitled
n.d.
Ceramic
16"x24"
Private Collection

JANE DALRYMPLE-HOLLO
"Pas de Deux"
1999
Oil on canvas
4'x5'

CAROLINE DOUGLAS
"Gaia"
2015
Earthenware with slips, and encaustic, graphite
21"x9"x9"

SALLY ELLIOTT
"Late Afternoon Memories"
2000
Gouache on paper
41"x33"

SALLY ELLIOTT
"To Bulgaria with Love"
2002
Gouache on paper
41"x33"

KIM FIELD
Untitled
n.d.
Fiberglass
12"x8"x5"
Collection of Gretchen King

MARGARETTA GILBOY
"Celebration"
1997
Oil on linen
40"x50"

JIM GREEN
"Sound Portraits"
1995
Sound
18"x 16"x1"

EMMA HARDY
"orangutan"
2011
Paper
42"x36 x32"

VALARI JACK
"Sunrise Processional"
1988
Silver gelatin photograph
18.25"x14.25"
Collection of the City of Boulder

VALARI JACK
"Afternoon Milking"
1988
Silver gelatin photograph
18.25 x 14.25"
Collection of the City of Boulder

VALARI JACK
"Basketball Game"
1988
Silver gelatin photograph
18.25"x14.25"
Collection of the City of Boulder

GRETCHEN KING
"Swimmer"
2008
Acrylic on canvas
23"x17"

TERRY KRUGER
"Generic Boulder"
n.d.
Poster
Martin and Taffy Kim Poster Collection
Museum of Boulder

ANDREW LIBERTONE
"Set Top Box"
2012
Powder-coated steel
35.5" and variable

MERRILL MAHAFFEY
"Visual Eyes"
n.d.
poster board
47"x20"
Collection of Elizabeth Black

CARRIE MALDE
"Grove"
2001
Oil on paper
26"x31"
Collection of Tom and Karen Ripley Dugan

JANICE MCCULLAGH
"Pine (Karasaki Matsu, Kenroku-en, Kanazawa)"
2016
Etching
30"x36"

FRAN METZGER
"Winter, Colorado"
2013
Pastel
26"x34"

GEORGE PETERS
"Storm Doors"
1987
Mixed Media
4'x8'x16'

JALALIYYAH QUINN
"Jack and the Milky Way"
2015
Watercolor
22"x30"

HELEN BARCHILON REDMAN
"Bearing: Pregnant Self-Portrait"
1964
Oil pastel
25 ½"x 9 ½"

CLARK RICHERT
"Entanglement"
2014
Lithograph
32"x32"

SUZY ROESLER
Untitled
1978
acrylic on paper
4"x35"
Collection of Margaret Neumann

JEAN ROLLER
"Procession of Diana"
1996
Mixed media box construction
16"x23"x2.5"
Collection of Mark and Polly Addison

MARTHA RUSSO
"caudal"
1998
Porcelain slip, pig intestine, mango, purple grapes
18"x8"x8"
Courtesy of Claudia Stone Gallery and Goodwin Fine Art
Photo credit: Wes Magyar

FRANK SAMPSON
"A Candle-light Party"
2015
Acrylic on Gaterboard
24"x19"

BARBARA SHARK
"Building on Blue Mountain Road: Dexter"
2000
Oil on canvas
60"x68"

KRISTINE E. SMOCK
"One is Silver…"
c. 1999
Welded recycled silverware, miscellaneous kitchen utensils
6'x3'x21/2'

ROBERT SPELLMAN
"Atlantic Folio #s" (three)
2011
All acrylic on canvas
21"x30" each

ISOLDE STEWART
"Priestess"
1998
Socks, stuffing, wool, cowrie shells, found objects, Sculpey, acrylics
9"x9"

ISOLDE STEWART
"New Moon"
1999
Socks, stuffing, metallic, hand-appliqued Hmong tapestry, found objects, Sculpey, acrylic
18"x11"

ISOLDE STEWART
"Sekhmet"
2000
Socks, stuffing, found objects, beads, sequins
8"x14"

THEA TENENBAUM & RAFFAELE MALFERRARI
"Clematis Woman"
2015
Hand-painted terra cotta with built-in wall hanger
15" diameter

THEA TENENBAUM & RAFFAELE MALFERRARI
"Geometric"
2015
Hand-painted terra cotta with built-in wall hanger
15" diameter

THEA TENENBAUM & RAFFAELE MALFERRARI
"Pears"
2015
Hand-painted terra cotta with built-in wall hanger
15" diameter

THEA TENENBAUM & RAFFAELE MALFERRARI
"Magpie"
2015
Hand-painted terra cotta with built-in wall hanger
15" diameter

RICHARD VARNES
"Suzy Roesler"
1997
Silver gelatin print
20" x 24" framed
Collection of the City of Boulder

BILL VIELEHR
"Neck"
n.d.
Cast brass
7"x8"
Collection of Gretchen King

DOUG WEST
"Winter Repose"
1997
Serigraph
48/75
13"x28"

SHERRY WIGGINS
"Performing the Drawing/ Realizar o Desenho"
2015
Digital images printed on watercolor paper and framed
9 images each 24"x24"
Installation: 76"x76"

JERRY WINGREN
"Torso"
2015
Bronze
5"x8"x13"

GEORGE WOODMAN
"Betty Woodman Pottery Seated"
n.d.
Poster
Martin and Taffy Kim Poster Collection
Museum of Boulder

GARY ZEFF
"Robin's Delight"
2009
Cherry, bamboo, willow, Western red cedar bark, yellow cedar bark, patina on brass
27"x6"

MARTIN AND TAFFY KIM POSTER COLLECTION
"Artfeast"
n.d.
Poster
Museum of Boulder

MARTIN AND TAFFY KIM POSTER COLLECTION
"Women's White Ware/Albatross"
n.d.
Poster
Museum of Boulder

MARTIN AND TAFFY KIM POSTER COLLECTION
"Boulder Artists' Guild Retrospective"
n.d.
Poster
Museum of Boulder

MARTIN AND TAFFY KIM POSTER COLLECTION
"Boulder City Pottery"
n.d.
Poster
Museum of Boulder

MARTIN AND TAFFY KIM POSTER COLLECTION
"Haertling Gallery"
n.d.
Poster
Museum of Boulder

MARTIN AND TAFFY KIM POSTER COLLECTION
"130 Portraits"
n.d.
Poster
Museum of Boulder

MARTIN AND TAFFY KIM POSTER COLLECTION
"Red Flinger Ball (Rare Silk and Peal)"
n.d.
Poster
Museum of Boulder

MARTIN AND TAFFY KIM POSTER COLLECTION
"Twelve Sculptors in the Park"
n.d.
Poster Museum of Boulder

❖ ❖ ❖

HOVAB @ Naropa
October 17-November 23, 2016
Curator: Charmain Schuh
Partial, full list not provided

KEITH ABBOTT
"Monk"
n.d.
Print
14"x16"

ELIZABETH ACOSTA
"Silver"
2015
Pastel
11"x14"

GINA ADAMS
"Broken Treaty Quilt"
2015
Fabric, thread on antique quilt
86"x96"

TYLER ALPERN
"Steppes of Russia to the Steps of Pittsburgh"
2016
Oil on canvas
30"x40"

JOAN ANDERSON
"Seventh Skin"
2013
Gouache sketch as photo transfer and found metal on leather.
40"x36", approximate

BARBARA BASH
"Water Words"
2015
Watercolor and ink
28"x42"

MARLOW BROOKS
"No Choice"
2015
Mixed media
7'x50"

LAURIE DOCTOR
"Convocation Poem"
1979
Ink on paper
22"x30"
Naropa University Collection

SUSAN HOLLELEY EDWARDS and GERALDINE BRUSSEL
Untitled
1984
Mixed media
15"x22"
Collection of Barbara Bash

SANJE ELLIOTT
Untitled
n.d.
Ink on paper
11"x14"
Naropa University Collection

DIANE STUM FEKETE
"Of Place and Time"
2015
Acrylic and graphite on paper
16"x20"

MICHAEL FRANKLIN
"Play of Consciousness: Backwards from a Dream"
n.d.
Mixed media construction
Size unavailable

BERNIE MAREK
Untitled
2005

BERNIE MAREK
"World in a Teacup"
1976
Ceramic
28"x28"x28"
Naropa University Collection

LAURA MARSHALL
"Rigden I"
1995
Oil on paper, mounted on board
40"x26"

LAURA MARSHALL
"Rigden II"
1995
Oil on paper, mounted on board
40"x26"

CYNTHIA MOKU
"In-Between the Folds"
2015
Mixed media
Size unavailable

HARRISON TU
Untitled
2005
Ink
Size unavailable

SUE HAMMOND WEST
"the ascent"
2014
Acrylic on canvas
6'x6'

❖ ❖ ❖

HOVAB @ MACKY
Shark's Ink
September 1 – November 15, 2016
Curator: Joan Markowitz

SUZANNE ANKER
"Push Bar"
1979
Color lithograph with collage
Edition 13
22"x30"

TERESA BOOTH BROWN
"Jacket, Bag, Dress, Watch, Ring"
2014
Color lithograph/digital/collage
Edition 25
30"x22"

MATTHEW CHRISTIE
"Presence"
1995
Color lithograph
Edition 15
17¼"x15"

MATTHEW CHRISTIE
"St. Vrain"
1995
Color lithograph
Edition 15
17¼"x15"

EVAN COLBERT
"Eye Candy"
2011
Color lithograph
Edition 20
15"x22"

LUIS EADES
"Transoceanic I"
1980
Color lithograph
Edition 40
30"x18"

LUIS EADES
"Transoceanic II"
1980
Color lithograph
Edition 10
30"x18"

JIM JOHNSON
"Mondrian Shadowed"
1988
Color lithograph
Edition 30
25"x22"

ANA MARIA HERNANDO
"Las Aberturas, Los Organos
que Esperan"
2005
Color lithograph diptych
with cut outs
Edition 25
24"x20"

BARBARA TAKENAGA
"Angel (Little Egypt) State I"
2007
Color lithograph with gold
metallic powder
Edition 15
24"x20"

BARBARA TAKENAGA
"Angel (Little Egypt) State II"
2007
Color lithograph with
pearlescent powder
Edition 15
24"x20"

BARBARA TAKENAGA
"Angel (Little Egypt) State III"
2007
Color lithograph with gold
metallic powder
Edition 15
24"x 20"

BETTY WOODMAN
"Alessandro's Room"
2013
Color woodcut/lithograph
triptych with chine collé
and collage
Edition 30
27"x 80"

❖ ❖ ❖

**HOVAB @ First United Methodist
Sanctuary Gallery**
Connecting Threads
Curator: Barb Olson

ANNE BLISS
"Organa"
1988
Handwoven wool, natural dyes
(Indigo, cochineal, ragweed)
15.2"x13.25

BETSY BLUMENTHAL
"Stained Glass"
2004
Wool
49"x29"

BETSY BLUMENTHAL
"Tyvek Tapestry"
2008
Tyvek
54"x 34"

DIANA BUNNELL
"Totaled"
2004
Cotton and silver metallic fabric,
metallic thread, fused appliqué
56"x56"

JUDY DUFFIELD
"Cabin Fever"
2014
Hand-dyed fabric
23"x23"

JUDY DUFFIELD
"Autobiography of an Artist:
PastPresentFuture"
2016
Hand-dyed and commercial fabric
24" x27"

JO FITSELL
"Acceleration"
2011
Fiber, hand-marbled fabrics
65"x20"

CAROL GARNAND
"Columbine"
Silk painting
2004
36"x36"

JEANNE GRAY
"Autumn Waning"
2014
fiber--paper
84" x32"

JEANNE GRAY
"End of the Season"
2015
Fiber
48"x22"

MARY HORROCKS
"Self-Portrait in Rust"
2008
PFD cloth, pastel, iron oxide
deposition, hand embroidery
60"x24"

MARY HORROCKS
"This Ruined House"
2016
Vintage silk Gauze kimono, needle
felting, photo transfer, hand
embroidery.
60"x48"

MELODY MONEY
"Moonlit Canyon"
2016
Mixed media textile
43"x41"

MELODY MONEY
"Sky Prayers-Chinook"
2015
Mixed media textile
43"x37"

DENISE PERRAULT
"Lords and Ladies"
2001
Beads
26"x31"

MARY ROWAN QUINN
"Winter Ravens"
2009
Fiber
52"x24 3/4"

MARY ROWAN QUINN
"Still Life with Reflections"
2011
Fiber
31"x30"

ISOLDE STEWART, CHARLOTTE
LASASSO, RENÉE NELSON,
KAYANNE PICKENS, LAURA
MARSHALL
"Solstice Altars"
2002
Mixed media
Size variable

JUDITH TRAGER
"Watermelon Summer"
2000
Fiber
54"x 51"

BECKY VANDERSLICE
"Blooming Leaf Enlightened"
2014
Optic fiber, LEDs, indigo cotton and
bamboo yarns and controller.
20"x24"

CAROL WATKINS
"Prairie Rainbow"
2009
Inkjet printed on canvas, stitched with
threads and various yarn, appliquéd
organza.
42 x 34 (diptych each 21" w)

CAROL WATKINS
"Songs of Amphitrite"
2015
Inkjet printed on canvas, stitched with
threads
and various yarn, appliquéd organza
65"x70" (5 panels 13" each)

JOAN WOLFER
"Dirty Laundry"
2003
Embroidery
32"x24"

JOAN WOLFER
"Leaving"
2012
Embroidery
38"x21"

CHARLOTTE ZIEBARTH
"Butterfly Dance"
2000
Woven tapestry
44"x52"

CHARLOTTE ZIEBARTH
"Reverberations: Yellowstone Waters"
2012
Digital print on silk
42"x 62"

❖ ❖ ❖

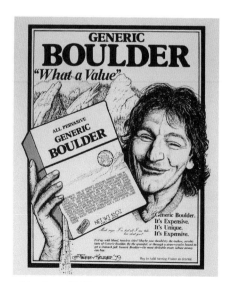

Terry Kruger, "Generic Boulder," n.d., poster. Martin and Taffy Kim Poster Collection, Boulder History Museum/Museum of Boulder.

Acknowledgments

In addition to our donors, curators, partners, contributors, and artists,
Celebration! A History of the Visual Arts in Boulder
wishes to thank:

15ᵀᴴ Street Gallery

Valerie Albicker & the University of Colorado Visiting Artist Program

Michelle Amateau Amato

Arrone Appel

Penny Barnow

Alexandra Baris

William Biety

Reed Bye

Jack Collom

Rebecca DiDomenico

Haley Garyet

Paul Gillis

Bruce Greene

Suranjan Ganguly

Mary Wohl Haan

Sandy Hale

Josie Heath

HR Hegnauer

Janet Heimer

Philip Hernandez

Ana María Hernando

Scarlett Joy

Alphonse Keasley

Jaime Kopke

Nicole Setty Koukou

Art Lande

Charlotte LaSasso

Kristen Lewis & the Museum of Boulder

David L'Hommedieu

Lucy R. Lippard

India Lovato

George Peters

Deborah Malden

Nikhil Mankekar

Bob Morehouse

Motus Theatre

Stanley Mullen

Bill Obermeier

Alan O'Hashi

Crystal Polis

Steven, Michael, & Jonah Markowitz

Lisa Metzger

Shannon Nesser

Katie Olson & Art Source International

Elvira Ramos

Greg Ravenwood

Elizabeth Robinson

Glenda Russell

Alyssa Setia

Sina Simantob

Dave Swartz

Brittney Scholnick

Jacob Ullman

Melanie Walker

Victoria Watson

Carl A. Worthington

Mary Dolores Young

And the many others who generously participated in HOVAB.

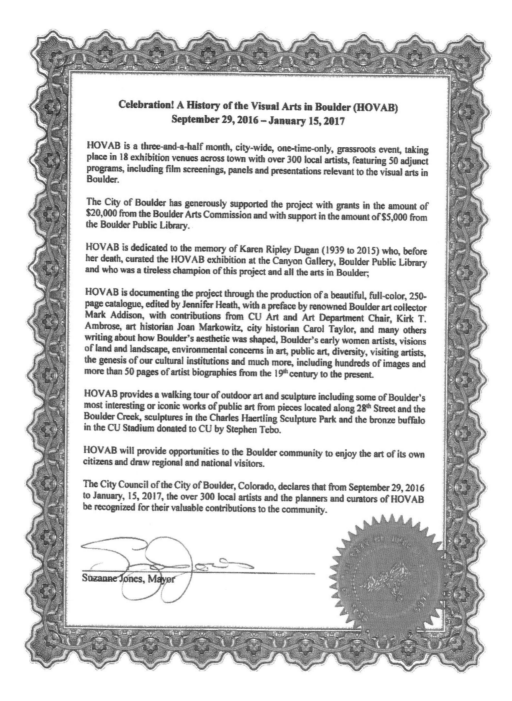

Celebration! A History of the Visual Arts in Boulder (HOVAB)
September 29, 2016 – January 15, 2017

HOVAB is a three-and-a-half month, city-wide, one-time-only, grassroots event, taking place in 18 exhibition venues across town with over 300 local artists, featuring 50 adjunct programs, including film screenings, panels and presentations relevant to the visual arts in Boulder.

The City of Boulder has generously supported the project with grants in the amount of $20,000 from the Boulder Arts Commission and with support in the amount of $5,000 from the Boulder Public Library.

HOVAB is dedicated to the memory of Karen Ripley Dugan (1939 to 2015) who, before her death, curated the HOVAB exhibition at the Canyon Gallery, Boulder Public Library and who was a tireless champion of this project and all the arts in Boulder;

HOVAB is documenting the project through the production of a beautiful, full-color, 250-page catalogue, edited by Jennifer Heath, with a preface by renowned Boulder art collector Mark Addison, with contributions from CU Art and Art Department Chair, Kirk T. Ambrose, art historian Joan Markowitz, city historian Carol Taylor, and many others writing about how Boulder's aesthetic was shaped, Boulder's early women artists, visions of land and landscape, environmental concerns in art, public art, diversity, visiting artists, the genesis of our cultural institutions and much more, including hundreds of images and more than 50 pages of artist biographies from the 19th century to the present.

HOVAB provides a walking tour of outdoor art and sculpture including some of Boulder's most interesting or iconic works of public art from pieces located along 28th Street and the Boulder Creek, sculptures in the Charles Haertling Sculpture Park and the bronze buffalo in the CU Stadium donated to CU by Stephen Tebo.

HOVAB will provide opportunities to the Boulder community to enjoy the art of its own citizens and draw regional and national visitors.

The City Council of the City of Boulder, Colorado, declares that from September 29, 2016 to January, 15, 2017, the over 300 local artists and the planners and curators of HOVAB be recognized for their valuable contributions to the community.

Suzanne Jones, Mayor

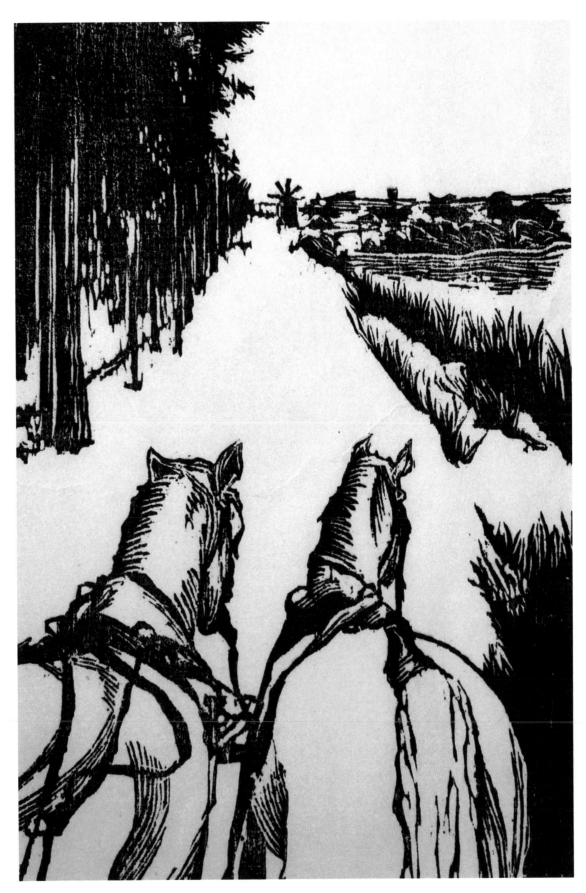

Dorothy Mandel (1920-1995), "In the Ruts of the Highway," n.d., woodblock print. Collection of Sibylla Mathews.

Gene Matthews (1931-2002), "Utterances 2," n.d. Oil on canvas. Collection of the First Congregational Church of Boulder.

Made in the USA
Charleston, SC
07 December 2016